TOULOUSE-LAUTREC

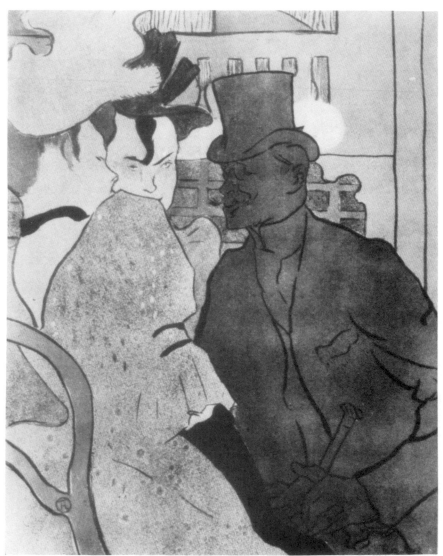

L'ANGLAIS AU MOULIN ROUGE

1892. COLOURED LITHOGRAPH. LUDWIG CHARELL COLLECTION, NEW YORK

GERSTLE MACK

TOULOUSE-LAUTREC

PARAGON HOUSE
NEW YORK

First Paragon House edition, 1989

Published in the United States by

Paragon House Publishers
90 Fifth Avenue
New York, NY 10011

Copyright © 1938 by Gerstle Mack

Published by arrangement with Alfred A. Knopf, Inc.

Library of Congress Cataloging-in-Publication Data

Mack, Gerstle, 1894–
Toulouse-Lautrec / Gerstle Mack. — 1st Paragon House ed.
p. cm.
Reprint. Originally published: New York : Knopf, 1938.
ISBN 1-55778-213-X
1. Toulouse-Lautrec, Henri de, 1864–1901.
2. Artists—France—Biography. I. Title.
N6853.T6M33 1989
760′.092—dc20
[B] 89-9288
CIP

Printed and bound in Canada

PREFACE

THERE arc painters whose work can profitably be examined, analysed, and evaluated as a thing apart, almost without relation to their daily lives. The artist can be separated from the man, the product from the producer. It would be impossible to apply such an impersonal method to a study of Henri de Toulouse-Lautrec. His background was woven so closely into the fabric of his art, his work and his life were bound together so intimately, that they must be considered as a unit. He painted no landscapes, no still lifes, no religious pictures, no abstract conceptions. All of his subjects, except for a few representations of animals, were people: real people whose lives were an integral part of his own life, whose characters and histories directly affected his own character and his own history. The setting, therefore, becomes immensely important, and a great deal of space is devoted to it in this book. To understand Lautrec, to appreciate his art, we must know the people he knew, the places he visited, and the circumstances that shaped his life.

Lautrec's viewpoint was intensely individual, yet curiously detached. He probed deeply beneath the surface, he exposed

vice with brutal frankness; but he condemned neither the victims of depravity nor the conditions that were responsible for it. He was content to record; he had no desire to reform.

As an artist he was a follower of Ingres, Daumier, Degas, and the Japanese rather than of the Impressionists and Cézanne. Drawing was more important to him than brush-work, line more significant than colour. He was a talented, sensitive, distinguished painter, not a strikingly original one. As a draughtsman, however, his right to a place in the front rank can scarcely be questioned. His drawings in pencil, crayon, and ink, his lithographs, coloured and uncoloured, are among the most superb examples of their kind. As a designer of posters he has never been surpassed.

" The evil that men do lives after them, the good is oft interred with their bones. . . ." It is not so much the evil that Lautrec did — for he did none, except to himself — as the sensational character of his life that has survived him. He is remembered, almost forty years after his death, as an aristocratic libertine, a frequenter of pot-houses and brothels, a dipsomaniac, a gnome with a warped body, who painted shocking pictures of prostitutes and the dissolute night-birds of Montmartre. All of this is true; but it is by no means the whole truth. There is another side to Lautrec, which — since it is less spectacular — has generally been slighted. He was at home not only in bars and brothels but in intellectual circles, among distinguished writers and poets, painters and engravers, doctors and musicians. He painted prostitutes and vagabonds, but he also painted an enormous number of portraits of eminently respectable friends. He had, indeed, a genius for friendship; he was able to inspire devotions and loyalties such as are given to few men. He possessed a keen intelligence, quick wits, captivating charm, and unquenchable courage. He was kind, generous, tolerant, scrupulously honest in thought and deed. But he was weak and he loved the good things of life too well: food

and drink, women, the gaiety of the dance-hall and the cabaret. Alcohol and dissipation killed him before he was thirty-seven.

To the many people who have given generous assistance in my quest for material, I gratefully tender my thanks. Especially, I am indebted to Madame Gabriel Tapié de Céleyran of Albi, Lautrec's cousin by both birth and marriage, for permission to visit the house in which Lautrec was born; to copy extracts from the unpublished manuscript of the Toulouse-Lautrec genealogy compiled by her late husband; and to examine a number of drawings by Lautrec in her possession. To Monsieur Edouard Julien, *conservateur* of the Albi Museum, for many photographs, both of Lautrec himself and of his works; for permission to inspect the portfolios of Lautrec's drawings owned by the museum; and for many other courtesies. To Madame Georges Dortu of Le Vésinet for permission to view her collection of Lautrec's works and to reproduce photographs of several items; to consult the original manuscript of the *Cahier de Zig-zags* and eight letters from Lautrec to Etienne Devismes, as well as a letter from Devismes to Lautrec's mother; and for much valuable assistance. To Madame Biais (Jane Avril) for many reminiscences of Lautrec and a detailed account of her own life. To Madame Michel Manzi for permission to quote extracts from an unpublished letter written by Lautrec's father to her husband, the late Monsieur Michel Manzi. To Monsieur Thadée Natanson and Monsieur Vuillard for personal recollections. To Monsieur and Madame Georges Séré de Rivière of Toulouse for permission to view their collection and to visit the château of Malromé. To Mr and Mrs Chester Dale of New York for permission to reproduce two paintings and a coloured lithograph in their collection. To Mr Sam A. Lewisohn of New York for permission to reproduce one painting, and to the Art Institute, Chicago, for permission to reproduce two paintings. To M. Knoedler and Company of Paris for photographs and many

courtesies. To the Kunstmuseum of Basel for permission to reproduce the *Portrait of Mademoiselle Gachet* by Van Gogh, and to the Gemeente Musea of Amsterdam for permission to reproduce the *Portrait of Van Gogh* by Lautrec.

<div align="right">G. M.</div>

Paris
April 1938

NOTE TO THE 1952 EDITION

Almost all of Lautrec's contemporaries who were living when this book was first published in 1938 are now dead. Among these are Jane Avril, who died in Paris about February 1, 1943; Yvette Guilbert, who died at Aix-en-Provence on February 2, 1944; and Tristan Bernard, who died in Paris on December 7, 1947.

Between 1938 and 1952 a number of Lautrec's works illustrated in this volume passed into the hands of new owners. The list of illustrations and the captions on Plates 9, 19, 20, 27, 29, 31, 34, 35, 37, 40, 45, 52, and 55 have been revised in accordance with these changes.

In order to bring the bibliography up to date I have added a list of books published since 1938.

<div align="right">G. M.</div>

New York
March 1952

ALBI

LATE one night in the eighteen-nineties a group of young painters and writers sat in a café in Montmartre. There were drinks on the little marble table; a huge pile of empty saucers indicated that a great many more had already been consumed. The air was hazy with smoke; glasses clinked; there was a steady buzz of conversation. At this particular table the talk was more animated and the laughter more uproarious than at any of the others. One man did most of the talking: a hideous little creature with a huge head, heavy eyebrows, an enormous fleshy nose, immensely thick lips that were very red and moist, and a short but bushy black beard that concealed his chin and partly covered the sides of his ruddy face. His ugliness was grotesque. His eyes, sparkling and intelligent, compensated to some extent for the unloveliness of the other features. But even they were far from perfect: decidedly myopic, they were disfigured by the thick lenses of a pince-nez attached to a black cord. His torso was ponderous, stocky, and ungainly. To complete the unprepossessing picture his body was shockingly ill-proportioned. From the waist up he was of average size, but his legs were so abnormally short that his total height did not exceed four feet six inches, and so weak that he could walk only with

3

the aid of a diminutive cane. They were the legs of a child feebly supporting the heavy body of a man of thirty.

That night as usual he was drunk, and his booming voice dominated the conversation at the table. He was obviously the leader of the little gathering. Stimulated by alcohol, his talk grew more and more brilliant, salty with epigrams and full of humorous allusions that sent his companions into gales of laughter. One of the listeners, a newcomer, rashly interrupted the little man.

" You are very witty tonight, Monsieur de Toulouse-Lautrec," he said.

" Sir," answered Lautrec, " in my family nobody has done a stroke of work for centuries. If I were not witty I should be a fool indeed."

Lautrec was not in the habit of boasting about his ancestors; in fact he seldom spoke of them, and when he did, it was generally in some such mocking fashion as this. Mockery was essential to him, as essential as the alcohol that flowed down his gullet in a steady stream. They were his only defences, and he used them both liberally. With their help he could live and work and even smile wryly when some chance remark called attention to his fantastic appearance. His friends, of course, had the good taste to avoid such slips; but strangers were not always so considerate. Once at the Moulin Rouge he was drawn into an argument between two women. One of them was boasting about her dog's pedigree.

" But he's hideous," the other protested.

The owner of the dog held her ground:

" Look at his black muzzle. That's a sure sign of breeding."

And turning suddenly to Lautrec, who was sitting at the next table:

" Isn't it true, monsieur, that one can be very ugly and still have an excellent pedigree? "

The painter brought his charcoal-smeared hand to his temple in a smart military salute as he replied:

4

" Are you asking *me*? "

Yet in his heart Lautrec was proud of his heritage, proud of his distinguished name and the knightly traditions of his family. And in his own curious fashion he succeeded in living up to those traditions. Though much of his short life was spent in the tawdriest of environments, surrounded by pimps and prostitutes in brothels, bars, and dance-halls, he remained from beginning to end the aristocrat he was born. His body was pitifully warped, but his spirit rose above deformity, defiant and free.

* *

The ancestors of Henri de Toulouse-Lautrec-Monfa fought and ruled in Languedoc for more than a thousand years before he was born. The record goes back without a break almost to the time of Charlemagne. The first name that occurs is that of Fulguald or Fulcoald, Count of Rouergue, envoy of Louis the Debonair to the wild plateau region of the Larzac, east of Albi, in 837. The county of Toulouse and the duchy of Aquitaine were annexed by Fulguald's elder son, Fredelon or Fridolo, who succeeded his father in 845 and was in turn succeeded seven years later by his brother Raymond I.

During the next two hundred years other lands and titles were added: the counties of Quercy, Albi, and Nîmes, the marquisates of Narbonne and Gothia. In the eleventh century two brothers, William IV and Raymond de Saint-Gilles, quarrelled over the succession, and the war between them lasted from 1066 to 1079. The dispute was settled by a separation of the estates; William, the elder, took the county of Toulouse with all its dependencies, while Rouergue and Narbonne went to Raymond. But very soon thereafter Raymond reunited most of the family heritage under a single head by purchasing the county of Toulouse from his brother. This same Raymond de Saint-Gilles played a prominent part in the First Crusade, to which he is said to have led a hundred thousand men.

5

His son Bertrand, who had been appointed administrator of the estates during his father's absence, was involved in a struggle with Aquitaine, now an independent duchy and a powerful rival of Toulouse. William IX of Aquitaine claimed the overlordship of Toulouse in the name of his wife Philippa, daughter of the William IV who had ceded the county to Raymond de Saint-Gilles twenty years earlier. William IX succeeded in capturing the city of Toulouse in 1098, but was forced to relinquish it two years later. The quarrel was renewed during the reign of Alphonse-Jourdain, Bertrand's half-brother and successor, who was born in Palestine and died there in 1148.

Raymond V, son of Alphonse-Jourdain, is best known to posterity as a liberal patron of the troubadours, the famous poets and minstrels of Provence. Through his first wife, Constance of France, daughter of Louis VI and sister of Louis VII, a strain of royal blood was introduced into the family. Once more war broke out with Aquitaine, now ruled by Eleanor, grand-daughter of William IX and wife of Louis VII of France. After Eleanor's divorce from Louis and her marriage to Henry II of England, Henry took up the quarrel and obliged Raymond V to do him homage for the county of Toulouse.

During the following generation Languedoc was drenched in blood by the cruel, relentless persecutions of the Albigensian Crusade. Failing to suppress the heresy by peaceful means, Pope Innocent III ordered the Cistercians to preach a holy war against the Albigenses in 1209. This intensely bitter religious struggle split the house of Toulouse into two factions. Brother fought against brother. Raymond VI, oldest son of Raymond V and Constance of France, took the part of the persecuted dissenters and battled desperately against the papal crusaders led by Simon de Montfort; while Baudouin, the youngest son, championed the opposing party. Captured by the Albigenses in 1214, Baudouin was condemned to death; and by his brother's order he was hanged from the limb of a walnut tree at Montauban.

6

Raymond VI was married five times. His fourth wife was Joan of England, daughter of Henry II and Eleanor of Aquitaine and sister of Richard Cœur-de-Lion. After the death of Joan's grand-daughter in 1271, without issue, the elder branch of the house of Toulouse came to an end. Its estates and titles were merged with those of the French Crown.

The younger branch, which still exists, springs from the unhappy Baudouin who was hanged by his brother at Montauban. About 1187 Baudouin married Alix, Viscountess of Lautrec, thus uniting the families of Toulouse and Lautrec. The genealogical records of the Lautrecs, like those of the counts of Toulouse, go back as far as the ninth century. They were, from the earliest days, a wealthy and powerful family, only less prominent in the history of Languedoc than the house of Toulouse itself. In the thirteenth century the name and estates of Monfa were added; but the combined name in its present form, Toulouse-Lautrec-Monfa, does not seem to have been used officially until the fifteenth century.

The semi-independent sovereignty of the counts of Toulouse ended with the extinction of the elder line in 1271. Thenceforth they were loyal subjects of the French king. For generation after generation members of the family filled high positions at court and as officers in the king's armies. During the Seven Years' War Charles-Joseph-Constantin de Toulouse-Lautrec played an active part in the campaigns in France. His son Raymond, born in 1771, emigrated to Holland during the Revolution and married there, but after the restoration of the monarchy he and his family returned to their estates in the neighbourhood of Albi. Raymond's great-grandson, Count Raymond-Bertrand, born in 1870, is the present head of the house.

Charles-Joseph-Constantin's youngest son, Jean-Joseph, was the great-grandfather of the painter Henri de Toulouse-Lautrec. Jean-Joseph had one son, Raymond-Casimir, who in 1837 married Gabrielle d'Imbert du Bosc. This union pro-

duced four children: Alphonse, born August 10, 1838, the painter's father; Charles, the " Uncle Charles " to whom Lautrec wrote a number of youthful letters; Odon; and a daughter, Alix.

Intermarriages were not uncommon in the enormous family of Toulouse-Lautrec-Monfa. Henri's father and mother, for example, were first cousins. His paternal grandmother, *née* Gabrielle d'Imbert du Bosc, had a sister named Louise who married Léonce Tapié de Céleyran; and their daughter, Adèle Tapié de Céleyran, became Henri's mother. Born at Narbonne on November 23, 1841, she was married to Count Alphonse de Toulouse-Lautrec-Monfa on May 9, 1863.

The Tapiés originated at Azille-en-Minervois in what is now the department of Aude. In the sixteenth century they moved to Narbonne, where the heads of the family were granted royal appointments as consuls of the city with the title of Seigneurs de la Clape. The name of Tapié de Céleyran was acquired at the end of the eighteenth century, when Esprit-Jean-Jacques Tapié was adopted by his *oncle à la mode de Bretagne* (his father's first cousin) Jacques Mengau, " *seigneur en toute justice haute, moyenne et basse* " of Céleyran, near Narbonne.

* *

Henri-Marie-Raymond de Toulouse-Lautrec-Monfa was born at Albi on November 24, 1864, at number 14 rue de l'Ecole-Mage. The street has now been renamed rue Henri de Toulouse-Lautrec, but little else about it has been changed since the day of his birth. It is narrow and winding, paved with rough cobbles. Number 14 is by no means impressive when seen from the street; but from the courtyard, and especially from the back of the house, which is built into the old town wall and overlooks the ancient moat, now filled in and skirted by a wide modern boulevard, the effect is very fine indeed. It is a large house, faced partly with red brick, partly

with stone. Some of it is probably as old as the medieval wall itself, but it has been added to and modified a dozen times in the course of centuries. This property was originally part of the estates of the Imbert du Bosc family, to which both of Lautrec's grandmothers belonged. It is now occupied by Madame Gabriel Tapié de Céleyran, herself a Toulouse-Lautrec by birth (a third cousin of the painter) and widow of Lautrec's first cousin.

In addition to the house in Albi a number of country estates and châteaux belonged to various branches of the family, and at one or another of these Lautrec spent several months of each year during his childhood. At irregular intervals these visits were repeated throughout his life. His favourites, as a boy, were Céleyran, situated on the site of the Roman Castra Cæsarea between Narbonne and the sea; and the Château du Bosc, nearer Albi in the department of Aveyron.

Although Lautrec's ancestors had been noted for centuries as brilliant soldiers, courtiers, and administrators, none had ever been distinguished in the gentler arts of painting, sculpture, literature, or music. Yet artistic ability of a sort was not altogether lacking in the family. Lautrec's father dabbled, now and then, in sculpture, modelling clay figures of horses, dogs, and other animals. His uncle, Charles, had a flair for sketching. Farther back, Lautrec's great-grandfather, Jean-Joseph de Toulouse-Lautrec, had revealed an unmistakable talent for painting. He exercised this talent only for his own amusement, as befitted a noble gentleman of his day; but he did produce a few small portraits of considerable merit. One of these is a pencil drawing of his son Raymond-Casimir (Lautrec's grandfather, born September 12, 1812) as a baby of fifteen months, in the act of dropping a coin in a beggar's hat; behind the child is a pot of fleurs-de-lis, and below is the caption:

"Etrennes à Maman
1er de l'an 1814"

9

This drawing is the subject of a letter written by Lautrec's father to Maurice Joyant shortly after the painter's death:

" Albi, Wednesday evening, 28 May 1902
" Dear Sir,

" It appears that your friendship for my son has been re-warded by a successful exhibition [of his works]. So much the better. I was somewhat doubtful about it myself, having but slight confidence. By this post I am sending you, registered, a photograph which is interesting from the point of view of ' atavism.' It is of a portrait, in pencil, of *my* father, drawn by *his* father, who was Henri's great-grandfather; he died young, at the same age [as Henri], about thirty-seven. The composi-tion is full of sentiment, for it combines the political faith of my family, symbolized by the fleurs-de-lis, with charity, and bears the simple dedication: a gift to Mother. If you consider it worthy of a place next to Henri's work I have no objection to its exhibition, if it is not too late.

Very cordially yours,
Alph. de Toulouse-Lautrec "

The first indication of a talent for drawing in Lautrec him-self appeared when he was a child of three. The occasion was the baptism of his baby brother Richard-Constantin-Marc-Marie, born at Albi on August 28, 1867. After the ceremony in the baptistery of the cathedral Henri toddled after the pro-cession to the sacristy, giving his hand to a canoness, who was shocked because the little boy's short socks exposed his bare legs in church. When the time came for the signing of the par-ish register Henri whispered:

" I want to sign too! "

" But you don't know how to write yet," answered the canoness.

But Henri was not to be discouraged so easily.

" Well then," he said, " I'll draw an ox! "

10

The baby Richard was not destined to live long. He died almost exactly a year after his birth, on August 27, 1868, at Loury, near Orléans, where his father had rented a large game preserve in the woods with a hunting lodge to accommodate his family.

During the sojourns at Céleyran, and perhaps sometimes at Albi as well, Henri's early education was supervised by Mademoiselle Armandine d'Alichoux de Senegra, a member of the Tapié de Céleyran household. Léonce Tapié de Céleyran, Henri's maternal grandfather, had married twice, and Mademoiselle Armandine was a sister of his first wife. She never married; after her sister's death and her brother-in-law's second marriage to Louise d'Imbert du Bosc, she remained at Céleyran as a welcome guest until she died in 1893.

The limits of Mademoiselle Armandine's erudition were soon reached, and more competent instructors were called in to continue Henri's education. Until he was eight years old he was not sent to school. He was a delicate child, slightly rachitic, and it was thought better for him to have private lessons at home. His mother, cultivated and well-read, took charge of some of his studies herself. She was especially proficient in Latin, and as Henri had a natural flair for languages he was soon able to read and write Latin with ease. A little later he studied Greek, German, and English. He could speak English fairly fluently. To perfect his knowledge of the language he translated an entire book from English into French: a work on falconry by Salvin. Joyant, from whom this information is derived, does not give the name of the volume; it was probably either *Falconry in the British Isles* by Salvin and Brodwick or *Falconry; its Claims, History and Practice* by Freeman and Salvin.

Lessons, of course, did not occupy all his time. There were plenty of companions of his own age to play with, a swarm of young cousins whom he saw frequently at Céleyran and the Château du Bosc, and who in turn were invited to visit him at

Albi. Though his health was anything but robust, he was not so fragile that he had to be treated as an invalid. He could romp and play games, if they were not too violent, as well as the other boys. The two things he loved best as a child were boats and animals. He never tired of sailing his toy boats when he was in the country; of seeing them scud across the perilous ocean which was the garden pond, at the mercy of every puff of wind; and of dashing to their rescue when, as often happened, they ingloriously capsized. An even greater delight was the farmyard: the patient draught oxen, the goats, pigs, ducks, and chickens; above all, the dogs and horses. He watched them, fascinated, for hours on end, noting every line, every curve, every movement of their bodies. This habit of concentration, of sharply focused observation, developed so early, remained with him throughout his life and profoundly influenced his work.

COUNT ALPHONSE

It is easy to account for Lautrec's love of animals, especially of horses. For generations his ancestors had been enthusiastic horsemen in war and peace, in cavalry charges and hunting parties. His great-grandfather, the Jean-Joseph who painted delicate little portraits, was thrown from his horse and killed, while hunting, at the age of thirty-seven. His great-uncle Pons, Jean-Joseph's brother, also met with an accident during a hunting expedition in the company of his friend the Count of Artois, afterwards Charles X of France; but on this occasion the result was much less tragic. A quaint rule of etiquette decreed that every rider, immediately after a tumble, should empty his bladder then and there; and the future King, seeing Pons pick himself up unhurt, shouted:

" *Vite, pisse Pons, pisse Pons!* "

And for the rest of his life the unfortunate gentleman was known by no other name than Pisse-Pons.

Lautrec's father inherited in full measure the family passion for riding and hunting. During his cadet days at the military academy of Saint-Cyr, and later as an officer in a regiment of mounted lancers, he was known as a daring, though not a reckless, horseman: a leader in racing, jumping, and the steeplechase. Fearless and tireless, he could wear out three horses in

a day and come home fresh, ready for a long night of dancing and love-making. When he married, at the age of twenty-five, he resigned his commission in the army. Thereafter he devoted himself entirely to hunting and other sports. He meticulously observed all of the elaborate rules of the game: his horses, hounds, and retrievers were trained to perfection, his guns and other equipment the finest that money could buy. To Count Alphonse the actual slaughter of the foxes, deer, and game-birds that he pursued so eagerly was far less important than the pleasure of the chase itself. He had a genuine love for the wild things of the woods and lakes, a sensitive appreciation of their grace and radiant beauty. In *Autour de Toulouse-Lautrec* Paul Leclercq tells of an incident that illustrates this gentler side of the count's character. One day he invited a friend, an enthusiastic sportsman, to shoot wild duck on his property near Orléans. It was very hot, and the expedition involved long hours of uncomfortable travelling, first by train and carriage and later on foot up interminable steep paths through heavy undergrowth. When at last they reached the lake, exhausted and sweating from every pore, they were rewarded by the sight of hundreds of wild birds flying overhead. The guest quickly unstrapped and loaded his gun, but Count Alphonse seized him by the arm:

" My dear friend, my *dear* friend," he begged, " please don't shoot. These birds are the delight of my eye, and if you shoot you will frighten them all away — they might never come back."

Of all forms of hunting his favourite was the ancient and difficult sport of falconry. The falcons were raised and trained for him by an expert named Martin at Rabastens, a village between Albi and Toulouse. It was no uncommon event to see Count Alphonse, in Paris as well as at Albi, carrying one of these savage birds of prey, hooded, on his wrist and feeding it dripping shreds of raw meat. He practised falconry as a fine art, with all the traditional ceremony of bygone centuries.

Lautrec's father was often in Paris, where for years he kept a room on the ground floor of the Hôtel Pérey, a quiet, aristocratic hostelry — which still exists — at 5 cité du Retiro, a sort of courtyard with two entrances, one from the north side of the rue du Faubourg Saint-Honoré, the other from the rue Boissy-d'Anglas. This refuge overflowed with miscellaneous objects pertaining to the chase: guns and fishing-rods, saddles and bridles, clothing and equipment for every conceivable form of hunting were piled in corners and festooned about the walls. He even kept some of his pet birds there, and one of them, according to an anecdote related by Joyant, was the innocent cause of a sensation in the French Secret Service. The bird in question was an eagle owl, called in French a *grand-duc,* used as a decoy to lure the falcons back to their owner after a flight. The count, shortly after leaving Paris for Albi, suddenly remembered that he had left this bird in his room at the cité du Retiro. Fearing that it might starve or die of thirst if left unattended, he telegraphed to the concierge:

" *Sauvez le grand-duc."*

Somehow the telegram attracted the attention of the police. Anarchist plots were prevalent at the time, and the authorities immediately suspected an attempt against the life of one of the Russian grand dukes who happened to be living in the rue Royale, only a stone's throw from the Hôtel Pérey. The mystery was cleared up, of course, but only after twenty-four hours of feverish activity on the part of the police.

As he grew older, Count Alphonse developed strange eccentricities. His unconventional behaviour gave rise to countless amusing anecdotes, many of which are vouched for by Lautrec's most reliable biographer, Maurice Joyant, who knew both the painter and his father intimately for many years.

The count loved to dress himself up in outlandish garments: one of his favourites was a Highland costume, complete with bonnet and sporran, in which he had himself photographed. He is said to have horrified his family by coming to dinner one

day in this Scottish dress, but with the kilt replaced by the tarlatan ruffles of a ballet skirt. Again, he would appear, to the amazement of the passers-by, in the fringed deerskin outfit and fur cap of a Canadian trapper and solemnly engage in an otterhunt in the streets of Paris. Sometimes he drove in the Bois in a Norwegian cart drawn by a Shetland pony. On other days he would sally forth in the barbaric costume of a wild Kirghiz horseman. His actions were as eccentric as his dress. He insisted on taking a party of embarrassed friends to a gala matinée at the Opéra-Comique in a little open carriage which he drove himself, with an enormous cage filled with twittering birds suspended between the wheels " to give them a breath of air." He was discovered by his servants, one dark night, with a lighted candle in one hand and a large hat-box in the other, looking for mushrooms in the garden.

Perhaps the most fantastic exploits of this extraordinary gentleman were his frequent excursions to the Bois de Boulogne, at the fashionable hour, on a mare saddled and bridled in Cossack fashion. Arrived at the most crowded and conspicuous corner of the park, he would calmly dismount, produce a large cup, and proceed to milk the mare; then, after drinking the milk with evident enjoyment, he would mount and continue his ride without the slightest trace of self-consciousness.

Count Alphonse had a quick temper and was inclined to resent any lack of deference from those whom he considered his social inferiors. On one occasion, as he was driving his four-in-hand in the country, a regiment of artillery crossed ahead of him and forced his team to one side of the road. That was bad enough; but when the colonel of the regiment, in passing, raised his whip as if to strike at one of the horses, the count's rage knew no bounds: he promptly attacked the offending officer and rained blows on him with the only weapon he had at hand — a large red umbrella.

Gustave Coquiot tells of another controversy with the eccentric nobleman: a controversy in which Coquiot was personally

involved, but which, fortunately, did not end in violence. In 1912 Coquiot was at work on the manuscript of his biography of Lautrec. The count, then seventy-four years old, was furious when he heard of the project; such presumption could not be tolerated for a moment. He immediately challenged the writer to a duel. It was to be no ordinary combat, however, but was to be fought according to the rules of chivalry observed by his long-dead crusading ancestors. He stipulated that Coquiot, a man of common clay, should be armed only with a wooden stick; while he himself, the aristocrat, was to carry a medieval lance. Furthermore, he was to stand in a sort of trench filled with soft earth, because his corns hurt him! After much argument the fiery old man was persuaded by his friends to forgo this knightly encounter, and Lautrec's biographer escaped the threatened chastisement.

Other tales are told which Joyant, while he does not accept them literally, admits are not inconsistent with the prankish character of Lautrec's father. One of these concerns a large tent made of camels' hair, which the count is said to have had erected in the square in front of the cathedral at Albi, and which he used as a temporary abode. Another tells of his supposed habit of washing his own clothes in the gutter of the cité du Retiro because he could find no laundress in Paris who would do them to his satisfaction.

From all of this it will be seen that Count Alphonse was something of an exhibitionist, and rather a trial to his friends and family. Yet it would probably be going too far to call him actually insane. Extravagant as many of his actions undoubtedly were, it must be remembered that, once a man has acquired a reputation for eccentricity, exaggeration inevitably creeps in: layer after layer of anecdote is added, some true, some invented, and some a little of both. Moreover, it is natural that, in such a man's life, all of the absurdities are remembered and recorded, while all that was completely normal, and therefore not amusing, is forgotten.

COUNT ALPHONSE

The married life of Alphonse de Toulouse-Lautrec and Adèle Tapié de Céleyran was not a happy one. Temperamentally the pair had little in common. The countess was shy, retiring, extremely devout, and a great reader. She had all the domestic virtues of a good bourgeoise. Unlike her husband, she was content with the quiet life of a small provincial town or an isolated château, far from the troubling gaiety of Paris. There was never a formal separation, and to the end Count Alphonse came home from time to time, for a week or a month; but for long periods he would stay away, in Paris or on his woodland property at Loury. The estrangement was fairly complete — probably complete enough to account for the fact that, after the birth and early death of little Richard, there were no more children. Except during that one short year of his brother's life Henri was an only child.

Count Alphonse and his wife, incompatible as they were, were alike in one respect: neither of them understood their son very well. But their behaviour towards him differed very much indeed. The countess adored him; all his life, though she was shocked and disturbed by his painting, and immeasurably bewildered and saddened by his mode of life, she remained near him, devoted yet not too demanding, always at hand when he needed her, resigned to loneliness when he did not. His father, on the other hand, paid little attention to him when he was a child. He was waiting impatiently for the day when the boy, strong and handsome, a true descendant of his heroic ancestors, would be old enough to accompany him on hunting expeditions. Until then he preferred to leave the boy's training to his wife. Henri was to be brought up as the son of a wealthy landed proprietor, with the expectation that, in the course of time, he would succeed to his father's title and estates. He was not destined to do so. Both of his parents survived him for many years. His father died in 1913 at the age of seventy-five; his mother in 1930, aged eighty-nine.

SCHOOL

IN 1872, when Lautrec was eight years old, the family moved to Paris. There they remained for three years, residing at the Hôtel Pérey. Lautrec was sent to school at the Lycée Fontanes (now the Lycée Condorcet) at 8 rue du Havre, near the Gare Saint-Lazare. He was registered as an *externe,* or day pupil, and lived at the hotel with his mother. The records of his career as a student, which are still preserved in the school archives, indicate that he was a brilliant scholar. In almost every subject, as well as in deportment, he received the highest marks attainable.

According to these records Lautrec first entered the school in October 1872, just before his eighth birthday, and was enrolled in the eighth form *préparatoire,* an intermediate class between the ninth or beginners' form and the eighth form proper. The eighth form *préparatoire* was under the supervision of Professor Mantoy. The following year he was not entered, for some reason — possibly ill health — until after the school term was well under way, in December 1873. In spite of the late start his marks in the eighth form, under Professor Jammes, were excellent, and when the term ended in July 1874 he was awarded several prizes: first prizes in Latin

composition, Latin translation, French grammar, and English; second mention in recitation, third mention in history and geography. In arithmetic, however, he received only fifth mention.

His third and last year at school was very short indeed, again probably because of his uncertain health. The records show that he entered the seventh form on November 23, 1874 and left, apparently for good, on January 9, 1875. Allowing for the interruption of the Christmas holidays, he can have spent only a few weeks at school during the entire year. This was the end of his school life, but by no means the end of his education. After a sojourn at Amélie-les-Bains, a watering-place in the eastern Pyrenees very near the Spanish frontier, his lessons were resumed at home with the help of private tutors under the watchful supervision of his mother.

At the age of ten, and perhaps even earlier, Lautrec's passion for drawing was already well developed. There was little opportunity for the formal cultivation of his talent at the Lycée Fontanes, but that did not prevent the boy from filling his lesson-books with sketches of horses, dogs, and birds, as well as amusing caricatures of his fellow students. One of these exercise-books, of a somewhat later date (1879–1880), is now in the possession of Madame Gabriel Tapié de Céleyran at Albi. The pages abound in little drawings that betoken a sense of form and a keenness of perception astonishing in a lad of fifteen.

It was at the Lycée Fontanes that he first made the acquaintance of Maurice Joyant, who afterwards became his closest friend. Joyant was born at Mulhouse, in Alsace, on August 16, 1864; the two boys were therefore of almost exactly the same age. They were in the same form at school, and inseparable. Later on, circumstances kept them apart for a number of years, and it was not until 1888 that they met again. Thenceforward, and particularly after Joyant was made director of the galleries of Boussod, Valadon et Compagnie, picture dealers, in 1890,

they saw each other almost daily until Lautrec died eleven years later. Joyant's loyalty did not end with the painter's death: during the years that followed he devoted much of his time and energy to the preservation of his friend's pictures and the defence of his reputation, both as man and as artist. Immediately after Lautrec's death his parents delegated to Joyant the formidable task of classifying, listing, dating, and marking with a special stamp every item of his work that was left in his studio: paintings, pastels, water-colours, and hundreds of drawings, finished and unfinished. The painter's mother gave Joyant some assistance in this labour of love; but Count Alphonse, realizing that he had never understood his son's work any better than he had understood his character, wisely kept his hands off. He wrote to Joyant on October 22, 1901:

" I am not pretending to be generous in turning over to you all my paternal rights, if I have any as the heir to what our dead son has created; your fraternal friendship has so gently replaced my feeble influence that it is only logical for me to ask you to continue to play your charitable rôle, if you are willing to do so, merely for the satisfaction of your kindly feelings towards your old school friend; now that he is dead, I am not likely to undergo a sudden change of heart and praise to the skies what I could never believe, while he lived, to be more than bold and daring studio productions."

And again on February 4, 1902:

" Although, for the most part, I considered his works a little too carelessly executed, you must believe that I am relinquishing my rights in them to you, with all my heart and without regret, purely from honourable motives, and not because I disdain them; if their author had not been my son, the mere fact that he was dead would not have made me go into ecstasies over pictures which seemed to me to be hewn with an axe, though that was really due only to the boldness of his temperament."

In a third letter, dated March 11, 1902, Lautrec's father stresses the same point:

" You have more faith in his work than I have, and you are right."

Fortunately this undertaking could not have been entrusted to more capable hands. Joyant's conscientiousness was above praise, and his familiarity with every detail of Lautrec's daily life enabled him to classify, and in most cases to date, his pictures and drawings with meticulous accuracy.

Joyant was largely responsible for the establishment of a museum for the permanent housing and exhibition of Lautrec's works in his native city of Albi. The museum, which was inaugurated on July 30, 1922, occupies several large galleries in the Palais de la Berbie, the ancient episcopal palace, a veritable fortress of red brick which stands just to the north of the great cathedral of Sainte-Cécile. Joyant, who was a member of the board of directors, gave to the museum several important pictures from his own collection and obtained a number of donations from other owners. In 1926 he published his excellent biography of Lautrec, so thoroughly documented and so full of personal reminiscences that it must always remain the chief source of information concerning the painter's life. Joyant died on November 6, 1930, as a result of injuries suffered in a motor accident four months earlier.

It was to Maurice Joyant that Lautrec once sent a photograph of himself as a child of four or five (Plate 3) with an inscription on the back: " *A M. J., l'autre homme célèbre.*" In return, Joyant sent Lautrec his own picture taken at about the same age.

Another friend of Lautrec's schooldays at the Lycée Fontanes was Louis Pascal, his cousin on the Tapié de Céleyran side. Pascal was in the same class as Lautrec and Joyant. He had pronounced literary tastes, and in January 1878 he founded a

tiny newspaper, *L'Echo Français,* in collaboration with an-
other school chum named Portalis. The youthful editors called
on Lautrec, then thirteen years old, to contribute a story; he
sent them *L'Histoire du Pélican et de l'Anguille,* which was
accepted with enthusiasm and duly printed. But this promis-
ing venture into journalism lasted only six months. When Pas-
cal and Portalis left the Lycée Fontanes in the summer of 1878,
the newspaper came to an end.

The friendship with Louis Pascal, however, continued
throughout Lautrec's life. Lautrec's mother was exceedingly
fond of the Pascals, who lived near Bordeaux; and it was chiefly
in order to be near Madame Pascal, her first cousin, that the
countess purchased the château of Malromé from the de For-
cade family, about 1880. It was a lovely old house beautifully
situated on a wooded hill in its own park, four miles from the
town of Langon in the department of Gironde and about thirty
miles from Bordeaux. Malromé was her favourite residence,
and Lautrec loved it too.

BROKEN BONES

On New Year's Day 1876, when Lautrec was eleven years old, his father presented him with a book on the subject nearest his own heart, falconry: *La Fauconnerie Ancienne et Moderne* by J.-C. Chenu and O. des Murs, published in Paris in 1862. On the fly-leaf was inscribed, in the handwriting of the sport-loving count, the following words:

" Remember, my son, that life in the open air and in the light of the sun is the only healthy life; everything which is deprived of liberty deteriorates and dies quickly.

" This little book on falconry will teach you to enjoy the life of the great outdoors, and if, one day, you should experience the bitterness of life, dogs and falcons and, above all, horses will be your faithful companions and help you to forget a little.

<div align="right">Comte Alphonse de Toulouse
January 1876 "</div>

There can be no doubt that this dedication was a sincere expression of the count's philosophy. In it are implied all his fondest hopes for his son's future: the boy was to grow up sound in wind and limb, an ardent sportsman, a magnificent

rider, a fearless hunter, a passionate lover of outdoor life. He could not foresee, as he wrote, that none of these wishes would ever be gratified; that, within the next three years, a series of accidents would change his well-proportioned son into a permanently deformed little monster.

The first of these disasters occurred on May 30, 1878, in one of the small drawing-rooms of the house at Albi. Lautrec, then thirteen years old, slipped on the hardwood floor and fell, breaking his left leg. Fortunately the family doctor, who was paying a professional visit to the boy's grandmother, was in the room when the accident happened, so the fracture received immediate treatment. For some months the leg was kept in a plaster cast, but as soon as the child could hobble about he was taken by his mother to recuperate at various resorts: Amélie-les-Bains, Nice, and Barèges — the last a prettily located spa in the heart of the Pyrenees south-east of Lourdes.

Fifteen months after this mishap, in August 1879, he broke the other leg at Barèges. A letter from Count Alphonse to Maurice Joyant, written after Lautrec's death and quoted in Joyant's biography, gives a graphic account of both accidents:

" His constitution was so frail that he fractured his left femur, and then, only a year later at Barèges, his right one, as a result of trifling tumbles.

" The first fracture took place here, at Albi, on May 30, 1878, on a poorly waxed floor, as he was getting up from a low chair with the aid of a cane, in the presence of his mother and my mother and, by the irony of fate, in the presence of the doctor as well! The second was due to a fall, not much more severe than the first, while he was taking a walk with his mother near Barèges; he rolled into the bed of a dry creek, not more than three or four feet deep. While his mother ran for the nearest doctor, who was at the military hospital, the injured boy remained seated without a whimper, carefully holding his broken leg straight out with his hands: his whole character is revealed

by that gesture. Brave in adversity, severe in his treatment of himself, he might have become embittered early in life and have borne a grudge against his mother and myself for having condemned him to a life of misery. But, as his real friends are well aware, he remained gay during the last twenty years of his life, and very popular, except with the bores whose conversation he hated . . . not very different in that respect, I suppose, from you or me."

The mention of a cane in this letter suggests that, even before the first of these unlucky fractures, Lautrec's legs were weak and unsteady. The origin of this infirmity cannot be determined exactly. Both his parents were apparently strong and healthy; but they were first cousins, and it is probable that some latent weakness that manifested itself in an abnormal brittleness of the bony structure, too slight to be noticeable in either his father or his mother, was transmitted to their son in an accentuated form. Evidently Count Alphonse himself believed the taint to be hereditary; such a belief is the only possible explanation of the phrase " a grudge against his mother and myself." Whatever the cause, the result of these two fractures was tragic. In spite of operations, exercises, and agonizing manipulations, the legs ceased to grow. The upper part of his body developed normally, year after year, until it became the body of a full-grown man. The legs remained those of a child of fourteen.

In 1878, while Lautrec was recovering from the effects of his first fracture at Barèges, he became acquainted with Etienne Devismes, a lad two or three years older than himself. When they parted in the autumn, Devismes returning to his home in Paris and Lautrec to Nice, with his mother, for the winter, a correspondence was begun which continued, at intervals, for the next three years. Eight of Lautrec's letters to Devismes have survived. Young Devismes seems to have shared Lautrec's passion for the sea: the letters are full of references to

ships, rigging, and other nautical matters, and some of them contain delightful sketches of boats. The first letter is headed merely: " Nice, Sunday "; a pencilled note by Maurice Joyant reads: " January 1879 — after his first fracture in May 1878." The nature of Etienne's " accident " is unknown:

" My dear friend, you would not believe how deeply I was moved by the news of your accident, although you make light of it. You tell me that you have suffered for three long months, and I made a fuss about being laid up for only forty days, during which I did not suffer half the time. Ah! how I should have liked to be able to keep you company, if I could have been sure of entertaining you even twenty or a hundred times less pleasantly than you made the time pass for me at Barèges. Do you remember those famous shrouds, hawsers, blocks, and bobstays? You say that you would like to see one of my masterpieces or sketches. I should like to send you something worth while, but I don't know what subject to choose. You will think my menu is very diversified, but it isn't; the only choice lies between horses and sailors; the horses are more successful. As for landscapes, I am quite incapable of doing any, even as backgrounds: my trees look like spinach and my sea looks like anything you want to call it.

" The Mediterranean is the devil to paint, just because it is so beautiful.

" The fleet has not returned, but I was impressed by the sight of the Russian frigate in the harbour of Villefranche; she was so dressed-up from the tip of her mainmast to the waterline, but not including the sailors, who were very poorly turned out. . . .

" Write to me as soon as possible what you would like to have from the three of us (myself, my palette, and my brush), and I shall send you a daub on which you can exist during a long sea voyage, on the larboard tack and with a spanking breeze behind you.

" Farewell, my very dear Etienne. I hope this letter will not give you a headache, for really the game is not worth the candle.

" I clasp your hand heartily and beg you to present my respects to your mother and affectionate greetings to André [Etienne's brother].

<div align="right">Henri de T.-L."</div>

The next letter is undated, but is marked by Joyant: " 1879 — Nice? " In his biography of Lautrec, Joyant places it first of all, even before the one just quoted, but he gives no reason for doing so. The point has a certain importance because of the mention of the broken leg: if this letter was written before the other, in January 1879, Lautrec must have been referring to the first fracture, but if it was written several months later he may have meant the second break, which occurred in August 1879. In either case Lautrec was evidently whiling away the tedious hours of convalescence by putting together a toy sailboat, in connection with which he frequently found it necessary to apply to his more expert friend for technical advice:

". . . On Monday the surgical crime was committed, and the fracture, so admirable from a surgical point of view (but not, be it understood, from mine), was laid bare. The doctor was delighted and did not bother me any more until this morning. Then, this morning, under the shallow pretext of making me stand up, he let my leg bend at a right angle and made me suffer atrociously.

" If you were here only five little minutes a day! How easy it would be for me to contemplate my future sufferings with equanimity! I pass the time making hatchways (the bobstays and shrouds kept me busy scarcely half a day). But wouldn't it be better to make the ramming-block out of brass instead of wood, and should it be painted or merely varnished?

". . . Must the sheet be unhitched from the jib in order to change it? "

Lautrec made a pencil sketch of one of the doctors who attended him; but as Joyant dates this drawing 1881, it probably does not represent the doctor who performed the operation mentioned above. The following letter indicates that Lautrec's passionate interest in everything pertaining to boats has subsided to some extent and that painting is beginning to absorb more of his attention:

" *Nice, 11 February 1880*

" *Mea culpa, mea culpa, mea maximissima culpa!!!!* I search in vain for other terms in which to make you understand, my very dear friend, all the regrets I feel for not having replied sooner to your charming and delightful letter. I am not at all anxious to have you file me away in your mind in the pigeonhole labelled *idiots* who are incapable of dipping their pens to answer a friend's letter.

" We are at Nice and you are in Paris; we have learned that from my grandmother, who received cards from you on New Year's Day. I imagine you are doing your best not to let the extraordinary weather, which the newspapers are bestowing on you with such prodigality, make you melancholy [the winter of 1879–1880 was one of the coldest on record throughout northern Europe].

" Here we have been broiling in the sun! I say ' have been ' because for the last two days (on account of the Carnival, no doubt) the Eternal Father has opened the celestial floodgates to their full extent; I could almost have sailed the cutter in the garden.

" Speaking of the navy, my enthusiasm has died down a little, but it has only changed its form; painting has replaced it, my room is full of things that do not even deserve the name of daubs. But it passes the time.

" And what are you doing, for what examination are you preparing, and do you often go to the Musée de la Marine?

" André must be at Arcueil now, according to the plans [he made] at Barèges, and he must be making valiant onslaughts against his compositions and his translations, those most infamous of all scourges!!!! I have seen Ludovic de Solages again, he has shaved his moustache to make it grow more luxuriantly. Do you ever see him?

" Now, my dear fellow, I must stop. I have a German lesson hanging over me like a sword of Damocles. I hope to resume these chats often if they do not bore you too much. . . ."

There are no more letters to Devismes, or at least there are none that have been preserved, for the next year and a half. During the interval Lautrec took the examinations for the first part of his baccalaureate in Paris in July 1881, but failed to pass. At about the same time Devismes wrote to him concerning a story he planned to write and asked Lautrec to illustrate it. The tale recounts the adventures of a horse named Cocotte and a certain curé. The original manuscript of this youthful effort and the twenty-three drawings in India ink that Lautrec made for it are now owned by Madame Gabriel Tapié de Céleyran. The story has never been published, nor have Lautrec's illustrations ever been reproduced. The drawings, made when Lautrec was not quite seventeen, are exceedingly lively and amusing. His letter to Devismes is undated; Joyant has marked it: " August 1881 ":

" *Hôtel des Bains, Lamalou-les-Bains (Hérault)*
" Dear friend,
" You must think me very ungrateful if you believe that I have forgotten the patience with which you used to sit by my bedside. I have left Paris, having failed in French recitation for the degree of Bachelor of Letters. I received your pearl in

prose only the day before yesterday. Here I am in a miserable desert of red earth, but the countryside looks something like Bagnols. I want to get to work, but I shall be glad to collaborate with you on your story. You are really too kind to take notice of my poor pencil, which will do what it can, you may be sure; nevertheless I hope to be able to produce something on the subject of *Cocotte*. I shall try to be quick about it."

In the next letter, also dated by Joyant: " August 1881 " and apparently written a few days later, there is another reference to the proposed collaboration:

" Are you at Barèges?

" That is the question that haunts me in my bath, in my bed, and on my walks. Truly, all the hideousness of this nasty place vanishes like a smudge of charcoal in a puff of wind when I think of the hours you were good enough to pass at my bedside.

" You will say that I am turning sentimental; nevertheless this is nothing but the truth.

" At present I am at Lamalou, a resort whose waters are impregnated with iron and arsenic (mildly, the doctor says), for the purpose of soaking myself internally and externally. It is much drearier than Barèges, *quod non est paululum dicere,* but at any rate one does not break one's shanks here (at least I haven't succeeded in doing so yet). Our winter in Nice ended badly on account of my aunt's illness, I took advantage of the delay to continue my sea baths. I had no less than fifty of them, in time I was able to jump out of a boat I was paddling about. This will demonstrate two things:

" 1st. That my locomotor extremities show considerable improvement.

" 2nd. That I have recovered my fondness for the sea and by the same token for little boats. At this very moment I am nego-

tiating for the construction of a two-foot wherry; the provoking part of it is that all of those I have seen have very broad hulls and ride low in the water, while I want mine to be very slim.

" But I see that I am chattering away like an old magpie, so, reiterating my request to be told what style of painting you require to conform to your ' inspiration ' (it's frightfully cheeky of me and I must get to work) , I clasp your hand heartily.

" P.S. Please write to me, for I look forward to your letters, at the Château de Céleyran, near Coursan (Aude) ."

When the drawings were finished Lautrec sent them off for his friend's approval with a letter ascribed by Joyant to: " August, September, or October 1881 ":

" *Etablissement Thermal de Lamalou l'Ancien* (*Hérault*)
" My dear friend,

" I have done my best and am sending you by this post twenty-three drawings, one of which is in duplicate because of an accident. Perhaps the sketches are a little too animated, but it seems to me that the text is no less lively. Poor *monsieur le Curé!* As I am entirely at your service, write to me if you want any modifications and return to me, if you please, any drawings that you cannot use. If you want an altogether new set of drawings, I am your servant, so happy am I that you have cast a glance at my rudimentary inspirations.

" I have tried to draw something real, not something ideal. Perhaps it is a fault, for warts do not appeal to me and I like to embellish them with playful hairs, to enlarge them, and to make the knobs shine.

" I don't know if you can control your pen, but when my pencil starts to go I have to give it its head, or *patatras!* — it won't work.

" Well, I have done my utmost, I hope that you will be indulgent. What joy if — but one must not count one's chickens before —

"Farewell, I clasp your hand cordially. The unfledged painter,

<div align="right">H. de T.-L.</div>

"P.S. — Write me a line quickly. Am feverish."

Devismes must have replied with a letter overflowing with enthusiastic praise, for a little later Lautrec wrote again. The letter is dated by Joyant: "November or December 1881," but may well have been written in October:

<div align="center">"<i>Château du Bosc, par Naucelle (Aveyron)</i></div>

"My dear friend,

"I thought I had gone a little mad when I read your generous and charming letter. I never expected such kindness: that you should accept my miserable sketches and thank me for them into the bargain. And you are most conscientious with regard to my drawings. Use any of them you like. I suggest especially the head with the rats and the skull surrounded by helmets. One in particular might be eliminated, the sentimental cottage. The others, *ad libitum*. I know that you will choose well, and am only too happy if a single one pleases you. I am returning your manuscript, which I kept in case there were more sketches to be made.

"Well, I am thrilled, delighted, mad with joy, at the idea that perhaps your prose will brighten up my sketches like a display of fireworks, that you offer me a helping hand along the difficult road of publicity, and finally that I have been able to appreciate a little an old friendship which only improves with age."

Lautrec painted a small portrait of Devismes which Joyant ascribes to 1881. If this date is correct he must have seen his friend some time during that year, but there is no other record of the meeting. In November Lautrec took his examinations

<div align="right">33</div>

for the baccalaureate again, this time at Toulouse, and passed successfully. In the last letter of this series, dated by Joyant: " 22 November 1881," he wrote the good news to Devismes:

" Albi, Tarn

" Dear friend,

" Caught up in the whirl of the baccalaureate (I passed this time), I have neglected my friends, my painting, and everything that is worth while in this world, for my dictionaries and the useful handbook.

" Well, the jury in Toulouse accepted me, in spite of the nonsense I uttered in my replies! I used quotations from Lucan that never existed, and the professor, wishing to appear erudite, received me with open arms. Well, it's over now.

" Would it be indiscreet to ask what is happening to *Cocotte*? . . . You will find my prose very flat, due to the moral flabbiness that has followed the tension of the examination period. Let us hope that it will be better next time."

The letter is adorned with an absurd drawing of Lautrec himself being quizzed by a pompous professor with a bald, dome-shaped head and immense spectacles; between them is a table littered with books and writing-materials.

After this there is no further mention of Etienne Devismes. He seems to have grown into a pious young man, devoted to good works; and as Lautrec's life developed along very different lines they naturally drifted apart. Nevertheless Devismes kept in touch with Lautrec's mother, whose piety was equal to his own, for many years. In 1910, nine years after Lautrec's death, Devismes entered a monastery. Before retiring from the world he proceeded to burn all the letters and other papers that reminded him of the life he was leaving, but he could not bring himself to destroy Lautrec's letters. Instead of consigning them to the flames he sent them to the countess on March 21, 1910, with a touching letter of farewell:

34

". . . Among them [my papers] I found a delightful little series of eight letters from your poor Henri, containing some charming sketches. In the midst of the emotion caused by the sacrifice of all my souvenirs, I had to smile at the memories evoked by them, and I have saved them from the fire in order to send them to you, knowing that your heart will cherish them lovingly. For you will find in them the imagination, the humour, and the gentleness of his early youth. And how clearly the artist and the humourist are foreshadowed in these drawings as well as in the text. . . ."

ZIGZAG JOURNAL

IT would not have been surprising to find that Lautrec's disposition had become permanently soured as a result of his physical misfortunes. The successive fractures, the long months of slow and often painful convalescence, the apprehension — which all too soon became a certainty — that he would be crippled for life: all this, coming at so early an age, might well have broken the boy's spirit and caused him to develop into a peevish hypochondriac. Nothing of the kind actually happened. At no time did his courage falter. With exemplary patience and phenomenal self-control he refused to clutter up his life with vain regrets. He never complained; he wanted no sympathy and snubbed unmercifully anyone unwise enough to offer it. There were moments of bitterness, of course. But life was still rich, and his ability to enjoy it was unimpaired. People interested him immensely, and his powers of observation were exceptionally keen, even in boyhood.

Lautrec's letters to Devismes are full of examples of his unquenchable gaiety and his bubbling sense of the ridiculous. An even better illustration of these qualities is to be found in the little journal that he kept during the month of January 1881, at Nice, when he was sixteen years old. This journal,

36

scribbled in an ordinary exercise-book, is garnished with sixteen pen-and-ink sketches drawn with great freedom and exhibiting a genuine flair for caricature. The original manuscript is now in the possession of Madame Georges Dortu of Le Vésinet. The journal is reproduced in full, with all the drawings, in *L'Amour de l'Art* for April 1931. It is headed *Cahier de Zig-zags appartenant à H. de T.-L.* and is dedicated " to my cousin Madeleine Tapié, with the praiseworthy intention of diverting her a little from the lessons of Madame Vergnettes — Nice 1881." In the following extract some of the less amusing portions are omitted:

"FROM NARBONNE TO NICE

" We left Céleyran in fine weather, but it was sloppy because it had been raining. Much mud. Having said farewell to Grandmother, Mother and I proceeded to get mildewed (we took turns at it) in the *salle des ' Pas Perdus,'* as one of the station employees called it while I was standing guard over the hamper. Mother went into the courtyard and came back again. We waited for Uncle Albert. Finally, as a last resort, we went into the waiting-room, where there was an English family (already). There was a big boy who looked like a mulatto, he was so yellow. Uncle Albert turned up at last, and we got ready to leave. We saw (in the buffet) a small boy who was being sent back to school, out of which he had been taken probably because of the New Year holidays. After a nap in the waiting-room a helpful assistant put us aboard the train, bound for Marseilles. It was about 11 o'clock and clear moonlight.

" As fellow passenger we had an indeterminate creature (I found out later it was a gentleman) who from time to time emitted sounds whose origin puzzled me completely. An ugly young man, who forgot to close the door after him so that a great deal of freezing air was blown into our compartment, got in. . . .

" This time we really started off. Morpheus, who is a very genial god (be it said between ourselves) overpowered me, and after waking up once at Arles I remained awake for good. Our fellow traveller woke up too, and I observed that he was a very chic person, a real gentleman. Then Marseilles. Everybody changed trains. We climbed into the same carriage as the chic gentleman, we changed again at Toulon and found ourselves with a family of foreigners (Mother insisted they were Portuguese) consisting of a father (an old fool), two daughters, a son (uncertain), and an old governess who was dreadfully ugly. Judge for yourself, my cousin, from the sketch (a flattering one) I made of her. Our trip was tiresome in every way because our seats were in the middle of the compartment and we had to eat our lunch in that position. I saw the fleet anchored off Golfe Juan, and the old patriarch waved a knitted cap thinking he had pulled out his handkerchief. This detail had escaped my notice; I am indebted to Mother for it. Tickets, please! Nice!!!

" We got out. No Adolphe. We hired a tattered vagabond for 50 centimes and went to the hotel on foot.

" Nobody had expected us on this train. M. Adolphe was busy making a screen to divide our room into two. It was Aunt Alice's room.

" AT NICE

". . . My neighbour is a certain Mademoiselle Lecouteur de Jessey. She is overripe. Opposite us are an Armenian and a young Russian doctor who is a nephew (by adoption) of M. Nanikoff. Most of the other guests are ugly old English ladies. We saw old Captain Campbell (an old acquaintance), the Misses Parson, American ladies whom we had the honour of knowing last year, and Mrs Elliot, who (I learned later) will soon be (keep it a secret) 50 years old, and who looks at most

30. She was married a little while ago to a Member of Parliament, Mr Isaac.

" *19 January.* — Forgive me, my dear cousin! Laziness, and still more the bad weather, have tied my hands!! Rain, *flic, flac,* mud, mire, irritation, all of these have been bestowed on us lavishly by the Eternal Father. Disgusting, isn't it?

" To continue. . . . It's not very gay here. . . . At the table I stare at the Armenian and pass the mustard to Mademoiselle Lecouteur. It's almost as lively as a convent. . . .

" M. Feltissoff (M. Nanikoff's nephew) has a brother who was married last night. To celebrate the occasion he gave a little party for the family. . . . Having arranged this for after dinner, they all got themselves up in style. We left our table, they took our places. I was in the hall, boring myself considerably, when Mlle Lecouteur came up, very politely (if I had only known what was in store for me!), and invited me to play some childish games. I had seated myself next to a very tall and very ugly Miss who arrived two days ago, when Adolphe came to tell me that a gentleman wished to speak to me (if I had only known!). I hurried to the lobby, but he dragged me into the dining-room. I had scarcely entered when M. Feltissoff stuck a flower (his own, if you please) in my buttonhole, and Madame, having made me sit at her right, ordered me four different things to drink. At first I protested, but M. Feltissoff would not listen. So I began to drink a little. M-m-m-m. Pretty good, eh? You know it's only the first glass that counts. It went down very nicely. Meanwhile the rest of the party, who had begun drinking some time before, became sentimental. There were toasts. To the newlyweds! Oh, Mme Viroulet! By that time things were so boisterous that M. Morgan and M. Virtain kissed Mme Viroulet. Eugène danced like a monkey, M. Lévi cried ' Hip, hip, hurrah! ' and I had a raging headache.

" A little later I went very sheepishly to bed. It was no use.

Oh, I felt very queer. I was beginning to ask myself if that would last long, when suddenly a frightful upheaval answered the question for me. You can imagine! I'll spare you a recital of the pretty names Mother called me.

" *Wednesday, 26 January.* — After an unpropitious start some money has been collected, and there is going to be a dance this evening. I shall try to tell you about it.

" Dinner at half past five. We were all nervous, in anticipation of the great event. Then the table was removed, and only a section left for the buffet. I watched these preparations in the company of a phlegmatic Englishman who smoked a pipe; the canvas dance floor was tacked down and made slippery with soap. We went to dress ourselves up. You can imagine what a serious matter it was, I looked almost clean."

Lautrec's drawing of himself looking " almost clean " that illustrates this page of the diary (Plate 7) is curious in one respect: it shows him with legs of normal length in proportion to his total height. Yet numerous photographs prove conclusively that at no time after the second fracture could his legs have been so long. Perhaps at the age of sixteen he was still hopeful that they would begin to grow again; therefore he represented himself as he wanted to be, not as he actually was. If he had any such illusion he soon discarded it. In all the later caricatures of himself the grotesque shortness and crookedness of his legs are, in fact, exaggerated; he did not spare himself. The journal continues:

" Downstairs again. We were still in the salon. There were two young Englishmen, magnificent, who have the room next to ours; their two sisters, exactly like umbrellas dressed in pink [Plate 7], were invited too, as well as a little Miss in blue with red hair. . . .

" I went into the hall. The orchestra was there, a piano (belonging to the hotel) , a 'cello, and a violin. . . . *Dzin, boum,*

boum, the ball was opened, with four dancers. We began to hum the tune, it was useless (two of the Misses who live in the hotel, the most enthusiastic dancers of all, were not there because of illness) until a bevy of innocent young beauties swept onto the floor; among them Mlle Lecouteur (aged 35), Miss Armitage (a female chimpanzee, a clergyman's sister, 50 winters old), and Miss Ludlow (who laughs like a hen and whose age is midway between the ages of the other two)"

PRINCETEAU

THE COURSE of Lautrec's life was profoundly affected by the failure of his broken legs to grow to average size and strength. He was doomed to a life of physical inactivity; the strenuous outdoor existence to which he had been dedicated by his father, and towards which, moreover, he was drawn by his own nature and his early training, was no longer conceivable. He could neither ride nor hunt nor take part in any sports that required physical endurance. He could swim fairly well, but the effort soon exhausted his feeble muscles. The occupations and pastimes traditionally appropriate to the life of a country gentleman were barred to him forever. Of all the vocations to which he was attracted by temperament only one was left open to him: crippled as he was, he could still draw and paint. Fortunately the urge was strong, and his talent could not be questioned.

To the biographer, speculations in the field of " might have been " are tempting but dangerous. One cannot help wondering what Lautrec's career would have been if he had had the health and strength and stature of the average man. Would he have become a serious painter just the same? Would he have abandoned painting altogether to devote himself exclusively to hunting and other sports? Or would he have tried to

42

combine the two, dabbling in art as a gifted amateur, like his great-grandfather, his father, and his uncle, while he continued to engage in more vigorous but equally congenial pursuits? It is at least probable that he would have been torn, all his life, by two conflicting ambitions: to excel in sports, and to paint great pictures. And it is not unlikely that he would have accomplished neither. With two such irreconcilable aspirations struggling for supremacy within him he could scarcely have given to either the necessary whole-hearted concentration.

Whatever *might* have happened, Lautrec's future was settled, irrevocably, by his deformity. His youthful interest in sports and games of skill remained with him throughout his life; he never lost his love for horses, dogs, and birds, for boats and everything pertaining to the sea. But all of these things became sublimated, of necessity, into subjects for his brush and pencil. He was a constant attendant at wrestling and boxing matches and a familiar figure at horse-races, where he haunted the paddocks and was on intimate terms with all the jockeys. He frequented the circus, fascinated by the equestrian performances, the capers of the trained dogs, the absurd antics of the clowns, and the daring exploits of the acrobats, whose grace was the antithesis of his own painful awkwardness. When the bicycle came into vogue in the eighteen-nineties Lautrec was among the most enthusiastic devotees of the new sport — as an onlooker, of course. He loved to watch yacht-races and regattas, and even went to bull-fights when, for a year or two, they were permitted in Paris. At all of these spectacles and entertainments Lautrec's sketch-book was in constant use. In his studio, aided by his pencilled notes but relying for the most part on his astonishing capacity for memorizing every detail, every posture, of the men and animals he studied so carefully, he produced hundreds of drawings, water-colours, pastels, and oils. A very large part of his total output consists of subjects connected, in one way or another, with the world of sport.

43

As if to compensate to some extent for his physical misfortunes, Lautrec was spared two of the difficulties that so often harass and check the budding artist: poverty and parental opposition. Here there was plenty of money: there was no necessity for him to earn his own living, and in fact he would have outraged all the aristocratic traditions of his family had he expressed a desire for a commercial career. On the other hand, painting, for one of his station, was considered an acceptable if not exactly an honourable vocation. To his father, Lautrec's deformity was a bitter disappointment which he made no effort to conceal. This dwarfed and almost helpless creature was nothing like the stalwart, handsome, dashing youth he had visualized as his companion on hunting expeditions. How could anyone be proud of such a miserable little cripple? Count Alphonse dismissed his son from his mind; he pitied him, when he thought of him at all, but he was supremely indifferent to the boy's future. Let him paint, if he wanted to, or sit at home and twiddle his thumbs. What difference could it make?

Fortunately it made a great deal of difference to Lautrec's mother. She adored her son and passionately wanted him to be happy — as happy as anyone with a pair of stunted legs could be. Without ever really understanding his work, she encouraged him and did her best to help him realize his ambitions.

* *

While Lautrec was still a schoolboy in Paris, his father had presented him to René Princeteau, at that time a well-known painter who specialized in pictures of horses and dogs. Princeteau, like Lautrec, was a native of the Midi: he was born at Libourne, not far from Bordeaux. He was a deaf-mute; possibly from Lautrec's point of view this affliction was a blessing, since Princeteau's teaching could never degenerate into tiresome lectures. During the period of Lautrec's adolescence, especially from his fourteenth to his eighteenth year, Prince-

teau's influence was paramount. It was on the whole a healthy influence: too academic and prosy to last, but just what Lautrec needed at the time. Princeteau was an uninspired painter but an exceedingly conscientious and capable teacher. Arsène Alexandre writes in *Le Figaro Illustré* for April 1902:

" One artist, moreover, had considerable influence over the young man; this was a painter of sporting and hunting sub-jects, M. Princeteau, with whom Lautrec, while still a school-boy, loved to spend his idle hours as a friend and neighbour. In his [Lautrec's] studio have been found sketch-books dating from his earliest years, containing sketches by Princeteau and himself, all mixed up together. Both groups exhibit much skill in their rapid strokes, their elaborate drawing; only a certain hesitation and inexperience characterize the pupil's work, and sometimes one must look twice to determine which is which. Princeteau's sketches are often full of imagination and gaiety, and these early lessons cannot have failed to de-velop Lautrec's comic sense."

This curiously assorted pair, the crippled boy and the middle-aged deaf-mute, spent much time together, not only in Paris but at Albi, where Princeteau was a welcome visitor. The older man patronized his young pupil, referring to him as his " studio nurseling"; while Lautrec called Princeteau " master " and made copies of his pictures. A large painting of a cuirassier, signed: " Lautrec 1881, copied after Princeteau," still exists. But Lautrec did not confine himself to copying; he did a vast amount of original work under Princeteau's amused but very alert guidance. Considering that these were the years of Lautrec's convalescence, that he was often in great pain, and that first one leg and then the other was encased in splints and plaster for months at a time, both the quantity and quality of these early studies are remarkable.

Princeteau sometimes entrusted to his young friend and dis-

45

ciple odd jobs of research and preparation for his own pictures. One such task is mentioned in two letters from Lautrec to his uncle, Count Charles de Toulouse-Lautrec, quoted by Joyant:

" *Céleyran, 2 January 1882*

" My dear Uncle,

" I have a commission from the master (Princeteau) to attend to; he has asked me to trace a drawing from one of his albums, no doubt for a picture he is working on, and I am going to ask you to be good enough to bring me the two Princeteau albums that are in Mother's linen cupboard (Grandmother will open it for you), in the same box as the books on falconry. The box is of white cardboard with green stripes, you have seen me paw through it often enough; please bring me the books from Albi.

" Long live painting!

Nepos "

Apparently something went wrong with this project, for a few days later Lautrec wrote again:

" *Céleyran, 17 January 1882*

" My dear Uncle,

" We have been the palpitating witnesses of plans and counterplans for going to Albi and returning here. Is it decided? But I want to tell you about the drawing for Princeteau.

" As I do not like to keep him waiting too long, and as I am not at Albi myself (obvious truth), I shall ask you to be kind enough to make the tracing in question. It's the second or third drawing in the large album, representing a pack of hounds holding a young boar (this is what Princeteau says) by the ears; you are to send it to him rolled up. . . ."

Coquiot quotes an extract concerning Lautrec from a letter written by Princeteau shortly before his death in 1914:

46

". . . I was distressed particularly by his ' lack of form.' My poor Henri! He came to my studio every morning; when he was fourteen, in 1878, he copied my studies and made a portrait of me that made me shudder.

" During his holidays he painted portraits, horses, dogs, soldiers, gunners practising their manœuvres, all from nature. One winter at Cannes [Princeteau should have written ' Nice '] he painted boats, the sea, and horsewomen.

" Henri and I used to go to the circus to see the horses, and to the theatre to see the settings. He was a great connoisseur of horses and dogs."

These visits to the circus and the theatre made a deep impression on Lautrec. The impression seems to have been almost exclusively a visual one: at the theatre it was the scenery, the costumes, and, above all, the gestures of the performers and the postures of the dancers that interested him. He cared very little for the play as a literary production. Words had no power to stir him. He was never fond of reading; books, to him, were but dull and inadequate substitutes for the movement and colour of the living world.

Princeteau's studio in Paris was located in a sort of impasse or courtyard at 233 rue du Faubourg Saint-Honoré. Several other artists had studios in the same building: among them the painters John Lewis Brown, Forain, and Busson, and the Viscount du Passage, a sculptor. Most of them were men of some social position, members of good clubs, frequenters of the equestrian promenades in the Bois de Boulogne, spectators at all the smart events of the racetrack and the horse show. Lautrec, while yet a child, was sometimes allowed to accompany them to these spectacles. He was received kindly, with a touch of condescension, in their studios.

John Lewis Brown, like Princeteau, was a painter of horses, especially in hunting scenes and military compositions. Though of Irish origin, he was born at Bordeaux in 1829 and

lived in France most of his life, dying in Paris in 1890. His influence on Lautrec was similar to that of Princeteau but less powerful, inasmuch as his association with the younger man was more casual and of shorter duration.

Much more important to Lautrec was his acquaintance with Jean-Louis Forain. Born at Reims in 1852, Forain began his career as an artist in orthodox fashion: he entered the Ecole des Beaux-Arts and enrolled as a pupil in Gérôme's atelier. But his independent and rebellious spirit soon put an end to his academic training. He was poor, and for a time was obliged to peddle his own drawings from house to house in order to earn a very meagre living. By the time Lautrec met him, however, Forain's talent was beginning to be recognized, and his circumstances had improved sufficiently to enable him to rent a studio. His drawings were accepted by various illustrated papers; at first only by obscure journals, but the beautiful quality of his line, economical yet extraordinarily powerful, eventually attracted the attention of more prominent editors. In the eighteen-nineties he became a steady and prolific contributor to several popular periodicals: *Le Courrier Français, Le Rire, La Vie Parisienne, Le Figaro, L'Echo de Paris,* and others. To most of these Lautrec also contributed during the same years, though the volume of his newspaper work never equalled that of Forain's.

Forain painted a great many pictures, but he is far better known for his lithographs and drawings. He was undoubtedly the greatest caricaturist of his day and one of the greatest of all time: a worthy successor to Daumier, to whom he has often been compared. With a few deft strokes of his pencil he laid bare, for all the world to laugh at, the petty meannesses and absurd pretensions of bourgeois respectability. He was caustic yet never spiteful: his attacks were directed against the foibles of a class, not against individual weaknesses. His subtle and occasionally ribald sense of humour took some — but not all — of the sting out of his bitter comments on the manners and

morals of contemporary society. All of this delighted Lautrec and exercised a certain influence over much of his later work. Not that he ever imitated Forain, either in his technique or in his approach to a subject; but Forain's gift for suggesting the essential character of his figures without a single superfluous line opened his younger colleague's eyes to the great virtue of economy. There was always, however, this difference between the two men: Forain, more the reformer, pilloried the infirmities of the world in which he lived, while Lautrec was content merely to present them.

BONNAT

AFTER he had passed the examinations for the first part of his baccalaureate at Toulouse in November 1881, Lautrec decided that he had had enough tutoring. He had no wish to be a scholar, and by this time all his thoughts and ambitions were focused on painting. It was an easy matter for him to persuade his indulgent mother and his indifferent father to let him do what he pleased. But he felt that he had outgrown Princeteau's teaching: it was time for a more formal course of instruction. Princeteau was of the same opinion and suggested that Lautrec should enrol as a regular pupil in Bonnat's atelier in Paris. To Paris, accordingly, Lautrec went in March 1882.

Léon Bonnat, born at Bayonne in 1833, had studied in Spain and Italy and had travelled widely in the Orient. He exhibited at the Salon for the first time in 1857; was made a Chevalier of the Legion of Honour in 1867, and a Member of the Institute in 1881. By the time Lautrec entered his studio Bonnat was one of the most popular painters in France. His pictures — especially his portraits — fetched high prices. In Bénézit's *Dictionnaire des Peintres, Sculpteurs, Dessinateurs et Graveurs* he is called " the favourite painter of millionaires." He was in fact the paragon of " official " painters: academic, dry, impervious to new ideas, and violently intolerant of unorthodox ex-

50

perimentation in any form. He was the implacable foe of the gallant little band of Impressionists who were then fighting their grim battle for recognition against the powerful forces of official reaction.

It should have been obvious from the first that Bonnat's atelier was no place for Lautrec. Even at the age of seventeen he had far too much originality and verve to be able to work contentedly in this atmosphere of academic dry rot. The few months that he spent at Bonnat's studio were not, however, entirely wasted. He worked industriously in charcoal as well as in oils, and his studies of the living model improved rapidly in firmness and economy of line. Bonnat himself, though quite without imagination, was a master of technique; his criticisms, which were generally harsh, taught Lautrec some of the elementary principles of composition. Undoubtedly he learned something from his fellow pupils also. It was the first time that he had worked in the company of young men of his own age, and he must have absorbed a good many useful ideas from the example and the shop-talk of his associates.

He found one of Bonnat's pupils, Henri Rachou, particularly congenial. This youthful friendship continued long after the atelier days were over: Rachou held his place in the small circle of Lautrec's intimates until the latter's death. He was the brother of a banker who lived at Albi; and when Lautrec went to Paris to study under Bonnat he was given a letter of introduction to Rachou by a common acquaintance, an Albi jeweller named Ferréol.

Very shortly after Lautrec's arrival in Paris he wrote to his favourite Uncle Charles. The letter is quoted by Joyant:

" *Paris, 22 March 1882*

" My dear Uncle,

" I am keeping my promise to let you know what is happening. In accordance with everybody's advice, I shall go to Bonnat's Sunday or Monday. Princeteau will present me. I have

been to see the young painter Rachou, Bonnat's pupil and a friend of Ferréol's, who is beginning to work on his own; he is sending a picture to the exhibition.

" Princeteau is working at a huge boar-hunting scene that strongly resembles the tracing of his sketch. He is working like a nigger, for he is behindhand. In the Hôtel Pérey there is a lady from the island of Mauritius whose coppery complexion would delight you.

" I have been to the exhibition of water-colours, a beautiful show in a magnificent setting. In particular there are a head by Jacquet, life-size, of a woman from the Béarn district, and some Tunisian scenes, done from nature, by Detaille.

" I am sending you the illustrated catalogue.

" Now as to my plans again. I shall probably enrol in the Ecole des Beaux-Arts in order to take part in the competitions, and work under Bonnat at the same time.

" All of this is very engrossing, all the more so because the Horse Show, the Marche [a park near Ville-d'Avray, where steeplechase competitions were held four times a year], and Auteuil [the races] fill the horizon. On Monday we dined with Uncle Odon [a brother of Count Alphonse and Uncle Charles]; the barber's shears have dealt harshly with his family. Raymond's hair has been cut short at the temples and Mlle Mahéas has arranged hers in a capricious and rollicking fringe. . . ."

Apparently Uncle Charles, who considered himself a connoisseur of pictures and was himself an amateur painter of some ability, had notified his nephew that he proposed to visit Paris to see the works of art displayed at the Salon, for shortly afterwards Lautrec wrote again:

" *7 May 1882 — Sunday morning*

" My dear Uncle,

" I have obtained the most precise information, not from M. Bonnat, who is too majestic for me to question, but from several of the exhibitors.

" The exhibition will be open until June 20, but it will close for a week at the end of May so as to give the jury a chance to deliberate over the awarding of medals. So you have time enough, but there is so much to see; I shall mention the *Portrait de Puvis de Chavannes* by Bonnat, the *Fête du 14 Juillet* by Roll, and the *Derniers Moments de Maximilien* by J.-P. Laurens.

" Perhaps you are curious to know what kind of encouragement I am getting from Bonnat. He tells me: ' Your painting isn't bad, it's clever, but still it isn't bad, but your drawing is simply atrocious.'

" And I must pluck up my courage and begin again, and erase all my work with bread-crumbs. . . ."

A strange criticism, truly, of the work of one of the world's great draughtsmen. A glance through Lautrec's sketch-books is enough to demonstrate how completely wrong Bonnat was when he called his drawing " atrocious," even at that early date. Yet, when we consider Bonnat's academic bias, it is not surprising that Lautrec's painting should have been more palatable to his master than his drawing. At seventeen or eighteen Lautrec was still conservative in the composition and technique of his paintings, while his drawings already exhibited unmistakable signs of an originality and power that could only have earned Bonnat's disapproval.

Lautrec was, in fact, on Bonnat's black list, not only during the short time that he spent in the atelier, but throughout his life and even after his death. In 1905, four years after Lautrec died, one of his finest portraits — that of *Monsieur Delaporte au Jardin de Paris* (Plate 8) — was purchased by the Société des Amis du Luxembourg and offered as a gift to the French nation. The picture was gratefully accepted by the Commission of National Museums, whose duty it was to pass on all entries into the public galleries of France; but it was promptly rejected by the Conseil Supérieur des Musées, presided over by

Monsieur Bonnat. Actually the Superior Council's jurisdiction was limited to questions involving the expenditure of public funds and was not intended to cover gifts for which no outlay was required: the Council was essentially a financial, not an artistic, body. Bonnat's insistence that the picture be refused was so vehement, however, that the timid Under Secretary of State for Fine Arts, Monsieur Dujardin-Beaumetz, upheld the illegal decision of the Council. The portrait of Monsieur Delaporte is today one of the treasures of the Carlsberg Glyptotek in Copenhagen. Apropos of this incident Joyant quotes the following extract from a letter written to him by Monsieur Raymond Kœchlin on June 21, 1925:

" Bonnat exhibited a kind of personal hatred for Lautrec: whenever his name, or that of Gauguin, was mentioned in front of Bonnat, the good man, who really had such excellent taste, flew into a passion. He seems to have made a particular point of the rejection [of the portrait of Delaporte], and the others yielded in order to please him."

Whatever Bonnat's sentiments towards his former pupil may have been, Lautrec did not hate his crusty old teacher. He could not, it is true, admire Bonnat's work; but he was generous enough to take up the cudgels on Bonnat's behalf in the face of what he considered an unfair attack. Once at a Salon *vernissage,* when Bonnat's academic pictures, once so popular, had become outmoded in favour of a newer style, Lautrec saw a group of people turn away from one of his canvases with a sneer and a contemptuous remark: " Oh, Bonnat! How awful! " For a moment Lautrec grinned with delight: " the delight," says Joyant, " of a redskin who has just scalped his enemy." Then the smile faded, and he turned to his companion:
" Monsieur, those people are unjust; he was a good craftsman all the same."

CORMON

IT is probable that Lautrec would have rebelled, sooner or later, against the hidebound formalism of Bonnat's teaching and sought a more congenial master, if Bonnat had not forestalled him by closing his atelier a few months after Lautrec entered it. A group of Bonnat's former pupils, among them Lautrec and Rachou, then asked Fernand Cormon to take them in hand. Cormon consented and opened an atelier at 10 rue Constance, on the hill back of the site afterwards occupied by the Moulin Rouge. A little later the studio was moved to 104 boulevard de Clichy.

Cormon, born in Paris in 1845, was a pupil of Cabanel, Fromentin, and Portaels. He painted elaborate " costume " pictures of historical and literary subjects, and almost from the beginning his career had been crowned by remarkable success. Cormon was as academic as Bonnat, and even less stimulating. Lautrec soon found that he had gained nothing by the change of masters. On February 10, 1883 he wrote to his Uncle Charles:

" For a long time, my dear Uncle, I have been intending to chat with you a little, but the daily grind has prevented me. I

hope that you will have missed nothing by having to wait so long for a dull letter. I am beginning to know Cormon, he is the ugliest and thinnest man in Paris. All due to necrosis. They even say he drinks. Cormon's criticisms are much milder than Bonnat's. He looks at everything you show him and encourages you heartily. You will be very much surprised, but I don't like that as well! In fact, my former master's raps put ginger into me, and I didn't spare myself. Here I feel rather relaxed and find it an effort to make a conscientious drawing when something not quite as good would do just as well in Cormon's eyes. In the last fortnight, however, he has turned over a new leaf and has frowned upon some of the pupils, including me. Since when I have been working again with enthusiasm. There are a lot of exhibitions: the Water-colourists, pitiful; the Volney, mediocre, and the Mirlitons, bearable.

" You see I dismiss them with very little ceremony, but they do not deserve any more. . . .

" Do you know that I have a little panel [in an exhibition] at Pau? . . . Why don't you pay a little visit to the capital? You would find plenty to interest you. Don't let the political situation upset you, we are all sleeping soundly and we read the manifestos with a serene eye.

" Your nephew,

H. de T.-Lautrec

" P.S. — You are not giving up your painting, I hope! "

If Lautrec learned little of value from Cormon, he acquired a great deal of helpful knowledge from the other young men who were studying at the atelier. In addition to Rachou these included Louis Anquetin, Adolphe Albert, Emile Bernard, Grenier, Claudon, and François Gauzi. The group, as a whole, was anything but docile. Most of Cormon's pupils were more or less vaguely dissatisfied with the unprogressive doctrines of the Beaux-Arts and ready to welcome, with youthful exuberance, the ideas and achievements of the innovators who dared

to flout official authority. And there were plenty of such innovators, plenty of new and exciting influences at work. After studio hours, when the comrades from the atelier gathered round a café table over their coffee and *apéritifs,* discussion grew lively and sometimes acrimonious. The informal debates broadened Lautrec's horizon: he learned to admire Delacroix and Manet, the Impressionists, Degas, and the Japanese.

In the eighteen-eighties Impressionism was still the subject of furious controversy. From 1874 to 1882, inclusive, seven exhibitions of the work of the Impressionists had been held in Paris. Each of them had been greeted with bitter recrimination from the outraged official clique of painters, jeering laughter from the public, and enthusiastic praise from a small but voluble minority of admirers. The influence of this revolutionary school of painting on Lautrec was somewhat ambiguous. For a short time he seemed to adopt the new technique whole-heartedly: he painted in almost pure colour, using the little dots and dashes so characteristic of Impressionism. Several portraits of this period were executed in the Impressionist manner — among them two of Suzanne Valadon (1885) and one of Lautrec's mother, reading (1887). But the influence did not last, except in one respect: his palette, which had become dark and muddy in the half-light of Bonnat's and Cormon's studios, grew light and fresh again as soon as he came into contact with Impressionism, and remained so to the end. He continued to admire Cézanne and Renoir; but it is worthy of note that the most typically " Impressionist " of the Impressionists — Monet, Pissarro, and Sisley — were precisely the members of the group who interested him least.

Probably this was because these artists were, above all, landscape painters; and Lautrec was not fond of landscape painting. He cared for nothing but the figure, human or animal. He had painted a few small landscapes without figures when he was very young, at Céleyran and in the neighbourhood of Albi, and he had attempted an occasional seascape during his months of

convalescence at Nice; but none of these was very successful. His trees, as he had written to Devismes in 1879, looked like spinach, and his sea like anything one cared to call it. Decidedly landscape was not his forte. He did use landscape fairly often as a background for figures painted in the open air, but the trees and flowers in his pictures are merely accessories and are treated sketchily, with a minimum of detail.

Characteristically, since he had no use for landscape painting as an end in itself, he went so far as to deny all virtue to this important branch of art: an illogical and narrow, though undoubtedly sincere, condemnation with which few of his friends and admirers agreed. Joyant tells of an incident that illustrates this point. In 1896 Lautrec, with Joyant and several other friends, made an excursion to the châteaux of the Loire. At Amboise, while the other members of the party were inspecting the historic building, Joyant and Lautrec sat quietly on the terrace of one of the great towers, looking at the view of the river and the low green hills in the distance:

" With this calm and majestic scene before us, the yellowish grey of the water blending with the pale bluish grey of the sky and mist, I imprudently said to Lautrec that in painting, landscape did have a certain importance after all, that the beautiful gradations of the greys spread out below us would have tempted a Monet, the only painter capable of doing them justice; and in fact I was thinking of his admirable series of pictures of Giverny and of the Seine at Vétheuil, with drifting ice.

" With sudden exasperation Lautrec poured out all his dislike of landscape painting and landscape painters, and there, on top of the tower, he made what amounted to a profession of faith, a kind of Sermon on the Mount, which the return of our friends from their tour of the château failed to interrupt. Said Lautrec:

" ' Nothing exists but the figure; landscape is nothing, and should be nothing, but an accessory; the painter of pure land-

scape is an idiot. Landscape should be used only to make the character of the figure more intelligible. Corot is great only on account of his figures, and the same thing is true of all the others, of Millet, Renoir, Manet, Whistler; and when figure painters paint landscapes they handle them like faces; landscapes by Degas are wonderful because they are dream landscapes; Carrière's are like human countenances. If Monet had not given up figure painting, what might he not have accomplished! ' "

Another influence of these early days came from Japan. In 1883 an exhibition of Japanese art was held at the Georges Petit galleries. Lautrec was enchanted. The flowing lines, the gay yet delicate colours of the prints and paintings, then almost unknown in Europe, were a revelation to the young student. He began to collect Japanese prints and *objets d'art* and to study them carefully. The deep impression made by these works from the Orient is apparent in much of Lautrec's later work.

But the most important and the most enduring of all the influences that affected Lautrec's art was that of Edgar Degas. Lautrec's admiration for Degas knew no bounds. He was the supreme master, the shining example of all that was best in painting, and Lautrec would permit no contradiction or even discussion of his idol's perfection. He never tired of pointing out to his friends the virtues of Degas. If his friends sometimes failed to share his enthusiasm, so much the worse for them. The painter Vuillard writes in *L'Amour de l'Art* for April 1931:

" I remember that Lautrec once gave us a striking and very characteristic proof of his admiration for Degas. It was about 1898 or 1899; Lautrec was giving one of those elaborate luncheons that he knew how to arrange so well, in honour of his friend Thadée Natanson, whose guests Lautrec and I had been

the preceding summer at Villeneuve-sur-Yonne. He knew the specialties of every restaurant in Paris; he decreed that this dish should be eaten at one restaurant, that dish at another. No effort was spared to turn the luncheon into a feast fit for kings. Lautrec had even brought wine from his mother's cellar. At the end of the meal, when our senses were stimulated to the highest pitch, we asked ourselves how we could put the final perfect touch to such a banquet; Lautrec, possessed by a brilliant idea, rose and started to lead us God knew where, without saying a word. A little suspicious of whatever extravagant notion might be sprouting in his unruly brain, we followed him up the three flights of stairs leading to the apartment of the Dihau family in the rue Frochot. Scarcely taking time to greet his hosts, Lautrec led us before the portrait of Dihau playing the bassoon in the orchestra of the Opéra, by Degas, and announced with a flourish: ' There's my dessert! ' He could conceive of no more exquisite treat for the entertainment of his friends than the contemplation of a canvas by Degas."

Coquiot quotes the personal reminiscences of several of Lautrec's fellow students at Cormon's atelier. The following account by François Gauzi gives us an excellent picture of the painter in his early twenties:

" Concealed under a mocking exterior Lautrec had a very affectionate nature; everyone was fond of him. He was extremely courteous and obliging. Physically weak himself, he admired strength in wrestlers and acrobats. He was very well brought up. In art he was always sincere. At Cormon's atelier he made a great effort to copy the model exactly; but in spite of himself he exaggerated certain typical details, sometimes the general character, so that he distorted without trying to or even wanting to. I have seen him force himself to ' prettify ' his study of a model: in my opinion, without success. The expres-

sion ' *se forcer à faire joli* ' is his own. The first drawings and paintings that he made after he left the atelier were always done from nature; he even insisted that he could not work if the least accessory was out of place when he was ready to begin. He had started a portrait of me; I had just come from the country and flaunted a superb fancy yellow waistcoat; it caught Lautrec's eye immediately, and he wanted to paint me in my shirt-sleeves, no doubt so as to show off the waistcoat to best advantage. He worked at the picture during several sittings; then I moved to new lodgings, and my waistcoat was stolen or lost; he refused to go on with the portrait, although it was well advanced; he painted a new and entirely different one.

" The painter he loved best was Degas; he worshipped him. His other favourites among the moderns were Renoir and Forain. He was fascinated by the Japanese masters; he admired Velázquez and Goya; and, astonishing as it may seem to some painters, he had an exceedingly high opinion of Ingres: in that respect he followed the leadership of Degas, who always praised the drawings of Dominique Ingres."

Henri Rachou has also left a record of his impressions, quoted by Coquiot:

" I knew Henri in Paris, through his mother, in 1882. He had already begun to work with our friend René Princeteau and, following the latter's example, was painting small canvases of horses.

" With me, he studied at Bonnat's atelier, then at Cormon's, where he worked very diligently in the mornings and spent the afternoons painting from our regular models: *le père* Cot, Carmen, Gabrielle, etc., either in the little garden of my house in the rue Ganneron, where I lived for seventeen years, or in the garden belonging to M. Forest in the rue Forest. I don't think I ever had the slightest influence over him. He often went with me to the Louvre, to Notre-Dame, to Saint-Séverin; but,

although he admired Gothic art, which I still esteem highly, he already displayed a marked preference for Japanese art and the works of Degas, Manet, and the Impressionists in general, to such an extent that he had outgrown the atelier while he was still working there.

" What struck me most forcibly about him was his splendid intelligence, always on the alert, his great kindness to the people who were fond of him, and his perfect understanding of men. I have never known him to be deceived in his estimations of our comrades. He had astonishing psychological insight; he never confided in anyone except those whose friendship had been tested, and sometimes treated outsiders with an impudence that was almost cruel. His manners were perfect when he wanted them to be; he could modify them at will to conform to the standards of any group he happened to be with.

" I have never known him to be either over-confident or ambitious. He was above all things an artist and attached very little value to praises, even though he welcomed them. In the circle of his intimate friends he very seldom displayed signs of satisfaction with his own work."

* *

At this time Lautrec visited regularly all of the exhibitions of contemporary painting as soon as they were opened. One of the sensations of the Salon of 1884 was a large picture by Puvis de Chavannes, *Le Bois Sacré Cher aux Arts et aux Muses.* The painting, filled with allegorical figures in slick impossible draperies, was as pretentious as the title. Lautrec, who had little sympathy with arid classicism, amused himself and his friends by producing an immense parody of *Le Bois Sacré.* The composition is similar to that of the original; the trees, the lake, the fragment of architecture, and the Muses themselves are all there, only slightly caricatured; but Lautrec added to these " idealized " elements a sort of Cook's tour of sightseers in the dress of the eighteen-eighties, complete with whiskers and

top hats. In the midst of this incongruous group is his own tiny, squat figure, seen from the back. This is certainly not one of Lautrec's important pictures, but the conception is clever and the execution, for so young a painter, remarkably skilful.

During the course of the same year he wrote a series of little articles, apparently not intended for publication, about the current shows. He was not yet twenty, and his taste was just beginning to develop. His comments on the work of the various exhibitors, many of whom are all but forgotten today, are generally witty and sometimes surprisingly penetrating. Of Sargent he wrote:

" Would you like to sell your pictures, Monsieur Sargent? Truly, you handle your brush marvellously, but your complicated manner will never regenerate international art."

An exhibition held at one of the smart clubs, the Volney, brought forth the following note:

" The Volney . . . includes several excellent painters among its members. M. Carolus Duran and M. Delaunay present a very charming contrast, the first by his splendid flexibility, the second by his firm and exact drawing.

" But, Monsieur Delaunay, why the green leaves that clash unpleasantly with the reds of your general colour scheme? Too many laurels, Monsieur Delaunay!

" M. Henner takes the prize with his head of a young girl; it would be impossible to be more nebulous without becoming mushy."

Lautrec was still loyal to his former teacher:

" M. Princeteau makes me feel that he knows how to estimate these club exhibitions at their true value. He sends the first sketch that comes to hand, which does not prevent him from taking an honourable place in the front rank. . . ."

Of the opening of a similar exhibition at another fashionable club, the Mirliton (not to be confused with the cabaret of the same name, of which more later), Lautrec wrote:

" What a crush! Quantities of people; quantities of women; quantities of silly talk! A hurly-burly of gloved hands carrying pince-nez framed in tortoise-shell or gold; but a hurly-burly all the same.

" Here are some observations I made among all those elbows.

" First, an exquisite study by Jacquet and a meticulously painted portrait by the same. You are well represented, Monsieur Jacquet! An old man by Cabanel and another old man by Cormon, who redeems his rather dubious pose by the perfection of the hands. A portrait of a young girl, by the same painter, which is the last word in the presentation of anæmia, the eyes spotted with freckles, the skin floury; all rendered with a sincerity which should be an excellent example to many of us. It is for your benefit that I say this, Monsieur Carolus Duran. In spite of all my admiration for your fertile temperament I cannot compliment you on your *Head of a Child*. . . .

" Oh! Monsieur Gérôme, what spicy sauce for your *Eunuch*, and a white eunuch at that. Why did you not bring to the execution of your *Portrait of Madame X* a little of the energy you put into the representation of that impotent orang-utan?

" M. Cabanel has recovered the distinction of his best days in his portrait of a blonde woman. Monsieur Detaille, I like your panoramas, but your two small canvases are vastly superior: not too many panoramas! Look at M. Dupray — there is a young man who is forging ahead; watch out, Monsieur Detaille! . . .

" Let us bow before M. Machard. I have never seen a woman's hand so charming, delicate, pale, adorned with a dark sapphire and posed naturally, without affectation, against a background of black fur: this hand is the best thing in the exhibition. . . .

64

" Conclusion: Many pretty things, but only pretty; the general impression is attractive, and, after all, how can one quarrel with people who entertain you for an afternoon? "

Lautrec found little of interest in a water-colour show:

" The water-colour is dead, only gouache survives. The group which until now has held its own brilliantly is falling heels over head into the abyss of commercialism. I must congratulate M. Bastien-Lepage, who is doing water-colours for the first time and who, by his simplicity, surpasses everybody. . . ."

In an exhibition devoted exclusively to paintings and sculpture by women, Lautrec was astonished to find that " these ladies rarely do good work except when they exaggerate the vigour of their craftsmanship. I have not seen a single truly feminine canvas here. . . ." Some of the ladies came in for severe scoldings:

" Mme de Goussaincourt is afraid of being too soft, so she paints wooden geraniums; the vigour of the background redeems this serious fault to some extent. I like her work better than the insipidities of Mme Coeffier, who gives us a *Marthe et Madeleine* (?) in sticky syrup. . . .

" Mlle Peyrol-Bonheur, faithful to the traditions of her family, perpetrates cows and bulls into which, unfortunately, she has forgotten to put skeletons. Therefore, collapse.

" Mme Jobard is full of whimsy. She paints a nude woman with a background borrowed from Henner's storehouse and calls it *La Femme aux Colombes*. No more doves than there are on my hand. I searched for them for three quarters of an hour, without success. Finally I gave up, partly through irritation, partly through chivalry. . . ."

65

The passion for honesty which was to be so characteristic of Lautrec in his later years is already apparent in these youthful criticisms. He hated affectation in any form and rarely missed an opportunity to attack it. There was no flaming revolt against the conservatives as yet, no ardent championship of new theories of art. Indeed, Lautrec was never a rebel in the way that the Impressionists were rebels. He never broke with the traditions of the past as they did; he founded no school, he undertook no revolutionary experiments in unexplored territory — except, perhaps, in the field of the poster, which he made his own as no other artist has ever done. By temperament he was allied to Degas, and through Degas to Manet and to Ingres. Yet he was no mere imitator of these masters: he accepted no ready-made solutions to his problems. He was an original and creative artist: vigorous, independent, patently sincere.

* *

Early in 1886 a strange figure appeared at Cormon's atelier for the first time: Vincent Van Gogh. He had come to Paris from Holland at the end of February to join his brother Theo, who had a responsible though not very well-paid position in the Goupil galleries. Vincent remained in Paris exactly two years. During that time he worked more or less regularly at Cormon's. Most of the students were in their early twenties; Van Gogh was thirty-three when he arrived in Paris, with years of poverty, hardship, and bitter disappointment behind him. He was too old, too sad, and too humourless by temperament to fit well into this group of light-hearted young Frenchmen, with their effervescent wits and pungent speech. Nevertheless he had a few good and loyal friends among the budding French painters: Gauguin, Emile Bernard, and Anquetin were perhaps his most intimate companions.

When Van Gogh made his shy début at Cormon's, Lautrec

had already almost given up the atelier in disgust. He did not break away suddenly: he simply drifted off, his attendance became less and less frequent. He did not, therefore, see very much of Van Gogh at the studio. They met occasionally at a café or at the lodging of some common acquaintance, and a record of their meetings survives in the form of a fine pastel drawing of Van Gogh by Lautrec, executed in 1887 (Plate 9). The portrait is obviously the result of close observation and careful preliminary study, though the actual drawing was probably made at a single sitting. Temperamentally the two men were too far apart ever to become intimate friends, but when Van Gogh left Paris for Arles in February 1888, he did exchange at least one or two letters with Lautrec. Very soon after he arrived at Arles he wrote to his brother Theo:

" Enclosed is a little note for [Emile] Bernard and for Lautrec, to whom I solemnly promised to write. I am sending it to you so that you can hand it to them whenever you have an opportunity, there is no hurry about it at all, and this will give you a chance to see what they are doing and to hear what they are saying, if you want one."

Van Gogh's letters to Emile Bernard have been preserved and published, but among them there is none addressed jointly to Bernard and Lautrec. In fact no letter from Van Gogh to Lautrec, or from Lautrec to Van Gogh, seems to have survived, nor is there any mention of Lautrec in the published correspondence with Bernard; so we are dependent on Vincent's letters to his brother for evidence of his interest in Lautrec's progress. In April (?) 1888 he wrote from Arles:

" Has Lautrec finished his picture of a woman with her elbows planted on a little café table? "

67

The picture in question is probably *A Grenelle,* inspired by Aristide Bruant's song of that name. In July Vincent wrote again to Theo:

" The Lautrecs have just arrived, I find them beautiful."

But here the reference is obscure. What Lautrecs, and why should any have been sent to Van Gogh at Arles? Four illustrations by Lautrec for an article by Emile Michelet, *L'Eté à Paris,* appeared in *Paris Illustré* for July 7, 1888; we may therefore surmise that it was a copy of this paper, and not a set of original works, that Van Gogh received. It is impossible to identify the painting by Lautrec mentioned in another letter from Van Gogh to his brother, probably written in August:

" Very soon you will make the acquaintance of [my picture of] *le sieur* Patience Escalier, a kind of *Man with a Hoe,* an old cowherd of the Camargue, now gardener on an estate in the Crau.

" Today I am sending you the drawing I made from this painting, as well as the drawing of the portrait of the postman Roulin.

" The colour of this portrait of a peasant is not as dark as that of *The Potato-Eaters* of Nuenen. . . . In fact I don't think that my peasant will go badly with the Lautrec you have, and I even venture to believe that the Lautrec will look still more distinguished by contrast, and that my picture will also benefit by the comparison, because its sunny, burnt quality, as of something tanned by the hot sun and the open air, will show up more effectively next to rice powder and a chic costume."

That Van Gogh shared Lautrec's low opinion of Cormon's academic, mechanical method of composition is indicated by a phrase in a letter to Theo of September (?) 1888. After noting that he himself is in the habit of calculating his probable

68

consumption of paints so accurately that he nearly always comes to the end of all his tubes of colour at the same time, but that this calculation is instinctive, not measured, Vincent adds:

" It is the same with my drawing, I hardly ever measure anything, and in that respect I am exactly the opposite of Cormon, who used to say that if he did not measure he would draw like a pig."

RUE CAULAINCOURT

In 1884 or possibly in 1885 — the exact date is uncertain — Lautrec decided to move to Montmartre. The district attracted him for many reasons. Most of his young friends lived there: it was rapidly becoming what the Latin Quarter had been a generation earlier, the centre of the artistic life of Paris. There were good studios to be found in the ramshackle old houses that clung to the steep slopes of the hill. The gay night life, the bars and cabarets and dance-halls of the neighbourhood, enchanted him. It was near Cormon's atelier, which he still attended from time to time. Most important of all, perhaps, the move made it possible for him to escape the restrictions of family life. At twenty Lautrec found the constant presence of his affectionate, devout, somewhat puritanical mother exceedingly irksome. He was truly fond of her and visited her often; ten years later he was quite willing to live with her again; but at this time he wanted complete freedom from all domestic ties.

His first residence in Montmartre was at 19*bis* rue Fontaine, where for several months he lived with Grenier, one of his fellow students at Cormon's atelier. Degas occupied a studio

in the building, across the court; and it must have thrilled Lautrec to know that he was working under the same roof as the master he revered as the greatest of contemporary painters.

A little later Lautrec moved to Henri Rachou's studio at 22 rue Ganneron, near the rue Camille-Tahan. In 1887 he returned to the rue Fontaine, this time to number 19, where he shared an apartment for four years with another friend, Dr Bourges. In 1891 they moved next door to 21 rue Fontaine. Independent as he was, Lautrec hated to live entirely alone. When, in 1893, Dr Bourges married and Lautrec was obliged to find another lodging, his mother solved the problem by taking an apartment in the same district, in the rue de Douai, and making a home for him there.

The rooms which Lautrec shared with Dr Bourges, as well as those which he later occupied with his mother, were only living-quarters; his studio was in another building. In 1887 he rented a large studio in a double house at the south-west corner of the rue Caulaincourt and the rue Tourlaque, near the Montmartre cemetery. The building, which still exists, had one entrance at 7 rue Tourlaque and another at 27 (now 21) rue Caulaincourt. The studio was a huge room on the fourth floor, with a high ceiling. A narrow stairway led to a balcony and a smaller room. Arsène Alexandre describes this apartment in *Le Figaro Illustré* for April 1902:

" The studio was very large, but there wasn't an empty corner in it. One had to take shelter on a divan; otherwise one was trapped in a jumble of easels supporting unfinished studies or temporarily abandoned canvases, of stools, ladders, piles of cardboard, lithographic stones, and two enormous tables placed against the walls, one near the entrance, the other on the opposite side of the room. The table near the door was covered with innumerable bottles and all the paraphernalia of a bar; here Lautrec mixed for you, often against your will, with the deftness of an expert, all kinds of cocktails — far too many

71

cocktails, alas! The second table was heaped with a miscellaneous collection of objects, each of which had some interest or association for him. In truth, any curiosity delighted him, stirred him to joyful enthusiasm; he would fish out such odds and ends as a Japanese wig, a ballet slipper, a quaint hat, a shoe with an exaggeratedly high heel, and show them to you with the most amusing remarks; or else he would unexpectedly turn up, in this pile of debris, a fine Hokusai print, then a letter written by some blackguard to his mistress, or inversely by an inmate of Saint-Lazare [a prison for women] to her lover, finally a set of photographs of splendid masterpieces of painting such as Paolo Uccello's *Battle* [*of Sant' Egidio*] in the National Gallery, or Carpaccio's *Courtesans Playing with the Animals* in the Correr Museum, all of which he accompanied by enthusiastic exclamations and sensitive or explosive comments."

Like most painters, Lautrec revelled in the untidiness of his studio. He would not allow it to be kept in order or even cleaned; his charwoman was forbidden to touch or displace any of the litter, and the whole place was usually covered with a thick layer of dust.

The " cocktails " mentioned by Arsène Alexandre were the delight of some of Lautrec's more rowdy companions, but the despair of those who really cared for him. His taste for strong drink developed early and remained with him throughout his life, taking a sinister toll of his small store of physical vitality and eventually bringing about his final collapse and premature death. He drank constantly: at first with moderation, but as the craving for alcohol took possession of him, his potations increased to an alarming extent. His friends remonstrated, but only succeeded in irritating him. He was impatient of restraint in any form and perversely proud of his ability to carry, with no apparent effect, a quantity of alcohol that would have put his fellow drinkers under the table. Having plenty of

money and a somewhat fastidious palate, he never drank cheap
adulterated spirits and thus escaped some of the worst effects
of over-indulgence. But if the quality of what he imbibed was
good, the quantity was enormous. Towards the end he was sel-
dom, if ever, entirely sober.

His fondness for mixing his drinks precipitated his down-
fall. He loved to dress himself in a white apron, roll up his
sleeves, and pour out the assorted contents of the various
bottles on his well-stocked table, forcing the results of these ex-
periments on his reluctant friends and partaking of them him-
self with huge enjoyment. Some of the weird concoctions he
produced would undoubtedly have made the hair of a self-
respecting professional barman stand on end with horror, but
Lautrec drank them all and invented others still more out-
landish.

He remained at 27 rue Caulaincourt for ten years. In 1897
he moved to another studio at 15 avenue Frochot, just off the
place Pigalle. Paul Leclercq gives us a description of it in his
book *Autour de Toulouse-Lautrec:*

" About twenty houses, surrounded by little gardens, lined
the tiny avenue, which ended in a blind alley.

" His studio was located on the second floor [the French
premier étage] of a square pavilion, at the farther end of the
street.

" It was a large room, well lighted, crowded with easels,
heaped-up tables, canvases, chairs, a rowing-machine, and an
enormous wicker armchair in which I sat while he painted my
portrait [Plate 48].

" A narrow inside stairway, very steep, along one wall, con-
nected the studio with two small rooms, one of which he used
as a bedroom, while the other served as his dressing-room."

The presence of the rowing-machine indicates Lautrec's in-
tense desire to strengthen his feeble limbs by means of exer-

cise. The rowing apparatus also provided him with a welcome opportunity to dress himself up in an outlandish costume, a form of amusement in which he took a childlike delight:

" He would put on a yachtsman's cap and a shirt of bright red flannel, and, tucking himself into a little machine equipped with oars, springs, and a seat moving on rollers, with his feet shoved firmly into a pair of leather straps, bending his body forwards and throwing it backwards, he would row and row for hours in the middle of his studio.

" One of his neighbours, who could not understand the reason for the curious and rhythmic noises, confided to several people in the quarter that Toulouse-Lautrec had acquired the eccentric habit of kneading dough with a rolling-pin and baking his own bread."

Unfortunately these heroic measures met with little success, and the machine, purchased in a moment of misguided optimism, was soon abandoned, though it continued to clutter up the studio long after it had ceased to serve any practical purpose. Lautrec's attention to hygiene was inclined to be fitful and capricious. From time to time he would embrace a new fad with tremendous fervour, only to discard it as soon as his initial enthusiasm waned. One of these fads, according to Leclercq, took the form of an exaggerated emphasis on personal cleanliness. He invested in an immense and exotic assortment of brushes, nail-files, sponges, and soaps, which he spread out in his dressing-room and wielded with such determination that he almost succeeded in scrubbing the skin off his deformed body.

When Lautrec moved from the rue Caulaincourt in 1897, he is said to have left behind him eighty-seven pictures, which he casually abandoned to the tender mercies of his concierge. These pictures, which Lautrec apparently considered of minor importance, included portraits of himself and of Aristide

74

Bruant, studies of local characters and of Montmartre prostitutes, and sketches made at the circus and the races. Their curious fate is the subject of an article, *Les Toulouse-Lautrec du Docteur,* that appeared in *L'Eclair* for June 18, 1914. According to this account — which may or may not be accurate — the concierge removed the pictures from the walls and stacked them in a corner when the new tenant, a Dr Max Billard, took possession of the studio. Believing them to be worthless, the concierge offered them to the doctor, who accepted thirty of the pictures without much enthusiasm. The others were distributed by the concierge among various cheap bars and cafés of the neighbourhood in exchange for a few glasses of wine. Dr Billard, whose appreciation of painting was no keener than that of the concierge, threw aside the thirty pictures he had acquired so easily and forgot all about them. When his economical housekeeper asked permission to use the stretchers for kindling the fire, the doctor welcomed the suggestion. The wooden frames of some twenty of Lautrec's pictures were thus broken up and burnt, and the canvases themselves were converted into rags and used for scrubbing and mopping up the floors. Some time later the servant returned to her native town in Savoy, taking with her all but one of the pictures that were left, which she foresaw would come in handy for stuffing the cracks in the walls and roof of her house. The canvases were heavy and of good quality, and the paint was waterproof: they would do very well to keep out the cold and damp of the Alpine winters.

After Lautrec's death, when the prices of his works had begun to increase rapidly, a group of Parisian picture dealers traced the doctor's housekeeper to her mountain retreat and offered what seemed to the ignorant woman an absurdly large sum for such trash, useful enough as a protection against the weather but surely of no value as works of art. She sold them gladly, and the dealers carried off their crumpled prizes, which were later disposed of for a small fortune.

Dr Billard cared no more for the single picture which remained in his possession (apparently by accident) than he had wanted the thirty-odd others that his servant had used for mopping the floor or mending the roof. One of his patients, however, had better taste and easily persuaded the doctor to give him the Lautrec in exchange for another picture, a completely worthless daub. Years later Dr Billard realized that he had thrown away a fortune. To punish himself for his stupidity, he hung the picture he had exchanged for his last Lautrec in a prominent place on the wall, where he was forced to look at it daily and so remind himself of his vanished treasures.

* *

Though Lautrec, with the intolerance of an artist whose talents demanded an entirely different expression, persisted in his denial of all virtue to landscape painting, he did frequently paint out of doors, using trees and foliage as accessories to the figure. During the ten years of his occupancy of the studio in the rue Caulaincourt he often posed his models in the near-by gardens belonging to a wealthy old man, Monsieur Forest. These picturesque gardens, situated below the Montmartre cemetery in the angle made by the rue Forest and the rue Caulaincourt where the two streets meet the boulevard de Clichy, have long since disappeared. On the site now rises the immense building of the Gaumont cinema, formerly the Hippodrome. But in Lautrec's time it was a peaceful, semi-rural hillside, undisturbed by the noise and bustle of the city below. The gardens were half cultivated, half wild, with great plane trees and lindens, lilacs and other shrubs and bushes growing at random, and a small summer-house or arbour. Monsieur Forest was an enthusiastic devotee of the sport of archery, and two or three times a week the gardens were invaded by the amateur archers of the neighbourhood, who set up their targets and diligently improved their marksmanship in this quiet enclosure. Most of the time, however, the gardens were nearly

empty, and Lautrec could paint here without interruption.

The subject of several of the portraits executed in the gardens of Monsieur Forest during the years 1889–1891 is a woman with red hair whose identity is unknown — probably a professional model. Lautrec adored red hair, and nearly all of his models were chosen because their hair approached in colour one of the many shades of red, reddish brown, or reddish gold. Perhaps the best of the garden portraits is that of *Berthe la Sourde,* painted in 1890 (Plate 11). The deaf woman is seated, full face, against a background of leafy saplings; her light summer dress, the filmy lace collar, the straw hat perched high on her head in the prevailing fashion and ornamented with a coquettish bunch of bright flowers, and the parasol, closed but not rolled, held horizontally across her knees, are in delightful contrast with the darker foliage through which the sunlight filters but dimly. By 1890 Lautrec had cast off the direct influence of the Impressionists, and in this portrait, as well as in many others of the period, his individual technique is clearly apparent. The picture is painted on cardboard in the very thin, slightly chalky medium that is characteristic of so much of Lautrec's work. The brush-strokes are free, yet placed with extreme care; the composition is a masterpiece of refined boldness.

It would be unprofitable, on the whole, to attempt to trace Lautrec's development chronologically. His life was so short that his entire career as a painter, once he had served his apprenticeship and had begun to create independently, covered a span of only fifteen years. In that brief period there was scarcely time for the appearance of the successive phases or " manners " into which the work of most artists can be subdivided. What changes might have taken place had he lived longer, it is impossible to guess. But Lautrec died before he was thirty-seven, and the bulk of his painting shows little variation in style from the beginning of his maturity to his premature end. Chronologically his output can be considered al-

most as a unit: there are only minor differences in technique between the works of 1889 and those executed a decade later.

A much more useful classification, however, can be made according to subject. For subject counted enormously to Lautrec. Not in a literary sense: his pictures told no stories, with the exception of those drawings and lithographs produced to order for various periodicals and as illustrations for books. But each of his works had, very definitely, a subject. The range, since it entirely excluded landscapes and still lifes, was narrower than that of most of his contemporaries or immediate predecessors. His themes were comparatively few in number, but he played infinite variations upon them. Dancers, single or in groups, in repose or nimble-footed movement; singers and *diseuses;* actors and actresses; circus folk and circus animals; portraits of friends and family, cool and penetrating, without mockery; prostitutes and Lesbians; surgical operations; sketches of personages connected with legal trials; sports of all kinds — horse-races, bicycle-races, wrestling matches, regattas; these were the subjects of Lautrec's paintings and drawings, and these also represented the principal interests of his life. The works of many — perhaps of most — artists can be studied without much reference to their daily lives; but Lautrec's life and work were woven together into a single indivisible pattern. What he lived he painted, and what he painted he lived, fully, intensely, with little thought for the morrow and the inevitable reckoning. To understand and appreciate his work, therefore, we must have an intimate knowledge of his background — rather, of his many backgrounds — and of the people with whom he associated.

MONTMARTRE

" MONTMARTRE," writes Léon Daudet in *Paris Vécu,* " is a Paris within Paris, a city apart, infinitely strange, full of contrasts, of shadows and gloom, of flashes of bright light; in the one mood it wears an air of provincial serenity, of friendliness, of innocent young love in a little garden; in the other we find only vice and foul debauch, slums and crime, and so-called gay resorts which are in reality abodes of heartbreak, idleness, ruin, slow poison, and shameful disease."

Undoubtedly it was the second aspect of Montmartre, rather than the calm rusticity of its steep streets and sunny hillside gardens, that attracted Lautrec. Yet he was no degenerate, wasting his life in idle dissipation. He was an extremely hard-working, intelligent painter, observant and eager, to whom the shifting kaleidoscope of Montmartre offered a wealth of material for his brush and pen — material that was exactly suited to his temperament. It was not so much the viciousness of the tawdry night life that appealed to him as its colour and movement, its animation, its gaiety, its wit and high spirits, its exuberant vitality. For there was a side to this life in which the sinister undercurrents played only a minor part. Many of the entertainers who lifted their voices or their skirts in the

79

brightly lighted cabarets and dance-halls were true artists, supreme in their own fields. The talents of Yvette Guilbert, Aristide Bruant, La Goulue, Jane Avril, Valentin le Désossé, and a host of other stars only slightly less brilliant brought to the Montmartre of the "gay nineties" a rare distinction, a sort of glamour, that has never been equalled in any other centre of amusement.

Lautrec was a highly sophisticated person, fully aware of the depravity that surrounded him on every side. His attitude towards it seems to have been one of cynical acceptance. He was neither tempted nor revolted by its worst aspects. Nothing shocked him. He was no reformer: he painted what he saw, transforming his sordid subjects into works of art by the magic of his brush, but without changing, or wishing to change, their essential character. Unlike Daumier or Forain, he was swept away by no strong current of moral indignation; he preached no pictorial sermons.

In *Steeplejack* James Gibbon Huneker writes of Lautrec:

"Power he has and a saturnine hatred of his wretched models. Toulouse-Lautrec has not the impersonal vision of Zola, nor the disenchanting irony of Degas. He loathed the crew of repulsive nightbirds which he pencilled and painted in old Montmartre before the foreign invasion diluted its native spontaneous wickedness. . . . We see the Moulin Rouge with its parasites, La Goulue and her vile retainers. The brutality is contemptuous, a blow struck full in the face. This Frenchman's art makes of Hogarth a pleasing preacher, so drastic is it, so deliberately searching in its insults. . . ."

Huneker, though a gifted and often penetrating critic, looked at Lautrec with too puritanical an eye and read into his work a great deal that was not there — a great deal, indeed, that was quite incompatible with Lautrec's nature. In all the hundreds of paintings, drawings, lithographs, and posters that Lautrec produced, there is not a shred of evidence that he

hated his models or preached a crusade against the vices of Montmartre. He was a painter, not a censor of morals. The comparison with Zola is particularly unfortunate: Huneker has, I think, completely misinterpreted both characters. It was Lautrec, not Zola, who was impersonal. Zola was at heart an ardent reformer, a man of action, a leader of campaigns, a champion of causes who, like Dickens, deliberately pointed out existing evils in order that they might be remedied. Undoubtedly Lautrec's pictures — at least those whose scenes are laid in dance-halls, cabarets, and brothels — are, as Huneker says, an arraignment of vice. But such an arraignment was no part of Lautrec's purpose in painting them. Nothing in his letters, nothing in the writings of his intimate friends, nothing, finally, in the pictures themselves, indicates any concern with the morality or immorality of his environment. Perhaps he would have been a nobler man if his social conscience had been more active, if he had condemned more and tolerated less. But if he had been a better citizen, he might well have been less of an artist. In the end, we must accept him as he was.

Young, enthusiastic, full of mental energy, with a tremendous capacity for enjoyment, Lautrec immediately felt at home in the convivial surroundings of Montmartre. No duck ever took to its natural element with more spontaneous delight. He quickly became a part of Montmartre, and Montmartre became a part of him. It was as the painter of Montmartre scenes that Lautrec was best known in his own time, and it is on his paintings of Montmartre that his fame rests most solidly today. No other painter, before or since, has been so completely identified with the exotic, artificial hilarity, the sordid despair, the grim tragedy and bubbling comedy that existed side by side in this gay little world on the edge of Paris.

*　　*

Montmartre has a long history as a riotous centre of dissipation, if not precisely of amusement. For at least three hundred

years the district has supported innumerable dens and dives in which drunkenness, prostitution, and crime of all kinds — not excepting murder — have flourished more or less openly. As far back as the beginning of the seventeenth century the taverns of Montmartre, then a village far outside the walls of Paris, were notorious — so notorious that they were subjected to severe, though seldom effectual, police regulations. It was forbidden, for example, to sell wine to the inhabitants of the neighbourhood; only travellers or visitors from the city were legally entitled to refreshment. Cards, dice, and similar paraphernalia of gambling were prohibited, presumably because of the frequent brawls that almost invariably resulted in bloodshed and broken heads. A curious ordinance of the period made it unlawful for any taverns in Montmartre to have a rear door; this rule was designed to prevent the escape to the open, unprotected countryside beyond the village of the many criminals who took refuge in these haunts. The tavern-keepers were generally in league with the outlaws and gave them warning of imminent raids by the gendarmes. In their efforts to curb the sinister traffic of the suburban establishments the authorities passed a law, early in the seventeenth century, requiring them to close at eight o'clock in the evening. In 1669, according to the account given by André Warnod in his book *Bals, Cafés et Cabarets,* the closing hour was shifted to seven o'clock in summer and nine in winter; and in 1714 to ten o'clock at all seasons.

The proprietors of the Montmartre taverns were repeatedly forbidden to keep women on the premises for the entertain- ment of their guests, but this restriction was almost universally ignored. Nearly all of the so-called cabarets were not only pot-houses for the refreshment of the wayfarer and temporary shelters for fugitives from justice, but houses of assignation, and often actual brothels, as well. The accommodations were primitive, and the unfortunate women who plied their trade

in the dirty, cell-like rooms were recruited from the lowest class of prostitutes.

André Warnod lists the names of some of the more celebrated resorts. Paradoxically, many of the foulest dives were graced by swinging signs bearing such incongruous names as L'Image Sainte-Anne, L'Image Saint-Louis (1687), and L'Image Saint-Martin (1686); a century later appeared La Croix de Lorraine and, in 1790, Aux Armes de Madame l'Abbesse. Perhaps some of these pious titles were survivals of the much earlier days when the slopes of Montmartre were, in fact, covered with churches, shrines, and monasteries. Certainly there was nothing holy about the shabby dens that flourished later under the protection of the sacred symbols.

Other cabarets were content with less godly names. Le Cheval Rouge opened in 1714, Les Rats and La Pie (The Magpie) were both founded in 1735. Still others, disdaining both the animal kingdom and the Kingdom of Heaven, adopted designations frankly suggestive of one department of their commerce. There could be no doubt as to the character of the pleasures awaiting the patrons of resorts named L'Ile d'Amour, La Fontaine d'Amour, Au Berger Galant, or Aux Caprices des Dames.

In the eighteenth century the reputation of the taverns of Montmartre, already evil enough, grew steadily worse. Prostitution, formerly secret, now flourished openly. Montmartre was infested by thieves, pickpockets, and cut-throats. Ten people were murdered at Le Cheval Rouge in a single week. The situation became intolerable even for that turbulent era. Respectable citizens learned to give Montmartre a wide berth, and many of the worst dens were obliged to close their doors for lack of victims, while others were forcibly suppressed by the police. During the lean years that followed, Montmartre almost ceased to exist as a so-called pleasure resort. A few cheap dance-halls and bars survived, but they were frequented

only by the people of the neighbourhood. Meanwhile a new centre of Parisian night life sprang up across the Seine in the Latin Quarter — the Latin Quarter of *La Vie de Bohême* and later of *Trilby*. Once established in different surroundings, the character of Bohemia underwent a transformation. The Latin Quarter was far less predatory, less dangerous to life, limb, and purse, than its forerunner. It was also much more amusing. The young artists and students who frequented the cafés of the *rive gauche* formed, on the whole, a law-abiding community. They were full of high spirits and frequently got into scrapes; they drank too much and disturbed their more sedate neighbours by dancing and singing through the streets in the small hours; there were casual love-affairs without number, with their attendant jealousies and quarrels; there was, no doubt, a vast amount of wasted time and talent. But there was much more healthy laughter and sparkling talk, dancing and music, than violence, bloodshed, and crime.

When, about 1880, the colony of painters, sculptors, musicians, and poets began their migration from the Latin Quarter to Montmartre, the almost extinct night life of the hillside bloomed once more. Cafés, bars, restaurants, cabarets, and dance-halls sprang up like mushrooms along the exterior boulevards and the steep side streets. They had little in common, however, with the dismal, uncomfortable, dangerous taverns of earlier days. Like their prototypes of the Latin Quarter they furnished genuine amusement and relaxation: not always chaste or innocent, it is true, but at least untainted by vicious brutality, thievery, and murder.

The entertainment offered by these new resorts was extremely varied. At the upper end of the scale were the *cabarets artistiques* such as La Grande Pinte, Le Chat Noir, Le Divan Japonais, and Le Mirliton — relatively " high-brow " establishments frequented by poets, playwrights, and other men of letters as well as musicians and painters, where serious and comic songs, recitations, and plays of considerable merit were

84

presented by talented artists. For those who preferred less intellectual fare there were the music-halls and cafés-concerts, most of which, however, were located in or near the boulevard de Strasbourg beyond the boundaries of Montmartre. There was in addition a large group of cabarets whose vogue depended mainly on their fantastic or macabre " atmosphere ": L'Enfer, Le Ciel, Le Néant, La Taverne du Bagne, La Taverne des Plaideurs. In another category were the innumerable *bals* or dance-halls of all grades, the most famous of which were L'Elysée-Montmartre, La Reine Blanche, La Boule Noire, the Casino de Paris (afterwards transformed into a music-hall, which still exists), the Moulin de la Galette, and the incomparable Moulin Rouge. There was an elaborate circus in Montmartre, the Cirque Fernando, now known as the Cirque Medrano. There were a few smart expensive restaurants — L'Abbaye de Thélème, the Café de la Place Blanche, Le Rat Mort — where champagne flowed and much furtive love-making went on behind the thick curtains of little private alcoves. In sharp contrast with these gilded resorts were the dingy, poorly furnished, but popular cafés and bars like the famous Lapin Agile, where friends could sit interminably over their beer, wine, or cognac. Lastly, there were a few small restaurants and cafés, notably Le Hanneton and La Souris, that catered almost exclusively to a Lesbian clientele.

This was the garish, boisterous, colourful Montmartre that provided a setting for much of Lautrec's life and work. For fifteen years he was a familiar figure in nearly all of these places, talking, laughing, drinking, observing, sketching, far into the night.

CABARETS ARTISTIQUES

THE FIRST of the *cabarets artistiques* in date, though not in importance, was La Grande Pinte at 28 avenue Trudaine, on the site now occupied by the restaurant L'Ane Rouge. It was founded in 1878 by a picture dealer named Laplace, who numbered among his friends and acquaintances most of the painters of Montmartre. Laplace deplored the banality of the existing cafés of the neighbourhood: they were all alike, none had any individuality; their owners made no attempt to provide a background worthy of clients of refined taste. " It is a disgrace," he protested, " that artists should be obliged to sit shut in between plain white walls, at ordinary marble tables similar to those at which bankers and grocers drink." The inauguration of La Grande Pinte put an end to this distressing situation. At considerable expense Laplace had his new cabaret decorated and furnished in the style — or at least in what he believed to be the style — of the sixteenth century. The walls were covered with carved wood panels and hung with tapestries. The tables and chairs were of dark, massive oak; scattered about the room was a miscellaneous collection of curious objects and " antiques," some genuine, some imitation.

86

An appropriately subdued light was supplied by a large window of stained glass.

All of this spurious magnificence sounds oppressive and slightly nauseating today; but at the time it was considered a model of elegant simplicity. La Grande Pinte quickly became a popular rendezvous, not only among the artists and writers for whose benefit it was designed, but in chic Parisian circles as well. Smart carriages drew up before the modest entrance; gentlemen in high silk hats and starched shirts, ladies in elaborate evening dresses sparkling with jewels, mingled with poets in baggy trousers and painters in broad felt hats and velvet jackets. There was no prearranged program of entertainment, but there was always some lively discussion of literature or art, and usually a recitation of his own works by some well-known writer, a few songs, or an impromptu concert of instrumental music played by the composer and his friends.

Before Laplace died, in 1884, the vogue of La Grande Pinte was already on the wane. It was supplanted in public favour by the much more famous Chat Noir, founded in 1881 by Rodolphe Salis. Salis was a fantastic character. Before he discovered his true vocation as proprietor of Montmartre's most celebrated *cabaret artistique* he had tried his hand at a dozen other pursuits and failed in all of them. Born at Châtellerault in 1851, the son of a prosperous distiller, he studied mathematics under a professor who had devoted his life to the invention of a system of multiplication, serenely unaware that Pythagoras had invented the same system two thousand years earlier. From mathematics Salis turned to art. He came to Paris, where for a short time he contributed caricatures to the newspaper *Le Citoyen*. Then he became a pupil of Pons Carle, the engraver of medals. He dabbled in archæology, but found it an expensive hobby and soon abandoned it for painting. He attended classes at the Beaux-Arts until his offerings were rejected at the Salon. He continued to paint, however, for a few months, at Marlotte in the forest of Fontainebleau, where his

striking costume, consisting of a great plumed hat, a scarlet cloak, and a rapier, was a source of profound astonishment to the natives.

Salis borrowed the idea of his cabaret from La Grande Pinte, of which he had been a regular client for some years. But he improved on his model by introducing an organized program of recitations, songs, music, and plays in place of the haphazard entertainment provided by Laplace. Opinions differ as to the function of Salis himself in the new enterprise. According to his admirers he was something of a genius whose witty remarks, jokes, and grandiloquent speeches contributed materially to the success of the Chat Noir; while the majority of those who knew him maintain that he was merely a shrewd business man, a charlatan with an extraordinary ability to exploit men of real talent: his persuasive manner convinced them that he was doing them a favour by allowing them to present their works, without recompense, at his cabaret, while in reality the sale of drinks brought him a huge profit in which his innocent protégés had no share.

Whatever his own qualifications as an entertainer may have been, there can be no doubt that Salis did know how to gather about him an extraordinary number of gifted painters, musicians, and men of letters. The nucleus of his regular clientele was a group of *émigrés* from the Latin Quarter known as the *Hydropathes*. Many of these young people became famous in later years. Among them were the writers Emile Goudeau, François Coppée, Paul Bourget, Anatole France, Catulle Mendès, Alphonse Allais, Georges Auriol, Paul Alexis, Jean Richepin, Guy de Maupassant, and Paul Verlaine; the painters Bastien-Lepage, André Gill, Adolphe Willette, and Jean-Louis Forain; the actor Coquelin *cadet;* and a few talented women, including Sarah Bernhardt. At the suggestion of Salis the *Hydropathes* deserted their former rendezvous at the Café de la Rive Gauche in the rue Cujas, near the Sorbonne, and

installed themselves at the Chat Noir, 84 boulevard de Roche-chouart, in the heart of Montmartre.

Like La Grande Pinte, the Chat Noir went in for " period " furniture and decorations. The style chosen was that of Louis XIII. The walls were panelled in walnut, stained to produce an effect of age and adorned with tapestries. The beams of the ceiling — exceedingly massive in appearance although they actually supported nothing — were artificially blackened as if by smoke. The whole place was cluttered up with a bizarre assortment of pottery, armour, weapons, ant-lers, wooden statues, wrought-iron lanterns, and chandeliers. There was an immense fireplace with gigantic andirons, and the bar was fashioned out of an old chest of carved wood. This was the " great hall " open to the public. There was in addi-tion a much smaller room seating not more than forty people, to which only the elect — the regular clients, the poets, paint-ers, and musicians who made of the Chat Noir a sort of artists' club — were admitted. This holy of holies was nicknamed the " Institute "; to emphasize its intellectual character, Salis dressed the waiters in the green costumes worn by members of the Academy. Here weekly literary discussions were held, and every night there was a recitation of new poetry, or a con-cert, or a shadow play written especially for the occasion and performed by puppets silhouetted against a white screen.

The Chat Noir published its own weekly paper, a magazine of four sheets to which the faithful clients contributed articles, poems, and drawings — some of them of considerable merit — free of charge. The first number, containing a long poem by Emile Goudeau, the editor of the little paper, was pub-lished on January 14, 1882. The issue of April 22 appeared with a wide black border and the announcement of the sudden death of Rodolphe Salis. This, of course, was only one of his extravagant jokes: Salis was very much alive and had, in fact, written his own obituary. According to this burlesque ac-

count, his prolonged association with the eminent writers of the Chat Noir had convinced Salis that he could write a novel himself. But when he read his masterpiece aloud to his friends in the " Institute " it was immediately seen to be no original work, but a literal copy of Zola's *Pot-Bouille*, then appearing serially in *Le Gaulois*. The shock of this discovery was too much for the subject of the " obituary." The delusion that Zola had stolen his ideas preyed on his disordered mind to such an extent that, when the sales of the real *Pot-Bouille* reached three hundred thousand copies, Salis blew out his brains. The notice ended with a solemn announcement of the funeral arrangements. And to complete the farce elaborate rites were actually organized, with Salis himself, dressed in a most uncorpselike costume of cloth of gold, walking at the head of his own funeral procession.

Occasionally the magazine meddled in politics. The number of January 6, 1883 was suppressed by the French authorities at the request of the German ambassador because of a violently anti-German article on the front page. A week later the unrepentant editors published the following open letter addressed to " Monsieur Von Bismarck ":

" The *Chat Noir* is proscribed by Germany! That is an honour! We have demonstrated our Gallic patriotism against the gloomy country of the evil-smelling and absurd Pomeranians; that is why that abominable race of crossing-sweepers and maggoty extortioners condemns us.

" The suppression of the *Chat Noir* is a certificate of anti-German Gallicism bestowed on the editor and the owner of this paper by the Emperor of all the Sauerkrauts. We thank him, while we wait for the hour of revenge to be struck by our stolen clocks, the hour of the liberation of our ancient and loyal province of Alsace-Lorraine! "

And on another page appears the warning:

90

" We want no Prussians in our cabaret, because we have two valuable clocks, and also because Prussians stink. . . ."

In June 1885 the Chat Noir moved from the boulevard de Rochechouart to 12 rue de Laval (now rue Victor-Massé). Always the exhibitionist, Salis made the transfer an excuse for another fantastic procession, with outlandish costumes, waving plumes, flaming torches, a brass band, and an enormous crowd shouting and dancing behind the carts that carried the heaps of furniture and bric-à-brac. In its new and more commodious quarters the Chat Noir continued to prosper for several years, but when Salis withdrew from active management and retired to the country, its popularity declined rapidly. A few months before Salis died, in 1897, the Chat Noir closed its doors.

ARISTIDE BRUANT

BOTH the Grande Pinte and the Chat Noir were immensely significant landmarks in the history of Montmartre and, as such, deserve more space than has been given to them here. But though they were integral parts of the fabric of that Montmartre which was Lautrec's background and, by helping to create his environment, exercised a certain influence over him, they had very little direct connection with his life. The heyday of La Grande Pinte came too early: when its decline began, in 1881, Lautrec was still a boy, painfully recovering the use of his fractured legs at Nice and writing long letters to Etienne Devismes. And the Chat Noir, though it flourished during most of the years that Lautrec spent in Montmartre, was never one of his favourite resorts. He knew most of its regular clients, and many of them were his intimate friends, but he seldom went there himself. The somewhat snobbish, self-conscious atmosphere of the cabaret repelled him, the literary chit-chat bored him, and he found the affected mannerisms of Rodolphe Salis extremely irritating.

Lautrec vastly preferred Le Mirliton, another of the famous *cabarets artistiques* of Montmartre, which took possession of the building at 84 boulevard de Rochechouart as soon as it was

vacated by the Chat Noir in 1885. Le Mirliton was an establishment of a different stamp, and the difference was due largely to the very dissimilar personality of the proprietor, Aristide Bruant. Whereas Salis assumed an exaggeratedly archaic courtliness, a kind of sword-and-buckler chivalry, addressing his clients with mock reverence, according to sex, as *messeigneurs* or *gentes dames,* Bruant bullied his customers unmercifully, greeting them with deliberately offensive remarks and ridiculing their clothes, their faces, and their manners in a few pat and often bawdy phrases. This novel formula for the entertainment of his guests was a purely accidental discovery. The opening night of Le Mirliton had been a grotesque failure: only three clients had trickled in during the course of the evening, and the total receipts amounted to exactly seven francs. To Bruant, who had sunk his entire capital of a thousand borrowed francs in the venture, such an inauspicious beginning meant disaster. His nerves on edge, and his throat raw from singing his full repertoire of songs to an almost empty room, Bruant suddenly turned on his three wretched auditors and poured forth his bitterness in a stream of vigorous abuse. To his surprise the outburst was received, as part of the show, with hearty cheers; and the delighted trio returned the following evening with several friends to demand a second instalment of invective. Bruant quickly took the hint and turned his impromptu *engueulade* into a permanent institution.

It was a tremendous success. Clients came again and again to hear themselves and their fellow guests lashed by Bruant's caustic tongue. To the initiated his impertinences were exceedingly funny, and the habitués enjoyed nothing more than the horrified astonishment or, still better, the spluttering rage of some newcomer from the country who, in search of an evening's entertainment, unexpectedly received one of his host's broadsides full in the face. Xanroff, writing in *Le Figaro Illustré* for June 1896, tells an amusingly improbable story of an impecunious but resourceful young man who lured his wealthy

provincial uncle to Le Mirliton. Bruant's insults so infuriated the old gentleman that he promptly and most obligingly succumbed to an attack of apoplexy, leaving the wily nephew sole heir to his estate.

The coarse remarks with which Bruant saluted his customers were, in fact, seldom resented. His sallies were delivered without malice: they were merely part of the stock in trade of his establishment and were usually received with roars of laughter not only by the onlookers but by the butts themselves. His wit and natural good humour took most of the sting out of his deliberate rudeness. After a particularly vicious onslaught he would always take pains to soothe the ruffled feelings of his victim by a charming display of good-fellowship. For Bruant was in reality a kind-hearted, generous, noble soul, quickly moved to sympathy.

Aristide Bruant was born in 1851 at Courtenay in the department of Loiret. His parents were at first sufficiently prosperous to be able to send their only child to a good boarding-school at Sens; but before his education was completed financial reverses put an end to his happy provincial childhood. The Bruants moved to Paris, where for some years the family fortunes went steadily from bad to worse. The father, a confirmed drunkard, was discharged from one position after another; the mother became, not unnaturally, shrewish and embittered. The household moved constantly from slum to slum, each time to meaner quarters and with diminished possessions. The young Aristide found employment as a lawyer's clerk, but the work was so uncongenial and so poorly paid that he soon abandoned it to become an apprentice in a jeweller's shop. Before he had more than begun to learn his new trade the Franco-Prussian War broke out. Bruant, then nineteen, returned to Courtenay, where he enlisted in a company of young volunteers, inadequately armed with obsolete weapons but full of patriotism and determination. The brave little troop was never called into action, and when the war was over, Bruant

returned to Paris and the production of cheap gimcrack jewellery. He detested the finicky work, but he stuck to it for four years until he was able to secure a position as clerk in the office of the Nord railway company in 1875. His father had long since given up his half-hearted attempts to find employment and now spent his days (and whatever small sums of money he could lay his hands on) in the grog-shops of the quarter. His mother earned a pittance by her needle, but Aristide was the principal breadwinner of the family.

Meanwhile he had become deeply interested in the lives and problems of the inhabitants of the poorest districts of Paris. He spent his evenings in the lowest dives of the slums, in the dens of thieves and the haunts of vagabonds, male and female. He remained singularly uncorrupted by the viciousness of his companions, while he was accepted by them as a sympathetic friend. He observed and noted, in particular, the subtleties of their curious language, the *argot* of the Parisian underworld, which gave to the conversation of these outcasts an inimitable tang. He soon mastered this strange and ever-changing vocabulary, but he was always careful to be strictly accurate in its use: whenever, in after years, he introduced a word of *argot* into one of his songs he would always verify it, to be sure that it was still in circulation, that it had not been superseded by a newer expression. Still later, in collaboration with Léon de Bercy, he utilized his knowledge of the *langue verte* in the preparation of a dictionary of *argot*.

While still in the employ of the railway company he began to write verses and short monologues dealing with the sordid tragedies of the poor, which he set at first to popular tunes and afterwards to music of his own composition. One night he ventured to sing a few of these ballads in a cheap café and succeeded in rousing his audience to unheard-of enthusiasm. He had a good natural voice of great flexibility, capable of expressing a wide range of emotions. This first success led to more serious experimentation in the same field. He tried his

luck at the café-concert of Les Amandiers, whose severely critical clients were in the habit of greeting unpopular entertainers with bombardments of orange peels and decayed vegetables. But when Bruant sang there were no missiles: only cheers and vociferous demands for more songs, until his repertoire, which consisted at that time of light and amusing *chansons* such as *Les Femmes, La Braise, Henri IV a Découché,* was exhausted. His appearances at Les Amandiers were followed by a professional engagement at L'Epoque, a café-concert of a better class in the boulevard Beaumarchais, which was so successful that Bruant decided, to the horror of his parents, to give up his clerkship in the Nord railway and devote himself henceforth to the writing and singing of his own works. This project was interrupted, in 1880, by a short period of military service in the 113th regiment. While on duty he composed a marching song, *Le 113ᵉ de Ligne,* which was immediately adopted as the official song of the regiment, and later, with a few necessary changes, by a number of other regiments as well. " Bruant's songs," said one of his fellow recruits, " would make a paralytic get up and march. You would think he had swallowed a trumpet."

From L'Epoque Bruant progressed to the more distinguished music-hall of La Scala, then to the ultra-fashionable Horloge in the Champs-Elysées. But his stock of gay light songs, though they were popular with his audiences, no longer satisfied Bruant himself. He could not forget the human wrecks he had seen, the countless tales of misery he had heard, in the slums he knew so well. He began to write and sing songs of a different kind, infinitely moving recitals of the tragedies of these broken and hopeless lives. He presented the first examples of the new series at the Chat Noir; when he founded his own cabaret, Le Mirliton, he added to them until his repertoire was made up almost wholly of ballads of this character, rich in picturesque *argot,* dealing with the flotsam and jetsam of the poorest quarters of Paris: *A Batignolles, A Montrouge,*

A la Bastille, A la Glacière, A Grenelle, A Montparnasse, A Belleville, A Ménilmontant, A la Madeleine, A la Chapelle, A la Villette, A Saint-Lazare, and many others.

The opening of Le Mirliton in 1885 coincided approximately with Lautrec's introduction to Montmartre. He immediately became one of the most faithful clients of the new resort, attracted not only by the noise and the gay crowds, the excellent singing and the amusing ribaldry, but also by the personality, the almost hypnotic charm of Bruant. The two men understood each other at once. Both were intensely interested in the living panorama of the streets, the bars, the dance-halls, and the brothels of Paris. Bruant was the more emotional: he had a deeper sympathy with the poor, both by temperament and because his own early struggles had given him an insight and an understanding that Lautrec, aristocratic and wealthy, never acquired. Lautrec was too fastidious to be able to share Bruant's benevolent conception of the brotherhood of man. The drabness of poverty, its bad smells and raggedness and dirt made Bruant furiously indignant, while they merely repelled the painter. Yet they had in common a sensitiveness of perception, an extraordinary ability to pick out essential details and to build them up, in their different mediums, into poignant characterizations. Bruant's songs about sots and dope fiends, prostitutes and pimps, and Lautrec's drawings and paintings of similar types, have the same universal quality, the same living reality that is altogether independent of time and place.

A striking example of the close artistic relationship between them is furnished by a drawing executed by Lautrec to illustrate Bruant's famous song *A Saint-Lazare.* Bruant, like Salis, published a small magazine in connection with his cabaret. It was advertised to appear " at very irregular intervals about twelve times a year," and in fact seventy-seven numbers were published between October 1885 and December 1892. The words of *A Saint-Lazare* were printed in the issue of August

1887. The song is in the form of a letter written by a prostitute, shut up in the women's prison of Saint-Lazare, to the man who has been living on her earnings — the man she really loves. The last verse runs:

> " *J' finis ma lettre en t'embrassant,*
> *Adieu, mon homme,*
> *Malgré qu' tu soy' pas caressant*
> *Ah! j' t'adore comme*
> *J'adorais l' bon Dieu, comm' papa,*
> *Quand j'étais p'tite*
> *Et qu' j'allais communier à*
> *Saint'-Marguerite.*"

Lautrec's drawing, in black and white, is reproduced on the cover of the magazine. It represents a young woman in prison dress, seated at a bare wooden table, writing. The character of the drawing and the spirit of the verses are in complete harmony: they supplement each other perfectly. One idea animates them both. The soul of the woman as it is unfolded in her letter, her hopeless resignation, her submission to her brutal and worthless lover, the childlike innocence which the degradation of her life has never quite destroyed, are all expressed in a few lines by Lautrec's subtle and penetrating study.

Lautrec made four other contributions to *Le Mirliton*. The issue of December 1886 contains a double-page reproduction of one of his paintings: a small panel, sketchily executed, known as *Le Quadrille de la Chaise Louis XIII à l'Elysée-Montmartre*. This quadrille was danced to Bruant's music and derived its name from a certain Louis XIII chair which had inadvertently been left behind at 84 boulevard de Rochechouart when Salis moved the Chat Noir, bag and baggage, to the rue Laval. Salis afterwards made a half-hearted attempt to recover his property, but Bruant refused to give up the chair. Instead, he hung it from the ceiling of the newly opened Mirliton as a symbol of good luck and composed a song about it:

98

"Ah! mesdames, qu'on est à l'aise
Quand on est assis sur la chaise
Louis Treize!
Elle est à Rodolp', cepenaant
Pour s'asseoir d'ssus, faut aller chez Bruant,
Au cabaret du Mirli,
Au cabaret du Mirli
Du Mirli ton taine et ton ton,
Du Mirliton!"

This song suggested to Lautrec the subject of another picture, a somewhat larger panel than the *Quadrille,* entitled *Le Refrain de la Chaise Louis XIII au Cabaret d'Aristide Bruant.* It shows Bruant standing on a bench, Maxime the waiter — the "legendary and incredible waiter," in the words of Oscar Méténier — the painter Anquetin, Lautrec himself, and several other people, with the famous chair suspended overhead. These two paintings — *Le Quadrille* and *Le Refrain* — as well as the original drawing of *A Saint-Lazare* and half a dozen portraits of women, painted in 1888, to which Bruant gave titles taken from his own songs, were hung on the walls of the cabaret. In this collection, which may be considered Lautrec's first public exhibition, was the picture called *Rosa la Rouge,* after the heroine of Bruant's song *A Montrouge:*

"C'est Rosa, j' sais pas d'où qu'a vient,
All' a l' poil roux, eun têt' de chien.
Quand a pass', on dit: v'là la Rouge
A Montrouge."

The words of a song also suggested the title of another portrait, *A la Bastille:*

"Son papa s'appelle Abraham
Il est l'enfant du macadam
Tout comm' sa môme en est la fille,
A la Bastille."

Still another derived its name from *A Batignolles:*

"*Quand a s' balladait sous le ciel bleu,*
Avec ses ch'veux couleur de feu,
On croyait voir eun' auréole,
A Batignolles."

The picture of a woman drinking absinthe at a café table was called *A Grenelle:*

"*Quand j' vois des fill's de dix-sept ans,*
Ça m' fait penser, qu'y a ben longtemps,
Moi aussi j' l'ai été pucelle
A Grenelle."

In January 1887 *Le Mirliton* appeared with a cover by Lautrec in black, white, and red. It was entitled *La Dernière Goutte.* A coffin draped in a black cloth and decorated with a skull and cross-bones is surrounded by lighted candles; in front stands a workman timidly sprinkling the bier with holy water, while a professional mourner, dressed in black, hovers in the background.

In February Lautrec contributed another cover to *Le Mirliton*. This was *Sur le Pavé:* a young milliner's apprentice, scarcely more than a child, carrying a hatbox, is accosted by a lecherous old man with a white beard, dressed in the height of fashion, with a silk hat, a monocle, and a cane:

" How old are you, my girl? "
" Fifteen, sir."
" Hm. A little too old for my taste."

It is probable that Lautrec did not invent this caption, but that it was supplied by Bruant or some other member of the staff, and that Lautrec simply made the appropriate drawing. Many of Lautrec's contributions to periodicals appear over ex-

planatory titles or bits of dialogue, but he seldom, if ever, wrote these himself.

Le Mirliton for March 1887 also has a cover by Lautrec, *Le Dernier Salut:* a workman is standing in an attitude of deep respect, cap in hand, while a funeral procession passes in the distance. These drawings for *Le Mirliton* were all signed " Tréclau " — an anagram of Lautrec. The subjects were obviously inspired by Bruant: somewhat sentimental conceptions, perhaps, but stripped of all traces of bathos by Lautrec's matter-of-fact presentation.

Bruant installed his mother and father in a comfortable apartment above the cabaret in the boulevard de Rochechouart. With them lived Bruant's illegitimate son, also called Aristide, the fruit of a liaison with a singer named Marioni, who died when the boy was three years old. Bruant himself, however, preferred another residence, his " farm " at the corner of the rue Cortot and the rue des Saules, on the northern slope of Montmartre. In this secluded neighbourhood he lived quietly in a tiny house, not much more than a hut, without interior partitions, which served as a combination of salon, dining-room, and bedroom. The kitchen was in a sort of shed, and across the garden were the " farm " buildings: a diminutive chicken-coop, a rabbit-hutch, a dovecote, and the cabin which sheltered the devoted François, Bruant's cook, valet, gardener, and general factotum. Fifty years ago this part of Montmartre was still almost in the country; the splendid view over the suburbs of Clichy, Saint-Ouen, and Aubervilliers was uninterrupted by buildings, and the hillside terraces were a tangled mass of shrubbery and small vineyards. Here Bruant composed many of his songs, and here also he found relaxation from his exhausting duties at the cabaret. He loved to tend his garden and feed his poultry; he had a veritable passion for dogs and was rarely to be seen without at least three or four of assorted breeds trotting at his heels.

Early in his career he had adopted a costume which he never

varied: a black velvet jacket and trousers, black leather boots reaching to the knee, a bright red scarf with the ends thrown over the shoulders, a black felt hat with an immense brim, and, for outdoor use, a long black cape.

In 1892 Bruant sang with enormous success at Les Ambassadeurs and L'Eldorado, and a little later he carried his repertoire of songs on a tour of the provinces, to Lyons, Bordeaux, Marseilles, and finally Algiers. During his absences the Mirliton was run by an assistant who wore Bruant's characteristic costume, sang his songs, imitated his manner, and maintained the tradition of greeting each newcomer with an impertinent and disconcerting refrain, in the chorus of which all the guests joined:

> *"Holà—là! Ah! c'te gueule, c'te binette!*
> *Holà—là! Ah! c'te gueule qu'il a!"*

Some of Bruant's songs were also presented by other entertainers — with his consent — at various cafés-concerts and music-halls. Among those who thus popularized his creations were Paulus, Félicia Mallet, and especially Yvette Guilbert. By 1895 Bruant had amassed a considerable fortune, sufficient to enable him to retire altogether from Le Mirliton and to set himself up as a landed proprietor on a modest scale at Courtenay, where he was born. He married an opera-singer, Mathilde Tarquini d'Or, whose son by a former marriage was of approximately the same age as Bruant's own son Aristide. At Courtenay Bruant led the placid life of a country gentleman. He loved to set out on long rambles with his gun and his favourite dogs, far from the feverish, strident gaiety of the boulevard de Rochechouart. He did not, however, lose touch with Paris entirely. He wrote several novels, as well as a few plays, in collaboration with Arthur Bernède, which were produced with considerable success at the Théâtre de l'Ambigu. In 1898, to the surprise of his friends, he became a candidate for

a seat in the Chamber of Deputies as the representative of the district of Belleville-Saint-Fargeau, one of the poorest sections of Paris. The campaign must have been unusually picturesque, for Bruant, instead of making political speeches, sang to his audiences. His ballads were received with vociferous applause, which did not prevent his opponent from winning the election by a substantial majority.

Another Parisian venture met with no greater success. Bruant purchased the café-concert L'Epoque, where he had sung many years before, at the beginning of his career. His wife, who continued to sing professionally after her marriage, organized a series of classical concerts at L'Epoque; but the enthusiasm of the audiences was, at best, tepid, and the project was soon abandoned. Thereafter the peace of Courtenay was seldom interrupted. Bruant accepted a short engagement in Paris in 1904, and another in 1905. He did not appear in public again, except at an occasional performance for the benefit of some charity, until 1913, when he yielded to the insistence of Paul Poiret and sang for a few weeks at L'Oasis, an open-air theatre constructed in the garden of Poiret's house in Paris, at a salary of a thousand francs a night.

The World War brought tragedy to Bruant. He was far too old to take an active part in it himself; but his only son, after having been wounded a number of times during the first three years, was killed in battle on April 16, 1917.

For the next seven years Bruant lived in retirement at Courtenay. In 1924, his fortune having been reduced as a result of the war, he was persuaded to give one more series of recitals in Paris. He was then seventy-three years old, but his voice was still powerful and his handsome features more impressive than ever. His engagement at the Empire music-hall, in the avenue de Wagram, began on November 23 and continued for a fortnight. He received an ovation almost unparalleled in the history of the Parisian theatre. To most of his auditors, born too late to have heard him in his prime, Aristide Bruant was

a legendary figure, a ghost from the dim past miraculously brought to life.

This was Bruant's last appearance on the stage. The effort left him exhausted. He returned to Courtenay, where for a few weeks he seemed to recover his strength. During the night of February 11, 1925 he had difficulty in breathing. Suddenly he collapsed; his wife hurried in from the next room to find him stretched motionless on the floor; and he died the following day without regaining consciousness.

DIVAN JAPONAIS

ANOTHER resort frequently visited by Lautrec was the Divan Japonais at 75 rue des Martyrs. The site had been occupied until 1860 by the Bal de l'Hermitage, so named because of a legendary hermit who was supposed to have inhabited a grotto in the hillside centuries before. The Bal de l'Hermitage was an unpretentious tavern, popular during the reign of Louis-Philippe among the small shopkeepers and apprentices of the district. It was succeeded by L'Elysée-Buffet, a cheap dance-hall that soon acquired an unsavoury reputation. The place was infested with thieves and pickpockets, and the coarse, blowsy women who frequented the dive were fit companions for these rascals. Drunken brawls were of almost nightly occurrence, and when knives flashed, the gendarmes, outnumbered and powerless, fled for their lives. The iniquitous den was finally suppressed in 1883, and after the building had been partly demolished and reconstructed, the Taverne du Bagne took its place. This was one of the " macabre " group of cabarets: the director, Monsieur Lisbonne, had been a political prisoner under the Commune, and his venture into the domain of entertainment was an ill-advised attempt to make capital of his experiences under lock and key. The cabaret was

fitted up as a dungeon, with stone walls, barred windows, chains, manacles, and even instruments of torture. Perhaps the gloomy atmosphere dampened the spirits of would-be revellers, or else the vigorous protest launched by Albert Wolff in *Le Figaro* against the exploitation for commercial purposes of one of the most tragic episodes in the history of France found a sympathetic echo in the hearts of the Parisian public. At any rate, this chamber of horrors failed to attract the expected number of customers, and the Taverne du Bagne lasted only three months in the rue des Martyrs.

After its departure the structure was completely torn down and rebuilt to accommodate a resort of a much more genial character, Le Divan Japonais, which flourished for about eight years. The proprietor, Jehan Sarrazin, had formerly earned a precarious livelihood as an olive-merchant on a small scale. In his hours of leisure he wrote poetry, and when he came to Paris from the provinces he conceived the original idea of combining business with art by selling his olives and his verses together. He soon became a familiar figure in the cabarets of Montmartre, where he wandered from table to table offering, for a few sous, a dozen olives enticingly disposed on a sheet of printed poems.

The Divan Japonais was a curious mixture of *cabaret artistique* and café-concert. Sarrazin copied the grandiloquent archaic phraseology originated by Rodolphe Salis; but the entertainment at the Divan Japonais, unlike that at the Chat Noir or the Mirliton, was provided almost entirely by a series of professional singers and dancers who were paid — modestly, it is true — for their services. The individual flavour of Sarrazin's literary style may be judged from the proclamation that announced the opening of the Divan, quoted in his gossipy little book *Souvenirs de Montmartre et du Quartier-Latin:*

" *Le sieur* Jehan Sarrazin invites his fellow citizens, vassals, and all others, as well as their ladies, wives, or concubines, to

visit him in his new abode, where they may drink heartily, amuse themselves, and ensure the eternal welfare of their souls and bodies by sampling the triply divine olive, unchallenged princess of the products of nature, served on dishes of gold and silver.

" *Le sieur* Jehan Sarrazin warns the people of Paris and its environs that, having been promoted to the office of Lieutenant-General of Pleasure, he has issued the strictest orders for the banishment of every trace of melancholy to a distance of more than two thousand leagues beyond the confines of his domain. Consequently, everyone plagued by sighs, sadness, preoccupation, or ill humour will be ruthlessly expelled from his castle, cut into slices, and shipped to the South Seas by the next steamship of the Transoceanic Line of the Polynesian Sandwich Islands.

" Clients possessing an authentic German accent will be lowered with the utmost care into an *oubliette* seventy-nine and a half metres deep, where they will receive no food except one small piece of bread for four people every eleven days, and whence they can be released only upon the application of members of their families who have been dead for at least twenty years.

" The discussion of politics will be forbidden, under penalty of a fine varying from five centimes to eight thousand dollars according to the position, the character, and the antecedents of the guilty party. . . ."

In spite of this promising announcement the Divan Japonais was something less than a success at first. Sarrazin found himself on the horns of a dilemma: if he made his resort too respectable, too bourgeois, it would become merely another café-concert among the already considerable number of such establishments, with nothing to distinguish it from its competitors; on the other hand, if he tried to endow it with too much individuality, it would be invaded by a crowd of young and

noisy merrymakers who might drive away his more sedate, as well as more remunerative, clients. At the beginning the audiences at the Divan Japonais were, in fact, so boisterous that the unhappy entertainers could scarcely make themselves heard above the din. Sarrazin, who seems to have had an exaggerated respect for the municipal authorities, was in a cold sweat of terror at the prospect of having his cabaret raided and closed by the police. Fortunately his fears proved groundless. Some of the riotous young people settled down to a calmer appreciation of the regular program, others found more congenial resorts where their disorderly behaviour went unrebuked.

Sarrazin had a genuine flair for ferreting out hidden talent, and the entertainment he provided was generally of a high order. There was plenty of variety in the programs: one week, a troupe of Spanish dancers headed by the seductive Paquita; the next, a complete *Guignol* or marionette show from Lyons; again, a versatile English comedian, Fred Evans, with his partner, Minnie Joe. One of the most popular singers was a Negress, Kadoudja, who wore a rainbow costume consisting of pink stockings, red shoes, a dress patterned in wide green and black stripes, and a hat adorned with yellow, blue, and purple flowers and an enormous orange bird. When this dazzling creature sang a lullaby, the contrast between her spectacular appearance and the plaintive, piping voice that issued from her thick lips was so grotesque that the spectators roared with joy.

Another singer who achieved a triumphant success at the Divan Japonais was discovered by accident. Sarrazin, walking down the rue de Rome one day, passed a house from which the furniture was being removed to a waiting van. One of the workmen was singing lustily as he carried chairs and tables down the stairs and dumped them on the sidewalk. His voice, though untrained, had a pleasing quality that caught Sarrazin's ear. The director of the Divan offered the furniture-mover an engagement at his cabaret; the labourer, willing to try anything once, accepted; and the bargain was sealed, then and

there, over copious draughts of wine at the nearest café. Sarrazin made the mistake, however, of dressing his new star in conventional evening clothes, which he had never worn before in his life. His first appearance on the stage of the Divan sent the entire audience, including Sarrazin himself, into fits of hysterical laughter. The muscular shoulders and powerful chest of the ex-workman had wrought havoc with the seams of his tight black suit; his cravat had slipped between his collar and chin, where it was slowly strangling him; his hands were held rigidly at his sides with every finger spread, so as not to split the new white gloves; and to complete the ludicrous ensemble his enormous feet were encased, not in the shiny evening shoes that had been selected for him, but in his own muddy, hobnailed workaday boots. After this inauspicious début the furniture-mover, once more attired in the comfortable clothes to which he was accustomed, was advertised as *l'homme en blouse.*

The glory of the Divan Japonais reached a climax with the engagement of Yvette Guilbert in 1891. The genius of the young and brilliant *diseuse* filled the concert-hall to the doors with an enthusiastic public, night after night. Her immense popularity lent such prestige to this scene of one of her earliest triumphs that Francisque Sarcey called the Divan Japonais " *le Théâtre Français de la chanson.*"

In December 1888 Sarrazin announced the opening of a new attraction, a large room in the basement where his clients, after the program upstairs had run its course, could retire to be diverted by another group of entertainers until two o'clock in the morning. The basement was even gayer than the main concert-hall and somewhat less proper: songs that Sarrazin considered too daring for presentation in the upper room could be sung with impunity below ground. The audiences in the concert-hall were composed largely, and in the basement almost wholly, of painters, sculptors, musicians, poets, and journalists. The habitués included, besides Lautrec, the painters and

cartoonists Adolphe Willette, Léandre, Forain, Desboutins, Raffaëlli, Roybet, Detaille, and Steinlen; the writers and poets Maurice Donnay, Georges Montorgueil, Emile Goudeau, Xanroff, Catulle Mendès; Aristide Bruant, Sarrazin's friendly rival; the critic Francisque Sarcey; the editors of several prominent newspapers: Arthur Meyer of *Le Gaulois,* Périvier of *Le Figaro,* Maizeroy of *Gil Blas.*

Lautrec went to the Divan Japonais to meet his friends, to drink, and to be amused, rather than to paint or draw. His only professional link with the cabaret is his magnificent poster *Le Divan Japonais,* executed in 1892. In it are seen the dancer Jane Avril and her escort, Edouard Dujardin, listening to a song by Yvette Guilbert, whose slim figure is sketchily indicated in the background (Plate 13).

ÉLYSÉE-MONTMARTRE

BY far the oldest, and for many years the most celebrated, of the dance-halls of the quarter was the Elysée-Montmartre at 80 boulevard de Rochechouart. During its long existence it witnessed a great variety of social changes; its fortunes advanced and receded, ebbed and flowed again like a slow irregular tide. Founded early in the nineteenth century, it began as an unpretentious *guinguette* or cheap beer-garden, where workmen in smocks and blouses and their womenfolk in white or coloured aprons drank and danced under the trees on summer evenings. Its clientele was drawn almost exclusively from the humbler elements of the local population; only on Sundays was it invaded by visitors from Paris in quest of country air and rural amusements. For at that time Montmartre was a separate community, little more than a village, shut off from Paris by a ring of fortifications.

After 1840 the status of the Elysée-Montmartre began to improve. Very gradually, as its popularity among Parisians increased, the original clients drifted off to less fashionable resorts. But it was not until 1860, when the wall encircling Paris was demolished and the suburb of Montmartre was an-

nexed to the city, that the Elysée-Montmartre really came into its own. The owner, Madame Serres, was a shrewd as well as an ambitious woman. To meet the requirements of her new and more sophisticated public she remodelled the entire establishment. A large pavilion for dancing, surrounded by galleries, was constructed; the orchestra was placed in an artificial rockery or grotto. In another building, a sort of chalet, there were a restaurant and a suite of gambling rooms. The gardens were embellished with cascades and flower-beds which, in the somewhat extravagant phrase of André Warnod, added greatly to " the fairylike beauty of this edifice." All of this magnificence, however, could not compensate for the lack of a good dance orchestra. The half-dozen mediocre musicians were deplorably inadequate, and at first the transformed Elysée-Montmartre was a pitiful failure. It did not regain its vogue until Adrien Serres, who succeeded his mother as proprietor, engaged Olivier Métra and his band to supply the music. Métra, young and talented, a composer as well as an excellent conductor, immediately attracted enormous crowds of smart Parisians, and the Elysée-Montmartre entered on a long period of prosperity. It soon became the most popular dance-hall in Montmartre, and with the single exception of the Bal Bullier in the Latin Quarter, the most popular in all Paris. Especially on Tuesday evenings, which for some reason were considered the most chic, every inch of space was occupied.

In 1867 the Serres family sold the Elysée-Montmartre to a Madame Roisin. Métra remained as leader of the orchestra under the new management. He inaugurated a series of costume balls at which all of the participants were required to wear masks. These fêtes were invariably crowded to the limits of the capacity of the pavilion, and the gay throngs overflowed onto the lawns and flower-beds of the garden. Sometimes the goings-on overstepped the bounds of decorum. There were

occasional brawls that resulted in minor casualties, black eyes and gory noses, until the police were called in and the offenders forcibly removed.

During the Franco-Prussian War the Elysée-Montmartre became, temporarily, the headquarters of the Club de la Révolution, an association of radicals whose aim was the establishment of a universal republic organized on vaguely communist lines. Each active member was required to sign a profession of faith in the revolution. When the premises were not being used by the club, concerts were given for the benefit of various patriotic societies. One of these recitals, the proceeds of which were donated to the ambulance service of the 37th battalion of the National Guard, took place on December 11, 1870, the eighty-fourth day of the siege of Paris.

The decade after the war witnessed another decline in the fortunes of the Elysée-Montmartre. Dancing was resumed, and the resort was just as crowded as before; but the clients were no longer drawn from the smart world of Paris. Instead, the dance-hall and gardens became the rendezvous of a plebeian assemblage: barbers and waiters, small shopkeepers, working-girls in search of a gay time and willing to pay for it with their virtue, though they still maintained a certain show of respectability. Mixed with these lower-middle-class elements was a considerable seasoning of the underworld: professional streetwalkers, procurers, and petty thieves.

The Elysée-Montmartre was sold again in 1881, this time to a Monsieur Desprez, who ran it for twelve years. Those years were the golden age of the establishment. Once more the character of the place underwent a complete transformation. Under the new management it again became the rage among fashionable Parisian pleasure-seekers as well as a favourite haunt of artists, writers, and musicians. Desprez, who was certainly not handicapped by notions of false modesty, advertised its attractions in glowing terms:

ÉLYSÉE–MONTMARTRE

" The Elysée-Montmartre is, at this moment, the only place in the world where gentlemen and pretty girls can meet in gay surroundings."

Louis Dufour, who had succeeded Olivier Métra as leader of the orchestra in 1874, was a less spectacular but equally competent musician. He introduced a new dance which quickly took Paris by storm: the *quadrille réaliste*. This quadrille was a variation of an older dance, the *chahut,* which had already achieved popularity under the Second Empire; but it was more dramatic, and the erotic element was emphasized to a much greater degree. It was a square dance performed by four people, two men and two women. There was much rivalry, not always very friendly, between the various groups of dancers as to which of the women could kick the highest and display the largest expanse of lacy underclothing. According to André Warnod, the women who danced the quadrille at most of the resorts were required to wear drawers; but an exception to this rule was made at the Elysée-Montmartre because " at that place each one danced for her own pleasure, and since every dancer exhibited her charms, nobody took the trouble to look! "

Evidently the ladies of the quadrille carried their exhibitions a little too far, or else the spectators were not as discreet as they should have been, for after all it was found necessary to make some attempt to curb the enthusiasm with which the dancers at the Elysée-Montmartre exposed their bodies. A special censor was appointed, Monsieur Courtelat du Roché, who was immediately nicknamed Père la Pudeur — Father Modesty. During the day he led a sufficiently humdrum existence as a photographer, but at night he blossomed forth as " Inspector of Dancing." Of his two vocations, needless to say, he vastly preferred the second. When he became a member of the staff of the Elysée-Montmartre, in 1871, he had already had twenty years of experience as a guardian of public morals in

similar establishments. Père la Pudeur's job was no sinecure. He took his duties seriously: he was constantly on the alert, ready to detect any violation of the proprieties; and whenever one of the dancers kicked too energetically and very obviously disclosed the fact that she was wearing nothing beneath her voluminous petticoats, Père la Pudeur would pop up suddenly at her elbow, frowning, scolding, and threatening expulsion from the premises. His conscientious efforts to maintain decorum, however, were not conspicuously successful. As soon as his back was turned, the unrepentant minxes would thumb their noses at him and lift their skirts higher than ever.

When Lautrec appeared on the scene the Elysée-Montmartre was enjoying its greatest, and last, period of prosperity. For a few years, from 1885 to 1889, he was often to be seen there. The noise and glitter, the feverish gaiety, the music and the spirited dancing, the flushed faces of the men and the sinuous, provocative grace of the women under the flaring gaslamps, stirred his blood and delighted his soul. He made a number of sketches at the Elysée-Montmartre which he afterwards used as notes for paintings. The first, and perhaps the most important, of these has already been mentioned: *Le Quadrille de la Chaise Louis XIII à l'Elysée-Montmartre,* executed in 1886. In the foreground, at the right, stands Père la Pudeur with a harassed expression on his pudgy face; his back is turned to the dancers, which may or may not have been intended as a sly hit at his futility as a censor. Still farther to the right and behind Père la Pudeur are the painters Louis Anquetin and François Gauzi. Behind them is the orchestra on an elevated platform, with the conductor, Dufour, flourishing his baton. Directly in front of the musicians stands Aristide Bruant in his characteristic broad-brimmed black hat, watching the quadrille which occupies the centre of the canvas. Two women are dancing, their skirts raised, their right legs pointing skywards out of a swirl of foamy petticoats. One of the dancers is Grille d'Egout, the other the famous La Goulue, whom Lautrec

painted so often during the next ten years. *Le Quadrille de la Chaise Louis XIII* is probably his earliest work in which La Goulue appears.

Lautrec painted three or four other pictures of scenes at L'Elysée-Montmartre. One of them, on cardboard, represents a masked ball: a woman in a white domino is seated at a table opposite a man in a top hat, with another man and a masked woman in the background. None of these are really finished paintings; they are executed in a rather sketchy manner in broad strokes, without well-defined details.

From time to time the Elysée-Montmartre was reserved for boisterous private parties to which admission was by invitation only. On such occasions the public was obliged to seek entertainment elsewhere. Perhaps the most successful of these gatherings were the fêtes sponsored by Jules Roques, director of *Le Courrier Français,* a periodical that specialized in articles and cartoons connected with the night life of Montmartre. The first *Courrier Français* ball took place in 1887. At that time the paper was engaged in a violent campaign against the prudish and ridiculous Senator Bérenger, whose attempts to impose severely puritanical standards of morality on the French people only succeeded in stirring up a storm of indignant protest throughout the country. Nowhere was the opposition to Bérenger's interference more vociferous than in pleasure-loving Montmartre. The guests at the *Courrier Français* parties at the Elysée-Montmartre defiantly snapped their fingers at the senator's austere prohibitions. On those nights wine flowed more freely, the orchestra played its gayest tunes, the eternal vigilance of Père la Pudeur was relaxed, the dancers indulged in the wildest and most acrobatic gyrations. Lautrec, who took a childlike delight in " dressing up," always attended these costume balls, though of course his deformity made it impossible for him to take part in even the soberest dances. At the *Courrier Français* fête in 1889 he made two sketches: the smaller one shows a man in Japanese costume and a woman,

also in fancy dress, seated at a table; the other is of Lautrec himself, pencil in hand, garbed as a choir-boy, and Aristide Bruant in the equally inappropriate guise of a saint.

Still more riotous were the parties given at the Elysée-Montmartre by the Quat'z-Arts. Coquiot tells us that Lautrec appeared at the first of these dressed as a lithographer's apprentice in a blue smock and a soft hat, through the crown of which he had stuck a pipe. But such a sedate costume was exceptional at these assemblies; at one of the later Quat'z-Arts parties, a medieval masquerade, decorum was thrown to the winds to such an extent that, long before the evening was over, figleaves were carried round the hall in baskets and distributed to those merrymakers who had light-heartedly discarded every vestige of their clothing.

After three quarters of a century of continuous existence the Elysée-Montmartre came to an end in 1893. Two factors contributed to its ultimate extinction. What had once been its greatest asset — the quadrille — became at last one of the principal reasons for its downfall. Little by little the dance grew so complicated, the intricate steps demanded so much skill and so many years of practice, that amateurs who danced merely to amuse themselves were unable to participate. The floor was given over wholly to professional performers. The quadrille became, instead of only an incidental entertainment or " number " in an evening of more conventional dancing, the entire program. People no longer came to the Elysée-Montmartre to dance; they came to watch others dance. The place gradually lost the character of a popular dance-hall; the spectacle was the sole attraction. Even so, the Elysée-Montmartre might have survived for many years if there had been no competition. But the opening of the Moulin Rouge in 1889 was a fatal blow to the older resort. The principal performers of the Elysée-Montmartre went over in a body to its more glamorous rival, followed by an enthusiastic public. Almost deserted, the Elysée-Montmartre kept up the unequal struggle until 1893.

Then it was purchased by a Monsieur Chauvin, who renamed it Le Trianon and turned it into a combination of theatre, dance-hall, and café-concert. In 1898 a season of light opera was given there, and a little later a series of lectures. An imposing new pavilion for dancing, lavishly decorated, was constructed; but on February 18, 1900 the entire resort was destroyed by a catastrophic fire. It was quickly rebuilt; the name was changed again, and as Le Trianon-Lyrique it still exists. There is little in the Trianon-Lyrique of today, however, to remind one of the vanished brilliance of the old Elysée-Montmartre.

MOULIN DE LA GALETTE

OF THE two dozen or more ancient windmills that once adorned the slopes of Montmartre, only one survives today: the Moulin de la Galette. Perched near the summit of the hill at 79 rue Lepic, at the top of the steep rue Tholozé, its wooden tower and spreading grey wings dominate the entire city. The old mill is no longer as conspicuous, however, as it was in Lautrec's time. The hillside, then only sparsely dotted with low houses surrounded by large gardens and vineyards, is now thickly settled, and the Moulin de la Galette is partly hidden behind tall apartment buildings. But the view over Paris from the terraced garden is still magnificent.

The actual age of the Moulin de la Galette is uncertain, but it probably dates back to the time of Louis XIII. Once at least in the course of its long existence it was the scene of violence and bloodshed. During the Napoleonic wars the mill belonged to a family named Debray, consisting of four brothers. The story of their desperate resistance and heroic deaths is told by Georges Montorgueil in *La Vie à Montmartre:*

" On March 30, 1814, the army of the Allies which was advancing on Paris camped on the plain below Montmartre.

119

The nine batteries connected with the mills were defended by the National Guard, who believed Napoleon to be in the neighbourhood. When the Russian armies overwhelmed them, the gunners let themselves be cut to pieces beside their cannon rather than surrender to the enemy.

" Three of the Debray brothers were killed. Their corpses, riddled with bayonet wounds, were left on the field of battle. When, just after midday, Joseph [Bonaparte] capitulated, the order to cease fire was given; but the oldest Debray brother, still unwounded, refused to surrender: he was determined to avenge his brothers. A column of the enemy passed within range of his guns; he saluted them with a volley of grape-shot. The Allied troops attacked and captured the battery, and their commander threatened to shoot all the members of the French detachment unless the man who had ordered the bombardment gave himself up. Debray stepped forward. A Russian officer placed his hand on the Frenchman's shoulder. Debray blew the officer's head off with a shot from his pistol. He was butchered then and there; his body was torn apart, and the pieces were hung on the grey sails of the windmill which you can see today, calmly oblivious of those tragic hours, soaring over Paris. Debray's son was skewered to a tree by the thrust of a lance, but survived the ordeal. Under cover of night the widow cut down the fragments of the dismembered corpse of her husband and gathered them into a flour-sack, which she buried secretly in the cemetery."

This gruesome incident, however, cast no shadow over the later history of the Moulin de la Galette. A grandson of the heroic Debray converted the mill into a *goguette,* or unpretentious wineshop, whose popularity among the lowly inhabitants of Montmartre was due largely to the excellence of the *galettes,* or little cakes soaked in wine, which gave the resort its name. The proprietor was a jovial little man who liked gay company, especially that of young people. To attract them to

the Moulin de la Galette he hired fiddlers, perched them on top of a huge wine-cask, and himself led the lively dances in which the entire assemblage joined. The terrace was approached from below by a broad flight of steps treated in " rustic " fashion. Part of the flat space was occupied by a large and airy pavilion; the dance floor in the centre was separated by a wooden balustrade from the surrounding area, which was reserved for the spectators, to whom drinks were served at small tables. The rest of the terrace was laid out as a shady garden, in which were installed swings, a merry-go-round, a shooting-gallery, and other paraphernalia appropriate to a carnival or street fair.

This picturesque resort never became a fashionable rendezvous. If visitors from the exclusive circles of Parisian " high-life " ever came there, they did so only when in a mood for slumming. The Moulin de la Galette led a sort of double life and catered to two entirely separate groups of clients. On Monday nights it was invaded by an exceedingly noisy, rowdy public. The men, for the most part, were of the type known as *apaches* — the forerunners of our modern gangsters — brutal and swaggering, well launched upon careers of petty crime; while nearly all of the women, if they were not already professional prostitutes, were destined to end their lives in brothels, the prison of Saint-Lazare, or the river.

On Sunday afternoons and evenings, however, from three o'clock to midnight, the Moulin took on a much less sinister complexion. An admission fee of one franc fifty centimes for " cavaliers " and twenty-five centimes for " ladies " was charged, and these gatherings were immensely popular, especially in the summer months, when the management provided the additional attraction of a *Grande Kermesse* in the garden. The Sunday crowds, though still noisy and boisterous, maintained a certain bourgeois formality. A few of the younger girls were still carefully chaperoned by watchful mothers; and even those who had already strayed had not yet lost their fresh-

ness. Most of the men who attended the Sunday dances were honestly employed as clerks or artisans during the week. There was no attempt to create a gala atmosphere. The women wore everyday dresses and felt slippers, and the elaborate lace-trimmed petticoats that were displayed so lavishly at the Elysée-Montmartre and the Moulin Rouge were replaced by much simpler and less costly garments at the Moulin de la Galette; while the men were permitted to dance without coats, collars, or ties, if they felt so inclined. The dancing was animated and almost wholly non-professional. The favourite dances were the waltz, the polka, and the quadrille; but this quadrille was nothing like the highly specialized and intricate performance that it became at other resorts: it was a comparatively simple though lively dance in which everyone could take part. The original band of fiddlers hired by Debray was soon replaced by a larger and excessively noisy orchestra in which the powerful brasses usually drowned out the weaker stringed instruments.

Neither the Sunday nor the Monday night aspect of the Moulin de la Galette was particularly attractive to Lautrec. The first, though not altogether devoid of character, was on the whole too colourless and bourgeois; the second was too blatantly tawdry and vicious. Moreover, the site was somewhat difficult of access: his feeble stunted legs could not carry his heavy body up the steep hill without considerable fatigue, yet the distance was hardly great enough to warrant the expense of a carriage. Nevertheless the Moulin de la Galette constituted one of the important elements of Lautrec's background. When, from time to time, he did make the effort to drag himself to the top of the rue Tholozé, he generally brought back a number of sketches which he afterwards incorporated in his paintings. In 1886 he made several drawings there of dancers. The following year he executed two more ambitious, but still sketchy, pictures of scenes at the Moulin de la Galette: one of Valentin le Désossé and La Goulue, one of Valentin with another partner. In all of these the emphasis is on the figures,

and the background is barely suggested: they might have been painted anywhere. But in 1889 he produced a large canvas, *Au Bal du Moulin de la Galette,* which is far more interesting both as an example of his work and as a representation of the resort. This picture, highly finished and more than usually complete in its wealth of detail, shows the painter Joseph Albert in the right foreground, seated at a table and leaning over the low railing that separates the dance floor from the slightly elevated *promenoir.* On the other side of the barrier three women are sitting on a bench: one has turned her head to talk to the painter; the other two, seen in profile, are watching the waltzing couples in the background while waiting to be asked to dance. The cheerful animation of the crowded dance floor is in marked contrast with the dinginess of the room and the shabby furniture: the bare wooden tables, the hard uncomfortable benches, the neglected pile of dirty saucers.

Again in 1891 Lautrec painted *Au Moulin de la Galette.* Here four standing figures, almost full length, practically fill the cardboard panel; the heads of three or four others appear farther back. There is no indication of the surroundings except a slight suggestion of the wooden railing in the lower left-hand corner of the picture. In the centre stands a girl with a small fur " tippet " draped carelessly over one shoulder; two men, one on either side of her, are engaged in conversation with a third, whose head only is visible; while at the extreme right an older woman, hatchet-faced and dour, with thin lips drawn down grimly at the corners, turns her back indifferently on the little group. All of the figures are in repose: there is no dancing, no movement of any kind. The young girl with the fur is the subject of another picture painted in the same year, *La Fille à la Fourrure,* probably a preliminary study for the principal figure in the larger work. Unlike most of Lautrec's studies, however, it is carried out in detail and is in every way a complete picture in itself.

In 1894 he painted another picture of the Moulin de la Ga-

lette, *Alfred la Guigne,* named after a character in a novel by his friend Oscar Méténier; Lautrec dedicated the painting to the author. The young blackguard Alfred stands at the bar, his hands in his pockets and a bowler hat perched rakishly on the back of his head. With him are two women, one young, bold, and trim, the other fat, coarse, and bleary-eyed. This is the last picture that connects Lautrec with the Moulin de la Galette.

MOULIN ROUGE

IT is almost impossible to refer to Lautrec without immediately conjuring up a vision of the Moulin Rouge, so intimately are their names associated in the public mind. This, of all the resorts in Montmartre or, for that matter, in any part of Paris, was the one he loved best. He was to be seen there night after night at the little table that was always reserved for him. Everything that appealed to him in the night life of Paris was concentrated in this one spot: bright lights and colour, animated crowds, spectacular dancing, lively music and witty songs, the presence of his friends, and the alcohol that lifted him, temporarily at least, into a happy dreamland where he could forget deformity and pain.

Unlike the Moulin de la Galette, the Moulin Rouge was not originally a real mill. There was no historical basis for the name; the only windmill that had ever occupied the site was the imitation one, painted a brilliant scarlet, that was perched on the roof over the entrance to the dance-hall. The red mill, with its four enormous rotating vanes outlined in glittering lights against the night sky, served no utilitarian purpose. It was purely and simply an advertisement, an effective trademark which soon became one of the standard sights of Paris, more

125

familiar to many tourists than the towers of Notre-Dame.

There had been a pleasure resort at 90 boulevard de Clichy long before the advent of the Moulin Rouge. La Reine Blanche, established on the site before 1850, was a popular dance-hall during the Second Empire. It differed from its contemporary rivals in one curious respect. While the feminine section of its public was composed almost wholly of the same prostitutes who frequented the other *bals* of the neighbourhood, the atmosphere was much less commercial: the women who attended the Boule Noire and similar resorts in their professional capacities flocked for relaxation and amusement to the Reine Blanche, where they could dance with partners of their own choosing. Little by little, however, the popularity of the Reine Blanche waned, and the building, empty and dilapidated, was torn down. In its place was constructed, in 1889, a far more pretentious edifice to house the Moulin Rouge.

At first the location of the new resort seemed ill chosen. The centre of the night life of Montmartre had always been the boulevard de Rochechouart; its western outpost was the place Pigalle. But the Moulin Rouge was erected some five hundred yards farther to the west in the boulevard de Clichy, on the other side of the place Blanche. There were gloomy predictions of failure: the place was too isolated, the fun-loving public would never take the trouble to go so far afield. The doleful prophets were mistaken. The success of the Moulin Rouge was immediate and sensational. While its only serious competitor, the Elysée-Montmartre, lost ground steadily, the attendance at the new dance-hall quickly broke all records. Its immense popularity was due largely to the genius of the director, Charles Zidler, who assembled at the Moulin Rouge all of the famous dancers of Montmartre: La Goulue, Grille d'Egout, La Môme Fromage, La Macarona, Rayon d'Or, Jane Avril, Valentin le Désossé. The dancing, which took place nightly from half past ten to half past twelve, was the principal

attraction; but for those who came early there was an additional treat in the form of a " concert," with comic or sentimental or dramatic songs presented by artists of the first rank — among them Yvette Guilbert, who sang there in 1890, at the beginning of her career.

Zidler himself was something of a " character." His brusque manners and uncouth speech concealed the kindest of hearts, a keen intelligence, and a profound understanding of human nature. He knew what the public wanted in the way of entertainment, his judgment was sound, and he was not afraid to take chances. He was a self-made man who had been brought up in a hard school of poverty and privation. At the age of ten he was apprenticed to a tanner and forced to work from dawn to dark with his feet in muddy water impregnated with tannic acid, half frozen in winter, nauseated in summer by the suffocating stench of hides. He had little formal education, but taught himself to read and write when he was fourteen years old. He was exceedingly ambitious and, considering the grimness of his childhood, his aspirations took a curious form. He was convinced that he had a flair for the organization of public amusements on a large scale: he saw visions of magnificent fêtes and pageants directed by himself. The first opportunity for the realization of these dreams came unexpectedly through a chance meeting with Joseph Oller, who already had connections with, and a certain amount of experience in, the world of entertainment. Oller and Zidler formed a partnership which launched a series of highly successful enterprises: the *Montagnes Russes* at Olympia in the boulevard des Capucines; the Hippodrome, originally located near the place de l'Alma, later moved to a new building on the site of the gardens of Monsieur Forest; the Moulin Rouge; and finally the Jardin de Paris in the Champs-Elysées. The last was an extremely smart resort in summer; almost all of the principal stars of the Moulin Rouge appeared there, though sometimes the repertoire of songs and dances had to be toned down so as not to scandalize

the fashionable audiences. Many of the habitués of the Jardin de Paris, however, were also assiduous attendants at the Moulin Rouge, where they remained until the end of the principal quadrille, about eleven o'clock; then they would troop in a body to the Jardin de Paris to watch the same dancers perform the same evolutions all over again. These roving enthusiasts became so numerous, in fact, that Zidler inaugurated a special line of omnibuses to transport the gay crowds nightly from Montmartre to the Champs-Elysées.

Zidler employed an assistant manager named Trémolada, who is identified by Jane Avril as the man standing next to Lautrec in the photograph reproduced on Plate 14. Trémolada was a sort of Père la Pudeur at the Moulin Rouge: his chief duty was to keep order on the dance floor.

In 1892 Oller succeeded Zidler as head of the Moulin Rouge and the Jardin de Paris. The change made little difference at either resort: the policy was not altered, and the same attractions were offered to similar audiences. The Moulin Rouge catered to a mixed clientele. There was the usual nucleus of artists and writers, most of whom knew each other well and kept more or less to themselves; there were worldly sightseers from Paris and open-mouthed provincials from other parts of France; a large and conspicuous sprinkling of foreigners, mostly English and American tourists, for whom a visit to the wicked Moulin Rouge was an indispensable feature of a trip abroad; and the inevitable army of predatory women, many still fresh and attractive, who swarmed in the *promenoir* and paraded their charms in the hope of securing generous companions for the night.

A description of the Moulin Rouge well calculated to dazzle the unsophisticated pleasure-seeker is given in the *Guide des Plaisirs à Paris* for 1900:

" From ten o'clock at night until half past twelve the Moulin Rouge presents a very original and quite Parisian spectacle

that is well worth seeing, even by husbands accompanied by their wives. . . .

"After you have surrendered your ticket in the foyer, you pass through a corridor, with red walls covered with photographs and posters, to the great dance-hall. The first view of it is far from commonplace: high and enormous, it looks like a railway station miraculously transformed into a ballroom.

"The orchestra, big enough for a circus, whose powerful brass instruments reduce to silence the gentle violins, sounds the charge for the battalion of *chahuteuses* [quadrille dancers] who leap forward with skirts lifted and legs uncovered.

"During the intervals in the program of dances men and women promenade up and down in a double stream as on a railway platform, jostling, rubbing elbows, forming eddies, under a bewildering confusion of hats of all kinds: the women wear huge feathered creations on their heads, while the men are in high silk hats, bowlers, soft felts, and sometimes even caps.

"Gay bodices of cerise, green, yellow, white, and blue satin, as well as skirts of all colours, provide a feast for the eye and fascinate the observer.

"An aroma of tobacco and rice powder envelops you.

"To the left, at little tables, sit the *petites dames* who are always thirsty, and who buy drinks for themselves while they are waiting for somebody to buy drinks for them. When that happens, their gratitude is so overpowering that they immediately offer you their hearts — if you are willing to pay the price.

"On each side of the room is a raised platform, a broad open gallery from which you can watch the dancing without taking part in it and enjoy a general view of all the women in full regalia, strolling about and parading before you in this veritable market-place of love. . . .

"The garden is to the left of the entrance; round the bandstand in the centre you see a bevy of damsels, trained and paid

to maintain at the level of its former glory the divine Parisian *chahut,* sought after and appreciated by people of all nations, who assemble here to enjoy its unconcealed beauties.

" A few English families, with a dozen children, are scandalized by the sight of these women who dance by themselves, without male partners, and whose muscular elasticity, when they spread their legs wide part in the *grand écart,* betokens a corresponding elasticity of morals. And when the lace petticoats of the dancers are suddenly lifted to their bellies, with a swirling movement that is far too suggestive, prudish Albion veils her face and beats a hasty retreat.

" Through the lace ruffles of drawers or the transparent gauze of silk stockings you can often catch glimpses of pink or white skin, displayed as samples by these pretty vendors of love. . . .

" In the old days, little Tunisian donkeys trotted in the garden, bearing these ladies on their backs; the riders engaged in wild races, which provided another excuse for the exhibition of their gartered legs, whose smooth roundness was not always entirely genuine.

" The donkeys have disappeared, but the elephant remains: a colossal elephant, as high as a two-storeyed house, an elephant that suggests the Trojan horse, and that carries in its belly an orchestra and a troupe of girls, experts in the contortions of the *danse du ventre.* . . ."

A typical advertisement of the Moulin Rouge during Zidler's administration appeared in *Le Chat Noir* for December 7, 1889:

MOULIN ROUGE, BOULEVARD DE CLICHY
RENDEZ-VOUS DU HIGH-LIFE — ATTRACTIONS DIVERSES
TOUS LES SOIRS, BALS — MERCREDI ET SAMEDI, FÊTE DE NUIT

The attractions were indeed diverse, but they were certainly not always in the best of taste. Perhaps the lowest point in all

the history of entertainment was reached when a singular in-
dividual billed as Le Pétomane was engaged to perform at the
Moulin Rouge. The unique talent of the Pétomane consisted
in the production of loud and obscene blasts that issued from a
portion of his anatomy not usually mentioned in polite society.
Years of practice had made him a master of this unconventional
accomplishment: he could (and did) vary the tone of his ex-
plosions at will in imitation of a wide range of musical sounds,
from sonorous base to shrill soprano. This novel " attrac-
tion " drew enormous crowds to the Moulin Rouge, where the
Pétomane was installed in the open belly of the huge *papier
mâché* elephant in the garden. He " sang " nightly between
the hours of eight and nine, and at a given signal the entire
audience, convulsed with laughter, would follow his leader-
ship in a resounding chorus. So great was the success of the
Pétomane that, when he ventured to duplicate his perform-
ance at a street fair in 1894, Oller of the Moulin Rouge
promptly sued him for breach of contract and demanded dam-
ages to the tune of three thousand francs.

The Moulin Rouge furnished the setting for a long series
of Lautrec's paintings and drawings. Many of them are among
his finest works. The earliest, *Au Moulin Rouge: la Danse,*
was painted in 1890 and hung for some years above the bar at
the entrance to the dance-hall. This large canvas represents
Valentin le Désossé dancing the quadrille with his partner (ap-
parently not La Goulue) ; surrounding the cleared space is an
admiring throng of spectators, among whom may be recog-
nized Jane Avril, Maurice Guibert, the photographer Paul
Sescau, and the painter François Gauzi. In 1891 Lautrec pro-
duced a coloured poster to advertise the Moulin Rouge (Plate
54) and a painting on cardboard, *Au Moulin Rouge: Repos
entre deux Tours de Valse* (Plate 18), which depicts La
Goulue, with her hand on her hip and a disdainful smile on
her thin lips, swaggering insolently about the dance floor on
the arm of her cavalier. Although there are actually not more

than ten figures in the composition, Lautrec has managed to create the impression of a densely packed and extremely animated crowd by the device of facing each of the promenading couples in a different direction, so that the lines of movement cross and recross endlessly. In the background Jane Avril is executing a *pas seul:* her skirts are lifted to disclose a pair of legs whose thinness is intentionally exaggerated. Her long, narrow feet are twisted at the ankles so that the toes point directly inwards. In the upper right corner is a suggestion of the orchestra on its elevated platform, which is protected by an ornate balustrade.

In 1892 Lautrec added more than a dozen pictures to his Moulin Rouge series. Several of these are portraits of Jane Avril in various poses and costumes, all painted on cardboard. *Jane Avril Sortant du Moulin Rouge* shows the famous dancer in sober conventional street dress and hat; at the left is Charles Conder, the English painter. *Jane Avril Dansant* (Plate 20) is more spirited: with her skirts raised to the knees, her right foot planted firmly on the floor, and her left leg bent at an acute angle, she is engaged in performing some complicated step of her own invention. One of the two small figures in the background is an Englishman named Warner, who appears again in a coloured lithograph, *L'Anglais au Moulin Rouge* (D. 12) ,* executed the same year (Frontispiece). Other works of 1892 are *Au Moulin Rouge: un Couple de Danseurs,* representing a man in a bowler hat and a woman with her petticoats hoisted to her waist standing side by side, ready to begin their dance, in front of the wooden barrier that separates the dance floor from the surrounding promenade; *La Goulue Entrant au Moulin Rouge,* in which the dancer, in a light dress cut so low that her breasts are almost entirely exposed through the filmy net of a transparent yoke, stalks majestically into the hall with her sister on one side and a younger *danseuse* on the

* Throughout this book, references marked " D." are to Loys Delteil: *Le Peintre Graveur Illustré,* Volumes X and XI, published in 1920.

other; and *Au Moulin Rouge: le Départ du Quadrille* (Plate 16), which shows two buxom women facing each other with arms a-kimbo, feet apart, and skirts lifted, as they wait for the opening measures of the dance to sound from the musicians' balcony, seen at the top of the picture. One of Lautrec's most famous works, also painted in 1892, is *Au Moulin Rouge: les deux Valseuses* (Plate 17). Two women, whose mannish features and severely tailored garments stamp them as Lesbians, are waltzing together; one of them is said to be the *clownesse* Cha-U-Kao, whom Lautrec painted several times in the costume of a Pierrette. To the right of the waltzers is Jane Avril, seen from the back; still farther to the right, at a table behind the barrier, is Charles Conder; and at the extreme left of the picture appears the head of François Gauzi. Another masterpiece of this year is *Au Moulin Rouge* (Plate 15), in which a great many local celebrities are gathered together. In the right foreground, partly cut off by the edge of the canvas, is a woman discreetly identified by Joyant as " Mademoiselle Nelly C."; in the centre, seated round a table, are Edouard Dujardin, Paul Sescau, Maurice Guibert, and the dancer known as La Macarona; in the right background stands La Goulue arranging her hair before a mirror while she chats with another woman; and directly behind the centre table are the figures of Lautrec's cousin Dr Gabriel Tapié de Céleyran, tall, thin, and gawky, and of Lautrec himself, grotesquely diminutive beside his gigantic companion. Finally, to complete the list of works of the year 1892 connected with the Moulin Rouge, there is the coloured lithograph of *La Goulue et sa Sœur* (D. 11). Only the back of La Goulue can be seen, while her sister Victorine — a heavier, more matronly edition of the dancer — has turned her head so that her profile is visible.

In 1893 Lautrec painted a group of six pictures which were reproduced in colour as illustrations for an article by Gustave Geffroy, *Le Plaisir à Paris,* in *Le Figaro Illustré* for February 1894. Four of the six almost certainly represent scenes at the

Moulin Rouge: *Deux Femmes Valsant* and *Deux Femmes au Bar,* both studies of Lesbian types; *La Vendeuse des Fleurs;* and *Au Moulin Rouge,* a picture of La Goulue in a cape and a small bonnet, Paul Sescau, and three unidentified figures, two women and a man. Joyant, usually accurate in his dating, ascribes all of these to 1894; but as they appeared in printed form so early in the year it is safe to assume that the original paintings were executed before the close of 1893.

One lithograph of the Moulin Rouge, *Un Rude! un Vrai Rude!* (D. 45), dates from 1893, and four were produced in 1894: *L'Union Franco-Russe* (D. 50) ; *Une Redoute au Moulin Rouge* (D. 65) ; *La Tige* (D. 70) ; and *La Goulue et Valentin le Désossé* (D. 71). In 1895 Lautrec painted several portraits of *La Clownesse* (Cha-U-Kao), and the following year, or perhaps towards the end of the same year, he made two or three drawings in black and white: one of these, *Au Moulin Rouge: Entrée de Cha-U-Kao,* was printed as a full-page illustration in *Le Rire* of February 15, 1896. After 1896 Lautrec ceased to visit the Moulin Rouge so frequently; and the famous dance-hall, for so many years his favourite rendezvous, does not appear again as a background for his paintings.

LA GOULUE

LOUISE WEBER, much better known as La Goulue — The Glutton — was a striking figure. Joyant ascribes the uncomplimentary nickname to her voracious appetite, Coquiot to her habit of drinking " bottoms up " out of all the wineglasses within reach as she strolled between the crowded tables. Supple, wasp-waisted, voluptuously curved, she swayed her hips provocatively as she walked nonchalantly about the dance-hall, conscious of the admiring glances of the spectators and disdainfully proud of her position as the reigning Queen of Montmartre. Her skin was fair; her features, especially her mouth and chin, inclined to heaviness. She was bold, coarse, shrewish, wanton, with the morals of an alley-cat and a vocabulary that would have shamed the most accomplished fishwife. In *La Chanson de ma Vie* Yvette Guilbert gives a vivid description of La Goulue in action:

" La Goulue, in black silk stockings, with one foot shod in black satin held in her outstretched hand, made the sixty yards of lace on her petticoats swirl and showed her drawers, with a heart coquettishly embroidered right in the middle of her little

135

behind, when she bowed her impertinent acknowledgments; knots of pink ribbon at her knees, an adorable froth of lace falling to her dainty ankles, now disclosed, now concealed her beautiful legs, nimble, adept, alluring. The dancer sent her partner's hat flying with a neat little kick, then executed a split, her body erect, her slim waist sheathed in a blouse of sky-blue satin, her black satin skirt spread like an umbrella five yards in circumference.

" It was magnificent! La Goulue was pretty and attractive to look at, in a vulgar way — blonde, with a fringe of hair hanging over her forehead down to her eyebrows. Her chignon, piled high on top of her head like a helmet, sprang from a single strand tightly twisted at the nape of her neck, so that it would not fall down when she danced. From her temples the classic *rouflaquette* [a coil or ringlet] dangled over her ears, and all the way from Paris to the Bowery in New York, via the dives of Whitechapel in London, every hussy adopted the same style of hairdressing and wore a similar coloured ribbon round her neck."

Coquiot contributes a less flattering picture:

" She is haughty and impertinent, this woman; she is ferocious, and she has the dull, torpid eyes of some great bird of prey. She is hard, rigid, terrifying, enigmatic, disturbing, and sullen. Her thin nose is pinched, her greedy lips are pressed tightly together, then they relax and are distorted into an expression of malevolence and suffering. This dancer is at once a goddess and a martyr; a goddess toasted and acclaimed by everybody; but also a martyr who shows us a stricken countenance: the most ravaged, the most withered, the most sorrowful, the most lined and relined, the most alert and the most languid, the most predatory and the most aloof, the most cruel and the most candid, the youngest and the oldest face in all the world."

136

La Goulue was afraid of nobody; she was no respecter of rank, and there were no limits to her impudence. Yvette Guilbert tells of an incident that took place when La Goulue was dancing at the Jardin de Paris. It was a gala night, the night of the Grand Prix, and all of smart Paris was there. Among the guests was the Prince of Wales, afterwards Edward VII. La Goulue, dancing the quadrille in front of his table, with one foot in the air and her petticoats floating like a lacy cloud about her head, rolled her eyes at him saucily and shouted at the top of her strident voice:

" Hi, there! Wales! Aren't you treating us to champagne? "

The shocked audience gasped in horror, but the Prince, far from being annoyed, roared with laughter and obligingly ordered wine for La Goulue and her thirsty partners.

Brazen as she was, there was one aspect of her life over which La Goulue tried, not very successfully, to draw a veil. Sexually promiscuous, she was generally believed to be as fond of women as of men; but she would never admit the truth of the accusation. Yvette Guilbert reports that La Goulue lived for some time with a " a strange little dancer who looked like a kitchen-maid," nicknamed La Môme Fromage. One day an indiscreet acquaintance tried to discover the facts concerning their relationship. La Goulue, suddenly overcome by modesty, protested indignantly that there was nothing more than a normal friendship between them; but La Môme Fromage, equally indignant, insisted that they were in love with each other. Yvette Guilbert describes La Môme Fromage as " a dachshund turned into a woman, short of leg, long of body, plumpish, with the head of a servant — a Venus of the barracks. I do not know how she acquired her name of Môme Fromage."

La Goulue is said to have begun her career as a laundress, at the age of sixteen. A year later she was dancing at the Moulin de la Galette, where she attracted the attention of one of the oddest characters of all the motley crew that gave colour to

the night life of Montmartre: Valentin le Désossé, Valentine the Boneless. Valentin was an extraordinarily agile dancer: his sense of rhythm was so highly developed and his muscular control was so perfect that he seemed to be made of rubber as he bounded through the intricate measures of the quadrille, or swayed and pivoted to the strains of a dreamy waltz. He could twist his joints into almost any position without apparent effort; the flexibility of his body was so phenomenal that it was almost impossible to believe that he possessed anything so rigid as a skeleton. As partners in the quadrille, Valentin and La Goulue were made for each other. Valentin was the more creative of the two: he invented new steps and taught them to La Goulue, who abandoned herself to his instruction with the greatest docility. For years they danced together almost nightly, first at the Moulin de la Galette, then at the Elysée-Montmartre, and finally at the Moulin Rouge and the Jardin de Paris, where their performances drew immense crowds and were greeted with wild applause.

Valentin's real name was Jacques Renaudin. Unlike most of the dancers in Montmartre, he came of a respectable family and had a modest private income. During the day he ran a small café in the rue Coquillière near the Halles Centrales, where he attended conscientiously to his business. But at night, when he had discarded his bartender's apron, he entered another world. Valentin danced for the love of dancing. Though he could have commanded a good salary for his performances in the quadrille, he would accept no professional engagements, preferring to remain unpaid rather than sacrifice his independence. On the dance floor, arrayed in his rusty black frock-coat, with a dilapidated high silk hat tipped over his eyes at an impossible angle, he resembled nothing so much as a dissolute undertaker on a spree. There was no romance, no suggestion even of the gigolo, in Valentin's grotesque appearance. He was immensely tall and unbelievably thin: " so

thin," says Coquiot, "that one could wind him round a gas-pipe." His head was the head of a lugubrious Punch, scraped to the bone: he had sunken eyes, half-closed, a narrow high-bridged beak of a nose, unsmiling thin lips drawn down at the sides in a grimace of perpetual woe, an enormous lower jaw thrust forward and ending in a bony, drooping chin.

The strong bond of sympathy between La Goulue and Valentin le Désossé was not confined to their common enthusiasm for the dance. There seems to have been nothing ardent, nothing in the least loverlike about their relationship, but they understood each other perfectly and enjoyed each other's company. Valentin owned a horse and a small open carriage, and the curiously assorted pair of dancers might often be seen bowling along through the Bois de Boulogne; Valentin, in redingote and top hat, erect, solemn, and taciturn, held the reins, while his companion, elaborately gowned but always without a hat, sat contentedly beside him and stared with bold disdainful eyes at the occupants of passing vehicles. Both La Goulue and Valentin liked to fish, and they would sometimes spend the whole day together placidly dipping their rods in one of the smaller streams near Paris, returning in the evening, if they had had good luck, with a string of minnows and other small fry. Later, when La Goulue had accumulated a comfortable sum of money, she bought a little house in Montmartre, with a tiny garden in which she took great pride. She tended her flowers with care, a task in which she was often assisted by Valentin. It must have been strange to see these two birds of the night, who could not exist without the bright lights and the intoxicating rhythms of the dance-hall, pruning and sprinkling, digging up and weeding the diminutive flower-beds as sedately as any suburban couple.

Yvette Guilbert tells an amusing anecdote concerning La Goulue and her beloved garden. One day, observing that her climbing roses failed to flourish to her satisfaction, the dancer

ripped out an impressive string of picturesque and highly seasoned oaths. Immediately, a gentle voice floated protestingly over the garden wall:

" My daughter, you should not swear like that; you are committing a sin against Heaven."

" What's that? What's that? "screamed La Goulue. " Mind your own business, you old fool! Just let me take a look at you! "

And with that La Goulue, spluttering with rage, planted a ladder firmly against the wall and scrambled to the top for a glimpse of her interfering neighbour. To her astonishment she found herself face to face with a benign old curé. Her anger cooled instantly; she apologized for her unconventional language; the priest smiled, La Goulue grinned, and the incipient quarrel was forgotten. Peace-offerings were tendered and accepted by both parties. The priest kept La Goulue's table supplied with grapes from his vine, and the dancer sent baskets of her choicest flowers, several times a week, to adorn the house of her new friend, the curé.

Since the quadrille was always danced by four people it was necessary for La Goulue and Valentin to find a pair of suitable partners. There was no lack of good dancers, and the two stars had plenty of promising material to choose from. Eventually they selected a man named Guibollard and a woman known by the unflattering sobriquet of Grille d'Egout, or Sewer-Grating. Apparently Guibollard was completely overshadowed by the incomparable Valentin, for little is known of him. Grille d'Egout, on the other hand, had a forceful personality and stood out as one of Montmartre's most picturesque characters. Georges Montorgueil writes of her in *La Vie à Montmartre:*

" Originally a dressmaker . . . her early training had endowed her with certain refined standards of taste; her clothes, which she made herself, were almost conventional, without os-

tentation, discreet, perhaps even a little dull. Was she pretty?
No. But she was amiable, kind, good-natured, with a friendly
smile that exposed two teeth, the teeth of a rodent, long and
terrifying, which projected over her lower lip and which Henri
Rochefort compared to the gratings of a sewer. The compari-
son was unfair: while La Goulue's language was often foul,
the speech of her partner, whom Réjane . . . so charmingly
addressed as ' Mademoiselle d'Egout,' was always refreshingly
decent. . . .

" She held herself aloof from the disorderliness of her com-
panions. Though she was generally modest, when the spirit
moved her she could kick a man's hat off his head as saucily as
anyone. When she pirouetted on her toes, disclosing her slen-
der calves, she was unrivalled; she could invent infinite varia-
tions on an orchestral theme, always keeping perfect time to
the music. . . . About her knees her lace flounces undulated
like the foamy crests of gently heaving waves. She avoided a
too lavish display of nakedness and allowed only a mere sus-
picion of pink skin to show between the tops of her well-
fitting black stockings and the embroidered ruffles of her
drawers. And never a suggestion of vulgarity! "

There was a streak of malicious cruelty in La Goulue that
found expression in her treatment of other dancers, particu-
larly those who, young and timid, were just beginning their
careers. She bullied these potential rivals without mercy,
mocking their clothes and figures, sneering at their perform-
ances, and in general making their lives a burden. But she
finally met her match in an Algerian dancer named Aïcha, who
sturdily refused to put up with La Goulue's insolence. One
night, after the two viragos had screamed insults and obsceni-
ties at each other until they were hoarse, they decided to settle
the quarrel once for all by a physical encounter, which accord-
ingly took place about one o'clock in the morning on the via-
duct that carries the rue Caulaincourt over a corner of the

Montmartre cemetery. A huge crowd, vastly entertained, formed a ring round the enraged women, and the epic struggle began. It was a battle without rules: the combatants clawed, kicked, bit, and pulled each other's hair with the fury of a pair of snarling tigresses. Unfortunately for La Goulue, the Algerian was both younger and a good deal stronger. The battle would have ended disastrously for the Queen of Montmartre if the bystanders had not rushed in and rescued her just in time to prevent her opponent from heaving her over the parapet into the graveyard below.

Between 1886 and 1895 Lautrec painted and drew more than a dozen portraits of La Goulue, occasionally with Grille d'Egout, more often with Valentin le Désossé or by herself. He painted her at the Moulin de la Galette, at the Elysée-Montmartre, and at the Moulin Rouge; or rather he made sketches of her against these colourful backgrounds and completed the pictures in the quiet seclusion of his studio. At first La Goulue, indifferent to art and perhaps somewhat repelled by Lautrec's hideous features and crippled body, refused to pose for him; but she was soon won over by his charming manners and his witty conversation. He never flattered her in his portraits; indeed, he never flattered anyone. All her coarseness, her rapacity, her sensuality, and her cruelty are exposed by his ruthless brush and pencil. At the same time his pictures do full justice to her more amiable qualities; her unsystematic, impulsive generosity, her capacity for genuine affection, her childlike enjoyment of simple pleasures.

The prosperity that enabled La Goulue to enjoy the luxuries of a house and garden of her own lasted only a few years. She began to grow fat, her crisp hawklike profile became blurred and puffy, her wonderful legs lost their grace. She fell rapidly from her high estate as star of the Moulin Rouge. By 1895 the once famous dancer had disappeared from Montmartre and was obliged to earn a living as best she could by the performance of a sort of *danse du ventre* at suburban street

fairs. Dressed in a gaudy, glittering Oriental costume, the unfortunate woman waggled her flabby belly and swayed her ponderous buttocks for the entertainment of uncritical holiday crowds. One of these exhibitions took place in 1895 at the annual Foire du Trône, near the place des Nations, in one of the poorer quarters of Paris. For this occasion La Goulue appealed to Lautrec to paint a pair of curtains for her booth. Joyant quotes her letter, in which she employs the familiar *tu:*

" 6 April 1895

" My dear friend,

" I shall be at your studio Monday, April 8, at two in the afternoon; my booth will be at the Trône, to the left of the entrance, I have a very good place and should be very happy if you could spare the time to paint something for me; you can tell me where to buy the canvas, and I shall bring it to you the same day.

La Goulue "

Lautrec, always loyal to his old friends, cordially agreed to decorate the curtains. They contributed materially to the success of La Goulue's appearance in what she called her *danse de l'almée;* many people who would have passed her rickety wooden booth without a glance were tempted to linger by the sight of Lautrec's colourful figures. When the Foire du Trône had run its course the booth and curtains were moved to another street fair at Neuilly, where La Goulue repeated her performance. The curtains, divided in the middle, were made of very coarse canvas. The panel on the left represents La Goulue and Valentin le Désossé at the Moulin Rouge, surrounded by an admiring audience. The other half shows La Goulue in Oriental dress dancing on a raised platform, with her right foot elevated to the level of her outstretched arm. Behind her, on the stage, are her musicians: a turbaned Moor beating a small drum with the palm of his hand, and a woman, also in

Oriental garb, shaking a tambourine. At the extreme left, in the background, Monsieur Tinchant is thumping vigorously on the piano. The foreground is peopled with spectators, most of them viewed from the back, and all of them authentic portraits of Lautrec's friends. In the centre is Jane Avril in a huge black hat covered with waving plumes; to her left is Monsieur Sainte-Aldegonde; and in the corner, in profile, are Lautrec's cousin Dr Gabriel Tapié de Céleyran, Maurice Guibert, and Paul Sescau. On Jane Avril's right are Lautrec himself and Félix Fénéon (Plate 19).

These curtains have had a curious subsequent history. La Goulue apparently sold them when she had no further use for them; thereafter, for some years, they passed from hand to hand and were lost sight of for a time. In 1926 parts of them were found in the shop of a dealer who had cut them up into eight large sections and a number of smaller scraps, some of which had disappeared. This act of vandalism was immediately denounced by outraged admirers of Lautrec's art, and steps were taken to locate the missing portions. Eventually all of the scattered elements of the work were reassembled, and in 1929 the various bits and pieces were purchased by the Louvre and carefully restored to their original state.

La Goulue sometimes added spice to her *danse du ventre* by performing it in a cage full of lions and other wild animals. These exhibitions were not as dangerous as they seemed, for the beasts were well trained, old, and docile, and in addition they were always more or less dazed by the bright lights, arranged so as to shine directly into their eyes.

The last chapter in La Goulue's association with Lautrec was written in 1914, thirteen years after the painter's death. In June and July of that year an important retrospective exhibition of Lautrec's works was held at the Manzi, Joyant galleries in the rue de la Ville-l'Evêque. La Goulue's booth of 1895, complete with curtains, was borrowed for the occasion and re-erected as one of the principal exhibits; and Maurice

Joyant conceived the idea of inviting La Goulue herself to repeat her performance of twenty years before. But when the dancer appeared, old, wrinkled, enormous, shapeless, with triple chins and rolls of flabby fat, she was hastily dismissed by the disillusioned committee. Time and the hearty appetite that had earned La Goulue her nickname had done their work too well.

The closing years of La Goulue's life were miserable and embittered. She took to drink; she grew ever fatter and blearier, more and more repulsive. She could no longer dance and was obliged to sell her menagerie. Soon the money from the sale of her animals was gone, and she found herself destitute. At the age of sixty she trudged about Montmartre with a basket on her arm, peddling candy and oranges from one café to another. Her mind began to fail; she remembered almost nothing of the events and companions of her youth. The mention of the name of one of her old friends kindled no spark of recognition in her eye. She lived squalidly in a ramshackle gypsy van, for the rent of which she paid twenty francs a month, in a suburban squatters' colony at Saint-Ouen. There was only one living thing to which she was still attached — a mongrel dog named Rigolo. At the end she begged to be allowed to remain in her van, with Rigolo, until her death; but this last wish was denied her. Ill and helpless, she was removed to the Lariboisière Hospital, where she died, a charity patient, on January 30, 1929.

JANE AVRIL

IN many ways La Goulue was an ideal model for Lautrec. As an artist to whom the representation of " character " was all-important, he exulted in her sensuality, her coarseness, her ripe physical allure, even her rapacious cruelty; and he portrayed her in all her viciousness, without pity, but also without rancour. But Lautrec was far too versatile a painter to limit himself to the delineation of a single type. Jane Avril, in almost every respect the antithesis of La Goulue, was in her own fashion an equally tempting subject. Dainty, charming, gracious, she possessed an innate distinction that set her quite apart from the other dancers at the Moulin Rouge. She never allowed herself to lapse into vulgarity. Though she danced with an almost frenzied abandon, her gestures were never lascivious or provocative; when she spoke, her conversation was untainted by lewdness. If La Goulue resembled a hawk, Jane Avril suggested a butterfly as she floated airily about the dance floor. She was thin, pale, graceful, exceedingly feminine, delicately built, with slender ankles and tiny narrow feet; she " had the beauty," writes Arthur Symons in the *Print Collector's Quarterly* for May 1922, " of a fallen angel; she was exotic and excitable. . . ."

For all her refinement Jane Avril was anything but a saint.

146

The list of her lovers and " protectors " was a long one; but her adventures were never the usual commercial transactions entered into by her more cynical colleagues: there was always at least affection in her relations with the various men she lived with, and often genuine, if evanescent, love. Her friends — and many of her friendships were purely platonic — were generally writers or artists, cultivated men in whose company she felt at ease. Though she had had but a scanty education, her instinctive good taste and her quick wits made her welcome at such " high-brow " gatherings as the literary assemblies at the Chat Noir. She read widely and could hold her own in serious conversations: she was able to discuss intelligently books with men of letters, pictures with painters, music with composers.

These were unusual accomplishments in a woman who danced at the Moulin Rouge in the eighteen-nineties. Jane Avril may have inherited her intellectual qualities from her father; certainly there was little in her early upbringing to account for her refinement. Born in Paris in 1868, she was the illegitimate daughter of an Italian nobleman and a Parisian *demi-mondaine.* Her father, distinguished, sensitive, polished, had escaped from the pious austerity of Italian family life to the freer air of Paris, where he proceeded to sow wild oats with passionate enthusiasm. His mistress was pretty and superficially charming, but her attractive exterior concealed a cruel, bitter, quarrelsome nature. For two years after the birth of their child the couple lived stormily together; then the Italian, exasperated, abandoned his daughter to the tender mercies of her mother. He did not, however, completely disappear out of their lives. Some years later his discarded mistress made repeated appeals to him for money; these visits, on which she was usually accompanied by the child, furnished Jane Avril with the only recollections of her father she was ever to have. Soon thereafter, ruined by his extravagance and stricken with paralysis, he returned to Italy to die.

147

JANE AVRIL

The first years of Jane's childhood were not unhappy. She lived with her mother's parents at Etampes, where she attended a convent school. But when she was nine years old she was sent back to her mother in Paris. The next few years were a nightmare. Her mother, half demented, the prey of strange morbid delusions, beat her cruelly; and the terrified child dared not complain. She was able to escape this wanton brutality only during the hours she spent at school. The expenses of her education, such as it was, were defrayed by a former lover of her mother's. When she was not at school, her mother forced her to sing in the streets and beg, in districts far removed from their lodgings so that she would not be recognized. The effects of ill-treatment and constant terror soon made themselves apparent. The girl developed a sort of facial tic, first symptom of an approaching nervous breakdown. Through the good offices of the same benefactor who had paid the cost of her schooling, she was admitted to the great Paris hospital for nervous disorders, La Salpêtrière. Here she was treated kindly; petted by the doctors and nurses, she found the grim asylum a paradise compared to the misery of home. When she was discharged, cured, she was obliged to resume her unhappy life with her mother; but as she grew older she lost some of her childish docility, until at the age of seventeen she suddenly put an end to the intolerable situation by running away.

For a penniless young girl, without training, adrift in Paris, there were but two alternatives: a lover or the Seine. Jane Avril chose the lover: a young medical student, with whom she lived for three months. Soon after this episode came to an end she discovered, by accident, that she had an unusual aptitude for dancing. The first night she was taken to the Bal Bullier, then the gayest resort in the Latin Quarter, she was so completely carried away by the lively music that she began to dance by herself, almost unconsciously, inventing steps and gyrations that brought spontaneous applause from the surprised spectators. That night proved to be the turning-point of her career.

From that moment she had but one ambition: to become a great dancer. She was completely untrained, and in fact she remained without formal training all her life. She danced for the joy of dancing, improvised as she went along, and depended wholly on her natural grace and her inborn sense of rhythm.

But while dancing satisfied Jane Avril's soul it could not, while she was still unknown, provide her with food and lodging. These necessities were supplied in part by a succession of lovers, in part by various jobs that had nothing to do with the dance. She was employed for a time as cashier at one of the " Streets of Cairo " concessions at the Exposition of 1889; later, in tights and spangles, she rode a horse at the Hippodrome near the place de l'Alma. Her first visit to the newly opened Moulin Rouge put an end to these interludes. Her talents were immediately recognized by Zidler, who offered her a salary to dance there as one of the regular troupe. Jealous of her independence, Jane Avril refused; but she danced at the Moulin Rouge almost every night for several years, generally without pay. The surroundings were congenial and the audiences enthusiastic. Although she did not mix much with the other performers, she managed to keep on good terms with all of them, even with the quarrelsome Goulue. Jane Avril almost always danced alone, usually a waltz of her own invention. When, on rare occasions, she joined in the quadrille, she was paid the same salary as her partners. In the summer she danced at the Jardin de Paris as well as at the Moulin Rouge.

The name " Jane Avril " was chosen by herself, for no particular reason except that she liked the sound of it. It was short, easily remembered; and the " Avril " seemed appropriate to the springlike quality of her youthful, delicate charm; while the cool English " Jane " fitted her better than the French " Jeanne." She was, indeed, often mistaken for an Englishwoman. It was the fashion in those days to bestow a nickname on every famous dancer, and Jane Avril, like the rest, acquired one: La Mélinite. But the name did not please her,

nor was it, in fact, well suited to her: though she danced with tremendous fervour, there was nothing violent, nothing explosive about either her movements or her temperament.

Now and then Jane Avril deserted her beloved Moulin Rouge and Jardin de Paris to accept other engagements. At the Folies-Bergère she danced the part of Pierrot in a ballet, *L'Arc-en-Ciel*. She appeared for a short time at the Cabaret des Décadents. She took the rôle of Anitra in Lugné-Poë's production of *Peer Gynt,* dancing to Grieg's music. In 1897, after a brief appearance in a quadrille at the Casino de Paris, she performed a similar dance at the Palace Theatre in London with three other women, exotically billed as Eglantine, Cléopâtre, and Gazelle. This venture was not altogether a success, on account of an unfortunate lack of harmony between the different members of the troupe: there was an outburst of jealousy and recrimination, with the dancers divided into two camps, Jane Avril and Eglantine against Cléopâtre and Gazelle. About 1900 Jane Avril set out on a tour of the provinces. She appeared at Clermont-Ferrand, Geneva, Nice, and Lyons, with considerable success; but she found the " road " a poor substitute for Paris and was glad to cut short her tour and return to the capital, where she presented her program of dances at L'Eldorado. Between all of these various engagements, however, Jane Avril never failed to dance at the Moulin Rouge or the Jardin de Paris.

During these years she continued to flit lightly from lover to lover. One of her liaisons resulted in the birth of a child — a boy — to whom she was passionately devoted, though she gave up neither her dancing nor her amorous adventures on his account. About 1901 she took the child to New York with the intention of making her home there; but a month in the unfamiliar American city convinced her that she could be happy only in Paris. After she returned, the Moulin Rouge was transformed into a theatre for the presentation of musical comedies and revues. Jane Avril was engaged to play in the first

offering, *Tu Marches?* and in several succeeding ones, including the triumphant success *La Belle de New-York*. Then came a revival of *Peer Gynt* with Jane Avril in her old part of Anitra; an engagement in *Claudine à Paris* at the Bouffes-Parisiens, with Polaire in the principal rôle; a dance in the ancient Roman theatre at Orange; and a season at the Bal Tabarin, which she detested. She journeyed to Madrid to dance in a quadrille, which was received without enthusiasm by the Spanish audiences, who not surprisingly preferred their own beautiful native dances to any foreign importations. Jane Avril liked Spain no better than she had liked America: the poverty and dirt, the swarming beggars, disgusted her; she found the passionate impetuosity of would-be Spanish lovers too overpowering and perceived nothing of the real charm of the country and its people.

This voyage marked the end of Jane Avril's career as a dancer. She was still young — in her middle thirties — but she felt that the time had come for her to settle down. For some years she had been faithful (with occasional brief lapses) to a " protector " of good bourgeois family; when this lover proposed marriage and the adoption of her illegitimate child, she accepted the offer, although with some misgivings. And in fact respectable married life in a quiet suburb of Paris did seem tame after so many years of gay, irresponsible activity; she missed the bright lights of the Moulin Rouge and, most of all, the opportunity to dance. Nevertheless she adjusted herself with remarkable success to domestic existence. Her husband was severely gassed during the World War and died, after years of illness and suffering, in 1926. Her son grew up and disappeared out of her life, and for some time Jane Avril lived alone in her modest suburban home. By 1933 her income, never large, had shrunk to such an extent that she was obliged to give up her house and take refuge in a Home for the Aged in Paris, where she is living today. At seventy, Jane Avril is resigned to a lonely, almost destitute old age in an institution supported by

charity. "In this retreat," she wrote to me on October 15, 1937, "I have nothing to keep me company but my precious memories." Yet her eyes still sparkle, her gestures are animated, her conversation amusing; she still has the erect carriage and slim figure of a girl of eighteen, her beautiful ankles are as slender as ever. She has not altogether lost interest in the world outside, with which she keeps in touch by turning on her radio; occasionally the voice of someone she once knew comes floating through the ether to remind her of her own brilliant, carefree youth.

In her memoirs, published serially in *Paris-Midi* for August 7–26, 1933, Jane Avril acknowledges gratefully her debt to Lautrec: " It is undoubtedly to him that I owe the celebrity I have enjoyed, which dates from the appearance of his first poster of me." She describes the painter as " a crippled genius, whose witty and biting raillery must have helped him to conceal his profound melancholy "; and goes on to relate that Lautrec often used to call for her, before her sittings at his studio, and take her to lunch at the restaurant of Père Lathuile in the avenue de Clichy or to some similar establishment in the neighbourhood, where they would feast on the special dishes and drink the excellent wines that Lautrec knew so well how to order.

They probably met for the first time at the Moulin Rouge, shortly after Jane Avril's début there in 1889. The earliest picture in which she appears is also the first that Lautrec painted with the Moulin Rouge as a setting: *Au Moulin Rouge: la Danse,* executed in 1890. Here Jane Avril is represented only incidentally in the distant ring of spectators; but her prominent position on the canvas, directly between the two central dancing figures of Valentin le Désossé and his partner, compensates for the lack of detail in the delineation of her features and the small amount of space she occupies in the composition. Lautrec's succeeding pictures of Jane Avril against the background of the Moulin Rouge have already been men-

tioned. In many of these she is alone — or if not entirely alone, at least the principal figure: *Jane Avril Sortant du Moulin Rouge, Jane Avril Mettant ses Gants, Jane Avril Dansant* (Plate 20), all of 1892. In others, such as *Au Moulin Rouge: Repos entre deux Tours de Valse* (Plate 18) and *Les deux Valseuses* (Plate 17), she shares the canvas with other celebrities of the dance-hall.

Lautrec did not confine Jane Avril to the setting of the Moulin Rouge. In 1892 he used her as the model for the chief figure in his poster *Le Divan Japonais* (Plate 13); in the same year he painted two or three portraits of her, in repose, with no accessories to indicate any specific background. One of these is a half-length picture of the dancer wearing a short cape with an upturned collar, and a black hat ornamented with curling plumes. Lautrec understood, and knew how to represent, all of the various aspects of Jane Avril's nature. In this portrait, for example, as well as in *Jane Avril Sortant du Moulin Rouge* and *Jane Avril Mettant ses Gants,* her expression is prim and " English." In the *Divan Japonais* poster, on the other hand, she is serene, elegant, full of social graces; while in the painting *Jane Avril Dansant* (Plate 20) and in the poster *Jane Avril au Jardin de Paris* (1893) she is the radiant and nimble dancer, oblivious of everything but the rhythm of the unseen orchestra.

In 1893 Lautrec paid a graceful tribute to Jane Avril's interest in the fine arts by portraying her in a coloured lithograph (D. 17) to be used as a cover of *L'Estampe Originale,* edited by Marty (Plate 53). At the left is the hand press, operated by Père Cotelle, on which Lautrec's lithographs were printed; at the right stands Jane Avril attentively examining a proof. She is wearing the same short cape with the high collar, and the same black feathered hat, that appear in the half-length portrait described above; but in the lithograph a good deal more of the costume is shown, and it is apparent that the little cape forms only the upper part of a long cloak of the same material. This garment, which completely covers the

dancer's body, is coloured salmon-pink in the lithograph and is edged with a narrow band of black fur. Jane Avril's hair is tinted a vivid orange; there is a tiny spot of scarlet on her lips, and the outlines of the figure, the features, and all other details are drawn in green.

After this Jane Avril appears only twice more in Lautrec's work. In 1896 he executed a poster, *La Troupe de Mademoiselle Eglantine,* to be used as an advertisement for the engagement at the Palace Theatre in London. From left to right the four figures represent Jane Avril, Cléopâtre, Eglantine, and Gazelle. And in February 1899, just a few weeks before the terrible breakdown from which he never wholly recovered, Lautrec designed another poster for Jane Avril, with one exception the last poster he produced. For some reason it was never used.

BARS AND RESTAURANTS

FOOD played an important part in Lautrec's life; wine (and, unhappily, stronger drink) an even more significant one. It was inevitable, therefore, that restaurants and cafés should have occupied a prominent place in his background. These establishments were of many kinds: they varied from the smartest and most expensive restaurants to the dingiest of little bars.

In the latter category, one of the most picturesque resorts was the Lapin Agile, a tiny café on the northern slope of Montmartre at the corner of the rue des Saules and the rue Saint-Vincent. Founded in 1886, it was called originally the Cabaret des Assassins — not because anyone was ever assassinated there, but on account of the curious collection of pictures of famous murderers and scenes of celebrated crimes with which the owner, Sals or Saltz, adorned the walls. Later the sinister name was changed to Ma Campagne; still later, in 1903, when the café passed into the hands of Frédéric Gérard, to Le Lapin à Gill, in honour of a decorative sign painted by André Gill. This sign portrayed a rabbit, in the costume of a chef, hopping out of a saucepan with a bottle of wine balanced precariously on one of its front paws. From Le Lapin à Gill to Le Lapin Agile, the present name, the transition was easy. It was always

an unpretentious resort: its three small rooms were dimly lighted and poorly furnished. The cheap wooden tables were rickety, the cane-seated chairs decrepit; the crockery and glassware, of the commonest kind, were cracked and chipped; the bar was constructed of packing-cases covered with coarse and dirty sacking. Yet with all its discomfort the Lapin Agile had " atmosphere " and soon became one of the favourite haunts of the artists and writers of Montmartre. It acquired something of the character of a *cabaret artistique:* the regular clients entertained each other, as well as any strangers who happened to drop in, with songs and music. Frédéric, the proprietor — or Frédé, as he was generally called — is described by André Warnod in *Le Vieux Montmartre:*

" He is, in his own way, a philosopher; he has written over his doorway, in white letters: ' The first duty of a man is to have a good stomach.' He preaches the worship of nature and the enjoyment of the good things of life; he expresses his ideas in phrases which sound like proverbs and which leave a profound impression. . . ."

After his retirement from the active management of Le Mirliton, Aristide Bruant frequently visited the Lapin Agile for a drink and a chat with Frédé. The little café was situated almost next door to the " farm " once owned by Bruant, whose affection for that almost pastoral corner of Montmartre survived long after he had ceased to live there. According to Jeanne Landre's biography of Bruant, his attachment was so strong that he purchased the property on which the Lapin Agile stood, when the landlord threatened to expel Frédé and demolish the building. By his generous act Bruant saved the picturesque resort from destruction until Frédé had accumulated enough money to buy it himself; by that time the value of the site had increased greatly, but Bruant turned it over for the price he had paid originally, stipulating only that the Lapin

Agile should be preserved intact, exactly as it was. Bruant's wish, on the whole, has been faithfully carried out. Although the Lapin Agile has been sadly commercialized by an invasion of tourists, it still remains, in appearance at least, one of the few authentic relics of old Montmartre.

A very different sort of place was L'Ane Rouge at 28 avenue Trudaine, opened in 1891 in the building formerly occupied by La Grande Pinte. L'Ane Rouge, at first a *cabaret artistique* like its predecessor, was afterwards converted into a restaurant, which still exists. It was owned and operated by Gabriel Salis, younger brother of the more famous Rodolphe who founded the Chat Noir. The walls were covered with pictures by Adolphe Willette, one of the faithful habitués of the resort. The poet Paul Verlaine came there sometimes during the last years of his life: he would sit at a table in the corner, drinking absinthe and scribbling little scraps of poetry. Next door was a rival cabaret, L'Auberge du Clou, which has also survived as a popular restaurant to the present day. Lautrec visited both of these places from time to time, but they were never among his favourites.

In the same district, but farther to the west, were several cafés and restaurants in which Lautrec was to be seen more frequently. Among these were the garden restaurant of Père Lathuile at 7 avenue de Clichy, and the Café de la Place Blanche, which specialized in late suppers and whose clients were drawn largely from the audiences of the Moulin Rouge, situated directly across the square. In the place Pigalle were the Café de la Nouvelle Athènes, successor to the old Café Guerbois as a rendezvous for insurgent writers and painters; L'Abbaye de Thélème, founded in 1886, which was a quiet respectable restaurant during the dinner hour but riotously gay and noisy after midnight, when it was invaded by a crowd of smartly gowned *demi-mondaines* and their escorts; and Le Rat Mort, somewhat less fashionable and expensive than the Abbaye de Thélème or the Café de la Place Blanche. According

157

to the *Guide des Plaisirs à Paris* for 1900, the Rat Mort owed its unpleasant name to " a rat which was punished by death for having disturbed a pair of clients who were enjoying a very private conversation in a very private dining-room."

In *En Cabinet Particulier* (1899) Lautrec painted one of these tête-à-tête suppers at the Rat Mort. The woman wears an elaborate domino with a hood; her companion, in formal evening attire, has turned his head so that his features are invisible, cut off by the edge of the canvas.

Lautrec took great pride in his reputation as a connoisseur of food and wines. The reputation was well deserved, in spite of the appalling mixed drinks and " cocktails " he loved to conjure up at home. He was an expert in the selection of rare dishes and the appropriate wines to accompany them. For several years he was a member of a group of gourmets who met regularly at Drouant's — then, as now, one of the best restaurants in Paris — every Friday evening for dinner. Gustave Geffroy, in a letter quoted by Edmond Richardin in his book *L'Art du Bien Manger,* claims the honour of being one of the creators of these feasts:

" I believe that the dinners were originated . . . by Claude Monet and myself after our return from Belle-Isle-en-Mer, at the beginning of the winter of 1887. . . ."

The list of attendants at these Drouant dinners included a number of men famous, or soon to be famous, in the world of art and letters: the painter Eugène Carrière, the sculptor Auguste Rodin, the writers Rosny, Georges Lecomte, Maurice Hamel, and Lucien Descaves; Jean Ajalbert, who was later to take an active part in the campaign for a reconsideration of the Dreyfus case; Frantz Jourdain the architect, Dr Vaquez of the Faculté de Médecine, the actor Coquelin *cadet* — " who sometimes," writes Geffroy, " flavoured our dessert with the

great poetry of a page of Molière." Distinguished guests, in-cluding Georges Clemenceau and Edmond de Goncourt, were invited from time to time.

Lautrec not only enjoyed the eating of good food, he loved to cook it himself. A record of his skill as a chef remains in the form of a painting by Vuillard: it represents Lautrec in a red shirt, baggy yellow trousers, and a grey felt hat, stirring a mess of *homard à l'armoricaine* in a saucepan. A reproduction of this picture serves as frontispiece to a book on cookery by Maurice Joyant, *La Cuisine de Monsieur Momo, Célibataire*, published in 1930. The volume, which is beautifully printed in a strictly limited edition, is further embellished with repro-ductions of twenty-four drawings and water-colours of game and other edible birds and animals selected from Lautrec's works: a snipe, a partridge, a wild boar, a hare, a pig, a cow, a goose, a snail, etc.

He liked to provide unusual dishes for his guests. Once, at the Nouveau Cirque, he saw a comic boxing match between a Negro and a kangaroo. The spectacle reminded him that he had read somewhere that the flesh of the kangaroo was consid-ered a great delicacy in Australia, and he decided to invite a few chosen friends, gourmets like himself, to a dinner of roast kangaroo. But after the invitations were issued Lautrec was surprised and disappointed to find that there was not a kanga-roo to be had at any of the butcher-shops in Paris. He would not, however, admit defeat: he had promised his friends kanga-roo, and kangaroo they should have. The dinner took place as scheduled, and with much ceremony a huge platter was carried to the table; it contained a whole roasted sheep, sitting up-right, to which Lautrec had attached the tail of a cow. To carry out the kangaroo illusion he had tied round the middle of the carcass a little white apron, out of the pocket of which peeped a dead mouse. Paul Leclercq, who tells the story, adds that Lautrec provided carafes of water for his guests; but to ensure

that nobody should be tempted to drink anything baser than the superlative wines he served, he had filled the water with live goldfish.

Lautrec amused himself and his friends by contributing lithographed menus for some of the lavish banquets he attended. The first of these is dated 1893: the subject of the lithograph is a fashionable dressmaker, Renée Vert, arranging hats on stands in her shop (D. 13). The next menu, for a dinner given on April 26, 1894 by Adrien Hébrard, director of the great Paris newspaper *Le Temps,* is ornamented with caricatures of Monsieur Hébrard and several of his associates (D. 66). For another dinner of 1894 Lautrec decorated the menu with an amusingly ribald version of the Judgment of Paris (D. 69) : Paris himself is represented as an old roué in a top hat, with his cane pressed to his lips in an agony of indecision, while the three naked " goddesses " display their charms in competition for the prize; one of the rivals is enormously fat, the second obviously *enceinte,* and the third angular and shrivelled. The menu of a dinner given by Paul Sescau, the photographer, on March 16, 1895 portrays the host playing a banjo; in one corner is a caricature of the head of Maurice Guibert (D. 144). As a tribute to Loie Fuller, the American dancer who was then the sensation of Paris, one of the dishes served at this dinner was christened *foies gras de l'oie Fuller.*

In 1896 Lautrec produced no less than five menus. For a banquet organized by a group of Tarnais — natives of the department of Tarn, of which Albi is the chief town — he lithographed a scene from the circus: an elephant standing on a sort of drum, faced by a clown (D. 197). The menu for the Sylvain dinner of December 2, 1896 represents a dog barking furiously at a wooden hobbyhorse mounted on wheels (D. 198). The menu entitled *Le Suisse* (D. 199), dated December 22, portrays a very gay scene: five men, among whom are Maurice Guibert and Dr Tapié de Céleyran, are seated at table; a bottle has been overturned, toasts are being drunk, and the party

is enlivened by the presence of two women; one of them is embracing the man on whose lap she sits, the other, clad only in corsets and a pair of ruffled drawers, perches on the table. Above is the figure of a Swiss Guard, the representative of law and order, armed with the long staff of his office.

The menu (D. 201) for a banquet given by May Belfort, the singer, in 1896 indicates that the guests dined, if not altogether wisely, at any rate exceedingly well:

POTAGE OXTAIL

HORS D'ŒUVRE

TRUITE DU LAC MICHIGAN

LE CUISSOT DE CHEVREUIL SUR PURÉE DE MARRONS

FOIE GRAS EN CROÛTE

SALADE

ENTREMETS

DESSERT

VIN GRAND ORDINAIRE VOUVRAY CORTON

Since May Belfort always carried a black cat in her arms when she sang, this menu is appropriately decorated with a lithograph of a cat chasing a mouse. The cat appears again, this time with a Negro playing the banjo, on a card of Christmas and New Year greetings (D. 202) executed for May Belfort in 1896.

The most amusing of all of Lautrec's menus is the one known as the " Crocodile " (Plate 21), designed for a dinner given on December 23, 1896. Among the guests were Maurice Joyant, Maurice Guibert, and Dr Tapié de Céleyran, all of whom had been Lautrec's companions on a trip to Touraine the month before. On that excursion the travellers had stopped at Blois, where Lautrec had been entertained by the story of Marie de' Medici's escape from a window of the château, in which she had been imprisoned by order of her son, Louis XIII. This incident is the theme of the lithographed

menu (D. 200) ; but the characters are drawn with more humour than historical accuracy. Marie de' Medici is represented by a young woman, naked except for one black stocking; her rescuer is the portly Maurice Guibert, attired in nightshirt and nightcap and holding a lighted candle; Joyant is symbolized by the crocodile; the grotesque head and long neck of Dr Tapié de Céleyran taper off into a wisp of smoke; and in the lower left corner is Lautrec himself, in shirt and braces, squatting on a low stool and busily sketching the fantastic scene.

For a dinner at the restaurant of La Souris on July 31, 1897 Lautrec produced a lithograph of Bouboule, the ugly bulldog that belonged to the proprietress, Madame Palmyre; in the foreground is a large mouse, and two more mice are playing near the dog (D. 211). The repast was even more elaborate than that provided by May Belfort:

TRUITE SAUMONÉE, SAUCE HOMARD

FILET DE BŒUF PORTUGAISE

CHAUDFROID DE VOLAILLE

JAMBON D'YORK À LA GELÉE

LIÈVRE EN TERRINE

SALADE NAPOLITAINE

BOMBE GLACÉE

DESSERT

Lautrec's last menu was designed in 1898. It is generally known as *La Fillette Nue* (D. 233) and represents a very young and almost naked girl submitting to the inspection of a fat, middle-aged man, who is seated in an armchair.

The bars and restaurants of Montmartre were not the only ones frequented by Lautrec. In 1895 and succeeding years he often descended to the neighbourhood of the Madeleine. Here were the Bar Picton at 4 rue Scribe, under the Grand Hôtel; Larue's, the fashionable and expensive restaurant at the corner of the rue Royale and the place de la Madeleine,

where it still exists; the Irish and American Bar at 23 rue Royale; and the Café Weber next door. The Bar Picton was run by Achille Picton, " usually known among men about town," says Delteil, " simply by his Christian name." He addressed Lautrec as *" Monsieur le Vicomte Marquis,"* much to the painter's amusement. Lautrec produced a lithograph *Au Bar Picton* (D. 173) in 1896; it represents a slim-waisted barmaid serving two customers.

Larue's was the setting for a coloured lithograph, *Snobisme,* also called *Chez Larue,* which appeared on the front cover of *Le Rire* for April 24, 1897. Dr Gabriel Tapié de Céleyran and a certain Madame Schuffly are seated at a table in the restaurant; in the background are the woman's jealous admirer (for whom the model was Maurice Guibert) and a waiter. The caption was supplied by Tristan Bernard:

" Jeanne, take my purse out of my overcoat pocket without letting anyone see you."
" And then? "
" Hand it to me with a flourish, when it is time to pay the bill, as if it were your own."

The Irish and American Bar, owned by Francis Brady Reynolds, was Lautrec's favourite resort outside the boundaries of Montmartre. It was a small place, consisting of a long narrow room with a leather *banquette* and a single row of little tables on one side, and a mahogany bar on the other. At the back a short flight of steps led to a tiny square room in which Lautrec usually sat; from this vantage-ground he could survey the crowd that milled in front of the bar during the *apéritif* hour. Ralph, the barman, claimed to be a half-breed of mixed Chinese and American Indian blood. He is described by Joyant as having " a round, yellow, hypocritical face, with almond eyes and slick black hair "; and he officiated with the impassivity of both races behind the bar, where he mixed exotic drinks

of all colours of the rainbow. The clients, for the most part, were connected with the racetrack: grooms, jockeys, touts, bookmakers, horse dealers, many of them English or Irish. There were also, on certain evenings, coachmen from various wealthy households who, while their employers dined luxuriously and in leisurely fashion at the expensive restaurants of the quarter, and the horses stood patiently outside in charge of their footmen, whiled away the tedious hours of waiting in the snug recesses of the bar.

Footit, the famous clown, and his Negro partner Chocolat often came to the Irish and American Bar after their performances at the Nouveau Cirque in the near-by rue Saint-Honoré; and among the regular clients for supper were the Irish singer May Belfort and the English dancer May Milton. After a few reviving drinks at the bar Footit and Chocolat, forgetting the fatigue that followed their strenuous antics at the circus, would often dance, with the most comical contortions, to the music of a mandolin played (according to Joyant) by an Englishwoman or by her son, the fruit of her union with a Texas mulatto. A coloured lithograph by Lautrec of Chocolat dancing in the Irish and American Bar was printed on the back cover of *Le Rire* for March 28, 1896; the preliminary sketch in Chinese ink is preserved in the museum at Albi (Plate 24). The Negro, with one hand on his hip and the other raised above his head, seems to be performing a kind of double shuffle. He wears a short jacket and skin-tight trousers; a Sherlock Holmes cap of some checked or plaid material is pulled far over his eyes. The musician — presumably the young man of mixed ancestry mentioned by Joyant — is twanging a stringed instrument that resembles an antique lyre. At the left stands the half-breed barman, and in the background is the fat English coachman of Monsieur de Rothschild, wearing a top hat.

Lautrec also made use of the Irish and American Bar for two of the four water-colours with which he illustrated the story of *Le Bon Jockey* by Romain Coolus, published in *Le*

Figaro Illustré for July 1895. One of these portrays the interior of the room with the row of tables extending to the windows at the rue Royale end; at the left is the long polished bar. In the foreground an Englishman, in a top hat, droops over his table. Ralph, the barman, stands behind the bar facing two Englishmen, one very large and fat, the other very small. In the second water-colour Ralph's Oriental head can be seen peering over the bar, at which a jockey in a bowler hat, a short light overcoat, and checked trousers is drinking; at the left is the elegant figure of a man about town in a top hat and a long overcoat, with a flower in his buttonhole.

The Irish and American Bar was eventually swallowed up by the expansion of its sturdier neighbour the Café Weber, which still flourishes at the same address in the rue Royale. In the nineties the Café Weber, though very popular, was not nearly so large as it is today. Somewhat less colourful than the Irish and American Bar, it was even more crowded, especially from six to eight in the afternoons. It was frequented by a number of different groups that seldom mixed, though Lautrec was *persona grata* with all of them. Some of the clients belonged to the sporting world, others were eminent as writers or painters or musicians; and at one special table there was usually a gathering of explorers fresh from the jungles of the Congo or the deserts of Algeria, to whose tales of adventure Lautrec loved to listen. Claude Debussy was sometimes to be seen at Weber's; Oscar Wilde, during the years of exile that followed his trial and imprisonment, appeared there occasionally; Marcel Proust, nervous, frail, aloof, with the collar of his overcoat turned up about his ears and his pockets bulging with books, would sit restlessly at a table for a few minutes and then dart out into the street. The management of the Café Weber imposed certain restrictions on the behaviour of its clients: the smoking of pipes, even on the sidewalk *terrasse,* was forbidden, as well as the use of dice. Lautrec, however, was a privileged patron. He did not, indeed, smoke a pipe; but he insisted on

having on his table a leather dice-box and a set of ivory cubes, with which he gambled for drinks with his companions; and the proprietor, though scandalized, made an exception in his favour. For Lautrec, in spite of his diminutive stature, had an air that commanded respect and generally obedience. He liked to do things in his own way and usually succeeded.

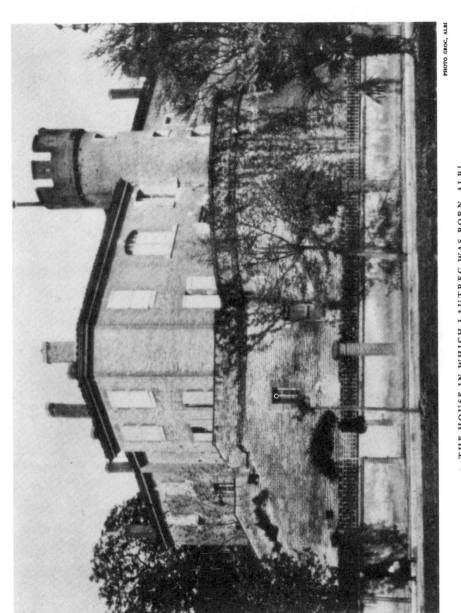

1. THE HOUSE IN WHICH LAUTREC WAS BORN, ALBI

FROM A PHOTOGRAPH

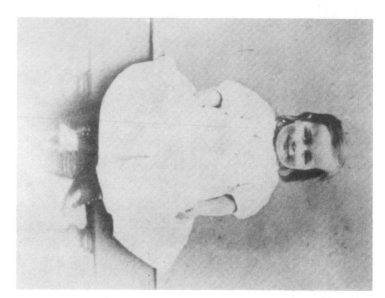

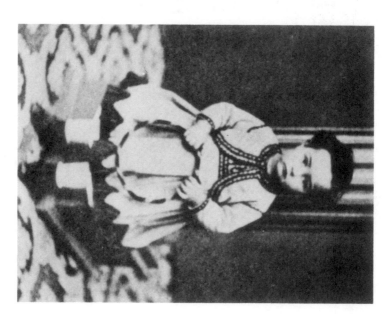

5. PORTRAIT OF LAUTREC'S MOTHER
1881. MUSÉE D'ALBI

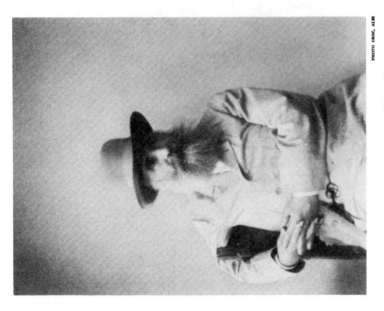

4. COUNT ALPHONSE DE TOULOUSE-LAUTREC
FROM A PHOTOGRAPH

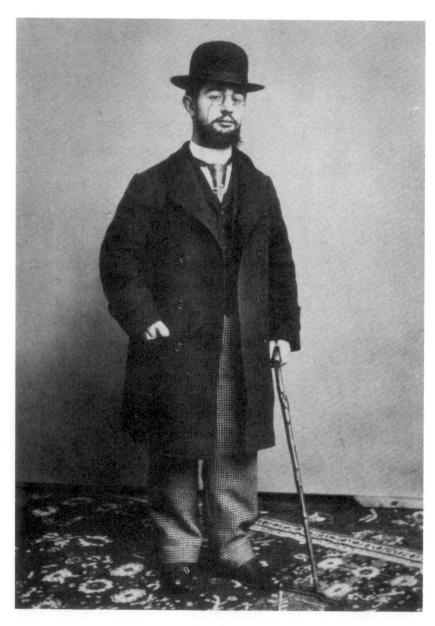

6. LAUTREC

FROM A PHOTOGRAPH

"TWO SISTERS, EXACTLY LIKE UMBRELLAS"

"I LOOKED ALMOST CLEAN"

7. TWO DRAWINGS FROM THE CAHIER DE ZIG-ZAGS

1881. DORTU COLLECTION, LE VÉSINET

8. MONSIEUR DELAPORTE AU JARDIN DE PARIS
1893. CARLSBERG GLYPTOTEK, COPENHAGEN

PHOTO VIZZAVONA

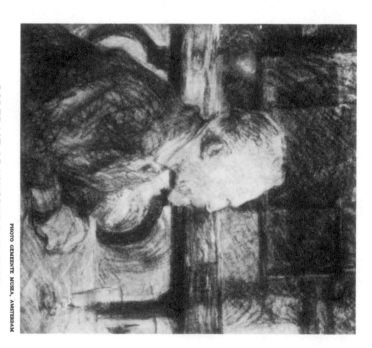

9. PORTRAIT OF VINCENT VAN GOGH
1887. PASTEL. V. W. VAN GOGH COLLECTION, ON LOAN TO
GEMEENTE MUSEA, AMSTERDAM

PHOTO GEMEENTE MUSEA, AMSTERDAM

10. LAUTREC IN HIS STUDIO, RUE CAULAINCOURT
1890. FROM A PHOTOGRAPH

11. LAUTREC PAINTING BERTHE LA SOURDE
1890. FROM A PHOTOGRAPH

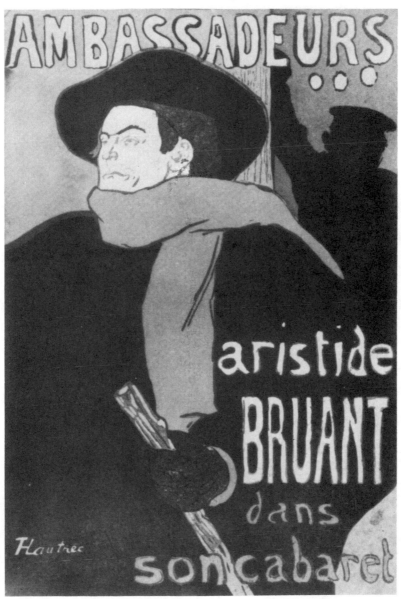

12. ARISTIDE BRUANT AUX AMBASSADEURS
1892. POSTER

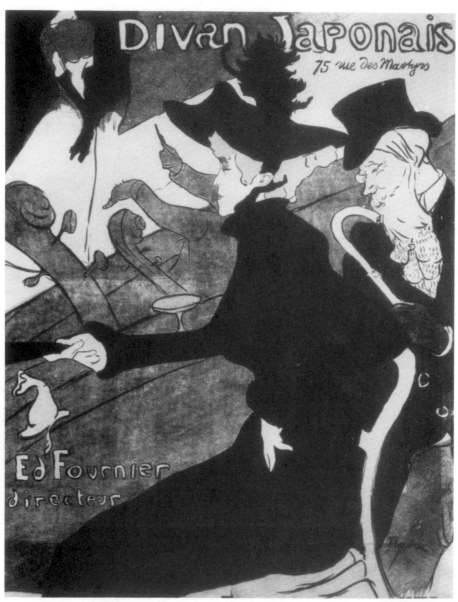

13. LE DIVAN JAPONAIS
1892. POSTER

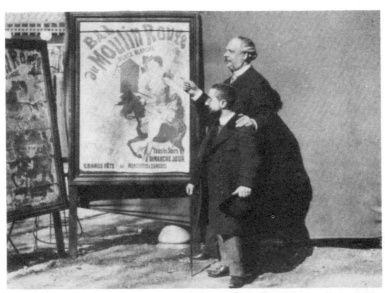

14. LAUTREC WITH TRÉMOLADA AT THE MOULIN ROUGE
ABOUT 1890. FROM A PHOTOGRAPH

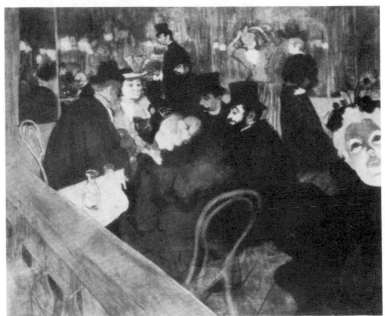

15. AU MOULIN ROUGE
1890. ART INSTITUTE, CHICAGO

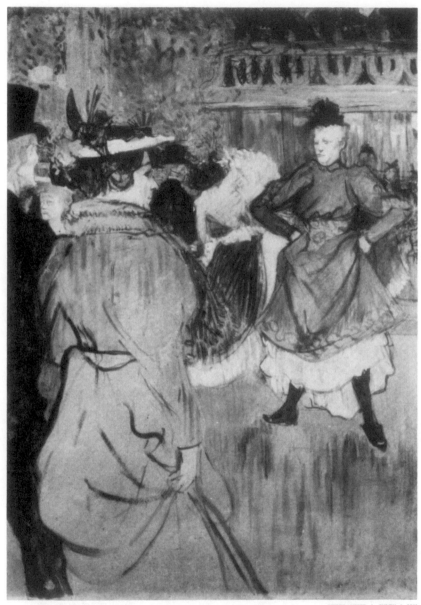

16. AU MOULIN ROUGE: LE DEPART DU
QUADRILLE
1892. CHESTER DALE COLLECTION, NEW YORK

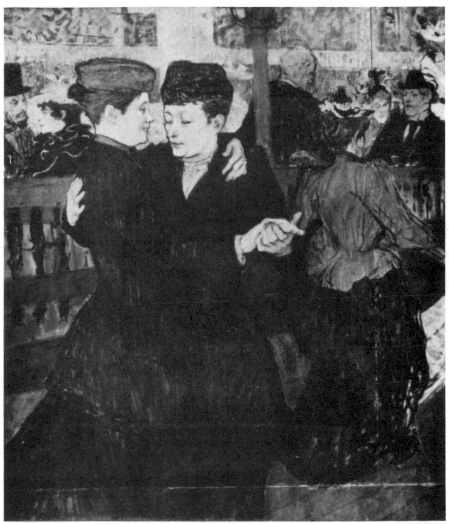

17. AU MOULIN ROUGE: LES DEUX VALSEUSES
1892. ČESKY ODBOR MODERNI GALERIE, PRAGUE

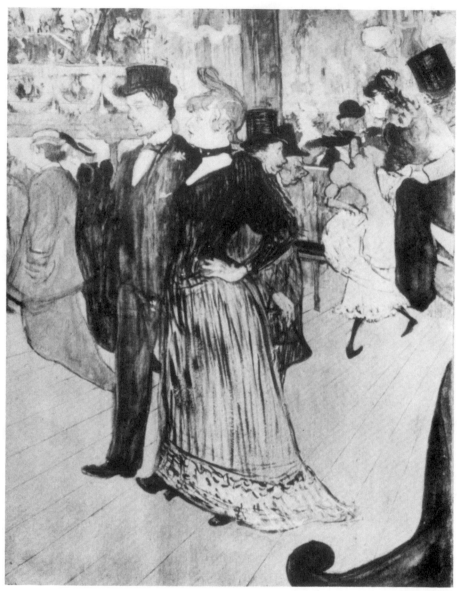

18. AU MOULIN ROUGE: REPOS ENTRE DEUX
TOURS DE VALSE
1891. BERNHEIM JEUNE COLLECTION, PARIS

19. CURTAINS FOR LA GOULUE'S BOOTH

1895. LOUVRE, PARIS

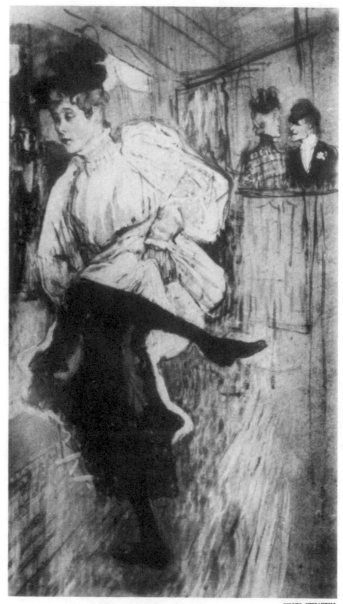

20. JANE AVRIL DANSANT
1892. LOUVRE, PARIS

Diner du 23 Décembre 1896

Hultres de Burnham

Consommé Royal — Potage St-Hubert

Barbue Sylvain

Cuissot de Chevreuil sauce Poivrade, Purée de Marrons et Purée Soubise

Pintadeaux rôtis sur Canapés

Salade de Saison

Mousse Chocolat praliné

21. MENU: LE CROCODILE
1896. LITHOGRAPH

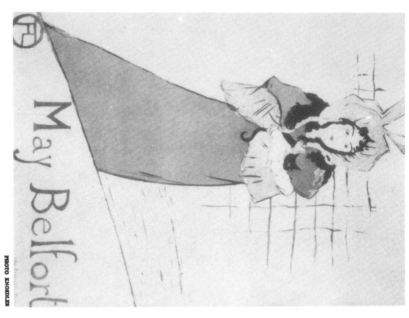

22. MAY BELFORT
1895. POSTER

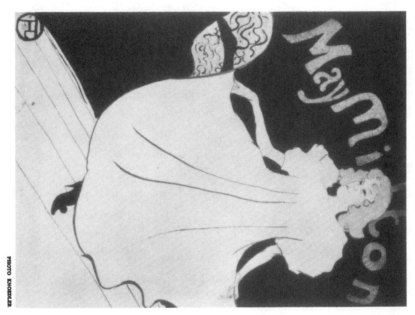

23. MAY MILTON
1895. POSTER

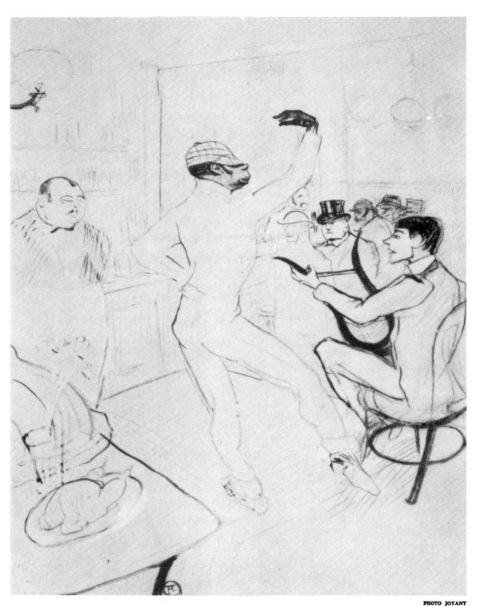

24. CHOCOLAT DANSANT

1896. DRAWING. MUSÉE D'ALBI

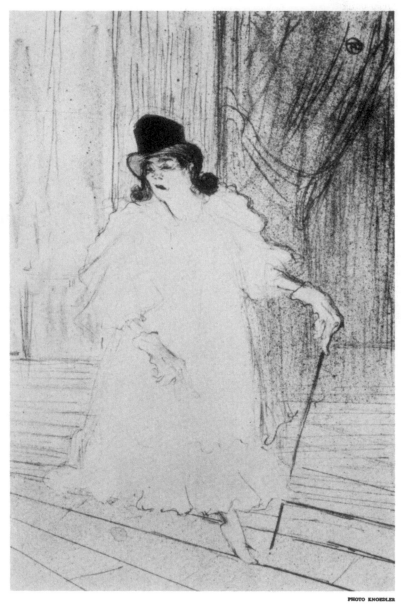

25. CISSIE LOFTUS
1895. LITHOGRAPH

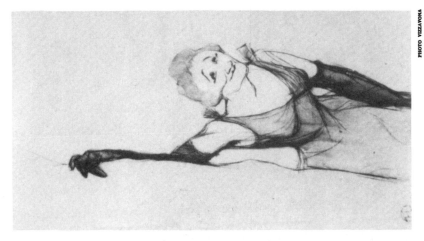

27. YVETTE GUILBERT SALUANT
1894. MUSEUM OF ART, RHODE ISLAND SCHOOL
OF DESIGN, PROVIDENCE

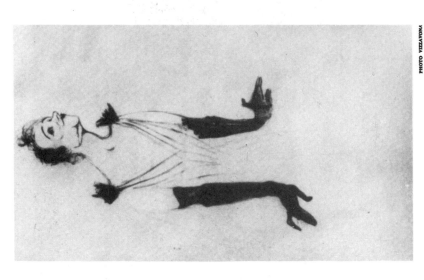

26. YVETTE GUILBERT: PROJECT FOR A
POSTER
1894. MUSÉE D'ALBI

28. PORTRAIT OF HENRY SAMARY
1889. JACQUES LAROCHE COLLECTION, PARIS

30. LA DANSEUSE

1896. DECOURCELLE COLLECTION, PARIS

29. MARCELLE LENDER DANSANT LE PAS DU BOLÉRO

1896. COLLECTION OF MR AND MRS JOHN HAY WHITNEY,

NEW YORK

31. MESSALINE

1900. LOS ANGELES COUNTY MUSEUM, LOS ANGELES

32. L'ÉCUYÈRE

1888. ART INSTITUTE, CHICAGO

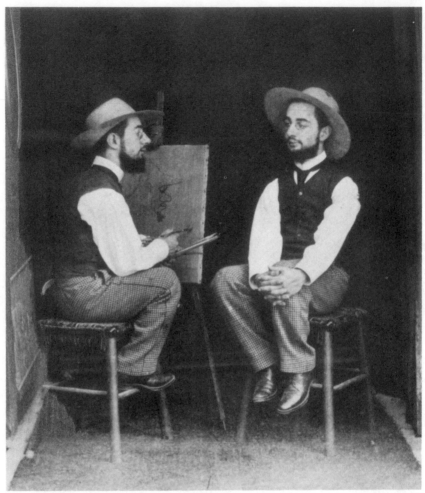

33. LAUTREC
FROM A DOUBLE PHOTOGRAPH

35. AU CIRQUE: ÉCUYÈRE DE PANNEAU

1899. DRAWING. COLLECTION OF MR AND MRS EDWIN C. VOGEL,
NEW YORK

34. AU CIRQUE: LE PAS DE DEUX

1899. DRAWING. CHESTER JOHNSON COLLECTION, CHICAGO

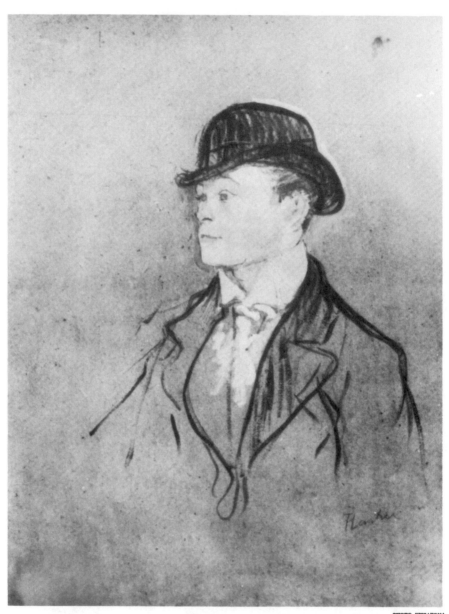

36. TÊTE DE LAD D'ÉCURIE
1895. MUSÉE D'ALBI

37. TRISTAN BERNARD AU VÉLODROME BUFFALO
1895. COLLECTION OF MR AND MRS PHILIP ISLES, NEW YORK

38. DOCTOR GABRIEL TAPIÉ DE
CÉLEYRAN
1894. MUSÉE D'ALBI

39. DOCTOR GABRIEL TAPIÉ DE
CÉLEYRAN
1891. DRAWING. MUSÉE D'ALBI

40. UNE OPÉRATION DE TRACHÉOTOMIE
1891. PRIVATE COLLECTION

41. AU LIT: LE BAISER
1892. GALLIMARD COLLECTION, PARIS

42. ÉROS VANNÉ
1894. LITHOGRAPH

43. LA VISITE: RUE DES MOULINS
1894. CHESTER DALE COLLECTION, NEW YORK

44. AU SALON: RUE DES MOULINS
1894. MUSÉE D'ALBI

45. LA FEMME AU BOA NOIR

1892. LOUVRE, PARIS

47. MADEMOISELLE GACHET
(BY VINCENT VAN GOGH)
1890. KUNSTMUSEUM, BASEL

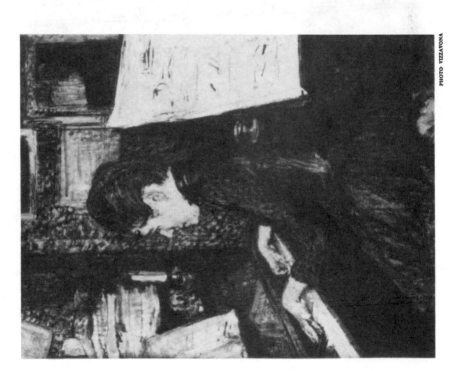

46. MADEMOISELLE DIHAU AU PIANO
1890. MUSÉE D'ALBI

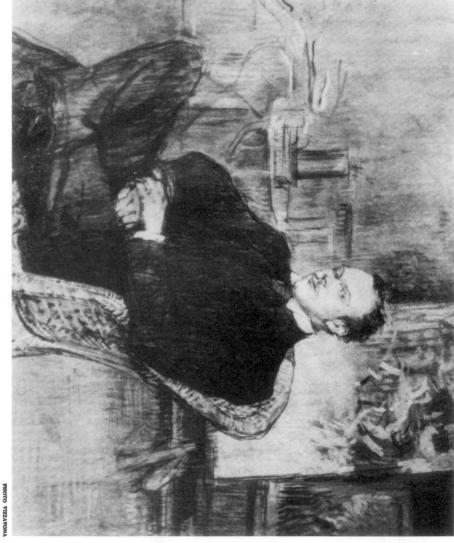

48. PORTRAIT OF PAUL LECLERCQ

1897. LOUVRE, PARIS

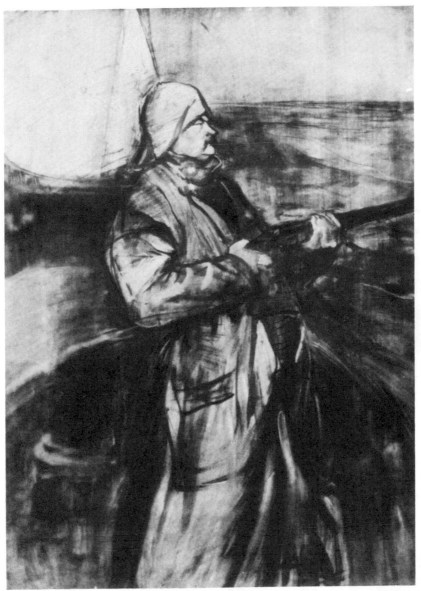

49. PORTRAIT OF MAURICE JOYANT
1900. MUSÉE D'ALBI

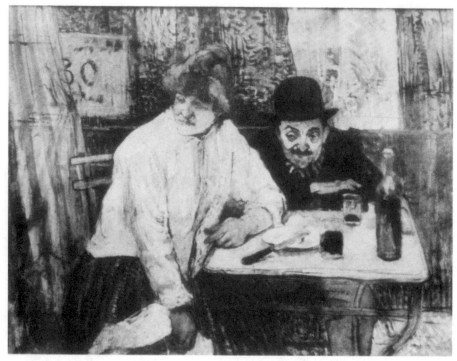

50. À LA MIE
1891. BERNHEIM JEUNE COLLECTION, PARIS

51. MAURICE GUIBERT AND A MODEL POSING FOR
À LA MIE
1891. FROM A PHOTOGRAPH

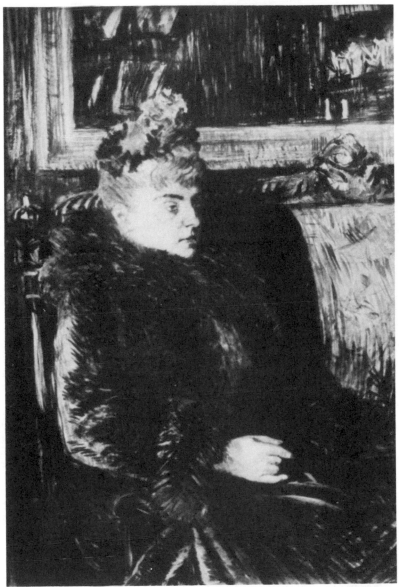

52. PORTRAIT OF MADAME DE GORTZIKOFF
1893. JAKOB GOLDSCHMIDT COLLECTION, NEW YORK

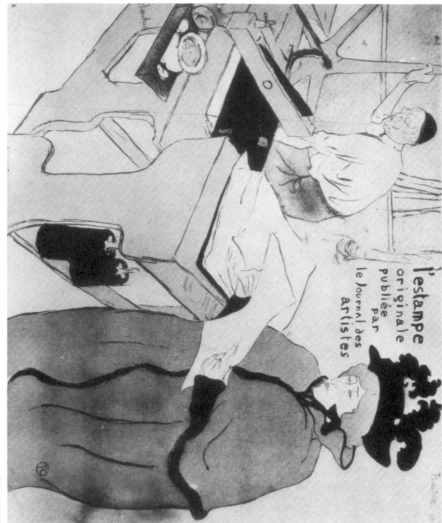

l'estampe
originale
publiée
par
le Journal des
artistes

53. COVER FOR L'ESTAMPE ORIGINALE
1893. COLOURED LITHOGRAPH

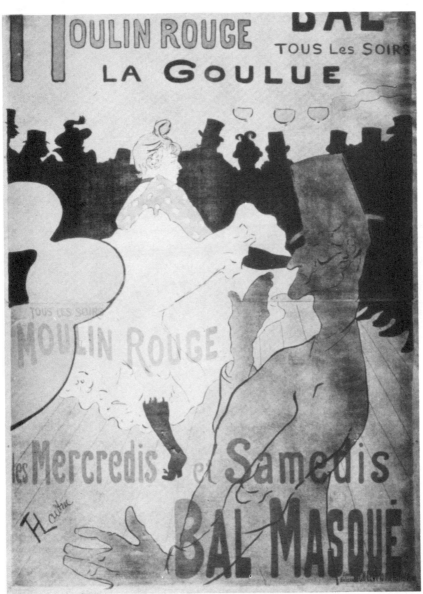

54. MOULIN ROUGE: LA GOULUE
1891. POSTER

55. PORTRAIT OF OSCAR WILDE
1895. CONRAD H. LESTER COLLECTION, BEVERLY HILLS,
CALIFORNIA

57. INVITATION À UNE TASSE DE LAIT
1900. LITHOGRAPH

56. LE JOCKEY
1899. LITHOGRAPH

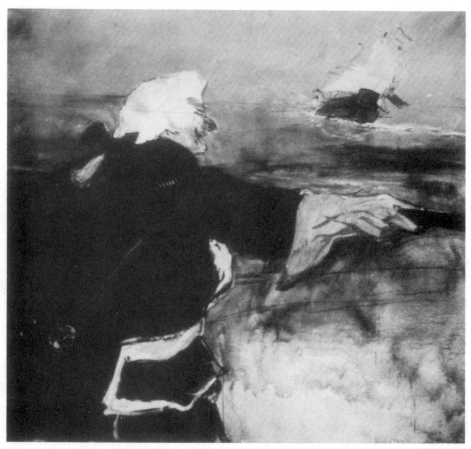

58. PAUL VIAUD AS AN ADMIRAL
1901. MUSEE D'ART, SAO PAULO, BRAZIL

CAFÉS–CONCERTS

IN 1893 Lautrec collaborated with Henri-Gabriel Ibels and Georges Montorgueil in the preparation of an album, *Le Café Concert,* published by *L'Estampe Originale.* Montorgueil supplied the text, while Ibels and Lautrec each contributed eleven lithographs. Some of these were reprinted in the illustrated literary supplement of the *Echo de Paris* for December 9, 1893. Lautrec took for his subjects eight of the most celebrated music-hall stars — both singers and dancers — of the day: Jane Avril (D. 28), Yvette Guilbert (D. 29), Paula Brébion (D. 30), Mary Hamilton (D. 31), Edmée Lescot (D. 32), Abdala (D. 33), Aristide Bruant (D. 34), and Caudieux (D. 35). The last three lithographs of the series represent Ducarre, director of Les Ambassadeurs (D. 36), a woman spectator (D. 37), and an unnamed American singer of comic songs (D. 38).

Lautrec loved the café-concert for the same reasons that he loved the Moulin Rouge: the bright lights and the gay audiences, the music, dancing, and singing, the convivial drinking in the company of friends. "The café-concert," writes Gustave Geffroy in *Le Figaro Illustré* of July 1893, "... is at once a meeting-place, a *salon de conversation,* a café, and a smoking-room; in addition one can find there both instrumental and

vocal music, droll songs in the choruses of which one may join, comic actors, singers in glittering costumes, sleeveless and *décolletés,* with flowers in their hair and bouquets in their hands. . . ." Here was the kind of entertainment that Lautrec enjoyed, as well as an inexhaustible wealth of material for pictures, drawings, and lithographs.

Long before Lautrec's time the café-concert had firmly established itself in Paris. In the eighteenth century the Café des Aveugles, located in a cellar under the arcades of the Palais-Royal, was considered one of the curiosities of the city because of its " concert ": an orchestra composed of five or six players, all blind; a woman who, according to François Fosca's *Histoire des Cafés de Paris,* " screeched at the top of her voice rather than sang "; and a ventriloquist, Valentin, known as " the man with the doll." During the Revolution the Café des Arts and the Café Yon, both in or near the boulevard du Temple, offered programs of music and singing for the entertainment of their patrons. The Café des Etrangers was celebrated for its concerts about 1800. There was dancing as well as singing at the Café des Porcherons, situated in what is now the place Blanche. Under the Directory and during the early years of the First Empire a number of popular *jardins de plaisir,* the forerunners of our modern Coney Islands and Earl's Courts, were opened: Tivoli, at the corner of the rue de Clichy and the rue Saint-Lazare; Le Ranelagh, at Bagatelle; Le Gymnase, in the Bois de Boulogne; Wauxhall d'Eté, in Passy; L'Elysée-Bourbon, in the Champs-Elysées; and many others. These resembled, as some of the names indicate, their contemporary English prototypes. Many varieties of amusement were at the disposal of the clients: swings and merry-go-rounds, fireworks, dancing, singing, orchestral music, sometimes gambling. Wines and liquors of all kinds, as well as coffee, tea, chocolate, syrups, and ices, were served at hundreds of little tables scattered about the gardens.

All of this was but the prelude, however, to the first appear-

ance of the café-concert as an independent institution, which took place in 1848. In February of that year of revolution the Estaminet Lyrique was opened in the passage Jouffroy, a covered arcade near the boulevard Montmartre. The proprietor, an actor thrown out of work because of his political opinions, installed a piano, some chairs and tables, and a barrel of beer in his dingy café. The patrons were workmen and clerks of the quarter; the entertainers were young women with more ambition than training, who sang sentimental songs and operatic arias. It was an unpretentious beginning which would probably have passed unnoticed had not the voice of an unknown young man made the Estaminet Lyrique famous overnight. The youthful singer was Darcier, of whom Tancrède Martel writes in an article, *Les Cafés-Concerts d'Autrefois,* published in *Le Figaro Illustré* for June 1896:

" This Darcier, who bewitched the public . . . was a true Parisian gamin. . . . At the age of twelve he sang in a church choir, where he was discovered one day by the chapel-master, the composer Delsarte. Impressed by his intelligence, Delsarte undertook his musical education. . . . Darcier, independent and Bohemian, soon slipped away to the provinces with a troupe of actors, damaged his tenor voice to some extent, gave lessons in piano-playing, singing, fencing, and boxing, and, intoxicated by the revolution [of 1848], returned to Paris, where he made the fortune of the Estaminet Lyrique. . . . The café-chantant of the passage Jouffroy was copied, imitated, plagiarized. Singing was introduced at cafés all over Paris: in the boulevard du Temple, in the Palais-Royal, especially in the Champs-Elysées. . . . Of these establishments, Parisians remember particularly the Café Moka, situated in the rue de la Lune [a narrow street off the boulevard Bonne-Nouvelle]. Darcier sang there after he left the Estaminet Lyrique. Now celebrated, he was urged to sing in private salons and was offered engagements at various theatres. In vain! After Decem-

ber 1851 the ' *ténor du peuple* ' slid rapidly downhill, hiding himself in miserable and obscure dives. His name was forgotten. In 1881 people heard almost with astonishment that he was still alive. A splendid performance organized for his benefit at the Gaîté rescued him from abject poverty. Darcier died three years later. . . ."

The movement launched by Darcier spread rapidly throughout Paris, but for many years the cafés-chantants, or *beuglants* as they were contemptuously called (from *beugler,* to bellow) , though popular as well as numerous, were in general cheap and tawdry resorts with little glamour and less art. The appearance of the great Thérésa in the eighteen-sixties marked the next step forward. This singer, the creator of a new and individual style, was born at La Bazoche-Gouet in the department of Eure-et-Loir in 1837. Her real name was Emma Valadon. According to an article by Maurice Vaucaire in *Paris-Illustré* for August 1, 1886, her father was a tailor, her mother a fortune-teller. Orphaned at the age of twelve, Thérésa was apprenticed to a dressmaker for several years. Her stage career began in 1856, when she appeared as a " super " in *Le Fils de la Nuit* at the Théâtre de la Porte Saint-Martin. Her work attracted little attention, however, and for some time she disappeared from the theatre and worked as cashier at the Café Frontin. She did not return to the stage until 1863, when she sang first at the Alcazar d'Hiver, then at Lyons, and again in Paris at L'Eldorado. None of these engagements was particularly successful; but a second appearance at the Alcazar was a sensational triumph, and within a few days Thérésa found herself famous. Her voice, a powerful but pleasing contralto, was well suited to her repertoire of comic songs. All Paris flocked to hear her; her popularity was so great that she was commanded by Napoleon III to sing at the court of the Tuileries. After the Franco-Prussian War she appeared in a number of operettas at various Paris theatres. In 1884 Thérésa returned

to the Alcazar d'Hiver, whose manager, Monsieur Donval, she had married some years earlier. Although no longer young, she had lost neither her voice nor her curiously elusive charm, and she continued to draw crowds to the Alcazar and to the other music-halls in which she sang until her final retirement in 1891. " After Thérésa's time," writes Tancrède Martel, " the café-chantant became officially the café-concert. . . ."

In *Le Figaro Illustré* for June 1896 Gaston Jollivet points out the contrast between the café-chantant of early days and the colourful café-concert of the eighteen-nineties:

" To begin with, the difference in price. . . . During the latter half of the Second Empire, one franc gave you the right, at the Café de la Rue de la Lune, to sit in the best seat . . . and drink a glass of beer. . . . In short, one franc for a performance lasting three hours. . . .

" It is true that the proprietors made up for the low prices they charged by paying their entertainers almost nothing. . . . Darcier . . . earned less than twenty francs a night at the café-concert in the rue de la Lune. . . . Hervé, already very popular, though not yet celebrated as the immortal author of *L'Œil Crevé* . . . was recompensed no more generously than Darcier.

" The smallness of the salaries paid to the performers and the low prices demanded for drinks were on a par with the unpretentiousness of the scenery and staging of the cafés-concerts of those days. In fact, these two items of expense did not account for a single centime in the budgets of such establishments. Even if a stage-manager had wanted to display such an unwonted luxury, the Ministry of Beaux-Arts would have stopped him with a peremptory prohibition. For staging and scenery presuppose a play . . . and the Government would not allow the presentation of a play on the stage of a café-concert. At that time the freedom accorded to the theatre was but a myth, and the Ministry of Beaux-Arts, the strict inter-

preter of the regulations, did not permit a café-concert to put on so much as a ' number.' Indeed, the singers were forbidden to appear in costume, even at carnival time. Formal evening clothes were prescribed for the male entertainers, while the women were condemned to wear those eternal low-necked dresses. . . .

"As to the clients who crowded into these resorts. . . . There were many shopkeepers from the neighbouring quarters, many clerks from shops and offices, from time to time loose women, of a fairly low class, escorted by weedy youths. . . . In short, the nucleus of this public was the class that is to be found today in the second or even the third balconies of our theatres. . . . At the end of twenty years of hard work the proprietor of the Café de la Rue de la Lune or the Café du Géant, for example, might have earned enough to enable him to retire to a cottage at Montreuil-sous-Bois, but that was the best he could look forward to. The café-concert had neither chic . . . nor a fashionable clientele. . . ."

During the Franco-Prussian War the singing in the cafés-concerts took on a patriotic and political character. The tone was set by Thérésa, who sang the *Marseillaise* at the Alcazar d'Eté in the Champs-Elysées " with all the fervour of Rachel." But when the war was over, the entertainments became once more frankly " naughty " and suggestive, the favourite theme for songs being comments on what Jollivet calls " all of the various protuberances of the female body." " Essentially," he writes, " this is still characteristic of the café-concert in this spring of 1896. Its æsthetics have not changed since 1860, except that the censorship is now very much more tolerant." But if the repertoires were as unrefined as in the old days, the social status of the patrons had undergone a notable transformation. " The elegance, or at least the comfort, of the new establishments has at last succeeded in attracting a public that, until now, has always sneered at the café-concert. . . . Today there

is a new and faithful clientele drawn from the upper classes
. . . the ladies attend in elaborate gowns and the gentlemen in
formal evening dress. . . ."

According to an article *Le Monde et les Etoiles des Cafés-Concerts* by Charles Dauzats in the same issue of *Le Figaro Il-lustré,* there were no less than 274 cafés-concerts in Paris in
1896; between 10,000 and 15,000 new songs were presented
annually in these resorts, and their total receipts (in 1895)
amounted to approximately 9,500,000 francs.

Most of the women who sang their gay and more or less dar-ing *chansons* at the cafés-concerts of the nineties were re-cruited from one of two different groups. Some had begun
as dressmakers, milliners, saleswomen, or artists' models;
equipped with good looks, bold manners, voices that were sel-dom better (and often a good deal worse) than mediocre, and
a little training, they were able to find employment in the less
pretentious establishments. At the better cafés-concerts the
entertainers were usually women who had once aspired to sing
at the Opéra or at least in some good musical comedy, but who,
either because their voices were not quite adequate or because
they were unable to defray the expenses of thorough musical
training, as well as of the diversified wardrobe essential to an
operatic career, were obliged to accept engagements of less dis-tinction. The café-concert did, after all, offer certain compen-sations to these disappointed songbirds. Their fees, while sel-dom large, were more generous than the salaries doled out to
singers of minor rôles in opera or operetta; and it was certainly
much more agreeable to be " starred " and envied at the café-concert than to be a mere member of the chorus at the Opéra
or an insignificant understudy at the Opéra-Comique.

Some of the male singers had drifted onto the stage of the
café-concert after having been trained for, and in many cases
having practised, various professions quite unrelated to the
theatre. The article by Charles Dauzats in *Le Figaro Illustré*
continues:

"Prominent among the men are . . . two former sub-prefects, three doctors, five lawyers, an engineer of roads and bridges, an ex-attaché of an embassy, several vaudeville actors . . . two light-opera tenors . . . a police commissioner, and a former grave-digger. . . .

"This mixture of origins indicates that, except in rare instances, the café-concert was not a vocation in the true sense of the word. One did not dedicate one's life to the music-hall in early childhood, as one dedicated one's life to the theatre. . . .

"Contracts are made by the performance, by the month, or by the season, according to the expectations aroused by the voices and talents of the singers (if they are men) and also by their beauty (if they are women). The fees for a single evening vary between five and ten francs; monthly salaries between 140 and 200 francs; the payment for a season, which divides the year into two approximately equal periods (the winter season from September to April, and the summer from April 5 to September or October), never exceeds 1,500 francs for beginners. . . .

"While there are . . . at La Scala, Les Ambassadeurs, Parisiana, and the Folies-Bergère a few stars who receive fees of 500 francs and more a night, ten or fifteen louis per song, there are also, in establishments of equal importance, fees of one louis, ten francs, five francs, even one franc fifty centimes. . . .

"There is an intimate, though sometimes scandalous, friendliness in café-concert life. In this world one can find examples of touching, even prodigal, generosity which one might seek in vain among any other group. . . .

"There are daily rehearsals . . . lasting from two to five hours, of the songs and ballet, to which are added topical ' acts ' as desired. The repertoire of songs is changed, at least in part, every day. . . ."

* *

From 1892 to 1896 Lautrec was a constant patron of the cafés-concerts. At that time there were two principal café-con-

cert districts in Paris: one centred on the boulevard de Strasbourg and the boulevard de Sébastopol, the other (open in summer only) was concentrated in the Champs-Elysées. Only three establishments of any importance were situated in Montmartre itself: Le Divan Japonais, already described, which was half café-concert, half *cabaret artistique;* La Cigale at 122 boulevard de Rochechouart, on the site formerly occupied by the dance-hall of La Boule Noire; and Les Décadents at 16*bis* rue Fontaine.

At La Cigale the concert took precedence over the café. It was not, in fact, a café at all, but a small theatre decorated by Willette, with a stage fully equipped for the presentation of the playlets and revues that constituted the chief attractions of the resort. These offerings were almost without exception as " naughty " as the most liberal interpretation of the already free and easy censorship laws could make them. So bawdy were the jokes, so frank the exposure of naked female bodies, that the anonymous author of the *Guide des Plaisirs à Paris* for 1900 thought it advisable to issue a warning to prospective visitors to La Cigale — a warning that sounds quaintly Victorian today: " Ladies will do well to provide themselves with fans."

Les Décadents was noisier, more picturesque, and less elaborately housed than La Cigale. The proprietress, Madame Duclerc, was a retired singer who had once been popular at Les Ambassadeurs, but who was now ravaged by the tuberculosis which was soon to cause her death. Lautrec came often to Les Décadents, especially in 1895 when Jane Avril danced and May Belfort sang there. May Belfort was a young Irishwoman who specialized in old English and Irish songs, Negro melodies, and sentimental ballads. She was intelligent, ambitious, and handsome, with dark hair and regular features of the " colleen " type. On the stage she always wore Kate Greenaway dresses in plain colours, all made exactly alike, with short puffed sleeves terminating in lace ruffles; on her head was a sort of mob cap, ruffled and tied with a bow of coloured ribbon, beneath which

her long hair escaped in a cascade of dark curls. Her appearance was intentionally babyish, and the lisping voice in which she sang

"I've got a little cat,
I'm very fond of that . . ."

served to enhance the illusion of her extreme youth. Coquiot contemptuously dismisses May Belfort's songs as " silly nonsense " and herself as " a bleating ewe "; but he admits that she was " comically childish, dressed as a baby, with her curls falling loosely over her shoulders. She mewed, holding a black cat in her arms, or sometimes without one; and the clients of Les Décadents shouted the choruses of her songs while she stood erect and motionless as if carved out of wood." In 1895 Lautrec painted several portraits of May Belfort: one in a yellow dress, in profile, with the black cat cradled in her folded arms; another in the same costume and with the same cat, but full face, standing before the footlights at the Décadents; one in a red dress, a preliminary study for the poster (Plate 22) which afterwards appeared on all the hoardings of the Paris boulevards; one in pink muslin, full face but without the cat; a three-quarter view of her head alone; and a number of water-colours and lithographs (D. 117–123). In one lithograph (D. 123) May Belfort is shown at the Irish and American Bar, with the Rothschild coachman and Ralph, the barman, in the background.

During the course of the same year Lautrec painted two portraits of another May: May Milton, an English dancer. " There was nothing to hold one's attention," writes Joyant, " in her pale, almost clownlike face, rather like that of a bulldog, but her suppleness, her typically English choreographic training . . . were a sort of revelation in those days." May Milton and Jane Avril were close friends. The French dancer took the English " Miss " under her wing, introduced her to a number of acquaintances, and saw to it that she received her

176

share of invitations. When Jane Avril was asked to join a supper party she usually suggested that " Miss, aussi " should be included, so that May Milton soon acquired the nickname of " Missaussi." One of Lautrec's portraits shows May Milton in outdoor dress: a jacket with " leg-of-mutton " sleeves, a high fur collar that emphasizes the heavy contours of her bulldog chin and lower jaw, and a smart little bonnet perched on top of her head. The other is a poster of May Milton in dancing costume, holding her long full skirt outspread (Plate 23).

Entertainers from the British Isles are well represented in Lautrec's café-concert subjects. In addition to his portraits of the English May Milton and the Irish May Belfort he produced two lithographs of another English dancer, Ida Heath, and one of the mimic Cissie Loftus, who hailed from Scotland. The first of these, *Ida Heath au Bar* (D. 59), was executed in 1894. The fair-haired, fox-faced dancer, swathed in an evening wrap with a fur collar, stands in front of a bar talking to a man whose bloated features suggest the habitual drunkard. Behind them can be seen the partly hidden figure of the barman. The contrast between the sharply pointed profile and receding chin of Ida Heath and the beefy face of her companion, with its bulbous nose reddened by constant potations, is amusingly exaggerated. In the second lithograph of *Miss Ida Heath* (D. 165), dated 1896, the agile dancer in ballet costume is executing a difficult *pas seul:* the toes of one slipper-clad foot barely touch the boards of the stage, while the other foot, pointed skywards, is on a level with the performer's head.

Mary Cecilia Loftus — better known as Cissie or, to the French, Cecy — was born in Glasgow in 1876; she was therefore only nineteen when Lautrec lithographed her in 1895. She had made her first appearance on the stage in England two years earlier in a series of imitations, which she afterwards presented in Paris. It is as a mimic that Cissie Loftus is seen in Lautrec's lithograph (Plate 25). Although she wears a fluffy and altogether feminine gown, her top hat, short gloves, and

jaunty cane indicate that she is, at the moment, impersonating a man as she swaggers across the stage, with her mouth impishly twisted to one side. Later she was to enjoy a long and distinguished career (which, happily, still continues) in the legitimate theatre in England and America; her repertoire has included several Shaksperian parts and a leading rôle in the well-known play *If I Were King,* written by her first husband, Justin Huntly M'Carthy.

* *

The two most famous resorts in the centre of the real café-concert quarter were La Scala at 13 boulevard de Strasbourg and L'Eldorado, almost directly opposite, at 4 boulevard de Strasbourg, both of which have recently been converted into cinemas. In the eighteen-nineties they were, like La Cigale, theatres rather than cafés, with rows of orchestra stalls, boxes and loges for those who could afford them, balconies and galleries for less prosperous patrons. Gaston Jollivet writes in *Le Figaro Illustré* for June 1896:

". . . La Scala and L'Eldorado are real theatres in which singing is no longer almost the sole attraction. At these places revues are presented, splendidly mounted and with magnificent choruses. Therefore I can see little difference between these establishments and those others which are specifically labelled theatres, except that here smoking is permitted and hats are worn."

La Scala was built on a site once occupied by the Café du Cheval Blanc, one of the oldest taverns in Paris. As early as 1886 La Scala was frequented by well-bred and even fashionable crowds: in *Paris-Illustré* for August 1 of that year Maurice Vaucaire writes that " the public of La Scala is, for the most part, a public of good social standing. There is a certain air of luxury about this resort." By 1900, according to the *Guide*

des Plaisirs à Paris, the setting, both on the stage and in the auditorium, had become still more luxurious, but the audiences were no longer quite so respectable:

" The theatre, now very handsomely redecorated in white and gold, presents a very gay and pleasing appearance with its tiers of upper galleries and the uncovered loges of the ground floor, in which the most celebrated *demi-mondaines* display themselves in all their finery, their gowns of lace or silk.

" The stage is superb, the scenery ravishing, and one can imagine nothing more delightful and more refreshing to the eye than the sight of all these costumes, which are often no costumes at all and which expose, with subtle art, a collection of the most beautifully turned legs in Paris.

" La Scala is a theatre of girls and ' girl shows '; of revues in which the whole charming battalion of Cythera parades, at the same time engaging in artful skirmishes with the monocles and opera-glasses belonging to the occupants of the loges."

L'Eldorado, the aristocrat of the cafés-concerts, is described by Maurice Vaucaire in *Paris-Illustré* for August 1, 1886:

" L'Eldorado, if not the oldest, is certainly the most important of all the concerts. It is the Opéra of its class. The singing there is decorous and in conformity with tradition.

" All of the great comic or sentimental singers, all of the women who trill ballads or naughty airs, made their débuts there. . . . The always numerous clients are drawn from the bourgeois families and prosperous merchants of the neighbourhood.

" The songs are of all kinds, but more discreet than at other similar places; the theatrical numbers are very well produced. Every year the director puts on a revue that is surely one of the most amusing in Paris. . . ."

The director, or rather the directress, of L'Eldorado was a Madame Allemand, a formidable and grasping woman whose appearance, if we may judge from Yvette Guilbert's description in *La Chanson de ma Vie,* was no more attractive than her character:

" I could not take my eyes from her face, already old [this was in 1889], covered with pink and mauve make-up; her purple lips that disclosed yellow teeth; her frizzled and refrizzled hair. On top of all that she wore an amazing hat that looked like a fantastic hearse ornamented with funereal plumes, diamonds in her ears, turquoises on her fingers, gold chains about her neck, bracelets on her wrists; yet in spite of all these vulgar trappings she retained a suggestion of her former beauty, for the woman had once been beautiful. . . ."

Madame Allemand managed the theatrical side of the enterprise while her husband, an " insignificant, colourless, dull little man," ran the café attached to L'Eldorado, where refreshments were served during the intermissions. Madame Allemand was also the power behind the throne at La Scala, operated by her son-in-law Marchand. Many of the famous stars of the café-concert appeared first at one, then at the other, of these two leading establishments. Yvette Guilbert sang at L'Eldorado in 1889, at La Scala from 1892 to 1900; Anna Held at L'Eldorado in 1892, at La Scala later in the same year. Lautrec made two lithographs of Anna Held: once as she appeared in *Toutes ces Dames au Théâtre* in 1895 (D. 100), the second time with the actor Baldy in 1896 (D. 168).

The Eden-Concert in the boulevard de Sébastopol, directed by Madame Saint-Ange, was an unusually proper café-concert that catered to the " family " trade. The most prudish mothers could bring their young daughters there, secure in the knowledge that nothing would be seen or heard to shock their tender sensibilities. Every Friday there was a classical concert of old

French songs. Unfortunately these innocent programs failed to appeal to the general public: the Eden-Concert was never a great success.

The Folies-Bergère at 32 rue Richer suffered from no such handicap as excessive purity. The management had no illusions as to the kind of entertainment that would please its clients. Decorum was all very well, but a few spicy songs and a goodly display of unveiled feminine charms could be counted on to fill a music-hall, and the Folies-Bergère offered these in full measure. As a result it was for many years (and indeed remains today) one of the most popular of Parisian resorts. The programs were full of variety and exceedingly lavish. At each performance there were sixteen to eighteen " numbers " that included everything from trained seals to light opera. Jugglers, acrobats, clowns (among them Little Tich and the Marco Brothers), famous singers like *la belle* Otero and Lina Cavalieri (both of whom were celebrated for their beauty as well as for their voices), the Barrison Sisters, and the American dancer Loie Fuller all appeared at one time or another on the stage of the Folies-Bergère. The long intermissions were often as lively, in a different way, as the performances themselves. The immense bar and *promenoir* were the happy hunting-grounds of hundreds of prostitutes of the better class, euphemistically called by the *Guide des Plaisirs à Paris* " the aristocracy of the *demi-monde*."

Lautrec, who often visited the Folies-Bergère, found the place rich in material for paintings and drawings. Two scenes from this music-hall appeared in *Le Rire*. In the issue of December 21, 1895 the back cover is a lithograph, in black and white with just a touch of colour, entitled *Aux Folies-Bergère: Brothers Marco (Etude de Disloqué)*. One clown, very tall, is doubled up in a contorted position with his head between his legs, while the other, a dwarf, makes jokes at his expense. The second lithograph, in full colour, is published in *Le Rire* for June 13, 1896; the caption reads: *Dans les Coulisses des Folies-*

Bergère: Mrs Lona Barrison avec son Manager et Epoux.
Epoux was, presumably, the name of the white horse ridden
by Lona Barrison whenever she sang on the music-hall stage.
The Barrison sisters were Americans, young and pretty, whose
" act " had been an outstanding success at the Chicago Expo-
sition of 1893. The following year they embarked on a tour
of Europe, playing first at the Folies-Bergère in Paris, later in
Berlin and Vienna, to enthusiastic audiences.

In the autumn of 1892 Loie Fuller made her début at the
Folies-Bergère. This famous dancer had already had a long
and active (but until shortly before her Parisian appearance,
not a conspicuously successful) career. Born in 1862 in a small
Illinois town, she began to sing and play the piano in public
at the age of five. At thirteen, as a temperance lecturer, she
succeeded in moving her audiences to tears by citing horrible
examples of the effects of drink. Later she acted in various
Shaksperian dramas with a troupe of " barnstormers "; then in
turn at Hooley's Opera House in Chicago, with Nat Goodwin
in the burlesque *Little Jack Sheppard* in New York, and in a
dramatization of H. Rider Haggard's *She* in the same city.
These New York engagements, moderately successful, were
followed by the disastrous and costly failure of an elaborately
planned South American tour. In 1889 she went to London
and appeared in several productions, all of which closed ig-
nominiously after short runs.

Until now Loie Fuller had been an actress, and by no means
a brilliant one. But soon after her return to New York, some-
what discouraged by her recent failures, she discovered by ac-
cident that she could dance. As she was posing idly before a
mirror with a piece of translucent material draped about her
body, a shaft of amber light reflected through a window caught
the rippling fabric and made it glow like a sheet of living fire.
The phenomenon immediately suggested to her a dance that
was to be a combination of movement, colour, and light. After
some experiments she invented the " serpentine " and other

dances in which changing lights and the manipulation of float-
ing draperies played a more important part than the actual
steps. With these creations, then entirely new, Loie Fuller at
last achieved success, in Europe as well as in her native Amer-
ica. At the Folies-Bergère her program comprised five selec-
tions from her repertoire: the Serpentine or Fire Dance, the
Violet Dance, the White Dance, the Butterfly, and a series of
gyrations in which the dancer's figure was illuminated from
below by coloured lights shining through a square of glass set
into the stage floor. Lautrec painted two or three studies of
Loie Fuller in 1893, and one of his finest lithographs (D. 39)
portrays her in the Fire Dance, a swirling column of gauzy
smoke and flame. This lithograph was printed in black ink,
but each of the fifty prints was tinted in water-colours by Lau-
trec himself. For this purpose, says Delteil, he used a wad of
cotton wool instead of a brush. As a finishing touch he sprin-
kled the prints with gold powder. Since these additions were
made by hand, the completed lithographs exhibit a good many
variations in detail.

A singer whose name was intimately associated with both the
Folies-Bergère and L'Eldorado was Anna Judic, a lithograph
of whom (D. 56) Lautrec executed in 1894. She is shown in
her dressing-room, talking to the composer Désiré Dihau,
while a maid arranges her costume. Judic, however, belonged
to an earlier generation and in Lautrec's day was already past
her prime. Born in 1850, she made her début at the Théâtre
du Gymnase, of which her uncle was the director, at the age of
seventeen. Her maiden name was Anna Damiens, but for the
stage she adopted the sobriquet of Judic, the nickname of her
husband, whose real name was Israël. When Israël became the
manager of L'Eldorado in 1868, Anna Judic appeared there
in a program of songs that brought her instant celebrity. She
sang a few years later at the Folies-Bergère, and in 1876 was
engaged by the Théâtre des Variétés to create the principal
rôles in several operettas, including the popular *Mademoiselle*

Nitouche. When Lautrec knew her she was well over forty, but her voice was still fresh and sweet, and her appearances at L'Alcazar d'Eté and other music-halls were always greeted with prodigious applause. Judic died at Nice in 1911.

Other lithographs by Lautrec with a Folies-Bergère setting are *Répétition Générale aux Folies-Bergère* (D. 44), a dialogue between two actresses, Emilienne d'Alençon and Mariquita; and *Folies-Bergère: les Pudeurs de M. Prudhomme* (D. 46), a scene from a farce presented in December 1893.

There were many other cafés-concerts, less important than the foregoing, in the side streets near the boulevards. Two of them were sufficiently prominent to require a brief notice. The Alcazar d'Hiver in the rue du Faubourg Poissonnière (which had no connection with the Alcazar d'Eté in the Champs-Elysées) is described by Maurice Vaucaire as " one of the cafés-concerts that seems most like a café-concert." Under the management of Donval, husband of the great Thérésa, it was the scene of many of that singer's later triumphs. It was at the Alcazar d'Hiver that La Goulue and Grille d'Egout, fresh from the Moulin de la Galette and not yet enthroned at L'Elysée-Montmartre, introduced the *quadrille réaliste* to the boulevards in 1885.

The Concert-Parisien was a small but at one time a popular music-hall in the rue du Faubourg Saint-Denis. When it passed into the hands of Auguste Musleck, a former swimming-teacher at one of the bathing-establishments in the Seine who knew nothing about the management of a café-concert, its vogue declined rapidly until, in 1892, the owner was declared bankrupt. In a desperate attempt to recover at least a part of his lost capital, Musleck persuaded Thérésa, who had retired from the stage a year or two before, to appear at the Concert-Parisien for a fortnight in a series of farewell performances. The situation was saved for the moment; but the music-hall could not have survived another season had not Yvette Guilbert (according to her own account in *La Chanson de ma Vie*)

given it a new lease of life by presenting herself there on October 5, 1892, three days after Thérésa's departure. In spite of the large salary demanded by Yvette, her popularity was such that Musleck soon accumulated a new fortune. But after fourteen successful months the association came to an abrupt end in a stormy scene, culminating in a lawsuit which Musleck lost. Soon after the termination of Yvette Guilbert's engagement the Concert-Parisien closed its doors.

* *

In summer three popular, fashionable, and relatively expensive cafés-concerts set out their little tables under the trees of the Champs-Elysées. Two of these, L'Alcazar d'Eté and Les Ambassadeurs, were on the north side of the main avenue; the third, L'Horloge, was situated on the opposite side between the Restaurant Ledoyen (which still exists) and the place de la Concorde.

L'Horloge was run by a family named Stein, originally from Vienna, who lived in the house, or rather the pavilion, that formed part of the property. The site and buildings, including an open-air stage, belonged to the city of Paris; and the tenants were obliged by the terms of their lease to continue the operation of this garden theatre as a café-concert during the summer months. Since the Steins were extremely wealthy they made no attempt to wring a profit from the enterprise thus forced upon them, but ran it principally for the amusement of their young daughter, an invalid; from the balcony of her room in the pavilion she enjoyed listening to the music and watching the antics of the clowns on the stage below. The public was admitted, of course, but the Steins intentionally kept the entertainment on too sedate a plane to attract large and boisterous crowds. According to Maurice Vaucaire, this quiet resort was characterized by " good singers, an excellent orchestra, and a contented and sober public. There was never any uproar, never any disorder — in which respect it differed nota-

bly from Les Ambassadeurs." From the point of view of the entertainers, who naturally preferred a more numerous as well as a more responsive audience, the side of the Champs-Elysées on which L'Horloge was located was considered the " poor " side, that of Les Ambassadeurs and L'Alcazar d'Eté the " good " side.

About 1892 this situation was unexpectedly, though temporarily, reversed. The Steins, at the suggestion of their daughter, engaged Yvette Guilbert to sing at L'Horloge. The popular star filled the café-concert, for the first time in years, to capacity; to the great distress of the Steins, until they were reconciled to the loss of their peaceful semi-privacy by the delight of their bedridden child at the unaccustomed sight of huge crowds. But a year later this cultured and charming family left Paris, and L'Horloge was taken over by a couple named Debasta, who commercialized the resort and destroyed its individual character. Monsieur and Madame Debasta must have been, in truth, exceedingly vulgar people, to judge from the nickname which was universally applied to them: Les Mômes Caca. L'Horloge did not long survive its transfer to their management. When the original site of the Jardin de Paris in the Champs-Elysées was appropriated for the construction of the Grand Palais, one of the principal buildings of the Exposition of 1900, the Jardin de Paris dispossessed L'Horloge and set up its own establishment in its place. Today all traces of the resort have disappeared. The buildings have been demolished, and the site is covered by green lawns, flower-beds, and trees.

L'Alcazar d'Eté and Les Ambassadeurs, on the " good " side of the Champs-Elysées, were smarter and more animated than L'Horloge. Both were restaurants as well as cafés-concerts, and both were expensive, though Les Ambassadeurs was a little dearer than its neighbour. " At L'Alcazar and at Les Ambassadeurs," reports the *Guide des Plaisirs à Paris* for 1900, " the dainty costumes of the singers lend a voluptuous grace to the

spectacle; they add a typically Parisian note of elegance that is charming to the eye." And of Les Ambassadeurs: " One would think oneself in a great park, a guest at some royal fête. All of the greatest singers, male and female, appear at the Café des Ambassadeurs. In summer it is a delightful and very Parisian spot. . . ."

The Café des Ambassadeurs has been established for well over a century. It was already in existence during the Directory, at the very beginning of the nineteenth century. Since then it has known many ups and downs, many changes of character and clientele. Today it is again one of the most fashionable and expensive summer restaurants in Paris, but it is no longer a true café-concert, nor is the elaborate " floor show " now presented in the open air. The restaurant and stage are housed in a modern building, completely enclosed except for a small terrace. When Lautrec frequented Les Ambassadeurs in the eighteen-nineties the atmosphere was very much less formal. Then the stage alone was roofed over; the rest of the space was open to the sky, and in wet weather a canvas awning was stretched over the heads of the spectators. It was soon found, however, that the drumming of the rain on the taut canvas tended to drown the voices of the entertainers, and before 1900 a permanent roof was built over the auditorium; but the sides were left open. The restaurant in those days was located on a raised terrace at the back, overlooking the rows of seats and the stage at the far end.

According to Delteil, the director of Les Ambassadeurs, Pierre Ducarre, " was born at Châteauneuf-sur-Sornin in the department of Saône-et-Loire in 1830. After an apprenticeship at Lyons, Pierre Ducarre came to Paris, where he made his début in 1848 as a waiter at the Café Turc in the boulevard du Temple. Then he founded the Café des Porcherons, which he left in 1867 to undertake the management of the Concert des Ambassadeurs, which under his intelligent direction became one of the most famous establishments in the world at

which one is entertained — or deafened." Ducarre is repre-
sented in one of Lautrec's lithographs (D. 36) in the album
Le Café Concert.

Yvette Guilbert describes Ducarre as " a little old man with-
out education, always dressed in a black frock-coat and a white
tie; he looked like a guest at a poor man's wedding. He was
extremely courteous, with an easy sort of politeness, and the
entertainers were very fond of him."

The summer season at Les Ambassadeurs opened in May
but did not really get under way until June, when the races
and other attractions brought the fashionable world to Paris.
At the height of the season the audiences were well-behaved
and considerate, but during the first month of each term Les
Ambassadeurs was invaded by a different public — a public
apparently determined to make as much noise as possible. For
these weeks, therefore, Ducarre chose singers with throats of
brass. Even so, the orchestra and entertainers were often over-
whelmed by the barrage of whistles and catcalls that burst from
the audience. This uproar did not indicate disapproval of the
performance: it was a tradition of long standing. For some
reason Monday evenings were always the most riotous; Mau-
rice Vaucaire tells us that " the young people of fashion have
chosen Monday for their disorderly exhibitions at Les Ambas-
sadeurs. The police are prepared for them. On Mondays the
squad of guardians of the peace is doubled, but the audience
bellows just the same. After each disturbance the police eject
a dozen of the brawlers, but those who are expelled come right
in again by another door. All of which fills the coffers of the
concert. . . ."

The unfortunate entertainers knew what to expect from
these rowdy audiences and continued imperturbably to sing
whether their voices were audible or not. Even the popular
Paulus, perhaps the greatest of all male stars of the music-hall
since the time of Darcier himself, was not spared these an-
noying demonstrations. One evening, writes Yvette Guilbert,

Paulus lost his temper and shouted to the noisy crowd: " If you want to sing with me, at least sing in time, *nom de Dieu!* " The audience applauded, and Paulus, seizing the baton from the hand of the conductor, beat time for the chorus, in which the whole mob joined.

In *Paris-Illustré* for August 1, 1886 Vaucaire writes of Paulus:

" One may say and write what one likes; M. Paulus is the most amusing singer of the cafés-concerts. . . . M. Paulus sings every kind of air, therefore he pleases everybody. His success is as great in sentimental ballads as in comic songs. . . .

" M. Paulus has a powerful and true voice. A musician to his finger-tips, he knows how to charm. . . .

" He is said to have a quick temper; M. Paulus does not deny it. Since he was born in the Basque country and brought up at Bordeaux, we can well afford to forgive him his hot blood, especially as it is the chief source of his fervour.

" Without him the café-concert would not amount to much. . . ."

Jean-Paul Habans, who adopted the name of Paulus for the stage, was born at Bayonne in 1845. He came to Paris while still in his teens and made his début inconspicuously in 1864 at a small café-concert in the Belleville quarter. Engagements followed at L'Alhambra and L'Eldorado, but Paulus remained obscure, and in disgust he left Paris for the provinces, where he met with moderate success. In 1874 he returned to Paris; this time his appearances at various music-halls were greeted with enthusiasm, but four years later he interrupted a promising career to engage in the business of selling paints at Marseilles. This venture proved a failure, so he came back to Paris once more and for a decade held sway as one of the most popular entertainers at La Scala, L'Alcazar, and other cafés-concerts. An enthusiastic supporter of General Boulanger,

who almost succeeded in bringing about an anti-republican *coup d'Etat* in 1889–1890, Paulus went into semi-retirement after the royalist general, in disgrace, fled to the island of Jersey and committed suicide in 1891. Paulus did sing occasionally at Les Ambassadeurs and Bataclan during the nineties, however, and Lautrec must have seen him several times, though he has left no pictorial record of the great performer.

Paulus was one of the most important milestones in the development of the art of the café-concert, principally because he was the first to introduce gestures and pantomime into his interpretations. Georges Montorgueil writes in *Les Demi-Cabots*:

" Our celebrated Paulus . . . seems to have been the first to take into account the influence of movement on the revival of the French *chanson*. Before his time singers always stood stiffly erect, facing the prompter. . . . His success is largely due to his pirouettes, his marches up and down the stage, his prancings, his imitations of various forms of infirmity, of the crippled and the maimed. This is an entirely new art that must be learned."

But the pantomime invented by Paulus, while it undoubtedly enlivened and lent variety to his own singing, was carried too far by some of his less gifted followers. Among these was Kam-Hill, whom Lautrec sketched two or three times in 1893 and who is taken severely to task by Montorgueil:

" What was Paulus's method? Kam-Hill was to demonstrate it with excessive zeal. By using exaggerated gestures and a too vigorous delivery the hard-working imitator, sweating, puffing, groaning, toiling . . . still further emphasized the mechanical quality of recitation accompanied by gesticulation."

Two of the music-hall singers selected by Lautrec for portrayal in his series of lithographs for *Le Café Concert* were

Paula Brébion (D. 30) and Madame Abdala (D. 33). Montorgueil describes them both briefly:

" Mlle Brébion, dark and stout, with limpid wide-open eyes and the lisping voice of a little girl, and pretty arms that writhe mournfully as she sings . . . tells us incessantly: ' Ah! how I love the soldier-boys! ' She knows a great many barrack-room ballads in which the soldiers are always rewarded for their heroism. She sings them with an air of martial innocence and flippant grace that seems a little childish."

And of the comic singer Abdala he writes:

" She is endowed with an extraordinary scragginess . . . in a grimacing competition . . . she would need to play no tricks in order to win the prize . . . her own face would win it for her. . . . She does all the things that nasty little girls who stick out their tongues, squint, make faces, and goggle their eyes can think of. . . . She takes great pains to make herself ugly. . . . Under certain conditions of light and shadow Abdala, angular and with all her bony structure visible, suggests a drawing by Daumier."

The wasp-waisted Mademoiselle Polaire, whose belt, writes Yvette Guilbert, " might have served her for a collar," also sang at Les Ambassadeurs during the eighteen-nineties. Lautrec executed a coloured lithograph of her that was reproduced on the back cover of *Le Rire* for February 23, 1895. The pose, impudent and *gamine,* is characteristic of Polaire: her body is bent forward, the shoulders hunched, the arms, protruding from short puffed sleeves, are held stiffly at her sides; her feet, set far apart, are planted firmly, almost defiantly, on the stage. The caption is an amusing verse:

> " *Que de Paimpol à Sébastopol erre*
> *Le vieux monsieur, à l'air pot, pot l'air,*
> *Pourrait-il dégoter étoile plus—polaire?* "

Polaire, whose real name was Emilie Zouzé (or Zouzée), was born in Algeria in 1879. When she was scarcely more than a child she earned a precarious livelihood by singing in some of the least pretentious of the cafés-concerts of Paris. Though she had little beauty, her dramatic talent and her curious gypsylike verve soon made her a popular idol, not only in the music-halls but as a leading actress in numerous comedies. Lautrec lithographed her a second time in 1898 (D. 227).

Lautrec contributed seven illustrations to an article by Gustave Geffroy, *Le Plaisir à Paris: Les Restaurants et les Cafés-Concerts des Champs-Elysées,* published in *Le Figaro Illustré* for July 1893. Two of these were of Yvette Guilbert, then appearing at Les Ambassadeurs. One of the remaining five represents a man and woman standing in front of the entrance to the restaurant and watching the arrival of an open carriage, from which an elaborately gowned woman is alighting. Another is *La Roue,* a backstage view of a dancer executing a high kick, with her skirts swirling like a wheel over her head. A third is *M. Praince, Acteur de Café-Concert:* the entertainer, dressed as a beggar in a checked suit, holds out his ragged hat to the audience as he sings. The next portrays another well-known music-hall singer, Caudieux, a pot-bellied man in undershirt and trousers, putting on his make-up in front of a mirror in his dressing-room. Caudieux also figures in one of the lithographs of the album *Le Café Concert* (D. 35), as well as in a poster (D. 346) produced the same year. The last of this group of illustrations is *Aux Ambassadeurs: Gens Chic.* Seated at a small table are a woman (seen from the back) and a fair-haired young Englishman, the painter Charles Conder, whom Lautrec had painted the year before as an auxiliary figure in two pictures: *Jane Avril Sortant du Moulin Rouge* and *Les deux Valseuses.* At the extreme left of *Gens Chic* is Yvette Guilbert, very tiny and far off on the stage, but recognizable by her long black gloves.

Charles Edward Conder (1868–1909) is best known for his

paintings on fans, though his output comprises a great many drawings and pictures of larger dimensions. His work is delicate and pretty; some of it is obviously influenced by Beardsley, but in general it lacks Beardsley's strength. Born in London, Conder was taken as a baby to India, where his father had a position as an engineer. When he was five years old his mother died, and the boy was sent back to England alone. He remained at school in England until he was fifteen. He wanted to be a painter, but his father insisted on training him to follow his own profession of civil engineer; and at the age of seventeen Conder was sent to Sydney to join his uncle, a surveyor in the employ of the Government of New South Wales. Finding the practice of engineering extremely distasteful, he began to paint and managed to earn a meagre living by drawing small landscapes for the *Illustrated Sydney News* at a salary that never exceeded two pounds a week. He went to Melbourne, where he lived for two years and exhibited his pictures several times. In 1890 he returned to Europe. After three months in England he settled in Paris and remained there, or in some of the neighbouring towns, until 1894, when he went back to London for good. During his sojourn in Paris Conder studied for a short time at Julien's atelier, but he found the teaching too academic and soon drifted off to Montmartre. There he met Anquetin and Lautrec, into whose convivial circle he was immediately drawn. The friendship lasted for several years after Conder's return to England; whenever Lautrec made one of his frequent trips to London, the English painter was on hand to welcome him and conduct him to his favourite places of amusement.

YVETTE GUILBERT

I<small>N</small> *La Chanson de ma Vie* Yvette Guilbert writes that her first meeting with Lautrec occurred at a luncheon party in her own house in May or June 1895. But she is somewhat vague about dates, and there is good reason to believe that the encounter must have taken place the year before. The first of Lautrec's works in which Yvette appears is the poster *Le Divan Japonais* (Plate 13), executed in 1892. This was followed by *Aux Ambassadeurs: Gens Chic* and two other illustrations of the series of seven, already mentioned, for Gustave Geffroy's article in *Le Figaro Illustré* for July 1893. In the poster and *Gens Chic* Yvette is placed in a subordinate position, indicated without detail and completely overshadowed by the larger figures in the foreground; in the other illustrations she stands alone before the footlights, singing, in a low-cut green dress and the characteristic long black gloves. But all of these early likenesses might have been, and probably were, reproduced from casual notes or even from memory; they do not prove that Lautrec had actually been presented to Yvette at that time. There is almost conclusive evidence, however, that he did meet her several times in 1894. Joyant quotes a series of letters from Yvette to Lautrec in which the progression from the formal *Monsieur* to *Cher Monsieur* and finally to *Cher ami* presup-

194

poses a growing friendship. The first of these, apparently a reply to Lautrec's offer to do a poster for her, is dated July 1894:

" Monsieur,
" I shall be very happy to see your posters; I shall be at home Thursday at seven-thirty or, if you prefer, Saturday at two.
" Many thanks.

<div align="right">Yvette Guilbert "</div>

It is unlikely that Lautrec would have asked Yvette for an appointment and then neglected to keep it, so we may assume that he did visit her to submit a sketch of the proposed poster on one of the two days indicated. And in fact her next letter, which although undated must have been written very soon after the first, indicates that they had met in the interval:

" *Cher Monsieur,*
" I told you that my poster for this winter has been ordered already and is almost finished! Therefore, yours will have to be postponed. But for the love of Heaven don't make me so atrociously ugly! Just a little less! A great many people who have been here screamed like savages at the sight of the coloured sketch.
" Not everybody will look at it only from an artistic point of view — and there you are!!!
" A thousand thanks from your grateful

<div align="right">Yvette "</div>

It is not altogether surprising that Yvette Guilbert herself, as well as the people who " screamed like savages," failed to appreciate Lautrec's interpretation of her. The poster was never executed, but the large sketch (Plate 26) , now in the museum at Albi, is anything but flattering. The head with the pointed chin uptilted at the end of the long neck, the pursed mouth, the impudent nose, the straight pencilled eyebrows, is the head

of a clown; the arms and hands encased in long black gloves are held awkwardly, with the fingers stiffly outspread. Certainly this is no pretty picture. It goes much deeper: it presents in a few strokes of the brush the whole personality of the great *diseuse*. The touch of caricature that Lautrec introduced into this sketch, as into all of his representations of Yvette Guilbert, helped immeasurably to impress her individuality, her " silhouette " (as she calls it), on the public mind.

Another reason for the presumption that Lautrec and Yvette became acquainted in 1894, and not in 1895, is the publication in *Le Rire* for December 22, 1894 of a coloured drawing: *Yvette Guilbert dans " Linger, Longer, Loo! "* Yvette bends forward from the waist as she sings, her black-gloved hands clasped coquettishly beneath her chin. This is Lautrec's first contribution to *Le Rire;* and a note in the same issue states explicitly that Yvette sat in person for the sketch:

" As the readers of *Le Rire* will see with pleasure, M. H. de Toulouse-Lautrec gives us today his first drawing in colour.

" It is a striking portrait of Yvette Guilbert interpreting the celebrated English song *Linger, longer, loo!;* this portrait was executed in circumstances particularly flattering to our collaborator and to ourselves.

" The star was just about to leave for London. But when she learned that Toulouse-Lautrec wished to draw a picture of her for *Le Rire* she not only consented, but insisted on sitting for him and singing the charming air especially for him.

" Therefore, on the appearance of this historic portrait, we send across the sea our best wishes for the success of, and our thanks to, the splendid and unique artiste whom we admire with all our hearts."

Finally, Lautrec produced a magnificent series of sixteen lithographs of the singer (D. 79–95) for an *Album d'Yvette*

Guilbert, with text by Gustave Geffroy, published by André Marty in August or September 1894. The frontispiece is a sketch of a powder-puff and a pair of long black gloves — those gloves that Yvette adopted as a feature of her " silhouette " and that were as familiar to her audiences as her face and voice — flung carelessly onto some steps. The sixteen lithographs that follow depict Yvette in various characteristic poses and costumes; for the last of the series (D. 95) Lautrec made the preliminary study reproduced on Plate 27. Apparently Yvette did not see these lithographs until the book was published, and Joyant tells us that when she received a copy she was at first furiously angry. The frankness with which Lautrec had recorded and even exaggerated all that was grotesque in her features and her postures enraged her to such an extent that, egged on by her mother and her friends, she seriously considered an action for libel against the painter. Her wrath was not appeased until several articles praising the lithographs (as well as herself) appeared in various newspapers: among them one by Clemenceau in *La Justice* for September 15, 1894, one by Gaston Davenay in *Le Figaro,* and one by Arsène Alexandre. After that Yvette decided to accept Lautrec's interpretations without protest.

It is not easy, however, to reconcile this report of Yvette's displeasure with the very cordial letter to Lautrec (published by Joyant himself) in which she acknowledged the receipt of the book, unless we assume that the letter, which is dated merely " 1894," was written after the newspaper comments had brought about a change of heart:

" *Cher ami,*

" Thank you for your lovely drawings for the book by Geoffroy [*sic*]. I am delighted! delighted! and you have all my gratitude, believe me. Are you in Paris? If so, come to my new house, 79 avenue de Villiers, for lunch next week.

" Kind regards and again thanks.

<div align="right">Yvette "</div>

Whatever the date of Yvette Guilbert's first meeting with Lautrec, her account of it in *La Chanson de ma Vie* gives us a vivid impression of his startling appearance:

" It was in May or June 1895 that he came to lunch with me one day in the avenue de Villiers. He was accompanied by Maurice Donnay.

" My butler, after he had admitted the two men, came running to warn me with a frightened look on his face: ' Mademoiselle! oh! mademoiselle! Monsieur Donnay is here — with a funny little thing.'

" ' A funny little thing? What do you mean? '

" ' A little thing — a sort of Punchinello.'

" I went in to greet my guests and came to a dead stop in front of the ' little thing ' standing at Donnay's side.

" Imagine the enormous head of a Gnafron (from the Guignol of Lyons) stuck on top of the body of a tiny dwarf! A dark, huge head, with a very ruddy complexion, a black beard, a greasy, oily skin, a nose big enough for two faces, and a mouth! a mouth that cut across his face from cheek to cheek, like a great open wound. Flat, thick, flabby, purple lips surrounded this dreadful and obscene chasm. I was aghast, until I looked into Lautrec's eyes. How beautiful they were, how large, how wide, rich in colour, astonishingly brilliant and luminous!

" I looked at them for some time, and suddenly Lautrec, noticing my glance, took off his glasses. He was well aware that his eyes were his only attractive features and generously unveiled them for my inspection. His gesture allowed me to see his strange little dwarf's hands, perfectly square, attached to the extraordinary little arms of a marionette."

Here Yvette Guilbert's description is somewhat unreliable. Lautrec's photographs show his arms and hands to have been of normal size; there was nothing dwarfish or deformed about him except his stunted, undeveloped legs.

" Maurice Donnay said: ' You see — I have brought Lautrec to luncheon, he wants to make some drawings of you.'

" ' Good — I'll tell my mother to have another place laid.'

" I really wanted to give my mother some idea of the shock that awaited her when she should see Lautrec. And although she had been warned she stood speechless before the great artist, so upset that she shook hands with Donnay, bowed to Lautrec, and left the room without being able to utter a word of greeting. She was rigid with amazement.

" While we waited for luncheon we chatted, but I was pre-occupied by the problem of seating Lautrec at the table. Should I give him a little stool to help him climb onto his chair, cushions to raise him to the proper height?

" I was on pins and needles and decided to wait until the dwarf himself should give me a cue. To my astonishment he hopped onto his chair without help, placing the palms of his hands on the seat to give himself the necessary purchase before he jumped. Well! that was over! His body was in place! His little legs hung down without support, and though I felt that he was uncomfortable, since my chairs had no horizontal cross-bars, I dared not interfere. Donnay pushed Lautrec and his chair towards the table, and then I noticed that his chin was only eight inches above the cloth."

Though Yvette Guilbert obviously intends to suggest that Lautrec was a dwarf from the waist up, this last statement, if accurate, does in fact indicate precisely the opposite. Eight inches from table-top to chin is little less than the average distance; and it must be remembered that Lautrec would have been fairly short, though by no means a dwarf, even if his legs had grown to normal length.

" I shall never forget that lunch. The food disappeared into the abyss of his mouth, and every movement of his jaws displayed the moist and salivary working of his stupendous lips.

When the fish with a *sauce rémoulade* was served, there was an extraordinary smacking noise.

" But the man talked; that day his charming simplicity made us forget everything else. . . ."

Lautrec and Yvette saw each other frequently thereafter and became good friends. He did not hold it against her when she inadvertently wounded him with a thoughtless word:

" One day, as I was looking over some of the drawings he had made of me, I became annoyed because he had distorted me to such an extent and said: ' Really, you are the genius of deformity.' In a voice as sharp-edged as a knife he answered: ' But — naturally! ' I realized at once what a *gaffe* I had made and turned red with embarrassment."

The singer invited Lautrec and Gustave Geffroy to visit her in the modest country house, where she spent her summers, at Vaux on the Seine near Meulan, about thirty miles from Paris. According to Joyant (who does not, however, vouch for the truth of the story), all three went on the river in a row-boat: Geffroy and Lautrec wielded the oars while Yvette took charge of the tiller. And Lautrec said: " I've had the good fortune to be piloted by a star! "

Yvette Guilbert sometimes called Lautrec, playfully, " little monster." " I was never able," she writes, " to persuade Lautrec to give me a single drawing for which I had served as model. Many other artists presented me with examples of their works; Lautrec never. One day, nevertheless, he noticed a table made of turquoise-blue tiles which I had ordered in England and which was large enough to seat twelve people. Since he admired it I expressed a wish that he would make me a piece of pottery to be used as the top of a tea-table; he did not reply, but he brought me a caricature of myself to be signed, on which

I wrote: '*Petit monstre!! Mais vous avez fait une horreur!! Yvette Guilbert.*' A little later a tile made from the drawing arrived, with my comment and signature inscribed on it."

This tile was Lautrec's only venture into sculpture, if such it can be called. It was really no more than a drawing scratched into the flat surface of the clay — an amusing " stunt," but one that he was not tempted to try again. The plaque, about twenty inches high and eleven wide, was executed in 1895 and cast by Emile Muller at Ivry. Only a few examples were turned out. It represents the singer in a yellow dress and black gloves against a green background. With the exception of this decorative but unimportant piece of pottery, Lautrec's pictorial record of Yvette Guilbert, abundant as it is, consists almost exclusively of lithographs and drawings. She appears in one or two paintings and a poster, but only as an incidental figure.

* *

Yvette Guilbert was born in Paris on January 20, 1868. Her father, the son of a poor Norman farmer, was a wastrel who contributed less than nothing to the support of his family; until his death, in 1884, he was a constant source of worry and expense because of his passion for gambling. Fortunately for Yvette, her mother was a woman of strong character. Madame Guilbert had been brought up in comfortable, if not luxurious, surroundings, but her dowry was soon dissipated by her worthless husband, and she found herself obliged to earn a living for herself and her child by her needle. She had a flair for dressmaking, but the work was poorly paid. There were occasional short periods of comparative prosperity during which Yvette was sent to a good school; more often mother and daughter, working together from morning to night, could earn barely enough to pay for their frugal meals. At fifteen Yvette obtained employment as a mannequin in a dress-shop; but after a few months of constant standing and walking about, twelve hours a day, her health broke down and she was obliged

to stop. Her next job at the department store of Le Printemps ended in another illness; thereafter Yvette sewed at home and sold her millinery and lingerie for a pittance to small shops and a few private customers — who often forgot to pay their bills.

A chance meeting with Charles Zidler, then director of the Hippodrome (this was before the opening of the Moulin Rouge, in 1889) , changed the course of Yvette Guilbert's life. Zidler proposed to train the girl to be an equestrienne in his show, but Yvette, having no desire to risk her neck, rejected the offer. Nevertheless the suggestion turned her thoughts to the stage: she had a thin but pleasant voice and hoped that she might be able to obtain small parts in operettas or at the music-halls. A kindly dramatic critic, Edmond Stoullig, made it possible for her to take lessons in acting and singing, and after eight months of study she made her début at the Théâtre des Bouffes-du-Nord in *La Reine Margot,* a dramatization of the novel by Dumas. For the next few years Yvette played minor rôles in half a dozen theatres without achieving more than a very moderate success. But she had learned a great deal, not only about the stage but about herself. She realized that her voice would never be powerful enough for opera or even operetta, but it was quite adequate for the café-concert; and she knew that if a singer at cafés-concerts once succeeded in pleasing her public, she could be certain of much more rapid advancement and a much higher salary than she could hope for in the legitimate theatre.

In 1889, trembling but determined, Yvette Guilbert wheedled a contract out of the redoubtable Madame Allemand, directress of L'Eldorado; but as several weeks were to elapse before the beginning of her engagement she tried out her repertoire, in the interval, on a provincial audience at Lyons. The tour was a dismal failure; so was her début at L'Eldorado. The patrons of that resort, unaccustomed to her novel method of half singing, half reciting her lines, without gestures or pan-

tomime, listened in stony silence. The only audible comment came from the lips of a rival entertainer, Mademoiselle Bloch, an enormously fat star whose reputation as a comic singer was already well established: " Why, the girl's as skinny as two Englishwomen; how can she expect to make her audience laugh? " After the fiasco of the opening night Yvette was shifted to the least desirable place on the program. A month later Madame Allemand declared her hopeless and tore up the contract.

Her next engagement, at the Eden-Concert in the boulevard de Sébastopol, was more successful. Yvette had now added a number of new songs to her repertoire, including several by the poet Xanroff. She also established the characteristic " silhouette " of costume and make-up that emphasized and subtly exaggerated her distinctive features: red hair, white skin, round eyes, a long and comically uptilted nose, a large expressive mouth. She wore simple, tight-fitting, low-cut gowns that showed off her long flexible neck and girlish figure; the black gloves that she affected increased the apparent length of her thin arms. After two seasons at the Eden-Concert and a summer tour to Liége and Brussels, Yvette appeared at the Moulin Rouge and the Divan Japonais; she sang at the Moulin during the first part of each evening, then hurried to the Divan in her costume and make-up to present a different group of songs. Montmartre approved of this new star and applauded vigorously. Then followed more engagements in the heart of Paris: at the Concert-Parisien, La Bodinière, the Nouveau Cirque, La Scala (where she sang during the winter season for eight years), L'Horloge, and Les Ambassadeurs. Songs by Bruant, Richepin, Maurice Donnay, and a host of other contemporary poets enriched her programs; her dramatic instinct and her superb diction raised the standard of café-concert entertainment to a level it had never approached before. Wherever she appeared, Yvette Guilbert was acclaimed, fêted, and of course imitated.

Many of the most popular songs in her repertoire were de-

cidedly " naughty." Victorin Joncières writes in *Le Figaro Illustré* for June 1896:

" Yvette Guilbert, who shines today as the most brilliant star in the galaxy of the café-concert, has completely revolutionized the method of presenting songs. She understands the art of making obscenities palatable by uttering them with a nonchalant air. Her drawling monotonous voice adds to the illusion of innocence with which she delivers the most outrageous verses. . . ."

Arthur Byl, who supplied the text for a new set (D. 250–260) of lithographs of Yvette Guilbert executed by Lautrec and published in London in 1898, writes that her style " consisted in singing coldly, and without gestures, songs of a concentrated spiciness calculated to bring the blush to a monkey's cheek." She was, in fact, hailed as the greatest singer of *risqué* songs in the world; but this somewhat unsavoury renown did not altogether please her. After a severe illness in 1900 that kept her off the stage for more than a year, Yvette changed the character of her programs. Instead of the indecently comic songs of the nineties she now presented a rich selection of old French ballads culled from ancient books and manuscripts. She retained, however, many of Bruant's compositions — *A Saint-Lazare, A la Villette,* etc. — as well as a few other dramatic gems, including *La Glu* by Richepin. In what she calls her " second career " Yvette Guilbert has achieved a popularity even greater than that of her earlier days. Today, at the age of seventy, she remains without a rival in her field. The body that was once sneered at because it was " as thin as two Englishwomen " has now become matronly in its proportions; but her voice, her magnificent diction, her striking personality still have the power to hold her audiences spellbound.

THEATRE

LAUTREC was attracted to the theatre much less by the literary quality of the plays than by the acting, the portrayal of character, the gestures, the movement, the colour and splendour of the costumes, and the subtleties of make-up. He was interested too in the audiences: in their smart clothes, their contagious laughter and tears, in that indefinable air of excitement that a good theatrical performance never fails to evoke. In *Autour de Toulouse-Lautrec* Paul Leclercq writes:

" The red velvet of the stalls, the comfortable springs of the seats, the respectability of the ancient ushers in their bonnets, the slightly out-of-date but traditional way in which the actors presented their repertoire meant much more to him than the plays themselves, for which he cared very little.

" He loved the atmosphere of the theatre, its peculiar smell, the elegant manners of the ticket-takers, the broad aisles, the foyer, the green-room. . . ."

A large and very important part of Lautrec's output was devoted to various aspects of the theatre. Not including the numerous pictures of music-hall and café-concert subjects, at

least twenty paintings and a great many more lithographs and drawings bear witness to his love for this glittering world of make-believe. These works include scenes on the stage, in dressing-rooms and green-rooms, in the auditorium and foyer; designs for stage settings; lithographed programs; and an enormous quantity of portraits of actors and actresses. In addition to their distinction as works of art, their historical value is immense: they provide an unequalled record of the Parisian stage during the last decade of the nineteenth century.

Lautrec's first important theatrical painting, executed in 1889, is the portrait of Henry Samary of the Comédie-Française in the rôle of Raoul de Vaubert in a comedy by Jules Sandeau: *Mademoiselle de la Seiglière* (Plate 28.) The young actor (Samary was then twenty-five years old) is foppishly dressed in the fashion of the early nineteenth century: he wears a plum-coloured coat, black knee-breeches, silk stockings, and a frilled shirt with an enormous collar; one hand holds a silk hat, the other daintily lifts a monocle to his eye, while a supercilious smirk plays over his expressive features. In the background is a suggestion of painted scenery, broadly indicated.

The talented actress Marcelle Lender is the subject of a long series of lithographs and drawings. She first appears in 1893 in two lithographs: *Aux Variétés — Lender et Brasseur* (D. 41) and *Lender et Baron* (D. 43). In 1894 she is represented in a scene from *Madame Satan,* a play by Ernest Blum and Raoul Toché produced at the Théâtre des Variétés (D. 58). The following year Lautrec executed no less than eight lithographs of Lender (D. 102–109), including one in colour for the German magazine *Pan.* In 1896 he made her the central figure in one of his largest paintings: *Lender Dansant le Pas du Boléro dans Chilpéric* (Plate 29). *Chilpéric,* an operetta by Hervé (the author of *L'Œil Crevé* and numerous other works, who shared with Offenbach the distinction of being the most popular composer of light operas of his day), was revived at

206

the Théâtre des Variétés in February 1895 with a brilliant cast. In the scene portrayed by Lautrec, Marcelle Lender is dancing the bolero before the assembled court of King Chilpéric; on the stage are grouped the actors Lassouche, Vauthier, Brasseur, Baron, and Simon, the actress Amélie Diéterle, and several members of the chorus. The picture was the result of long and intensive study. Lautrec's notebooks are filled with sketches, made during the performances, of each of the individual figures; the final composition was painted in his studio from memory, aided by these notes. A lithograph of *Chilpéric,* representing Brasseur, on a white horse, about to make his entrance on the stage (D. 110) dates from 1895. Romain Coolus, writing in *L'Amour de l'Art* for April 1931, reports that Lautrec insisted on dragging him to *Chilpéric* some twenty times during the winter of 1895–1896:

"The lovely Marcelle Lender was playing an important rôle in it; she was dressed, or rather undressed, in such a way that not a single muscle of her back escaped the scrutiny of the levelled opera-glasses. When, after the sixth repetition, I grew a little weary of hearing the famous chorus . . . I asked Lautrec why he made a point of gorging me night after night with such obvious melody. 'I come only to see Lender's back,' he replied. 'Look at it carefully; you will seldom see anything so magnificent. Lender's back is splendid.' And indeed his works include a number of studies of Lender's back."

Lautrec also found material for his notebook at the dignified Comédie-Française. Here he was generally accompanied by his cousin Dr Gabriel Tapié de Céleyran; the two men, one so short and stocky, the other so tall and cadaverous, must have presented a startling picture as they stalked side by side down the aisle in formal evening clothes. Lautrec's impressions of the classic repertoire of the leading French theatre are recorded in six lithographs, all dated 1894: Réjane and Galipaux

in *Madame Sans-Gêne* (D. 52) ; Bartet and Mounet-Sully in *Antigone* (D. 53) ; Leloir and Moreno in *Les Femmes Savantes* (D. 54) ; *Brandès dans sa Loge* (D. 60) ; Brandès and Le Bargy in *Cabotins* (D. 61) ; and Brandès and Leloir, also in *Cabotins* (D. 62).

Theatrical subjects held Lautrec's attention for several years. In 1893 he made a lithograph of Sarah Bernhardt in *Phèdre* at the Théâtre de la Renaissance (D. 47) ; in 1894, Antoine in *L'Inquiétude* (D. 51) and Antoine with Gémier in *Une Faillite* (D. 63) at the Théâtre Libre, and Lugné-Poë with Berthe Bady in *Au-dessus des Forces Humaines* (D. 55) and in *L'Image* (D. 57) at the Théâtre de l'Œuvre; in 1895, *Yahne dans sa Loge* (D. 111), Yahne and Antoine in *L'Age Difficile* (D. 112), and Yahne with Mayer in the same play (D. 113), a comedy by Jules Lemaître, at the Gymnase. An important series of thirteen lithographed portraits of well-known actors and actresses also dates from 1895 (D. 150–162). Delteil is doubtful about the identity of three of the subjects, tentatively labelled Subra of the Opéra, Marcelle Lender, and Yvette Guilbert. The others are portraits of Sarah Bernhardt in *Cléopâtre,* Cléo de Mérode, Coquelin *aîné,* Jeanne Granier, Lucien Guitry, Jane Hading, Polin, Eva Lavallière, Emilienne d'Alençon, and Cassive. In 1898 Lautrec executed two more lithographs of Jane Hading (D. 262–263), two of Jeanne Granier (D. 264–265), one of Réjane (D. 266), a *Chanteuse Légère* (D. 269), and Guy and Mealy in *Paris qui Marche* (D. 270).

Although most of Lautrec's theatrical portraits were made with the lithographic crayon, there were a few paintings as well. A water-colour and two sketches in oil represent Lucien Guitry and Jeanne Granier in scenes from *Amants,* a play by Maurice Donnay produced at the Théâtre de la Renaissance in November 1895. In 1897 he painted a portrait of Berthe Bady, seated with one hand resting on the back of her chair, the other cupped under her chin.

Only a few of Lautrec's works are connected with the Opéra. In 1893 he produced a lithograph of Madame Caron in *Faust* (D. 49) ; the singer stands stiffly with her hands clasped, while a man in doublet, hose, and a black velvet cap bawls with wide-open mouth. The same opera figures again in a lithograph of 1896, *La Loge, Faust* (D. 166), which shows the interior of a box from which a man and woman in evening dress are watching the performance on the stage. For the back cover of *Le Rire* for February 8, 1896 Lautrec contributed *Les Grands Concerts de l'Opéra,* representing the aged composer Ambroise Thomas listening to a rehearsal of his opera *Françoise de Rimini.* The conductor on his little platform flourishes his baton as he leads the invisible orchestra; between him and the composer a man holds a sheet of music from which he sings his part; other members of the cast are sketchily indicated, while the foreground is filled by the enormous plumed hats of two women sitting in the front row of the stalls. Another theatrical illustration, *Baron dans Les Charbonniers,* appeared in *Le Rire* for January 30, 1897 with the following note:

" The newspapers announce that M. Baron, the celebrated actor, is about to leave the Théâtre des Variétés, where he has had so many brilliant successes."

Even the mechanical equipment of the stage provided Lautrec with the subject of a small picture, *Machinistes de l'Opéra,* painted in 1896. The glittering social functions, the masked balls that took place annually at the Opéra furnished additional material for his brush. The painting *Au Bal de l'Opéra,* in which the figures of the Prince de Sagan, Maurice Guibert, and Jane Avril are recognizable in the midst of the fashionable throng, served as one of the illustrations for Gustave Geffroy's article *Le Plaisir à Paris: Les Bals et le Carnaval* in *Le Figaro Illustré* for February 1894.

One of Lautrec's finest pictures of the theatre is *La Danseuse*

(Plate 30), painted in 1896. A girl in traditional ballet costume is posed gracefully against a background of painted scenery. The composition, though daring, is eminently successful: the figure is placed unsymmetrically, close to one edge of the tall narrow canvas, yet the picture is perfectly balanced. The subject recalls the numerous ballet paintings and pastels by Degas, but here the execution is much more robust. The short full skirt flaring out behind the dancer is brushed in with light bold strokes perfectly adapted to the gauzy, semi-transparent texture of the material, through which the green of the painted flats can be seen clearly.

The audiences that attended the theatre interested Lautrec almost as much as the players. In 1897 he painted *La Grande Loge,* showing a tier of four adjacent loges in diminishing perspective, each separated from its neighbours by low curved partitions upholstered in the customary red plush of the nineteenth-century playhouse. In the nearest loge are two women, both wearing hats; one has a program spread out before her, and a pair of opera-glasses rests on the little ledge behind the plush-covered parapet. The second and fourth loges are empty, while in the third sits Monsieur de Rothschild's coachman in solitary grandeur, wearing his immaculate evening clothes and glossy top hat with an air of comic dignity. This composition is repeated almost exactly in a coloured lithograph (D. 204) executed the same year. A lithograph in black and white, *La Petite Loge* (D. 209), is less interesting: here the partitions fill almost the entire space, and only the hats of the two occupants are visible.

Another coloured lithograph of 1897, *Idylle Princière* (D. 206), records one of the scandals in the world of fashion that upset the salons of the period. It represents the American heiress Clara Ward and her gypsy lover Rigo seated in a theatre box: Rigo has his back turned to the stage and gazes with soulful dark eyes at his beautiful and wealthy mistress. Clara Ward's career is summarized in a note by Delteil:

" This lithograph refers to the amours of Clara Ward, daughter of a Detroit millionaire, who married, at the age of eighteen, Prince de Caraman-Chimay; after six years of marriage she eloped with the gypsy Rigo, whom she married in 1904; she left him a little later and married first Peppino Ricciardo, then M. Cassaleta. Clara Ward died at Padua towards the end of December 1916 or the beginning of January 1917."

The theatre audience appears also in a lithograph of 1896, *Sortie de Théâtre* (D. 169), and in a drawing with the same title of 1898. The latter represents a lady and gentleman waiting for the *vestiaire* to hand them their coats after the performance.

Lautrec lithographed programs for nine theatrical productions. For the season of 1893 at the Théâtre Libre he contributed three programs in colour: *L'Argent,* a comedy in four acts by Emile Fabre (D. 15); a double bill comprising *Une Faillite* by Björnstjerne Björnson and *Le Poète et le Financier* by Maurice Vaucaire (D. 14); and *Le Missionnaire* by Marcel Luguet (D. 16). The program for *Le Missionnaire* is better known as *La Loge au Mascaron Doré;* it is another of Lautrec's impressions of the audience, representing Charles Conder and a woman seated in a gilded box decorated with an elaborately moulded grotesque mask in high relief. In 1894 he designed the program for a French adaptation by Victor Barrucand of the classic drama of ancient India, *Le Chariot de Terre Cuite* (D. 77). The double program for *Salomé* by Oscar Wilde and *Raphaël,* a comedy by Romain Coolus, presented at the Théâtre de l'Œuvre in February 1896, is embellished with lithographed portraits of the two authors (D. 195). For the season of 1896–1897 at the Comédie-Parisienne Lautrec illustrated the program of *La Lépreuse,* a play by Henry Bataille, with a lithograph of Berthe Bady in the leading rôle (D. 196). In 1897 he lithographed three programs: one for a benefit performance for Gémier at the Théâtre Antoine (D. 221); one

for a double bill at the same theatre comprising *Le Bien d'Autrui* by Emile Fabre and *Hors les Lois,* a one-act comedy by Louis Marsolleau and Arthur Byl (D. 220) ; and the third for a double bill at the Théâtre de l'Œuvre which included Ibsen's *Rosmersholm* and *Le Gage,* a play in one act by the Belgian architect Frantz Jourdain, whose portrait appears in the lithograph (D. 212).

Lautrec designed two projects for stage scenery, only one of which was actually executed. This was for the first act of *Le Chariot de Terre Cuite,* presented at the Théâtre de l'Œuvre in 1894. The Oriental background of the play is suggested by a huge clump of cactus and lotus flowers on one side of the stage and by the head, shoulders, and forelegs of a colossal elephant projecting from the wings on the other. In the distance the blue sky and sea of India meet at the horizon. The second project, a setting for a revival of *Paul et Virginie* at Bordeaux in 1896, never progressed beyond the preliminary stage of a water-colour sketch. The scene represents the wreck of the brig *Saint-Géran* on the jagged reefs of an island: the ship is seen in the distance surrounded by a wild mountainous landscape. Neither of these attempts to design scenery was conspicuously successful. Lautrec was too much a painter, and particularly a figure painter, to be at home in the three-dimensional structure of the stage.

A less ambitious but much happier contribution to the scenery of the theatre was his painting of *Lady Capulet,* used as an accessory in the pantomime *Amants Eternels* by Corneau and Gerbault, which was set to the music of André Messager and presented by Antoine at the Théâtre Libre in 1893. The pantomime, in three scenes, was a parody of Gounod's opera *Roméo et Juliette;* and Lautrec's absurd caricature of the family portrait of *la mère* Capulet struck exactly the right note for this gay bit of nonsense. Lady Capulet is represented as a buxom wench with golden hair, simpering red lips, and enormous languorous blue eyes; she is dressed in green and wears

a chaplet of pearls on the very top of her head; one hand is lifted to her breast in an affected pose. The picture is painted in broad flat tones like a poster, with a minimum of detail. What appears to be a beauty-patch below the raspberry lips is really a small hole drilled by a bullet: Antoine, the director of the theatre, amused himself occasionally by shooting at the effigy of Juliet's mother with a pistol.

Lautrec's love for the theatre remained with him to the end, even after the disastrous breakdown of 1899. Towards the close of that year he produced his last poster, for which as usual he made several preliminary sketches; it announced the appearance of the actress Marthe Mellot in the principal rôle of *La Gitane,* a play by Jean Richepin presented at the Théâtre Antoine on January 22, 1900. The opening was inauspicious, though Lautrec obstinately insisted that it was a brilliant hit. Joyant reports that after the dress rehearsal Lautrec proclaimed: " Tremendous success, *La Gitane,* an unheard-of success! " Most of those present disagreed with this verdict: " A success! Why, it's a complete failure, it was actually hissed." " That may be," retorted Lautrec, " but the hissers were just ill-natured." Joyant adds that Lautrec's opinion of the play was of slight value because he had, in fact, heard not a single word of it. During the entire performance he had sat on a high stool in the bar, drinking copiously with one of the employees of the theatre.

In June 1900 a chance meeting with Lucien Guitry at Honfleur prompted Lautrec to design his last theatre program, to be used for Guitry's revival of *L'Assommoir,* a dramatization of Zola's famous novel. Lautrec's drawing represents the interior of a bar with the character Coupeau, his wife and baby, and another drinker. The drawing was probably made at Le Crotoy, since the models, according to Joyant, were all inhabitants of that town: the family of the innkeeper Cléry, and a sailor. The play was produced in November 1900 at the Théâtre de la Renaissance.

Lautrec spent his last winter, the winter of 1900–1901, at Bordeaux. Here he went regularly to the theatre. Two productions in particular appealed to him as subjects for drawings and paintings: Offenbach's operetta *La Belle Hélène* and an opera by Isidore de Lara, *Messaline*. He was already familiar with *La Belle Hélène:* in 1895 he had executed a lithograph of Brasseur, Guy, and Madame Simon-Girard in a scene from that work (D. 114). Now, at Bordeaux, he made three admirable pencil sketches and a water-colour of the plump Mademoiselle Cocyte in the rôle of Helen of Troy, as well as a sketch of the chorus of Greek warriors in armour and plumed helmets.

The opera *Messaline* inspired six paintings and at least two drawings. One of the paintings represents a group of members of the chorus; the rest are all of scenes in which Messalina herself, played by Mademoiselle Ganne, figures prominently. In one of these (Plate 31) the empress, in a red robe, sweeps majestically down a great flight of steps past the chorus of court attendants; in the foreground stand two Romans in armour. The *Messaline* pictures are painted in a somewhat thicker medium than most of Lautrec's works. The canvas is completely covered, with no bare spots showing through, and the general smoothness and solidity of the surface indicate that Lautrec's technique was undergoing a definite change shortly before his death. The fluid, semi-transparent brush-strokes of his earlier years are replaced here by flatter, unbroken masses of colour. Whether this variation was merely an experiment or whether it implied a genuine transition to a new phase of his painting can only be surmised; but it is at least probable that Lautrec was on the threshold of a stylistic transformation when death put a premature end to his career.

CIRCUS

Lautrec never outgrew his childlike delight in the circus. He was introduced to the world of acrobats and clowns, jugglers and trained animals at an early age by his friend René Princeteau; and throughout his life he missed no opportunity to visit and revisit these enchanting spectacles. Of the many circuses then flourishing in Paris, two were his favourites: the Cirque Fernando (after 1898 known as the Cirque Medrano, which still exists) at 63 boulevard de Rochechouart; and the Nouveau Cirque, smarter and more pretentious, at 251 rue Saint-Honoré. The Cirque Fernando was housed originally in a wooden building; when it was taken over by the new owner, Medrano, it was rebuilt in stone. Less often Lautrec attended performances at the Cirque d'Hiver, directed by Franconi, and the Cirque Molier.

The earliest and perhaps the most important of all of Lautrec's circus pictures is the large canvas *Au Cirque Fernando: l'Ecuyère,* painted in 1888 (Plate 32), which hung for some years in the foyer of the Moulin Rouge. In the background is the curved parapet separating the ring from the rising tiers of seats, from which a few scattered spectators are watching the evolutions of a white horse as it canters slowly round the arena.

215

bearing on its broad back a smirking equestrienne in gauze and spangles. At the left of the picture the ringmaster cracks his long whip; his sleek head with the heavy jowl, hooked nose, and sharply receding forehead is more like the head of some evil beast than that of a man. Behind him a clown sits on a high stool, while another clown, with exaggeratedly flat feet and a comic top-knot, is engaged in some drollery at the extreme edge of the canvas. During the course of the same year Lautrec executed four other paintings of the Cirque Fernando — two of equestrian performances and two of clowns — and a charcoal drawing of a woman on a trapeze.

The Cirque Fernando is represented again in two pictures of a trapeze acrobat, painted in 1890, and in another of 1893. A small but very animated painting also dates from 1893: it depicts a clown in striped stockings, absurdly wide-bottomed trousers, a ruff, and a three-pointed cap, skipping rope with a small black pig; in the background another clown is haranguing the audience.

The Nouveau Cirque first appears in Lautrec's work in 1891 in a picture entitled *Au Nouveau Cirque: la Clownesse aux Cinq Plastrons*. It represents a woman, seen from the back, seated in a box; five clowns in a row, exactly alike, with white faces and ridiculous little hats, are staring at her from across the ring. Most of his interpretations of the Nouveau Cirque, however, were devoted to the two famous clowns Footit (or Footitt) and Chocolat. This extraordinary pair of comedians worked together for several years. In *Le Cirque et les Forains* Henry Frichet writes of Georges Footit:

" The son of the manager of a circus, he made his début as a performer on the tightrope at the age of twelve; later he became an expert on the parallel bars, then one of the glories of the flying trapeze, and after that a skilled equestrian. . . .

" Of slightly less than average height, stocky, with the neck of a bull, Footit nevertheless appears thin. His face is bony, as

if carved with a chisel, with a very deep furrow between the eyebrows; his eyes are merry, his mouth always disdainful; his features are full of contrast, passionate and stubborn. . . ."

The other member of the team is described as follows:

" A name almost inevitably associated with Footit is that of Chocolat, his partner, the Negro clown, discovered at Bilbao by Tony Grice [another celebrated clown of the day] and trained by him.

" Chocolat's talents as an acrobat are not without interest; he even has a special trick of his own, the monkey jump. As to his humour, well, that's another matter; in the ring he never says a word, but contents himself with expressing in panto-mime every variation of inanity, bewilderment, or malice for which there is room in the head of a Negro who has never been able to learn to read. . . ."

Lautrec contributed five drawings of Footit in various ludi-crous costumes and poses to illustrate a humorous article by Romain Coolus, *Théorie de Footitt* [*sic*] *sur le Rapt,* published in *Le Rire* for January 26, 1895. In some of these Chocolat also appears. In addition he produced two lithographs in 1894: *Footit et le Chien Savant* (D. 97) and *Footit et Chocolat* (D. 98). The latter was published in *Nib,* a supplement of *La Revue Blanche,* in January 1895. Another circus lithograph, *Clown et Clownesse après le Spectacle,* dates from 1899 (D. 324).

In November 1892 Donval, the director of the Nouveau Cirque, presented a sumptuous Japanese ballet called *Papa Chrysanthème.* For this spectacle the central section of the arena was flooded with water and turned into a small lake, on the surface of which floated masses of artificial water-lilies and other aquatic plants. Round this pool nymphs in diaphanous draperies postured and danced in a swirl of coloured lights.

Lautrec made two paintings of this scene, one of which was afterwards put to curious use. In 1895 he designed from it a cartoon for a window of stained glass, his only venture into the field of household decoration. The window was executed by Tiffany and shown at an exhibition of the Société Nationale des Beaux-Arts in April of that year. In the same exhibition were windows by several of Lautrec's contemporaries, including Besnard, Roussel, Vuillard, Bonnard, Ibels, Vallotton, Sérusier, and Maurice Denis. The vogue for Tiffany glass was then at its height, and the critics were almost unanimous in their enthusiastic praise. An article by Jacques-Emile Blanche in *La Revue Blanche* for May 15, 1895 is typical of these comments:

" M. Tiffany of New York carries off the prize of the exhibition. His offerings are numerous and exceedingly varied. . . . The American artist should be especially proud of his windows and of having confided the designing of the cartoons to French painters. . . . The most striking of these productions is perhaps that of M. de Lautrec [*sic*], who has composed, out of a circus scene and a woman's hat, the most beautiful and the most modern decorative scheme."

But the most remarkable of all of Lautrec's works on circus themes are undoubtedly the forty-odd drawings in coloured crayon, pencil, sanguine, pastel, and Chinese ink, executed during his internment in an asylum for mental patients after his collapse in 1899. They are extraordinary for two reasons: because they were produced by a man who was supposed to be desperately ill and who was certainly suffering from the effects of over-indulgence in alcohol to such an extent that he had to be forcibly restrained; and because they were done entirely from memory, unaided by either models or notes. Some of the memories were of scenes observed more than ten years before; yet even now, when his sanity was despaired of and his very life

was in danger, Lautrec's impressions were so vivid, his recollection of movements and postures and facial expressions so precise, his technical mastery so astounding, that he was able to reconstruct this long and exceedingly varied series of circus events with complete accuracy, down to the last detail.

Nine of the circus drawings appeared in *Le Figaro Illustré* for April 1902, after Lautrec's death, to illustrate an article by Arsène Alexandre. Twenty-two others were reproduced in an album entitled *Toulouse-Lautrec: au Cirque,* with a preface by Alexandre, published by Manzi, Joyant et Cie in 1905. The first group of nine drawings comprises four equestrian scenes, two pictures of female clowns, one of the Negro Chocolat, one of acrobats, and one of the Japanese ballet *Papa Chrysanthème,* which Lautrec had seen at the Nouveau Cirque seven years earlier. Of the twenty-two drawings included in the album ten are of equestrian subjects, four of clowns (among them two of Footit), four of trained animals (horses, monkeys, elephants, and a bear named Caviar), three of acrobats performing on the trapeze and the tightrope, and one of the grand ceremonial entrance of the troupe into the ring. A supplementary series of seventeen drawings was published by the Librairie de France in 1933.

Two of the drawings from the Manzi, Joyant album are reproduced here. *Le Pas de Deux* (Plate 34) represents an acrobat standing erect on the backs of two horses and holding his partner — a woman — in a horizontal position, with her feet braced against his flank. *Ecuyère de Panneau* (Plate 35) shows a dainty equestrienne — who, according to Joyant, is really a man in the costume of a ballerina — blowing a kiss to the clown Footit as she (or he) rides round the arena. Arsène Alexandre writes in the foreword to this album:

" The circus scenes presented here are among his [Lautrec's] most extraordinary works, executed altogether from memory, without documentation, without preliminary sketches, with-

out notes, references, or models of any kind; they are a real miracle of plastic intelligence, one of those achievements that many artists, unable to reach such heights themselves, would label 'mad.' Composition, the characterization of various types, humour, breadth of execution, everything that entered into Lautrec's talent, are all found or rather refound in these drawings, in which certain exaggerations in proportion only confirm the sincerity and intention of this venture, the triumph of this memory, the soundness of this painter's faculties. The drawings of a madman? They are the drawings of a madman indeed, but only in the sense in which Hokusai used the term when he called himself ' the old man mad about drawing.' "

Considering the difficult conditions in which these works were executed, they are an astonishing tribute to Lautrec's courage, his mental vigour, and his amazing ability to summon at will the most minute details from the depths of his memory. Yet they are, on the whole, a magnificent *tour de force* rather than an intrinsically important contribution to the sum total of his production. In spite of the beauty of many of the compositions and the anatomical accuracy of the drawing, there is little life in them. For one thing, they are too slick, too highly finished: the technique, quite unlike that of the rest of Lautrec's work, suggests the academy. Compared to such free and vital pictures as *L'Ecuyère* of 1888 (Plate 32) and the painting of the clown skipping rope with the pig, of 1893, these later drawings are static, uninspired. Their lifelessness is easily accounted for: it is probably due in part to the very fact that Lautrec made these drawings only from memory, without the stimulus of fresh models and direct observation; in part to the inevitable lassitude, mental and physical, that followed his breakdown — a lassitude that he was never again to throw off completely.

SPORT

THE LOVE of animals and the passionate interest in outdoor sports that characterized Lautrec's childhood remained with him throughout his life, but as subjects for paintings, drawings, and lithographs they were important only at the beginning and the end. His early sketch-books, some of which are dated 1873 — when he was only nine years old — are filled from cover to cover with studies of animals: horses, dogs, birds, and the oxen that drew the farm carts at Céleyran and Le Bosc. His father's enthusiasm for the chase naturally influenced Lautrec's choice of models: hunting horses, sporting dogs, falcons, are to be found by the dozen in these albums. The drawings of the mare Cocotte intended for the illustration of the story by young Etienne Devismes in 1881 have already been discussed, as have the sketches of boats produced by Lautrec during his convalescence at Nice. When he began to paint, at the age of fifteen, pictures of animals and boats made up the greater part of his output; and during the years of his apprenticeship to Princeteau animals — especially horses — continued to be his favourite subjects. But after 1882, when he settled in Paris and painted, first at Bonnat's and Cormon's studios and then independently, his pictures of animals became much rarer.

221

For more than a decade the more exciting, if less healthful, aspects of city life obsessed him: the dance-halls and cabarets of Montmartre, the cafés-concerts and theatres, the houses of prostitution, the world of wine, women, and song. It was not until 1895 that animal and sporting subjects again began to occupy a prominent place in his production. Thenceforth, until the end — less than seven years — Lautrec devoted a large proportion of his time to the portrayal of horses, dogs, and various forms of sport.

Many of his early pictures of animals are remarkable, not only for their fidelity to nature but for the extraordinary skill with which the young painter has succeeded in representing rapid and often complex movement. Noteworthy among these are a fine water-colour, *Nice: sur la Promenade des Anglais,* executed in 1879, when Lautrec was only fifteen. The spirited prancing of the black horses driven by a young woman in a little open carriage, with a liveried footman perched behind, is admirably rendered, and the whole picture is full of exuberant vitality. The same liveliness is apparent in such youthful paintings as the *Artilleur Sellant son Cheval,* also of 1879, and the *Mail Coach, Nice,* the *Cheval en Difficulté avec son Lad,* and the picture of a Gordon setter, *Dun,* all of 1881.

Between 1882 and 1895 Lautrec made only a few studies of animals, except those connected with the circus: a pencil drawing entitled *Gentleman Rider* (1888) ; *Cavaliers se Rendant au Bois de Boulogne,* one of four illustrations for an article by Emile Michelet, *L'Eté à Paris,* published in *Paris-Illustré* for July 7, 1888; a picture of the bitch *Follette* (1888) and one of the cocker spaniel *Tommy* (1890) ; a drawing of the Duc de Nemours on horseback (1894) ; and one or two other sketches of horses and dogs. In 1898 he produced a lithograph, *L'Amateur de Chevaux* (D. 234) , of a Monsieur Aclocque, an enthusiastic connoisseur of horseflesh, watching the spirited capers of a horse in the Bois de Boulogne. Another lithograph of the same year is labelled by Delteil *Le Vieux Cheval* (D. 224) ; but

according to Joyant the subject is the pony Philidor, a gentle beast frequently driven by Lautrec through the Bois, attached to a dog-cart. " Unfortunately," adds Joyant, " the drive was only an excuse to stop and drink at every café in the Bois." In 1899 Lautrec executed three or four more lithographs of horses, including *L'Amazone et le Chien* (D. 285), which represents a woman mounted on a horse; she is trying, with superb but comic dignity, to ignore the yapping little terrier that squats impertinently in the middle of the path.

Lautrec was a regular attendant at sporting exhibitions and competitions of all kinds. Coquiot tells us that he frequently accompanied Lautrec to wrestling matches at the Folies-Bergère, and that the painter sometimes sketched the struggling giants with their massive shoulders and over-developed muscles. Few of these drawings seem to have survived, although the subject of one dry-point engraving — a pornographic one — may, according to Delteil, be a wrestler named Ville (D. 7). Lautrec also went to boxing matches, but a single page of sketches of boxers in action is the only existing evidence of his fondness for the ring.

Another sport which Lautrec enjoyed hugely — as a spectator — but of which no pictorial record remains, was the bull-fight. In 1889 a large and completely equipped arena was inaugurated in the rue Pergolèse, near the avenue de la Grande-Armée. Some of the best Spanish fighters were imported to demonstrate their skill before the Parisian audiences, and for a time the *corridas* enjoyed an immense vogue. *Le Chat Noir* published an enthusiastic notice in its issue of August 31, 1889:

" The directors of the *Gran Plaza de Toros* of the Bois de Boulogne continue to attract a numerous and select public. Last week the star performer was Lagartys, this week we have Angel Pastor and Valentin Martin. In short, the best *spadas* [*sic* — for *espadas,* the men who kill the bulls with their swords]

of Iberia. The *apartado* (selection of the bulls) brings together all of the leaders of the sporting world on the morning of each performance. The *caballeros en plaza* and the splendid procession at the beginning, and the presentation of the *cuadrillas,* would be enough in themselves to ensure the attendance of all Paris."

In his biography of Lautrec, Théodore Duret writes:

" The bull-fights in the rue Pergolèse were an attraction to artists because of their picturesque and spectacular features. Many painters, including Anquetin, Grenier, Giran-Max, Caran d'Ache, Lautrec, and Molinard, went to see them. Lautrec, with his fondness for all kinds of shows, was among the most assiduous attendants. In conformity with his custom of sketching whatever interested him, he devoted a number of studies and pictures to the *toreadors* and bulls, both in actual combat and at other moments during the *corrida.*

" He became acquainted with the director of the *Plaza,* Fayot, a Frenchman; with Maria Gentis, a French equestrienne who, in Spanish costume, took part in the bull-fights as a *picador;* with several of the Spanish *toreadors* themselves: Angel Pastor, Currito, Manene (whose real name was Manuel Martinez and who was eventually killed by a bull) ; and with Agujetas, a famous *picador.* Of most of these people he made portraits, which he gave to them."

If, as Duret claims, Lautrec did paint or draw portraits of bull-fighters, the persons to whom he gave them must have thrown them away or else secreted them so carefully that they could never be found. Joyant lists no such pictures in his catalogue of Lautrec's works, nor have any sketches that might have served as preliminary studies for them been discovered in the painter's notebooks.

In spite of its success in sporting and artistic circles, the

introduction of bull-fighting into the heart of Paris was not welcomed by the French authorities. In 1892 the exotic entertainments were forbidden, and the arena, erected at great expense only three years before, was demolished.

The fashionable skating-rink in the Champs-Elysées, the Palais de Glace, provided another subject for Lautrec's pencil. In 1895 he made three drawings there, one of which was reproduced on the back cover of *Le Rire* for January 11, 1896 with the caption: *Skating — Professional Beauty.* The professional beauty, Mademoiselle Liane de Lancy, is far more in evidence than the skating; the only skaters are one man and one woman, very much in the background, skimming towards each other over the ice. The " beauty," wearing a feathered hat which, seen in profile, takes on the shape of a swan, is standing on the ice (presumably on skates, but her feet are hidden by the barrier that separates the rink from the *promenoir*) ; she is conversing — or flirting — with a bearded gentleman in top hat and monocle, the same Edouard Dujardin who appears in the poster *Le Divan Japonais,* sitting behind Jane Avril (Plate 13). The skating-rink is also the subject of a lithograph, *Au Palais de Glace* (D. 190), made in 1896.

The boats that Lautrec had loved as a boy never lost their fascination for him. He spent part of almost every summer at some small seaside resort on the bay of Arcachon near Bordeaux or, less often, on the estuary of the Somme. Pictures of boats do not figure prominently in his work after 1881, but those that do exist prove his familiarity with every detail of the construction and rigging of small vessels. He was expert in the handling of the little sailboat in which he loved to cruise about the lagoon of Arcachon. Once he succeeded in winning a yacht-race. The event is recorded in a letter from Lautrec's father to Maurice Joyant, written after the painter's death:

" One might add to the pen portrait of poor Henri, your dear friend, something about his enjoyment of the sports, such

as rowing and sailing, that he practised on the little inland sea of Arcachon. One day, in a regatta, he had to act as substitute for the commodore who owned one of the yachts, a M. Damrémont, the son of a well-known general, I think; the crew, well trained, though not of course by him [Lautrec], won the cup under his command."

It was at Arcachon too that Lautrec was able to indulge in two other favourite sports, swimming and fishing. Swimming was the only vigorous outdoor exercise in which he could take an active part. His crippled legs were too feeble to permit him to swim quickly or for long periods at a time, but he could splash about very happily in the warm still waters of the lagoon. Most of his fishing exploits were carried out with the aid of a pet cormorant named Tom, which had been trained to scoop up fish in its powerful bill and bring them back to its master. Lautrec was heart-broken when the cormorant was accidentally shot and killed by a careless sportsman.

Closely related to his fondness for horses was his interest in horse-drawn vehicles and in the harness and other trappings pertaining to them. The production of his early years abounds in sketches and paintings of the victorias, mail coaches, dog-carts, and similar equipages that were driven up and down the promenade des Anglais at Nice. Towards the end of his life carriages reappear in such lithographs as *Attelage en Tandem* (D. 218) and *Partie de Campagne* (D. 219), both of 1897, and *Tilbury* (D. 286) of 1899. Carriages were important in Lautrec's existence; since his legs were too weak to carry him far, and since he had plenty of money to spend on cab fares, most of his rambles about Paris were accomplished in hired fiacres. Leclercq tells us that as soon as Lautrec left his lodgings he would hail a passing cab by holding up his little cane — which he called his " buttonhook " — and hoist himself onto the seat. If the coachman drove badly or if the pace was either too slow or too fast to please him, he would rage and

curse, banging on the window or popping his head out of the door like a jack-in-the-box. Sometimes, after a long night of drinking and carousing, he would fall asleep in the carriage; if the driver indiscreetly tried to wake him when the vehicle stopped before his door, the little man would tell him, with a stream of oaths, to mind his own business. After which he would curl up on the cushions and go to sleep again until it suited his convenience to get out and retire to bed.

One of Lautrec's acquaintances was Edmond Calmèse, the proprietor of a livery stable in the rue Fontaine. Here there were carriages and coaches of all kinds, to be hired by the day or by the month; and Lautrec loved to wander about, admiring the curved polished surfaces of the vehicles, the colours of the upholstery, the gleaming metal of the trimmings, while he sniffed with evident enjoyment the odours of varnish and leather. In 1899 he lithographed a portrait of Calmèse (D. 291) and a study of one of his horses, *Le Petit Poney de Calmèse* (D. 287).

Towards the end of his life the first motor-cars began to appear in Paris, unwieldy little contraptions that trundled jerkily through the streets with prodigious grindings and chuggings and frequent breakdowns. In 1896 he produced a lithograph, *L'Automobiliste* (D. 203), in which Dr Gabriel Tapié de Céleyran, wearing a visored cap, goggles, and a voluminous fur coat, is seen perched on the high seat of one of these primitive horseless carriages.

But the sports to which Lautrec devoted the greatest number of paintings, drawings, and lithographs were the bicycle-races at the Vélodrome Buffalo and the horse-races held at Auteuil, Longchamps, and other tracks on the outskirts of Paris. In his boyhood he had frequently attended horse-races and had sketched thoroughbreds and jockeys with enthusiasm and considerable skill. Then, for some years, his interest languished; but it revived about 1895 and persisted to the end of his life. Of his four illustrations for the story *Le Bon Jockey* by Romain

Coolus, published in *Le Figaro Illustré* for July 1895, two —
those whose setting is the Irish and American Bar in the rue
Royale — have already been mentioned. The other two rep-
resent racecourse scenes. In the first a horse with a jockey in
the saddle is being led by a groom; in the distance can be seen
the paddock and grandstand. The second portrays a racehorse
covered by a blanket, following a groom and two men carry-
ing an empty stretcher. A fine portrait of a young English
groom in a bowler hat, *Tête de Lad d'Ecurie de Courses* (Plate
36), also dates from 1895. The next year produced a race-
course lithograph, *L'Entraîneur* (D. 172). In 1899, the year
of his breakdown, Lautrec commenced a series of lithographs
of racing subjects for the editor Pierrefort, but finished only
four (D. 279–282) : *Le Jockey* (Plate 56), *Le Paddock, L'En-
traîneur et son Jockey,* and *Le Jockey se Rendant au Poteau.*
These and a small picture, *Aux Courses,* painted the same year,
are his last works connected with the training and racing of
horses.

Lautrec's interest in cycling dates from 1895. At that time
bicycles were all the rage: they could not be turned out fast
enough to meet the demand. Races were frequent and well
attended; the rivalry between the champion cyclists, as well as
between the manufacturers of different makes of machines and
appliances, was intense. The most popular races were those
held at the Vélodrome Buffalo at Neuilly, between the porte
de Champerret and the porte des Ternes, and at the Vélo-
drome de la Seine. At both of these the Director of Sports was
Tristan Bernard, whom Lautrec had known a few years earlier
as one of the editors of *La Revue Blanche.* Tristan Bernard
was born at Besançon in 1864; he was therefore exactly the
same age as Lautrec. He was (and still is) a man of extraordi-
nary versatility: a distinguished journalist, author, and play-
wright as well as a noted sportsman. Bernard and Lautrec had
many traits in common: quick wits, a fondness for epigrams
and *blague,* a passionate devotion to sports, a cultivated taste

for food and drink. In *L'Amour de l'Art* for April 1931 Bernard writes:

"Lautrec was an enthusiastic habitué of the Vélodrome. He used to call for me every Sunday, we would lunch together and go to the Vélodrome de la Seine or the Buffalo. I let him enter the private enclosure with the officials. But usually he would wander away from them and sit on the grass by himself.

"I think the results of the races interested him very little, but he adored the setting and the people."

In 1895 Lautrec painted a picture of *Tristan Bernard au Vélodrome Buffalo* (Plate 37) : the director, stout and stocky, with a bushy black beard, is planted solidly on his feet in the middle of the empty racetrack, gazing across the lawn towards the distant grandstand; he wears a tweed jacket, knickerbockers, and a flat bowler hat tipped rakishly over his eyes. The bearded sportsman appears again in a delicate dry-point, this time of the head in profile, executed in 1898 (D. 9) .

Lautrec knew all of the most celebrated professional cyclists who raced in Paris: Arthur Zimmerman, little Jimmy Michael, the manager "Choppy" Warburton, Barden, Fournier, and others. Many of them, as their names indicate, were Englishmen or Americans. Several drawings and lithographs represent these stars on their bicycles or standing about in groups between the races; among them are *Zimmerman et sa Machine* (D. 145), *Au Vélodrome: W. S. Simpson et le Petit Michael* (D. 146), and *Au Vélodrome* (D. 147), all of 1895; and *Bicyclistes* (D. 267) of 1898. He was deeply impressed by the rigorous system of training that kept the cyclists in condition and did his best to persuade some of his friends, without much success, to submit to a similar routine. For himself, of course, such strenuous exercise was out of the question. He might have adopted, with great benefit to his constitution, some of the restrictions of the training-table in the matter of food and

particularly of alcohol; unfortunately he made no attempt to follow his own precepts, but contented himself with recommending them to others.

Not all of the best racing cyclists were professionals. One of the most famous was an amateur, Louis Bouglé, who raced under the pseudonym of " Spoke." Bouglé was a cultivated, methodical business man with a passion for sports; he affected English clothes and English manners and always took great care to keep up with the latest London fashions. As manager of a company that manufactured the Simpson bicycle chain, Bouglé organized races, both in Paris and in London, for the purpose of demonstrating the superiority of the appliances supplied by his firm. Once he transported most of the stars of the Vélodrome Buffalo, with their trainers, mechanics, bicycles, and paraphernalia, to England for a series of competitions. Joyant tells us that Lautrec, as a privileged character, accompanied the expedition and travelled about with it, equipped with nothing but a pencil, a notebook, and a little hold-all made of yellow canvas. In 1896 Bouglé commissioned Lautrec to design a poster to advertise the Simpson chain (D. 360). But the painter had to make two attempts at it before his drawing was accepted: in the first sketch he had made a mistake and placed the pedals slightly askew.

Bouglé himself was the model for several portraits: two drawings in 1896, another in 1898, and two paintings, also dated 1898. In one of the paintings Bouglé is in cycling costume, seated on a low wall or parapet; in the other he is attired in faultless frock-coat, grey trousers, double-breasted waistcoat, a stiff white shirt with a standing collar, and a top hat.

HOSPITAL

" IF I were not a painter," Lautrec is reported to have said to his friends, " I should like to be a doctor or a surgeon." The words cannot be taken too literally, but it is not difficult to understand his interest in certain aspects of medical — and more particularly of surgical — practice. For Lautrec was a master craftsman as well as a creative artist, a craftsman who could appreciate and rejoice in exhibitions of skill of every kind. The perfect balance and rhythm of an acrobat on the trapeze or the tightrope, the nimbleness of the juggler, the grace of a dancer executing a pirouette, the poise of a jockey perched on the neck of a racehorse, the control of a cyclist speeding round and round the track — such examples of mental and muscular co-ordination filled him with joy. Though he was himself incapable of attempting any of these exploits, his own expert manipulations of the brush, the pencil, and the lithographic crayon were not, in some respects, unlike the performances of trained athletes. Both required very much the same kind of delicate adjustment between nerve centres and muscles, a similar precise and instantaneous response to mental impulses. And since this co-ordination, this skill, this muscular deftness and perfect control are manifested

to a supreme degree in scientific surgery, it is natural that Lautrec should have been fascinated by the technique of an operation in which a false move or a clumsy gesture might easily have proved fatal.

Moreover, several doctors and surgeons were his personal friends, among them the Dr Bourges, with whom he lived in the rue Fontaine from 1887 to 1893. In 1891 he painted a full-length portrait of Dr Bourges in an overcoat and top hat, buttoning his glove. Even closer to Lautrec was Dr Gabriel Tapié de Céleyran, for many years his inseparable companion. Gabriel Tapié de Céleyran and Lautrec were *double* first cousins: the doctor's father, Amédée Tapié de Céleyran, was a brother of Lautrec's mother, and the doctor's mother, *née* Alix de Toulouse-Lautrec, was a sister of Lautrec's father. The relationship between the two families was complicated still further by the marriage of Dr Gabriel Tapié de Céleyran to his third cousin, Anne-Marie de Toulouse-Lautrec, who was also a third cousin of Henri de Toulouse-Lautrec. This marriage, however, did not take place until 1906, five years after Lautrec's death; the doctor was a bachelor during all the years of his association with Lautrec. In a preface to his unpublished manuscript of the *Généalogie d'Henri de Toulouse-Lautrec-Monfa* Dr Tapié de Céleyran writes:

" We were educated together as children, sometimes at Céleyran, sometimes at Le Bosc, sometimes at Albi, where I have inherited and now live in the house in which he was born; I have persuaded the municipal authorities to change the name of the rue de l'Ecole-Mage to the rue Henri de Toulouse-Lautrec.

" Later I spent several years with him in Paris, and we used to meet every evening after he had finished his work in his studio and I mine at the hospital. Everyone familiar with his pictures has recognized my likeness in many of his compositions."

The renaming of a street was not the only honour paid by the loyal doctor to the memory of his cousin. He shared with Joyant the labour and responsibility involved in the inauguration, in 1922, of the permanent exhibition of Lautrec's works in the museum at Albi, to which he donated a number of pictures from his own collection. He died in 1930.

The doctor, with his tall thin figure, his stoop, his sloping shoulders, his small head thrust forward at the end of a scrawny neck, his shambling gait, was almost as conspicuous a figure as Lautrec himself. He furnished a complete contrast to the undersized, stocky little cripple. Paul Leclercq gives a clear-cut if unflattering description of the doctor in *Autour de Toulouse-Lautrec:*

" His black pomaded hair was parted at the back of his head and carefully brushed over his temples. Between his prominent cheek-bones and flanked by a pair of side-whiskers, clipped in the Austrian fashion so as to leave the chin bare, an enormous red and pimply nose, surmounted by gold-framed spectacles, stuck out as if emerging from a piece of fur. His antiquated clothes looked like the garments belonging to some old family portrait, and when he smoked he slowly extracted his cigarettes from a large silver box decorated with coats of arms, just as in former days he would have taken a pinch of snuff. His hands, small and delicate, were loaded with heavy old-fashioned rings. And when he noticed, as we were chatting, that my curiosity was aroused by one of these unusual ornaments, he explained with gentle gravity that the stone I perceived in his cravat was not, as I might have supposed, a chrysoprase or an agate, but the tip of the shell of a marine animal seven yards long, whose Latin name he told me.

" I soon learned that this grave old gentleman, whom everyone called simply ' the doctor,' was in fact scarcely twenty-four years old, that he had come from Albi a few weeks before, and that he was in the second year of his medical studies. And I

defy anyone who had the pleasure of becoming acquainted with Lautrec's cousin at that period to forget the singular appearance of the good doctor."

Lautrec made good use of his kinsman's physical and sartorial eccentricities in numerous portraits. Dr Tapié de Céleyran appears again and again in Lautrec's paintings, lithographs, sketches, and caricatures: sometimes in a group, as in *Au Moulin Rouge* (Plate 15), more often by himself (Plates 38 and 39). Lautrec loved to tease the doctor and make jokes at his expense; but the victim of all this raillery accepted it with exemplary patience and good humour.

When Gabriel Tapié de Céleyran came to Paris, in 1891, he was admitted as an interne to the Hôpital International in the rue de la Santé, founded by the celebrated surgeon Jules-Emile Péan. Péan was one of the most spectacular figures in modern surgery: he was the inventor of many new instruments and technical methods, as well as a brilliant teacher and a daring, yet amazingly skilful, operator. Born in 1830 at Marboué, near Châteaudun, the son of a miller, and the eldest of seven children, Péan was ambitious to become a painter. But his father disapproved and kept him hard at work on the farm until he was rescued by his more sympathetic grandfather, who sent him to school. Armed with his bachelor's degree, Péan decided to abandon painting for a medical career; and in 1849 he came to Paris to study. When Tapié de Céleyran entered his hospital as an interne, Péan was over sixty years old and one of the greatest surgeons of his day. He died in 1898.

Through his amiable cousin, Lautrec obtained permission to watch Dr Péan operate at the Hôpital International. Far from being revolted by the horrors of the operating theatre, Lautrec was enchanted by what he saw. He loved the clean shining surfaces of walls and floors, the white uniforms of the doctors and nurses, the curious instruments that were so highly specialized and so perfectly adapted to their uses, the basins

and sponges, the gauzes, bandages, and other paraphernalia; above all, the quick deft motions of the surgeon's hands as they cut and probed into the bodies of his unconscious patients. The personality of Dr Péan appealed to Lautrec also: there was a good deal of the actor in the famous surgeon, and when he operated before a gallery of students he would often enliven his demonstrations with irrelevant chatter and flashes of wit, without neglecting for a second the grim work in hand. In those days the vital importance of asepsis was not recognized as it is today: although most of the attendants at an operation wore clean linen gowns, Dr Péan himself operated in his ordinary clothes, with a huge napkin knotted about his neck.

In 1891 Lautrec painted two important pictures of operations by Péan at the Hôpital International. One shows the entire room and contains a dozen figures. Péan himself, standing with his back turned, hides the inert body of the patient so that the gory details of the operation are invisible; other surgeons, including Dr Delaunay and Dr Baumgarten, are sitting or standing about, with several internes and nurses in attendance. In the other picture, *Une Opération de Trachéotomie* (Plate 40), the actual cutting is seen: the patient, with what seems to be a pad soaked in chloroform over his nose, lies motionless while Dr Péan forces the jaws apart and performs a delicate operation on the throat. In addition to these two pictures Lautrec made at least eighty drawings and sketches in pencil and in ink of scenes at the Hôpital International and the Hôpital Saint-Louis. Most of them are of Péan in various poses: operating, demonstrating, lecturing, washing his hands. Others represent Dr Baumgarten, Dr Roques de Fursac, Dr Delaunay, and the gawky Tapié de Céleyran. Lautrec also designed a title-page, a composition containing a mask and a skull enclosed in a decorative pattern, for the journal *La Chronique Médicale*, founded in 1891 by Dr Cabanès. The design was rejected as too macabre, but it was published after the painter's death in *La Chronique Médicale* for February 15, 1902, to-

gether with several other drawings of hospital scenes by Lautrec, to illustrate an article entitled *La Médecine et l'Art: Toulouse-Lautrec chez Péan* by Louis-Numa Baragnon.

Lautrec's intense preoccupation with surgeons and operations seems to have been confined to a single year, 1891. After that no more of these hospital subjects appear until the year of his death, 1901. The last picture he ever painted — that is, the last he finished, though not quite the last he worked at — is *Un Examen à la Faculté de Médecine,* depicting Dr Robert Wurtz and Dr Fournier, seated at one side of a table, giving the examination for admission to the Faculté to Dr Gabriel Tapié de Céleyran, sitting opposite. He also painted a portrait of Dr Wurtz alone as a preliminary study for the group canvas. Though executed only a few months before Lautrec died, when his system, undermined by alcohol, had already broken down once and was rapidly heading for a second collapse, these pictures show no traces of diminished vitality. The drawing is as firm, the brush-work as skilful, as ever: both as portraits and as pictorial compositions these last efforts of the dying painter rank among his most successful works.

LAW COURTS

THE DRY processes of the law would appear to offer little of interest to the painter, yet several artists before Lautrec had found rich material in the courts of justice. In particular, Daumier and Forain had exposed, with biting humour, the shrewd unscrupulousness of lawyers and judges in courtroom settings. Lautrec approached the subject from a somewhat different angle. He was less concerned with the moral shortcomings of those whose business it was to interpret and administer the law, more interested in the dramatic aspects of the trial itself: the tense attitude of the prisoner, the worried expressions of the witnesses, the gesticulations of lawyers, the sober attention of the judge, the boredom of the court attendants busy with routine duties, the excitement and sometimes the anger of the crowd of onlookers. Lautrec loved the theatre, and to him the courtroom was a theatre under another name. In both were to be found a stage and an auditorium, actors and spectators, suspense and emotion, drama and the clash of opposed wills. And just as in the theatre the plot meant little to him, so in the court of law the outcome of the trial, the triumph or defeat of justice, mattered less than the bearing and expres-

sions of those who took part in, or merely watched, the proceedings.

Lautrec's interest in legal matters was, in truth, neither profound nor lasting. It was not sufficient to inspire any major works: four lithographs and perhaps forty informal, hasty pencil sketches comprise his entire output of courtroom subjects. All of them are connected with one or the other of two famous trials that caused a tremendous stir in the year 1896: the Arton case and the Lebaudy affair.

The trial of Léopold-Emile Aron (better known as Arton) was one of the most sensational episodes in the complicated series of scandals that resulted from the failure of the French attempt to construct a canal across the Isthmus of Panama. The enterprise was promoted during the eighteen-eighties by Ferdinand de Lesseps, who had successfully completed the Suez Canal in 1869; but the Panama project was a far more difficult undertaking, and as the costs mounted to staggering heights while the actual work accomplished failed to keep pace with the expense, the French public stopped buying stock and construction came to a standstill. In February 1889 the Panama Company was declared bankrupt, and a receiver was appointed. At the same time sinister rumours of maladministration began to spread. In August 1891 an investigation of the company's affairs was set in motion, and for the next five years the litigation dragged through the courts. It was a discreditable business, for both the accused and the accusers. Many of the charges of mismanagement, bribery, corruption, and incompetence were undoubtedly justified; on the other hand the monarchists and other opponents of the French Republic took full advantage of this splendid opportunity to make political capital of the situation: irresponsible and often completely unfounded accusations were made against almost everyone associated in any capacity with the Panama enterprise or with the Government. In January 1893 the aged and senile Ferdinand

de Lesseps, his son Charles, and the brilliant engineer Eiffel, who designed the celebrated tower that bears his name, were among those convicted of misappropriation of funds and sentenced to long terms of imprisonment. The cases were appealed; owing to a technical flaw the convictions were held illegal, and the unreasonably severe sentences were never carried out. Two months later, however, Charles de Lesseps was convicted on another charge, bribery, and this time served a prison sentence of one year. The name of de Lesseps was afterwards cleared of any suspicion of wrongdoing, but the vindication came too late for Ferdinand de Lesseps, who died in 1894 at the age of eighty-nine.

Arton, or Aron, was born at Strasbourg in 1850. As a broker and go-between he was involved in a number of shady financial transactions, and when the Panama scandal broke he was charged with the bribery of a Government official. Arton managed to escape from France, but was tried by default and sentenced, on May 23, 1893, to the loss of his citizenship, five years in prison, and a fine of 400,000 francs. Meanwhile his whereabouts remained unknown. In 1895 he was finally located and arrested in London, extradited, and brought to Paris under guard to stand trial once more. This time he was acquitted of the specific charge of bribery for which he had previously been condemned by default, but convicted of other misdeeds of a similar nature and again sentenced to prison. So many people in high positions were involved by this time, however, that many of the sentences, including Arton's, were allowed to lapse. Though Arton was not imprisoned, he spent the rest of his life under a cloud; both his good name and his fortune were lost beyond hope of recovery, and in 1905 he committed suicide.

The prosecution of Arton in 1896, after his arrest and extradition, threw the whole of France into a turmoil. Though the prisoner in the dock was Arton, it was in a sense the French Republic that was on trial. There were so many wheels within

wheels, so many bitter recriminations, so many charges and countercharges, that the entire fabric of the Government was threatened. Lautrec was not vitally interested in politics and had never taken an active part in them; but by family tradition and early training he was at least passively a believer in the royalist cause, and he rejoiced in the discomfiture of the republican " upstarts." He was present at a number of sessions of the Court of Assizes during the Arton trial, sketching the prisoner, some of the witnesses, the court officials, and the curious spectators who packed every inch of the available space. But his interest in the proceedings soon subsided, and only three of the sketches were used later as preliminary studies for lithographs (D. 191–193) ; the rest lay neglected in his notebook.

The Lebaudy case involved another financial scandal, but one of a different kind. Max Lebaudy, an immensely wealthy young man, socially prominent, died of tuberculosis in a military hospital at Amélie-les-Bains in December 1895, at the age of twenty-three. A year or two earlier, upon reaching his majority, he had upset his family and friends by suing the trustees of his estate and forcing them to turn over to him the control of his large fortune. He was a spoilt and headstrong youth, extravagant and thoughtless, and with the help of several unscrupulous acquaintances who wormed their way into his confidence soon managed to lose a considerable part of his inheritance in various ways. In November 1894 he entered the army to perform his compulsory military service, but he was already seriously ill and was transferred from one military hospital to another until he died a year later. His death caused a sensation. There was a furious outburst of indignation against the military authorities, who were severely criticized for their refusal to discharge the sick boy from the army and send him home, where with good care his life might have been prolonged for several years. It was generally believed that Lebaudy was kept in the army, against his will and in spite of his obviously genuine illness, just *because* of his wealth and position; that his su-

perior officers, fearing that they might be accused of pampering the young millionaire if they allowed him to leave the army before his term of service expired, deliberately and cruelly rejected his repeated petitions for release, and so condemned him to a premature death. The accusation was unusual: generally it was the poor man without influence or family connections who suffered from social injustice, while in this case it was a rich man who became a martyr to his own wealth. There was probably a great deal of truth in the charges levelled at the army officers, but these charges were not in themselves the cause of the famous trial. They merely supplied the background.

Early in January 1896, only a week or two after Max Lebaudy's funeral, some startling accusations were made against half a dozen friends of the dead youth. These friends were all men of good family and supposedly without a stain on their reputations. Among them were Werther de Cesti, Ulric de Civry, Georges de Labruyère, and Armand Rosenthal, better known by his pseudonym Jacques de Saint-Cère, a journalist who wrote for the *New York Herald, Le Figaro,* and *La Vie Parisienne.* These men and two or three others were charged with extortion and attempted blackmail: specifically, of having demanded and obtained large sums of money from young Lebaudy in return for their help in attempting to secure for him a change of garrison, a leave of absence, and finally his discharge from the army. Lebaudy had, in fact, received none of these favours; his money remained in the pockets of his sympathetic cronies while he coughed away his life in the hospital.

This was one of those juicy scandals in high life that filled the courtrooms and the columns of the daily press to overflowing. Lautrec attended the trial for several days, during the course of which he made sketches of two of the defendants, de Cesti and Jacques de Saint-Cère, and of a witness, Mademoiselle Marsy. One of these sketches of Mademoiselle Marsy in the witness-box was afterwards drawn on stone and printed as a lithograph (D. 194).

LAW COURTS

Lautrec's drawings and lithographs of the Arton and Lebaudy trials do not constitute an important element of his production. But, slight as they are, these fragmentary notes are full of character; and they have a certain value as indications of the wide range of the painter's vision and the rich variety of his interests.

MAISONS CLOSES

THE UNFORTUNATE inmates of houses of prostitution supplied Lautrec with material for some of his most important works. From the beginning of 1892 to the end of 1894 such pictures were especially numerous: during those three years he executed more than fifty paintings, and dozens of drawings, of prostitutes. The dull and sordid lives led by these so-called *filles de joie* are frankly exposed in these pictures: all the hopelessness, all the boredom, all the degradation of existence behind the shuttered windows of the *maisons closes* appear in these scenes. Yet Lautrec painted them with the same detachment that he displayed when faced with the nightmares of the operating theatre or the ugly scandals of the courtroom. They were all aspects of life — of life as it was, not as it should be. He accepted them as he accepted his own deformity: without shrinking, without sentimentality, and without undue bitterness.

It would be idle as well as hypocritical to suggest that the sole purpose of Lautrec's frequent visits to houses of prostitution was his desire to paint pictures of the women who inhabited them. He had a sensual, ardent nature; the demands of the flesh were insistent, and he satisfied those demands as best

he could. Mis-shapen as he was, his physical misfortunes did not include impotence. Indeed, Emile Schaub-Koch insists in his *Psychanalyse d'un Peintre Moderne* that Lautrec's sexual prowess was nothing less than phenomenal; but as the writer cites neither chapter nor verse for his affirmation, it must be accepted with some reserve.

While Lautrec's deformity and extraordinary ugliness did not in any way reduce his need for sexual satisfaction, they did profoundly affect the conditions in which such satisfaction could be procured. Marriage with a woman of his own class was out of the question; almost as unthinkable was a liaison with a presentable woman from the *demi-monde*. It is most unlikely that either would have accepted him, the first as a husband, the second as a lover; and Lautrec was not the man to risk a rebuff. Joyant, it is true, tells us that after Lautrec's death a refined young woman of good family once said: " I should have been glad to take care of Lautrec, I think that I might have saved him by marrying him." But Joyant adds that the lady in question had never indicated her willingness to marry the cripple while he lived, so her good intentions, if genuine, were of no avail.

There is no reason to believe that Lautrec ever suggested marriage, or even thought of it seriously. Nor did he at any time have a mistress for whom he set up an establishment or with whom he remained on intimate terms for more than a few weeks, or at most a few months. Schaub-Koch lists the names of a few women with whom Lautrec is supposed to have lived for short periods. One was a certain Marie Charlet, an artists' model, very young and thoroughly debauched, whose career included incestuous relations with her drunken father. Another was Myriame Hayem, known as La Panthère, who had " the profile of a goat " and who posed as a model in Cormon's atelier while Lautrec was a student. La Panthère afterwards became the mistress of several prominent men in succession, and in

time accumulated a considerable fortune, all of which she gambled away before she died. A third attachment was to a woman named Véra, who had been the mistress of a wealthy collector of pictures. But again Monsieur Schaub-Koch fails to indicate the sources of his information concerning these intimate details of Lautrec's life; and since they are not confirmed by other biographers, and since, moreover, Monsieur Schaub-Koch's book is distressingly inaccurate in other respects, we must hesitate to place too much reliance on these unsupported statements.

Just what a devoted and faithful wife or mistress might have done for Lautrec, to what extent such a woman might have rescued him from the dissipations that resulted in his premature death, are speculations from which little profit can be derived. No such woman crossed his path; but we do know that his mother, whom he loved and who adored him, had almost no influence over her wayward son and could only watch helplessly while he wrecked his health with alcoholic and sexual excesses; and we may surmise, at least, that any wife or mistress would have tried in vain to reform him.

In the absence of any deep or permanent attachment the *maisons closes* answered Lautrec's requirements well enough. He not only visited them often, but actually lived for a time in one or two of them, having his meals served there and making himself thoroughly at home. There was a legitimate reason, however, for this unconventional choice of residence. It enabled him to observe and sketch the women when their masks were off, when they were not on parade before potential clients. The prostitutes became so accustomed to his presence that they behaved before him exactly as if he did not exist: they talked, played endless games of cards, quarrelled, polished their nails, combed their hair, or simply sat about in all stages of dress and undress, with folded arms and blank faces, waiting for customers. Their almost complete lack of self-conscious-

ness made them far more satisfactory to paint and draw than professional models. Lautrec was kind to these women who had never known kindness in their lives: he brought them presents, remembered their birthdays, and never failed to be courteous and charming. He treated them like human beings, and in return they confided in him, told him their troubles, petted and made much of him.

The sensational aspects of Lautrec's life are often exaggerated until they tend to overshadow the more prosaic realities. So much emphasis has been placed on his habit of living in brothels that a false impression has been created: it is sometimes supposed that he spent years at a time in these houses, sunk in debauchery. Nothing could be farther from the truth. His sojourns were never of long duration. Sometimes he remained for a few days, occasionally for two or three weeks. During these visits he was constantly at work, sketching, painting, and observing, storing up impressions which he later incorporated in his pictures. He made no secret of his whereabouts. Whenever he installed himself in a brothel for a week or so, his friends knew where to find him; and he sometimes took a mischievous delight in deliberately making appointments in one of the houses with unsuspecting strangers or acquaintances, just to see how they would behave when they discovered themselves in such an unseemly environment. Joyant tells us that when Monsieur Durand-Ruel, a distinguished and prudish old gentleman, asked Lautrec for a rendezvous, the painter sent word that he would meet his visitor at a certain address in the rue des Moulins. Durand-Ruel's coachman, who knew his way about Paris, was so horrified that he insisted on stopping his horses farther up the street, for fear that the carriage might be recognized; and the venerable picture dealer himself almost had an attack of apoplexy when Lautrec received him in the salon of the brothel and introduced him to the " girls."

In *La Chanson de ma Vie* Yvette Guilbert writes that she

once asked Lautrec to give her one of the drawings he had made of her, but that he pretended not to hear:

" Then, to tease him, I added: ' If you don't bring it to me, I'll just go to your house and take it.' At once he went into fits of laughter and cried: ' I'll bet you won't! Do you know where I am generally to be found, Yvette? '

" ' No — but no doubt at your studio.'

" ' Not at all,' said Lautrec, ' in a house with a very conspicuous number.'

" ' You really live there? Are you serious? '

" ' Quite serious, young Yvette.'

" ' Well, I suppose you are trying to elude your creditors — and that's your hiding-place. Certainly nobody would think of looking for you there.'

" Oh, his laugh! his laugh! and the piercing voice in which were combined his momentary preoccupation with the drawing he was working at and his consideration of the reply he wanted to make. And bit by bit, while he sharpened his pencil, he told me about his fondness for living in brothels, where he could observe the essence of prostitution, the absence of all modesty, and gain an insight into the misery of those poor creatures, the slaves of love. He was their friend, sometimes their adviser, never their judge; their comforter, even more their sympathetic brother. When he spoke of these unhappy women, at some length, the emotion in his voice betrayed such intense pity in his heart that I have often wondered if Lautrec did not find a kind of spiritual mission in this outpouring of brotherly Christian compassion for these women who had lost all sense of modesty and pride.

" He often said: ' Everywhere and always ugliness has its beautiful aspects, it is thrilling to discover them where nobody else has noticed them. . . .' "

But much as he may have pitied the women of the brothels, he had no illusions about them. He pointed out cynically that

247

their purchased caresses had little in common with love —
the love which he had never known and whose existence he did
not hesitate to deny:

" ' Oh, love! love! ' said Lautrec, ' you may sing about it in
every key, Yvette, but hold your nose, my dear! hold your nose!
If you were to sing about *desire* one could understand and even
laugh at the variety of its tricks — but love! my poor Yvette,
there is no such thing.' "

* *

The three houses of prostitution most frequently visited by
Lautrec were situated respectively in the rue des Moulins, the
rue Joubert, and the rue d'Amboise. The buildings were all
old; once luxurious private residences, they had fallen into
disrepair as the quarters in which they were located became un-
fashionable, but they still retained certain vestiges of their
former splendour: here a staircase with carved railings, there
a bit of delicate panelling or a fine mirror set into the wall.
The salon of the house in the rue d'Amboise was panelled in
wood, painted white in the style of the eighteenth century. In
1892 the *madame* who ran the establishment decided to re-
model this room and called on Lautrec to decorate the walls.
To the inhabitants of the brothels he was known, simply and
affectionately, as *le peintre;* they had no idea of his position in
the world outside, either as a member of an aristocratic family
or as an artist; and Lautrec, far from considering compliance
with such a request beneath his dignity, was vastly amused by
it and amiably set to work. Sixteen strips of canvas six feet
high and varying in width from eleven to twenty-six inches
were glued to the wood panels. These were covered with a
pale yellow background which blended with the white wood
of the doors and mouldings. On this Lautrec painted a series
of decorative motives: flowers, ribbons, conventionalized
leaves, etc. In the centre of each panel he drew an oval medal-

lion nine inches wide by ten and a half inches high, enclosed in a frame and surmounted by an ornate canopy; and in each medallion he painted the head of one of the inmates of the brothel. The portraits represented women of all types: dark and fair, fat and thin, smiling and grave. Lautrec painted all of these medallions with his own hand, but after he had completed one or two of the decorative patterns he left the others to various assistants — among whom, says Joyant, were a pupil of Puvis de Chavannes and a neighbourhood house-painter. After Lautrec's death the panels were removed from the walls and sold.

These decorations are pretty trifles of slight artistic value; but many of his other paintings of prostitutes are among the most important of all his works. Whatever sympathy Lautrec may have felt for these unhappy women, there is no pity in his pictures: they are brutal in their realism, their portrayal of blank despair. Yet his brush transmuted the essential ugliness of these sordid lives into objects of delicate refinement. He not only could discover beauty, as he said, where no other painter thought of looking for it, but he knew how to present that hidden loveliness, on canvas or on cardboard, for all the world to see. Since he was no moralist, no judge, but an artist concerned primarily with colour and line and composition, his pictures of brothel scenes are more significant as works of art than as social documents.

There is no sadism and, considering the subjects, very little eroticism in these works. To anyone who might expect to find in them something resembling the typical " feelthy peectures " furtively offered to gullible tourists on the street corners of Paris, they would be a sad disappointment. A few drawings and one or two lithographs such as *Dans le Monde* (D. 329) are decidedly pornographic; but they are redeemed by their frankly Rabelaisian humour, and moreover they were not intended for general circulation; they were distributed privately to Lautrec's intimates.

One aspect of Lautrec's representations of brothel life might

conceivably have shocked the public of the eighteen-nineties: his numerous studies of Lesbians. It happened not infrequently that these women, whose business it was to cater to the wants of men, fell violently in love with one another. There were also a certain number of Lesbians among the clients of the dance-halls, cafés, and restaurants of Montmartre. A few of these resorts, in fact, were patronized almost exclusively by women of the masculine type. The most famous Lesbian restaurant of the period was La Souris, in the rue Bréda (now rue Henry-Monnier). The proprietress, Palmyre, is described by Paul Leclercq as "a buxom woman with the ferocious appearance of a bulldog who, though in reality exceedingly kind-hearted, always seemed to be on the point of biting." Madame Palmyre not only resembled a bulldog, she also owned one: the celebrated Bouboule, already mentioned as the subject of one of Lautrec's lithographed menus (D. 211). Lautrec made drawings of both Palmyre and Bouboule in 1897, and they appear again in a lithograph of the same year, *A la Souris* (D. 210). Coquiot reports that Bouboule did not share his mistress's fondness for the society of women: the more Madame Palmyre tried to teach him to behave politely to her clients, the more obstinately savage Bouboule became. And if the women who frequented La Souris rashly persisted in fondling him against his will, he would manifest his displeasure by crawling under the table and, with infallible aim, drenching their exposed ankles.

Le Hanneton, at 75 rue Pigalle, was an establishment of the same special character, presided over by the imposing figure of Madame Armande. During 1897 and 1898 Lautrec was often to be found at one or the other of these resorts. At Le Hanneton he executed one lithograph (D. 272) and a few drawings. Lautrec was far too sophisticated to be shocked by the demonstrations of unorthodox affection that were displayed before him without reticence. He was accepted by the unconventional lovers, to whom he was known only as "Monsieur Henri," as a

kind and tolerant friend; to such an extent, indeed, that he was often called upon for advice or asked to settle some jealous quarrel that cropped up in the course of a passionate amour. Although sexually normal himself, Lautrec found something spicy and picturesque in these half-masculine, half-feminine intrigues. His interest in them was not that of the scientist or professional psychologist, but of the artist to whom life in all its manifestations was a rich field for observation and study. That he observed attentively, without excessive harshness but also without mercy, is attested by the magnificent series of works in which Lesbians are portrayed. Some of these have been discussed in earlier chapters: *Les deux Valseuses* (Plate 17), *Deux Femmes Valsant, Deux Femmes au Bar.* Others, painted in houses of prostitution, are more intimate, more frankly sexual: *Au Lit, Dans le Lit,* and *Au Lit: le Baiser* (Plate 41), all of 1892, and *Les deux Amies* (1893).

The only work in which Lautrec appears to condemn Lesbianism is the lithograph *Eros Vanné* (Plate 42), executed in 1894. Here, however, the moralizing is not Lautrec's but Maurice Donnay's, for whose monologue in verse the lithograph served as a cover (D. 74). Donnay's poem is the bitter lament of an outraged Eros who is obliged to play an uncongenial rôle in promoting the sterile, furtive loves of women:

> "*Elles ne sont pas prolifiques*
> *Mes unions, évidemment,*
> *J'assiste aux amours Saphiques*
> *Des femmes qui n'ont point d'amants. . . .*"

The monologue, in several stanzas, was recited by the author at the Chat Noir and afterwards by Yvette Guilbert as part of her repertoire. Lautrec's lithograph illustrates the text with caustic severity. Two mannish, hard-featured women are drinking at a bar, while an unhappy naked little Eros, crippled and deformed, stands disconsolately beside them; his face is

twisted in a wry grimace, his head is bandaged, one leg is encased in a plaster cast, and his frail body is supported by a crutch.

With the possible exception of three or four pictures there is nothing in the entire series of brothel scenes that could have offended the most tender susceptibilities, and it is not easy to understand why Lautrec himself should have considered these works unfit for public exhibition. Joyant tells us that for some time Lautrec refused to show them at all, except to friends; and that when he did consent to hang them, with many other pictures, in an exhibition held at the Manzi, Joyant galleries in the rue Forest in January 1896, he insisted that the brothel paintings should be displayed in a separate room, the key of which he kept in his pocket and to which he admitted only a chosen few. Those so favoured did not include picture dealers: " There is nothing for sale in there," said Lautrec firmly, and the door remained closed. Joyant adds:

" As to the unknown visitors who were attracted by the suggestion of a mystery, they stayed outside: they were not worthy of these ' ring-doves with olives.' ' They will never have them and they will never know what they are,' Lautrec would say with a knowing air.

" There is a story attached to this jest: at a dinner Lautrec once served an excellent dish which he had discovered at an old pastry-shop in the rue de Bourgogne, a dish made of young ring-doves stuffed with mincemeat and olives in a highly seasoned brown sauce. He had invited only a few carefully selected friends; others had been deliberately left out because they were not sufficiently discriminating to eat ring-dove with olives. Thenceforth the name of this dish became a symbol for a state of mind."

Lautrec was in the habit of interlarding his speech with expressions of this kind, verbal short cuts that were meaningless

except to those intimate friends who, knowing the circum-
stances that gave rise to the phrases in question, could follow
his train of thought. Joyant cites another example:

" ' Moustache ' expressed the idea of someone who struggled
miserably against an unhappy fate, as a result of the following
anecdote: during our excursions about the estuary of the
Somme one of our friends, Louis de Lasalle, a poet who was
killed in the War, accompanied us, insisting that he loved the
sea and sailing. A sportsman, proud of his muscles, handsome,
he had a magnificent pair of moustaches of which he took great
care, wrapping them up every night to keep them in curl. Lau-
trec, who had been asked by de Lasalle to paint his portrait,
had promised to do so, but only on condition that he cut off
his moustaches.

" As we drew out of the bay into the rough open sea our
passenger, smartly dressed in new yachting togs, quickly suc-
cumbed to seasickness, and very soon his moustaches were
drooping down in the most melancholy way.

" ' Moustaches, moustaches,' chanted Lautrec while the
heavy swell continued. ' Moustaches! ' — and that went on
monotonously for hours while Lautrec took off his heavy coat
and stood in oilskins, his face glowing, delighted to be buffeted
by the wind and spray, to be in a boat that skimmed like a por-
poise through the waves. I do not know if de Lasalle, irritated
beyond endurance, finally cut off his moustaches; but Lautrec
never painted his portrait."

Such idiosyncrasies of speech were undoubtedly piquant
when Lautrec himself used them, for many of his contempo-
raries have quoted them at considerable length; but set down
in cold print, without the accompaniment of his characteristic
intonation and droll facial expression, it must be admitted
that they do not seem either very witty or very funny.

There are a few nudes among Lautrec's paintings of the

maisons closes, but in most of them the women are at least half clad in chemises and stockings, as in the picture entitled *La Visite: Rue des Moulins* (Plate 43) , executed in 1894. This painting gives us an exceedingly intimate and by no means alluring glimpse into the life of the brothel. It represents two women standing in line for one of the physical inspections to which all of the inmates were obliged to submit, at regular intervals, to prevent the spread of venereal disease. In spite of its unpleasant subject the picture is a masterpiece of subtle characterization. There is, naturally enough, a complete lack of modesty in the poses and features of the women, to whom the inspection is merely part of the routine of the establishment, just one more tiresome interlude in a hopelessly dull existence.

Some of these pictures show the inmates in the act of dressing or undressing, washing, combing their hair, painting their lips, or manicuring their nails. Others are simple portraits of women fully clothed, with nothing to suggest the brothel except the hard, bold expressions of the faces and the excessive application of cosmetics. One of the finest paintings in this category is *La Femme au Boa Noir* (Plate 45) . Many of the pictures, among them *Ces Dames au Réfectoire* (1893) and the different versions of *Au Salon,* portray groups of women waiting languidly, indifferently, for casual clients. In *Au Salon: le Canapé* (also known as *Le Divan*) there are three figures: the woman in the centre is seen full face, the one on the right in profile. They are just sitting, passive, unthinking, weary, while their slightly more energetic companion on the left is laying out a pack of cards in an attempt to make the tedious hours pass more quickly. They are all wrapped from head to foot in long dressing-gowns, and their expressionless faces and vacant eyes are the essence of abysmal boredom.

The largest and most important picture of the entire brothel series is *Au Salon de la Rue des Moulins* (Plate 44) , painted in

1894. Before he began this ambitious work Lautrec made separate studies of most, if not all, of the individual figures, as well as sketches of the architectural background, the furniture, even the cushions. Later he repeated the whole composition, full size, in pastel, simplifying the details to suit the different medium. Six women appear in *Au Salon*. One at the extreme right, seen from the back and cut vertically in half by the edge of the canvas, is standing; her only garment in addition to shoes and stockings is a chemise which she has lifted to the level of her waist. The other women are seated on divans, placidly doing nothing. Four of them are lolling about or leaning back against the soft cushions; but the one at the right, in a long pink gown buttoned to the neck, with hair piled high and falling in a fringe over her brow, sits very straight and seems to be more wide awake than her companions: her prim expression suggests that she is either the *madame* herself or, more probably, one of her deputies entrusted with the maintenance of order. In the better class of brothels, such as those frequented by Lautrec, very strict rules of decorum were laid down, and infringements were severely punished. The inmates were forbidden, for example, to use improper language; and Joyant records that on one occasion, when the women inadvertently allowed a few highly coloured phrases to slip out in Lautrec's presence, the offenders were sharply reprimanded by the assistant *madame:*

" Ladies! ladies! where do you think you are? "

Occasionally Lautrec painted pictures of brothel subjects in which the " ladies " themselves do not appear. Such are *Monsieur, Madame, et le Chien* (1893) and *Le Blanchisseur de la Maison* (1894). In the first a man and a middle-aged, stout woman, the proprietors of the establishment, are seated stiffly side by side on a divan in front of a mirror. Their faces are comically stupid and brutish, rather than sinister; the snarling little dog held in the woman's lap seems to be by far the most

intelligent member of the trio. *Le Blanchisseur* depicts the delivery of a bundle of washing to one of the houses: the laundryman, in smock and cap, holds the linen while the *madame* or her assistant, informally attired in a dressing-gown, checks over the list.

PORTRAITS

ONE might be tempted to conclude that Lautrec's unconventional mode of life and his undisguised fondness for disreputable company had alienated him from his family and the social world to which he belonged by birth and fortune. Actually no such breach occurred. No matter how energetically tongues might wag and heads might shake over his escapades, he never became *déclassé*. It is true that he was seldom to be seen in the salons or at the tables of smart hostesses; but that was because the formality and dullness of " society " bored him, and his physical ugliness and deformity made him feel ill at ease in worldly gatherings, not because the doors of fashionable houses were deliberately shut against him. Among the more strait-laced households of Paris there were undoubtedly some in which the presence of a man with so unsavoury a reputation would have been unwelcome; but on the whole he could go where he pleased. His mother deplored his excesses and their disastrous effect on his constitution, and most of the other members of his family, as well as many of his friends, disapproved of him; but they all accepted him, greeted him cordially when he chose to visit them, and made heroic attempts to forgive, or at least ignore, his trespasses.

The long list of portraits that he painted, drew, and litho-
graphed of his relations and his " respectable " acquaintances
— acquaintances in no way associated with cabarets, bars, or
dance-halls, houses of prostitution, the café-concert, the thea-
tre, the circus, or the world of sport — is sufficient proof that
Lautrec was anything but a social outcast. The immense num-
ber of these works is astonishing, especially when we remember
that he never accepted a commission to paint a portrait. His
income made it unnecessary for him to commercialize his tal-
ent, and he painted only people whom he knew and who ap-
pealed to him, for one reason or another, as models. Many of
these portraits, including the numerous representations of Dr
Gabriel Tapié de Céleyran and Dr Péan, the portraits of Dr
Bourges, Tristan Bernard, Princeteau, Vincent Van Gogh, and
the famous *Monsieur Delaporte au Jardin de Paris,* which was
refused by the Luxembourg in 1905, have already been dis-
cussed at some length.

Lautrec painted few portraits of himself. He did execute
one or two self-portraits when he was very young, and later he
introduced his squat little figure into several group pictures,
notably the large canvas *Au Moulin Rouge* (Plate 15) , painted
in 1892. With these exceptions all of his interpretations of
himself are in the form of amusing caricatures. In one of these,
dated 1888, his head is attached, backwards, to the body of a
dog; in some he is naked; in others he is seated on an absurdly
low stool, painting, as in the Crocodile menu of 1896 (Plate
21) . He did not spare himself in these sketches: he exaggerated
unmercifully his crippled legs and the ugliness of his heavy
bearded head. He permitted his friends to draw and paint him
as they pleased, but few of their studies of him are as revealing
as his own. Among others, Henri Rachou, his fellow student
at Cormon's atelier, painted Lautrec in 1883; Anquetin drew
him with charcoal and pencil in 1889; Charles Maurin made
an etching of his head in 1890, and Léandre a devastating cari-
cature in the same year; in 1897 Vuillard painted two portraits,

one a serious and not unflattering study of his head in profile, the other the picture of Lautrec cooking lobsters which afterwards served as a frontispiece for Maurice Joyant's book *La Cuisine de Monsieur Momo, Célibataire*. Adolph Albert, the etcher, produced a pencil drawing of Lautrec, and Louis Bouglé, the versatile bicycle expert, tried his hand at a caricature, both in 1897; and finally Maxime Dethomas executed two charcoal drawings during a holiday at Granville in 1898.

Lautrec painted no important pictures of his eccentric father, but he did make several sketches and caricatures of him. The earliest is a small painting of 1881 in which Count Alphonse is represented, appropriately, on horseback with a falcon on his wrist. In 1889 the painter drew a disrespectful but very funny caricature of his father dressed in a hat and nothing else whatever. In 1892 he made two sketches, in one of which Count Alphonse is seen from the back, carrying an umbrella; in the other he is in hunting costume and carries a gun. Still other drawings are dated 1895, 1896, and 1899. In the large canvas *Au Moulin Rouge: la Danse* (1890) Lautrec's father may be recognized among the spectators by his white beard, seen in profile; and in a lithograph of 1893 entitled *Au Moulin Rouge: un Rude! un Vrai Rude!* (D. 45) he appears again, seated at a table with the painter Joseph Albert, another man, and a woman. The portrayal of Count Alphonse in the guise of an old roué in these two pictures does not necessarily prove that he ever actually visited the Moulin Rouge, though of course he may have done so; on the other hand Lautrec may well have introduced his father's portraits into these scenes merely as a joke.

He permitted himself no such liberties with his mother. His portraits of her are all serious, dignified studies in which no trace of caricature is perceptible. The first, a charcoal drawing of 1880, was followed in 1881 by a much more ambitious canvas in which the countess, in a white dress, is seated at a table on which repose a cup and saucer (Plate 5). Her expression is

sweet and gentle, and the whole picture, admirably composed and painted, is a remarkable achievement for a boy not yet seventeen years old. A smaller painting of her, reading a newspaper, dates from the same year. In 1882 Lautrec produced three portraits of his mother: one at Céleyran, the second in the garden at Malromé with a background of flowers; the scene of the third is uncertain. During this period he executed several charcoal drawings of the countess: one in 1882, another in 1883, still another in 1885. In 1887 he painted her again, this time in profile, reading in the salon of the château of Malromé. His last likeness of his mother is a pencil drawing of her head made at Bordeaux in 1895.

In his eager search for suitable models Lautrec did not overlook the other members of his enormous family. Many of these portraits, especially those of his youth, are mere sketches. In 1881 he painted a small picture of his third cousin Raymond de Toulouse-Lautrec, who was then about eleven years old, in sailor costume. This cousin is today the head of the Toulouse-Lautrec family. In 1882 Lautrec produced a whole series of family portraits: a painting and two charcoal studies of his favourite uncle, Charles; drawings of his two grandmothers, who, it will be remembered, were sisters; of his cousin and boon companion Gabriel Tapié de Céleyran, then aged twelve, whom he was to paint so often in later years; of other young Tapié de Céleyran cousins, Béatrice and Odon; of his uncle Amédée Tapié de Céleyran. In 1887 he painted another cousin, Juliette Pascal, seated in the salon at Malromé; in 1888 he sketched two more Tapié de Céleyran relations, Raoul and Emmanuel. Louis Pascal, the cousin with whom Lautrec went to school, appears in two portraits of the year 1893, jaunty and distinguished in shiny top hat and smart overcoat, with a cigar in his mouth and a cane under his arm. In 1895 he painted a superb portrait of Madame Pascal, mother of Juliette and Louis, playing the piano in the salon at Malromé; in 1896 a small picture of Madame E. Tapié de Céleyran; and in 1897

one of Béatrice Tapié de Céleyran, now a young woman of somewhat formidable appearance.

<p style="text-align:center">* *</p>

Among the " respectable " friends whose portraits Lautrec painted were the members of the Dihau family: two brothers, Désiré and Henri, and a sister. The Dihaus were musicians from Lille. Désiré, born in 1825, played the bassoon in the Pasdeloup and Colonne orchestras in Paris; when he became acquainted with Lautrec, about 1890, he was playing the same instrument at the Opéra. He was also a prolific composer, and Lautrec was commissioned to design lithographed covers for a great many of his published musical works. Mademoiselle Dihau gave piano and singing lessons. All three of the Dihaus were intelligent and charming, but in Lautrec's eyes their intelligence and charm were overshadowed by the prestige given them by their intimate friendship with his adored master, Degas. Degas was idolized by the Dihau family as extravagantly as by Lautrec. They had known him for years, and Degas had painted several pictures of the Opéra orchestra in which Désiré and his bassoon figured prominently, as well as a small portrait of Mademoiselle Dihau. One of the orchestra paintings by Degas belonged to the Dihau family and hung in their modest apartment in the rue Frochot; this was the picture that Lautrec reverently showed to his friends by way of " dessert " after the banquet described by Vuillard. And when Lautrec, who was usually indifferent to praise or blame, exhibited his own portraits of the Dihau family he would inquire timidly and humbly if they would bear comparison with the painting by " Monsieur Degas." Though Degas often visited the Dihau apartment, he and Lautrec seem to have met but seldom; the younger painter was content to worship from a distance.

In 1890 Lautrec painted a portrait of *Mademoiselle Dihau au Piano* (Plate 46), which was exhibited at the Salon des Indépendants of that year. There is a striking similarity between

the composition of this picture and that of a portrait by Van Gogh, *Mademoiselle Gachet* (Plate 47), one of the last he painted before he committed suicide in July 1890. The position of the head and body of the musician, the angle at which the piano is set, the placing of the hands on the keyboard, are almost exactly the same in both pictures.

Van Gogh left the asylum at Saint-Rémy on May 17, spent two or three days in Paris with his brother Theo, and then went to Auvers-sur-Oise, where he was placed under the care of Dr Gachet. From Auvers, a few weeks before he died, he wrote to Theo that he had just painted a portrait of the doctor's daughter playing the piano, and drew a sketch of the picture in the margin of his letter. Van Gogh's painting was executed some months after Lautrec's portrait of Mademoiselle Dihau, which was already on exhibition at the Indépendants; so it is obvious that Lautrec could not have been influenced by the Dutch painter. On the other hand it is extremely probable that Van Gogh's composition was inspired by, if not actually copied from, the Lautrec portrait. Just where and when Van Gogh saw the picture is uncertain. We know that he came to Paris for a day or two, apparently in June, after he had settled at Auvers. But in 1890 the Salon des Indépendants was open, according to the catalogue, only from March 20 to April 27. Either the exhibition was prolonged for a month or more, or Van Gogh saw the portrait of Mademoiselle Dihau elsewhere. But he undoubtedly did see it and was impressed by it, for after his return to Auvers from this excursion he wrote to his brother:

" I have very pleasant memories of this trip to Paris. . . . The picture by Lautrec, the portrait of a woman playing the piano, is very remarkable, I was deeply moved by it."

The letter is undated, so it is impossible to say with absolute certainty that Van Gogh saw Lautrec's picture before he

painted his own portrait of Mademoiselle Gachet. If he did not, the coincidence is extraordinary — so extraordinary as to be almost incredible.

Lautrec painted another portrait of Mademoiselle Dihau in 1898, *La Leçon de Chant.* The musician, now somewhat older and stouter, is seated at her piano in very much the same position as in the earlier picture; behind her stands her pupil, Madame Favereau, to whom she is giving a singing lesson. In 1891 he painted Henri Dihau, soberly dressed in bourgeois fashion with a top hat in one hand and a cane in the other; and two portraits of his brother Désiré, one full-face, the other in profile, reading. All three of these pictures were painted in the garden of Monsieur Forest. A fine lithograph of Désiré's head (D. 176) is undated.

Lautrec was also on terms of intimate friendship with several members of another distinguished family, the Natansons. The three Natanson brothers, Alexandre, Thadée, and Louis-Alfred, founded the *Revue Blanche* in 1891 in collaboration with Jeunehomme de Paix, a Belgian, and Charles and Paul Leclercq. *La Revue Blanche,* a lively magazine devoted to contemporary arts and letters, attracted a group of young writers and painters, many of whom Lautrec found congenial. Tristan Bernard was the editor, and among the contributors were Romain Coolus, Paul Adam, Jacques-Emile Blanche, Jules Renard, the painter Vallotton, and Lautrec himself. The Natansons were hospitable people who frequently gave amusing parties to which Lautrec was invited; he enjoyed the informality of these entertainments, the gay company, the sparkling conversation, the excellent food, and — not least — the inexhaustible supply of wine and spirits. In 1895 he painted a picture of one of these dinners, *A Table chez Monsieur et Madame Thadée Natanson;* seated at the table are the host and hostess and two guests, the painters Vuillard and Vallotton. In February of that year he lithographed an invitation to a reception given by the Alexandre Natansons. In the upper

left corner is a representation of a bar; the lettering is in English — slightly bizarre English, for which Lautrec himself may have been responsible:

AMERICAN

AND OTHER DRINKS

Mr and Mrs Alexandre
Natanson will be very
pleased of your company
at 8 h.½ on the __ February
1895.

R.S.V.P.
60, Avenue du Bois de Boulogne.

The invitation is signed with Lautrec's initials inscribed in the body of an elephant, above which is the tiny silhouette of a kangaroo. At this party Lautrec took charge of the bar. He wore a white linen jacket with a Union Jack for a waistcoat and diligently superintended the professional barmen who assisted him in the mixing of the "American and other" drinks. Joyant quotes some verses composed by Romain Coolus and sent to Lautrec the day after the party:

> "*Ah! je comprends que l'on jalouse*
> *En barman ton profil grec,*
> *Extraordinaire Toulouse*
> *Lautrec!*"

Lautrec's favourite model in this family was the gracious and beautiful Missia Natanson, Thadée's wife. In 1895 he designed a poster for *La Revue Blanche* (D. 355) in which Madame Natanson appears in outdoor costume with a short fur cape, a muff, a hat with towering feathers, and a veil. In a lithograph which served as a cover for the last issue of *L'Estampe Originale* (D. 127), published in March 1895, Missia Natanson is seen from the back seated in the loge of a theatre; and

in 1896 she figures in a poster (D. 365) for the Ault E. Wiborg Company, American manufacturers of printing and lithographic inks: here Madame Natanson is again in a theatre loge, but this time the view is from the front, and she is accompanied by Dr Gabriel Tapié de Céleyran. A small head of the same lady in pastel and gouache also dates from 1896. In 1897 Lautrec painted two more portraits of Madame Thadée Natanson. In one she is seated in a garden, reading; in the other, larger and more important, she is playing the piano. This picture is full of charm; the lovely features of the sitter, her graceful hands lightly touching the keys, her dainty muslin dress, the rich wood of the piano, and the background of figured wallpaper or damask all blend in delightful harmony. Both of these were painted during one of Lautrec's sojourns at the Natanson country house at Villeneuve-sur-Yonne, not far from Sens. Lastly, in 1898 he made two pencil drawings of Madame Natanson asleep, with her head pillowed on her arm.

Lautrec visited Villeneuve-sur-Yonne several times. Among the guests who enjoyed the hospitality of the Natansons while Lautrec was there was the writer Romain Coolus. In *L'Amour de l'Art* for April 1931 Coolus tells us that one day, as he was working in his room, Lautrec suddenly burst in and swept all his papers to the floor. " You have done enough work for today," said the painter, " I want you to come with me." Coolus, thinking that Lautrec merely wanted company on one of his frequent excursions to the village bar, protested that he was too busy to waste his time in frivolous drinking; but Lautrec insisted that he had something much more serious in mind. The writer's curiosity was aroused and he followed Lautrec obediently to a room which had been fitted out as a studio. " Sit down over there," commanded Lautrec, " I am going to paint your portrait in the manner of El Greco." There is actually not the slightest suggestion of El Greco in this picture: it is pure Lautrec and one of his most successful portraits. It was painted late in 1899 (or possibly in the spring of 1900)

after his breakdown; but there is no hint of feebleness or indecision in the bold brush-strokes. It inspired Coolus to send Lautrec several verses of slangy doggerel beginning:

"Dimanche, 22 avril 1900.
"Toulouse, quel est ton fricot?
T'es-tu luxé le haricot
A redemander aux échos
Le portrait de ton ami Co
Dans la manière du Greco?"

Lautrec presented the portrait to Coolus, who afterwards donated it to the museum at Albi.

Another guest of the Natanson family was Cipa Godebski, whose portrait Lautrec painted at Villeneuve-sur-Yonne in 1896. Godebski, of Polish origin, was a brother of Madame Thadée Natanson. Paul Leclercq records in *Autour de Toulouse-Lautrec* that Godebski and the painter proposed to collaborate in the publication of a collection of aphorisms: the book was to appear over the signature *Le Célibataire,* and presumably Godebski was to supply the text and Lautrec the illustrations. But Lautrec was enjoying the country air and the bathing in the river too much to be willing to sacrifice much of his time to work, and the project fell through after only one page had been completed.

As one of the founders of *La Revue Blanche* Paul Leclercq was naturally drawn into the Natanson orbit. In 1897 Lautrec painted a magnificent portrait of Leclercq (Plate 48) in the studio in the avenue Frochot. The writer, whose features are sensitive and intelligent, lounges in a huge armchair with his legs crossed and his hands folded; in the background is an easel with a large unfinished canvas. Leclercq describes the sittings:

" I was particularly conscious of the prodigious facility with which he worked when he painted my portrait, which I eventually gave to the Louvre.

" For at least a month I went regularly, three or four times a week, to the avenue Frochot, but I remember clearly that I did not pose more than two or three hours in all.

" As soon as I arrived he would ask me to sit in an enormous wicker armchair, and after he had put on the little soft felt hat he always wore in the studio he would plant himself in front of his easel.

" Then he would stare at me through his lorgnon, blink his eyes, take up his brush, and, after having thoroughly studied what he wanted to see, he would place a few light touches of very thin colour on the canvas [the portrait was actually painted on cardboard].

" While he painted he was silent and, with his wet lips, he seemed to be tasting something that had a delightful flavour.

" Then he would begin to sing the *Chanson du Forgeron* [an old song with bawdy words], lay down his brush, and announce abruptly:

" ' Worked enough! Weather's too fine! '

" And then we would take a walk in the neighbourhood.

" He seldom passed a sort of cheap café at the corner of the rue de Douai without going in.

" There he would order a *Byrrh* and, with childish joy, he would drop two sous into the ear-splitting mechanical orchestrion to make it play the *Marche Lorraine*."

Still another member of the Natanson circle was Félix Fénéon, editorial secretary of *La Revue Blanche,* who figures prominently as a spectator in the foreground of the right-hand curtain for La Goulue's booth (Plate 19). Lautrec made a drawing of Fénéon the same year (1895) and another in 1896.

Lautrec drew and painted portraits of a number of other men of letters. Some of these are mere sketches: in 1890, a caricature of Raoul Ponchon, poet and *boulevardier;* in 1893 and again in 1895, drawings of Louis-Numa Baragnon, author of the article *La Médecine et l'Art* in *La Chronique Médicale*

for February 15, 1902; in 1894, a sketch of Achille Astre, who afterwards wrote a biography of Lautrec; in 1898, a dry-point of W. H. B. Sands, a Scottish editor (D. 5). More important are the two portraits of the poet Georges-Henri Manuel painted in 1891. In one Manuel is standing, tall and lanky, in overcoat, top hat, and gloves, holding an umbrella; in the other he is seen in profile, sitting in Lautrec's studio. The composition of this second painting seems to have been influenced by Whistler's portraits of his mother and of Thomas Carlyle: the poses are almost exactly the same, but in Lautrec's picture the background is a complex pattern of frames and panels set at various angles. Lautrec made use of a similar composition for his portrait of Monsieur de Lauradour in 1897. In 1893 he painted a portrait of Monsieur Boileau; he is represented at a café table with half a dozen other figures in the background. Boileau was an obese journalist who specialized in the publication of scandalous and gossipy items.

Among the acquaintances portrayed by Lautrec there were naturally several artists. Some of these, including Grenier, Anquetin, François Gauzi, and Adolphe Albert, had been his fellow students at Cormon's atelier. In 1884 he made a pencil sketch of Grenier, whose apartment at 19*bis* rue Fontaine he shared for a short period. In 1888 he painted a small portrait of the same friend and two more important pictures of his wife, Madame Lili Grenier, whom he had also sketched in 1886. The Greniers made frequent excursions to the village of Villiers-sur-Morin, east of Paris, and Lautrec sometimes joined them there. During one of these sojourns in 1885 the inclement weather kept Lautrec indoors for several days; to amuse himself he painted a series of four murals on the walls of the public room of the inn, run by a man named Ancelin. These decorations were all representations of ballet scenes at the Opéra. In one the stage-manager, in a tasselled skull-cap, is ringing a bell and shouting to summon the dancers to the stage; in the second a dancer is putting the final touches to her

ballet costume in her dressing-room while a gentleman in evening dress looks on; the third depicts a ballet chorus in action, with the hands of the orchestra leader beating time; and the fourth is a view of the *poulailler* or upper gallery of the auditorium with a row of spectators, meanly dressed; among them is Lautrec himself in a workman's cap and the red scarf of an *apache*.

Anquetin appears in a slight but brilliant caricature dated 1888. The portraits of Gauzi are more numerous: a pencil sketch of 1885 and two paintings, one of the head alone (1887), the other a full-length profile (1888). Adolphe Albert, the etcher, is represented in a fine lithograph of 1898 entitled *Le Bon Graveur* (D. 273).

In 1885 Lautrec painted two portraits of the late Suzanne Valadon, a well-known painter in her own right and the mother of a greater one, Maurice Utrillo. Suzanne Valadon was born at Limoges in 1867; brought to Paris when she was a child, she went into training as a trapeze acrobat at the Cirque Molier, but six months later she fell from her trapeze and was injured so seriously that she was obliged to abandon all hopes of a circus career. She then supported herself by posing for several painters, among them Renoir and Puvis de Chavannes. In her spare time she drew and sketched, but at first there seemed to be no future for her as an artist. She is said to have occupied a studio in the same house in which Lautrec's studio was located. Lautrec, then twenty years old, saw her drawings and was impressed by her unusual talent; he encouraged and befriended her, showed her work to his friends, and gave her a letter to Degas, who also admired her sketches and showered her with advice which she made no effort to follow. Lautrec's two portraits of Suzanne Valadon at the age of eighteen were painted in the gardens of Monsieur Forest; in one she is wearing a yachting cap, in the other a bonnet ornamented with a large bow of ribbon.

Other painters whose portraits appear in the list of Lau-

trec's works are Albert Besnard, of whom Lautrec drew a wildly exaggerated caricature in 1888; Francis Jourdain, the son of the architect Frantz Jourdain, who posed for a dry-point in 1898; and Maxime Dethomas, one of Lautrec's closest friends, with whom he made several excursions and whom he painted in 1896 as a spectator at the Bal de l'Opéra. In 1893 he produced a painting and a pen-and-ink drawing of Henri-Gabriel Ibels, the illustrator who had collaborated with him in the album *Le Café Concert*. In 1897 he painted two portraits of Henri Nocq, jeweller and designer of medals, dressed in a long black cape. A drawing of the engraver and illustrator Henry Somm dates from the same year, and a dry-point of Somm from 1898 (D. 6). Lautrec also executed a dry-point (D. 3) of Charles Maurin, painter, etcher, and engraver, who was largely responsible for the development of the art of colour-printing in the eighteen-nineties. Lautrec produced only nine dry-points, all of them in 1898; seven of these were issued in the form of an album by Manzi, Joyant et Compagnie.

One of Lautrec's favourite models was the photographer Paul Sescau. He appears as an auxiliary figure in several group pictures, notably in *Au Moulin Rouge: la Danse,* of 1890; *Au Moulin Rouge* (Plate 15) ; and the right half of the curtain for La Goulue's booth at the Foire du Trône (Plate 19) . Lautrec painted a more serious portrait of Monsieur Sescau, standing alone, in 1891; in 1895 he made a small caricature of the photographer and in 1896 a drawing. Sescau appears for the last time in the lithograph *Promenoir* (D. 290) of 1899, strolling with Dr Tapié de Céleyran and ogling two women as they pass.

In 1889 Lautrec painted a portrait of Monsieur Fourcade, in evening dress, walking briskly with his hands in his pockets. The scene is apparently the Bal de l'Opéra: there are several figures wearing dominoes and masks in the background. A delightful pencil sketch, full of animation, of the violinist Dancla

dates from Lautrec's sojourn at Bordeaux in 1900, as well as half a dozen beautiful drawings of Dancla's hands.

Maurice Joyant, who shared with Dr Gabriel Tapié de Céleyran the responsibility as well as the honour of Lautrec's most intimate friendship, appears in only one portrait, painted in 1900 (Plate 49). There are, however, several preliminary studies for this picture, one of which is carried almost as far as the final version. The portrait is unquestionably one of Lautrec's masterpieces. Painted on wood, it represents Joyant, in oilskins, standing on the deck of a yacht, holding a gun. In spite of the marine setting it was actually painted in Lautrec's studio. Joyant describes the painter's procedure:

" The portraits he painted were often tortures of boredom to his models; not that he worked very long on any one day, but there were so many days.

" Mine required no less than seventy-five sittings, and he worked over the entire picture each day, ultimately producing an effect of facility and simplicity. As to the background, which, with the boat and sail, was sketched in all at once, Lautrec would never finish it in spite of the precise documentation he demanded for it. Once the figure was done, the rest was of no importance to him, except the blue brush-strokes of the Channel which brought out the yellow of the oilskins."

The background is in fact so sketchily indicated that the grain and colour of the wood panel are clearly visible through the thin glaze; yet the picture does not seem at all unfinished. Lautrec also made one sketchy caricature of Joyant in monotype, with the legend: *M. Joyant, sénateur*. But monotype did not appeal to him as a medium, and he produced only two others, both scenes from the circus.

Another maritime painting is the portrait of Emile Davoust at the tiller of his yacht *Cocorico* in the bay of Arcachon,

271

painted in 1889. The stout yachtsman, wearing a checked shirt and a cap, with a pipe in his mouth, stands solidly in the stern of his boat against a background of rigging, sunlit water, distant shores, and sky.

The rotund countenance and well-fed figure of Maurice Guibert, another of Lautrec's constant companions and cherished friends, are prominent in all of the Moulin Rouge groups in which the photographer Sescau is represented. Lautrec painted no serious portrait of the jovial Guibert, but he made at least sixteen or eighteen drawings of him. Most of these are caricatures, and many are distinctly pornographic. In 1891 Lautrec painted a curious picture entitled *A la Mie* (Plate 50). It is of a man and woman seated under an arbour at a small table, on which are scattered a bottle of wine, two glasses, and a plate of cheese with a knife. The man, wearing a shabby bowler hat and a scarf, leans heavily on the table with folded arms; he is the typical *apache,* brutal, dissipated, degenerate. His companion, in an untidy cotton blouse, is a bleary, hopeless, miserable slattern. As a picture of human degradation at its worst this has no rival among Lautrec's works; none of his paintings of prostitutes or of the habitués of the dens of Montmartre exhibit such unmitigated bestiality. But in this case the viciousness was not inherent in the models: it was entirely the product of Lautrec's imagination. The sinister *apache* of *A la Mie* was, in real life, the amiable and charming Maurice Guibert, while the abandoned slut was nothing worse than a young and pretty professional model. The two sitters were dressed in disreputable garments, posed to Lautrec's satisfaction, and then photographed by Paul Sescau; from this photograph (Plate 51) Lautrec painted his picture, retaining the essential elements of the composition but changing many of the details and transforming the innocent expressions of the models into evil, repulsive masks.

Though Lautrec did not frequent the drawing-rooms of Parisian " high-life " and was not interested, as a rule, in

women of fashion, he did have a few acquaintances among women of gentle breeding outside of his own family circle. Two or three of these sat to him for their portraits. In 1887 he painted a delightful picture of Madame Aline Gibert, reading, with a cup of tea on a small table at her elbow. In 1891 at Arcachon he painted *La Femme au Chien,* a portrait of Madame Fabre in a loose blouse and striped skirt, sitting in a garden and holding a small dog in her lap. One of his most successful works is the portrait of the refined and aristocratic Madame de Gortzikoff, swathed in rich furs and wearing a jaunty little bonnet trimmed with flowers (Plate 52).

Among the last portraits painted by Lautrec are those of the architect Octave Raquin and the poet André Rivoire, both executed in 1901. A few months later, after Lautrec's death, Rivoire wrote in the *Revue de l'Art Ancien et Moderne* for December 1901:

" He never painted a portrait without having thought about it for months, sometimes for years, without having lived in almost daily contact with his model. . . . But the actual execution . . . was rapid. Two or three sittings, sometimes only one, were enough for him. . . . And all of these portraits are manifestly true. Even without knowing the models it is impossible to imagine them different from his conception."

This statement agrees very well with Paul Leclercq's report that he " did not pose more than two or three hours in all " for his portrait, but it is more difficult to reconcile it with the experience recorded by Joyant, whose portrait required seventy-five sittings and was completely worked over each time. It must be remembered, however, that Lautrec made a number of preliminary studies for Joyant's portrait, and many of the sittings must have been devoted to these. Apparently Lautrec varied his method of painting in this respect; but in general he seems to have spent much more time in the contemplation and

study of his model than in the actual execution of the picture. Rivoire's article is continued in a later issue of the same periodical, that of April 1902:

" To appreciate the extraordinary sureness of his touch one must have watched him at work on a canvas or a sheet of cardboard, or seen him bent over a lithographic stone. Sometimes, before he even began to sketch in the ensemble, he would amuse himself by completing some detail, working over and over in one little corner. [His procedure] made little difference to him; his work was there, all ready in front of him; his eyes could visualize it in its complete form on the canvas as clearly as if it existed there beforehand; he seemed simply to be tracing over invisible lines. He would sing, laugh, and chat like a common workman over his task. He was preoccupied only with technical problems. Very rarely, from time to time, one became aware of a more minute attention, not so much an uncertainty of mind as a greater carefulness of his hand. He always had several canvases under way at the same time; he would constantly switch from one to the other, then would stop suddenly to start work on yet another. . . ."

POSTERS

LAUTREC's influence on the painters of the succeeding genera-
tion — that is, the influence of his *painting*, as distinguished
from that of his drawings, lithographs, or posters — is some-
what difficult to trace and even more difficult to define. The
recent tendency towards abstraction in art is largely an in-
heritance from Cézanne, in spite of the fact that Cézanne him-
self produced no pictures in which the abstract quality is domi-
nant over what he called his " sensations in the presence of
nature." Cézanne had no intention of founding a " school "
and died without knowing that he had done so; yet today his
enormous influence on the work of younger artists is as obvious
as it is freely acknowledged. But while the inspiration which
flows from Cézanne may be considered the main stream of
modern painting, it is not the only one: there are many others
running parallel to it or even across it. Among these is the un-
broken and still vigorous current that connects Ingres with
Degas, Degas with Lautrec, and Lautrec with many painters
who are living and working today. The contribution of Lau-
trec's painting to contemporary art, while it cannot be com-
pared with that of Cézanne's work, is by no means negligible.
Picasso, for example, was strongly influenced by Lautrec, espe-
cially at the beginning of his career: the realistic works of the

275

Spanish painter's early period, about the turn of the century, bear a close resemblance to much of Lautrec's production both in execution and in subject.

But if, as a painter, Lautrec is only one of the many complex influences apparent in the art of today — one of the minor influences, perhaps — there is at least one field in which his supremacy cannot be questioned: that of the poster. Here he is both pioneer and master. To a far greater extent than any of his predecessors or followers he succeeded in raising the design of posters to the level of a fine art. Every artist who has devoted his talents to the production of pictorial announcements and advertisements since Lautrec's time owes him an inestimable debt.

Lautrec himself recognized no distinction, no snobbish arbitrary barrier, between " commercial " and " pure " art. He applied the same standards to both: his illustrations and posters were executed with as much verve, as much inspiration, and as much technical care as his most ambitious paintings. They were in no sense pot-boilers; there was nothing perfunctory about them. Théodore Duret writes in his biography of Lautrec:

" True artists have never admitted the rigid separation which certain people have tried to establish between what they call great art, or pure art, and art that is applied to industrial purposes. Art is art and it may become manifest, in varying degrees, in any field, wherever the hand of a gifted individual may introduce and implant it. The real artists of all times have resorted to the most varied methods and procedures in order to express themselves. They have turned sometimes to what is known as great art, sometimes to decorative art, sometimes to industrial art. They have produced engravings, etchings, ceramics, carvings in wood or stone, works in metal, in response to the taste, the temperament, and the ability which impelled them to one medium rather than another.

276

" Lautrec never submitted to conventional restrictions, to the supposed difference between pure art and industrial art. He produced works of all kinds as they were suggested by the sights that met his eye and the impulses of the moment: paintings in oil or water-colour, on canvas or cardboard, drawings and sketches both realistic and humorous, lithographs in black or in colours, and, related to these last, posters."

Lautrec was not actually the originator of the pictorial poster, but he developed its hitherto unexplored possibilities so effectually that he completely overshadowed his forerunners. The poster as we know it today scarcely existed before about 1830. Until then placards and announcements consisted simply of lettering, varied in size to attract attention and often artistically disposed, but without pictorial embellishment. Handbills on which pictures in black and white were printed or lithographed were not uncommon, but their diminutive size and the small scale of the designs made them unsuitable for display on walls or hoardings; they were intended for careful inspection at close range, and were generally used to announce the publication of new books. Arthur Symons writes in *From Toulouse-Lautrec to Rodin:*

" The modern artistic poster movement began in 1836 with one done by Lalance as an advertisement for *Comment meurent les Femmes;* which was followed in 1837 by Célestin Nanteuil, an advertisement for *Robert Macaire,* done before he began his famous illustrations for Balzac and for Gautier. Next comes Gavarni, with his series of *Les Affiches Illustrées. . . ."

In 1862 Daumier designed a poster to advertise the wares of a coal-merchant: it represented a housewife welcoming, with outstretched arms, the delivery of a sack of fuel. In 1868 Manet executed a poster (which Symons condemns as " atrocious and almost obscene ") to announce the publication of a

book on cats by Champfleury: a black tom and a white tabby making love by moonlight on the rooftops. The lithographed design was on a separate sheet of paper pasted over a blank space in the larger sheet which contained the printed text.

These primitive posters were all in black and white. The technique of colour-printing as applied to posters was, if not invented, at least enormously developed and refined by Jules Chéret, Lautrec's most distinguished predecessor in this field, during the eighteen-eighties. Chéret's charming, frivolous Harlequins, Columbines, and Pierrots, his girls and boys in masks and fancy dresses, were a delight to the eye; his brilliant yet delicate colours danced like flickering sunbeams over the grey stone walls of Paris. The posters turned out by other contemporary designers were, by comparison, vastly inferior in composition, crude in colour, and slipshod in execution. For more than a decade, until the advent of Lautrec, Chéret had no serious rival: he was the only creative artist who really understood the decorative possibilities of the poster.

Lautrec admired but never imitated Chéret. There is a world of difference between the light, airy, graceful, but essentially " pretty " conceptions of his predecessor and his own bold, solid, intensely vital designs. Lautrec was willing to profit by Chéret's experiments with various mechanical processes of reproduction in colour, but he owed little, if any, of his inspiration to the older designer. The quality that set Lautrec's posters apart was derived largely from a study of Japanese prints, which had always enchanted him; he collected them and pored over them at every opportunity. His love for Japanese art, then an exotic novelty in Europe, came to him through two channels. One was direct: his first glimpse of these fragile prints and paintings, so simple and unpretentious, yet so subtle in colour and so sure in outline, stirred him profoundly; and the more he saw of them, the more deeply he was impressed. The other was indirect, through Degas, whose enthusiasm for the work of the Japanese was naturally echoed by

his adoring disciple. Lautrec did not, of course, slavishly copy Japanese prints; but he adapted many of the elements of their design to the requirements of his posters: the simple masses of flat colour, the definite outlines, the contrasts in value that emphasized the silhouettes of the figures, and often the quality of the line itself with its subtle alternations of curve and angle.

The Japanese used wood blocks for their prints, a separate block for each colour and a key block for the outlines and drawing. But it was impracticable to use wood blocks for posters as large as Lautrec's; the only suitable medium was stone. A description of the successive steps employed by Lautrec in the preparation of his posters is given by Joyant:

" Lautrec proceeded in the same manner for his prints as for his paintings: first he made notes, then tentative sketches, then preliminary studies in oil on cardboard; only after these did he begin the actual execution of the poster. On a huge sheet of paper backed with canvas he drew his outline in charcoal; this was transferred to the stone; over this charcoal drawing, which he often reinforced with oil paint, he placed a large tracing on which he tried out his colours. Thus, when he started to work on the stone itself, as little as possible of the design remained to be determined by chance.

" This method of procedure permitted him to insist tyrannically on his own selection of colours in spite of the objections of printers trained in the old school.

" Lautrec, when he went to [his printers] Chaix, Ancourt, or Verneau, knew exactly what he wanted and was able to impose his will on the workmen, who soon came to love him. Often he would appear at seven in the morning, still in his formal evening clothes, with his pockets bulging with the toothbrushes he used for the preparation of *crachis* [a system of spattering parts of the surface of the stone with tiny dots].

" He became, indeed, a master of the art of sprinkling his stones with colour; to emphasize his outlines, he was able by

this method to produce an effect of richness in his flat surfaces without resorting to hatching or the modelling of his shadows.

" This novel technique mystified the workmen who printed the lithographs; so much so that on one occasion, when he had spattered an immense *crachis* on a stone, he found it completely scrubbed off the next day. There is no need to describe his reaction to this mishap, which demonstrated the unfamiliarity of the professional lithographers with everything pertaining to the new uses of the *crachis*."

Lautrec employed several different printers for the reproduction of his designs. At first he went to Lemercier in the rue Mazarine, who in 1890 was almost the only printer in Paris sufficiently skilful and meticulous to carry out delicate lithographic work. Later he entrusted many of his lithographs to Stern, an excellent workman who faithfully fulfilled Lautrec's exacting requirements. The posters were generally printed by Verneau or Chaix. But Lautrec's favourite workshop was that of Ancourt in the rue du Faubourg Saint-Denis. Ancourt's comprehensive knowledge of his trade and his phenomenal patience recommended him not only to Lautrec but to many of his fellow artists. Moreover, Ancourt numbered among his employees several superlative craftsmen who were able to turn out perfect reproductions of almost any lithograph or coloured print placed in their hands. The most celebrated of these craftsmen was *le père* Cotelle, an old man whose eccentricities gave him the reputation of a " character "; he knew all the tricks of his trade and took a keen interest in the solution of difficult technical problems. In the coloured lithograph of Jane Avril (Plate 53) designed in 1893 as the cover for *L'Estampe Originale,* Père Cotelle is seen at the left turning the wheel of a hand-press. He is in his shirt-sleeves, with arms bare to the elbows, and wears a tiny black skull-cap far back on his head. According to Joyant, this insignificant scrap of headgear had remarkable virtues:

" It is to the skull-cap that *le père* Cotelle owes his place in the lithograph: this little cap was cut out of an old felt hat and was one of its owner's most cherished possessions; for, as it fitted closely to his greasy scalp, it became stickier day by day throughout the years; and *le père* Cotelle, as he pulled his proofs, gave the stone the benefit of the grease he so diligently accumulated. In doing this he was only following an ancient tradition which is still practised by all good lithographic crafts-men.

" One can easily understand that Lautrec would not miss the chance to preserve for posterity the features of the owner of a little cap which played such an important rôle in enhancing the quality and beauty of his lithographs."

* *

Thirty posters by Lautrec are listed and reproduced by Delteil. One additional poster, not mentioned by Delteil, is ascribed to Lautrec by Joyant, but its authorship is not abso-lutely certain. If it was in fact designed by Lautrec it was his first attempt, antedating the poster for the Moulin Rouge by three or four years at least. It was executed for a philanthropic society, L'Union du Commerce: the allegorical figure of Com-merce (?), represented by a woman holding a caduceus, ex-tends a palm branch over the head of a youth who leads an old beggar by the hand. The composition is stiff and academic, with none of the qualities that are characteristic of Lautrec's work.

With the possible exception of this early design of dubious authenticity, Lautrec's first poster was produced in 1891 as an advertisement for the Moulin Rouge (Plate 54). It represents La Goulue executing a high kick in a cloud of lingerie; in the foreground is the scarecrow figure of Valentin le Désossé in profile, and in the back a row of spectators. The only part of the composition that is drawn in detail is La Goulue's head. Valentin is merely a bold outline with a few of the most im-

portant lines of his face and clothing indicated in black, and the onlookers at the back are treated as solid black silhouettes. The colours are more subtle and varied than in any of Lautrec's later posters — almost too subtle, perhaps, to fulfil the primary purpose of a poster: to attract and hold the attention of the casual passer-by. This Moulin Rouge poster requires close inspection to be fully appreciated. La Goulue's face and neck are tinted a delicate flesh colour, her eye is blue, her lips red, and her piled-up hair a curious shade of pinkish orange; the ribbon about her throat is bright purple, her bodice a deep rose ornamented with conspicuous white spots and toned down with a black *crachis,* her stockings and the one visible shoe are pinkish violet, also modified with *crachis.* The generous expanse of underclothing is white — or rather very pale yellow, as pure white paper was reserved by law for official proclamations. The figure of Valentin le Désossé is a blend of rose and grey liberally spattered with black *crachis;* the gas-lamps and the strange unexplained flowerlike form at the extreme left are deep yellow; the floor and wall are a lighter yellow spattered with blue. The lettering is in red and black. This exceedingly complex colour scheme required the use of an immense number of different inks, and its mechanical reproduction must have presented enormous difficulties to the inexperienced workmen of that day. It is not surprising that Lautrec never again attempted such a wide range of colour in any one poster. Experience taught him the wisdom of simplification.

This poster, so different from anything that had been created before, brought Lautrec his first public recognition. He was, in fact, well known as a designer of posters long before he was acclaimed as a painter; since he made no effort to sell his pictures and had, at that time, exhibited but a few, they were scarcely known outside of the small circle of his friends; but the Moulin Rouge poster was seen and admired by thousands. It was the subject of numerous critical articles and comments,

nearly all laudatory. Commissions for other posters quickly followed.

Lautrec's second poster, *Le Pendu* (D. 340), announced the publication of a series of articles by Siégel on *Les Drames de Toulouse* in a provincial newspaper, *La Dépêche de Toulouse*, in April 1892. The macabre subject is in striking contrast with that of its gay predecessor. A corpse in shirt and knee breeches hangs limply from a noose suspended over a door-frame, while a man whose powdered hair is tied with a black bow in the fashion of the eighteenth century holds a guttering candle to illuminate the ghastly scene. The lettering was printed on separate strips of paper which were glued over the top and bottom of the poster.

Four more posters appeared in 1892. One was *Le Divan Japonais* (Plate 13), with the figures of Jane Avril, Edouard Dujardin, and Yvette Guilbert. The colour scheme, in which green, yellow, and black predominate, is much simpler than that of the poster for the Moulin Rouge. Jane Avril's face and hands, her escort's collar, ruffled shirt, and monocle, and the champagne glass are all in the greenish white of the paper itself; her hair is a *crachis* of bright orange over a yellow ground, and the face of Dujardin a more subdued shade of the same colour. Dujardin's hair, beard, and cane, the chair on which Jane Avril sits, her purse, most of Yvette Guilbert's dress, and the floor of the stage are yellow. Jane Avril's dress, hat, and fan, Dujardin's hat and coat-collar, Yvette's gloves, and the background directly behind her are black. Everything else is in various shades of green. The relatively restricted range of colours, the larger scale of the figures, the suppression of detail, and the simplicity of the composition combine to make this a far more successful poster, as a poster, than the one for the Moulin Rouge.

Reine de Joie (D. 342), the poster advertising the novel of that name by Victor Joze (the pseudonym of a Polish writer, Victor Dobrski), is one of Lautrec's most biting satires. Seated

at a richly appointed supper table is an old man in evening dress, bald, fat, and hideous, with thick lascivious lips; a courtesan with avaricious, sharply pointed features sits on his lap and embraces him, while the third member of the party, a young nincompoop, stares vacantly in front of him, unmoved by the love-making of his repulsive companions. The colours are more intense than in any of the earlier posters: there are great masses of brilliant scarlet, flaming yellow, black, white, and a little green, laid on in flat tones almost unbroken by shading or *crachis*.

Lautrec designed four posters for Aristide Bruant. The first was intended to advertise Bruant's engagement to sing at Les Ambassadeurs in 1892 (Plate 12). Ducarre, the director, would have preferred a more conventional artist, but Bruant insisted that nobody except Lautrec could do the kind of poster he required. Ducarre gave in with a grimace, but balked at the price demanded by the painter. In her biography of Bruant Jeanne Landre quotes a letter concerning this episode:

" *Mon vieux Bruant,*
" Here are the proofs you asked for. . . . The manager [of Les Ambassadeurs] has been stingy and has cut down my price, which was less than Chaix charged for the printing alone. So I am being paid nothing at all for my own work.
" I am sorry that he has taken advantage of my friendship with you to squeeze this out of me. We must hope that next time we shall be more on our guard.

<div align="right">

A toi.
T. Lautrec "

</div>

Fortunately Lautrec received an ample allowance from his family, so Ducarre's niggardliness was not such a serious matter. Had Lautrec been obliged to earn his living he might have supported himself in comfort, though perhaps not in luxury, by his posters and illustrations alone; but in fact those for which

he was paid at all brought in very little, and most of them were actually an expense to him rather than a source of income. His independence as an artist was far more important to him than additional revenue, and he generally preferred to pay out of his own pocket a large part or even the whole of the cost of printing. By so doing he was free to design his posters and lithographs and have them executed exactly as he pleased; he was under no obligation to modify them in deference to the wishes of his clients, often at variance with his own.

The difficulties between Lautrec and Bruant on the one hand and Ducarre on the other were not yet over. Having successfully reduced the price of Lautrec's poster to a figure that did not cover even the printer's bill, Ducarre apparently accepted it; but the wily director had another trick up his sleeve. Without saying a word to Bruant he commissioned another artist to design a poster which he intended to substitute for Lautrec's at the last moment. On the opening day of Bruant's engagement, however, when these surreptitiously prepared advertisements unexpectedly appeared on the hoardings, there was a violent explosion. Bruant refused flatly to sing a note unless Lautrec's posters, and no others, were displayed; and in the face of the star's furious indignation Ducarre was forced to surrender.

Lautrec's second poster for Bruant (D. 344) announced the appearance of the famous singer at L'Eldorado, also in 1892. It is practically a repetition of the Ambassadeurs poster with the design reversed as if seen in a mirror. The figure of Bruant in his black cape and hat and his red scarf faces to the right instead of to the left; a few minor details are changed, and of course the lettering is different. But the poster of *Aristide Bruant dans son Cabaret* (D. 348) of 1893 is an entirely new conception. Both in colour and composition it is one of the simplest of all of Lautrec's posters as well as one of the most striking. There is no background except the pale yellow of the paper itself, and only four flat colours are used: black for the cape,

hat, and gloves, vermilion for the scarf and a tiny patch of sleeve, buff for the hair, and olive green for the heavy outlines. The figure of Bruant is seen from the back with the head in profile. The fourth and last poster for Bruant (D. 349) was produced in 1894. It is another rear view, full length this time, with the leather boots prominently displayed. This poster served two purposes. On one version the caption reads: *Tous les Soirs Bruant au Mirliton — Bock, 13 Sous;* on the other: *Le Deuxième Volume de Bruant Illustré par Steinlen. Vient de Paraître. En Vente chez tous les Libraires et au Mirliton.*

In 1893 Lautrec designed a poster for Jane Avril's début at the Jardin de Paris (D. 345) . The figure of the dancer is enclosed in an irregular frame or border, one side of which is elaborated into the top of a bass-viol grasped by a hand. The colour scheme is orange, yellow, olive green, and black. Another poster of the same year (D. 346) advertises the appearance of Caudieux, probably at Les Ambassadeurs: the burly singer strides energetically across the stage with the tails of his dress-coat flying. The last poster of 1893 (D. 347) recalls the gruesome *Le Pendu* of the previous year. It announces the serial publication of *Au Pied de l'Echafaud* in *Le Matin* and represents a prisoner, with his arms bound and an expression of grim agony on his face, about to die under the guillotine. The executioner places his hand on the doomed man's shoulder; in the background are a priest and a line of mounted soldiers; in the foreground stands the grisly instrument of death with its tall scaffold, the triangular knife, the board with its rounded notch, and the basket open and ready to receive the severed head.

The following year Lautrec executed a poster in four colours (D. 353) to advertise the photographic studio of his friend Paul Sescau at 9 place Pigalle. It shows Sescau half hidden beneath the black cloth of his camera, which is levelled at a woman dressed in a sort of domino; she holds a fan and a lorgnette in her gloved hands. A poster for L'Artisan Moderne

(D. 350), a firm of dealers in furniture, bric-à-brac, and *objets d'art,* dates from the same year. This is one of Lautrec's more frivolous productions. It represents an attractive young woman in elaborate négligé sitting up in bed, while a small dog frisks about on the coverlet; a young workman in a smock, carrying a hammer and a tray of nails, advances into the room, and a scandalized maid hovers in the background. The model who posed for the figure of the workman was Henri Nocq, the engraver of medals. Another poster of 1894 is an advertisement for the confetti manufactured by J. and E. Bella of Charing Cross Road, London (D. 352). The conception is appropriately gay: a laughing girl holds her large hat on her head as she tries to escape a shower of confetti thrown by three armless hands. The last poster of the year (D. 351) announces another novel by Victor Joze, *Babylone d'Allemagne.* A Prussian officer, erect and rigid, rides haughtily up the street on a white horse, preceded by three other horsemen; he stares directly ahead and appears to notice neither the bearded soldier who comes smartly to attention in front of his sentry-box nor the young woman who tries to ogle him from across the road. According to Joyant, this poster, which so obviously ridicules the insolent bearing of the German military caste, offended the German ambassador and nearly precipitated an international incident.

The year 1895 produced five posters, including those for May Belfort (Plate 22), May Milton (Plate 23), and *La Revue Blanche* (D. 355), already mentioned. *La Châtelaine* (D. 357), also known as *Le Tocsin,* probably the least interesting of all of Lautrec's posters, informed the public that a new series of articles was about to be published in the newspaper *La Dépêche de Toulouse.* It represents a woman in a long white robe, with the air of a somnambulist, walking through a desolate forest; she is followed by a starved and wolfish dog, and in the background is a turreted castle seen by the pale light of a crescent moon. The poster of *Napoléon* (D. 358), dated

September 1895, has a curious history. The firm of Boussod, Valadon et Cie, an associate of the Manzi, Joyant galleries, opened a competition for a poster to be used as an advertisement for a new biography of Napoleon by Professor Sloane, published by the Century Company of New York. Lautrec entered the competition with twenty others and submitted a design of Napoleon on a white horse riding between a marshal in uniform and a Mameluke in Oriental robes. The jury, composed of three academicians of the old school — Detaille, Gérôme, and Vibert — rejected Lautrec's project and awarded the first prize to Lucien Métivet, the second to Chartier, and the third to Henri Dupray. Lautrec's poster was then offered to Frédéric Masson, another writer of Napoleonic history, but he too proved to be a die-hard reactionary, and the design was refused again. It was never, in fact, displayed as a poster; but Lautrec had one hundred copies printed at his own expense.

In 1896 Lautrec designed eight posters, his largest output for any single year. One was the advertisement for the Simpson bicycle chain, *La Chaîne Simpson* (D. 360), which had to be redrawn because Spoke noticed that the pedals were incorrectly placed. A second cycling poster of the same year (D. 359) represents Jimmy Michael on his racing wheel, with Frantz Reichel, the trainer " Choppy " Warburton, and another cyclist in the background. This design was never used as a poster, but a number of copies without the lettering were sold as prints. The poster for *La Troupe de Mademoiselle Eglantine* (D. 361), already described, also dates from 1896. To announce the publication of an American magazine, *The Chap Book,* Lautrec produced a poster representing the interior of the Irish and American Bar in the rue Royale (D. 362) : two liveried coachmen (one of them the fat driver of Monsieur de Rothschild's horses who appears so often in Lautrec's work) are seated at the bar, behind which the barman is mixing drinks. Another poster advertises a French illustrated peri-

odical, *L'Aube* (D. 363) : it depicts a dust-cart drawn by a plodding white horse through the wintry streets. The driver is muffled to the eyes; two poorly clad women, shivering in the cold of early morning, follow the cart; the scene is dimly lighted by the rays of a street lamp. *La Vache Enragée,* a monthly illustrated review founded by Adolphe Willette, is the subject of one of Lautrec's most amusing posters (D. 364) . *Manger de la vache enragée* means to suffer privations, to starve; and a yearly festival of *La Vache Enragée* was held in Montmartre, where the majority of the artists and writers were popularly supposed to be in a chronic state of destitution. Many of them were, in truth, on the verge of starvation; but the annual fête they organized was nevertheless a gay, hilarious event. Lautrec's poster represents an old man running for his life down one of the steep cobbled streets of Montmartre, hotly pursued by an infuriated cow which is in turn being chased by a policeman. On one side a dog keeps pace with the flying procession, on the other a Pierrot and a Columbine mounted on a tandem bicycle (a tribute to Willette's famous drawings of Pierrots) coast down the slope; while an urchin in a smock stands in the background and watches the headlong flight. The poster *La Passagère du 54,* also called *Promenade en Yacht* (D. 366) , announced the opening of an exhibition at the Salon des Cent in 1896; it shows a woman reclining on a canvas chair on the deck of a steamer. Lautrec made the sketch for this poster during a voyage from Bordeaux to Lisbon earlier in the year. The eighth and last poster of 1896 is *Au Concert* (D. 365) , executed for the Ault E. Wiborg Company, with the figures of Madame Natanson and Dr Tapié de Céleyran.

During the last five years of his life Lautrec produced only two posters: one for Jane Avril in 1899 (D. 367) and the announcement of Richepin's play *La Gitane* (D. 368) in 1900. The poster for Jane Avril, which was never used, is inferior in every way to his earlier ones of the same dancer: it is hard and dry in execution, and the serpentine pose is ungainly.

Lautrec was unquestionably one of the greatest poster designers the world has known. But there is one element that seriously mars the grace of these magnificent creations: the lettering. The baleful influence of the style known as " Art Nouveau " — an influence that fortunately had very little effect on his work as a whole — is only too apparent in the weak, badly formed, poorly spaced characters. Lautrec never understood the importance of good lettering; or, if he did understand it, he was unable to apply his knowledge. There is no beauty in these sprawling, untidy forms. Without exception his posters are vastly improved by the elimination of all lettering: the examples printed before the addition of the captions are much more pleasing than the lettered versions of the same designs.

ILLUSTRATIONS

In the field of illustration Lautrec's output, considering the short span of his life, was enormous. He worked quickly but never carelessly; the same deliberate observation, the same meticulous attention to detail that preceded the execution of his most elaborate paintings entered into the composition of every print. Joyant tells us that until about 1894 Lautrec's first step in the development of an illustration was a large charcoal sketch; this was followed by a series of tracings in wash or Chinese ink until a definite outline, suitable for mechanical reproduction, emerged; finally, for a colour-print, the required tones were indicated in oil or water-colour. Later he became so expert that he was able to eliminate much of this preliminary labour: after 1894 he discarded the charcoal sketch and tracings in favour of a quick pencil drawing, which he then elaborated and defined in ink and, if desired, in colour. In order to ensure the sharpness and clarity of every detail he always made his drawings much larger than the printed reproductions.

Lautrec's illustrations may be grouped under five headings:

1. Contributions to periodicals;
2. Illustrations for books;
3. Book covers and jackets;

4. Illustrations for printed music;
5. Reproductions of his own works, issued in sets, without text.

Certain examples in the first category have already been discussed in previous chapters: the contributions to *Le Mirliton* (1886–1887), to Gustave Geffroy's articles on *Le Plaisir à Paris* in *Le Figaro Illustré* (1893–1894), and to *Le Rire* (1894–1897).

Lautrec's association with the various periodicals to which he contributed was sometimes complicated by his unwillingness to be tied down to definite dates. His financial independence made him a little arrogant: the editors could take his illustrations or leave them. Most of the publishers cheerfully accepted his conditions and found space for his drawings as and when they were delivered. Jules Roques, who founded *Le Courrier Français* in 1884, was an exception. The first drawing by Lautrec ever to be published in a periodical appeared in *Le Courrier Français* on September 26, 1886. It was entitled *Gin-cocktail* and represented two men seated on high stools in front of a bar, with two barmaids standing on the other side. At the same time Lautrec submitted five other drawings which Roques accepted but never published. The editor of *Le Courrier Français* disliked Lautrec intensely, both as a man and as an artist. He disapproved of the painter's morals and, while he did not deny that Lautrec had talent, he considered that talent unwholesome and his influence pernicious. The five unpublished drawings and the original of *Gin-cocktail* were sold at auction by the directors of *Le Courrier Français* in June 1891, for prices ranging from two to ten francs each.

Lautrec sent four more drawings to *Le Courrier Français* in 1889, and this time Roques did not permit his personal feelings to interfere with their publication. It was, in fact, at the request of the editor that the drawings were made. They were all black-and-white renderings of Lautrec's own paintings:

Gueule de Bois, which appeared in the issue of April 21, 1889; *A la Bastille* (May 12) ; *Au Bal du Moulin de la Galette* (May 19) ; and *Boulevard Extérieur* (June 2), a study of the picture *A Montrouge* painted the year before.

In 1888 Lautrec contributed four illustrations to an article by Emile Michelet on *L'Eté à Paris,* published in *Paris-Illustré* for July 7: *Cavaliers se Rendant au Bois de Boulogne, Le Côtier de la Compagnie des Omnibus, La Blanchisseuse* (a tired woman waiting to carry her heavy basket of washing across the street), and *Un Jour de Première Communion,* in which a girl in a white dress and veil is seen walking to mass with her family. The painter François Gauzi posed for the figure of the father, in the Sunday clothes of a workman, pushing a perambulator.

The first number of *L'Escarmouche,* an illustrated weekly paper founded by Georges Darien, appeared on November 12, 1893. It was an ambitious project: the preliminary announcements promised that each issue would contain, in addition to articles by distinguished writers and small drawings, three full-page reproductions of hitherto unpublished drawings or lithographs by prominent artists, including Anquetin, Ibels, Vuillard, Willette, and Lautrec. Unfortunately there were not enough subscriptions to cover the costs of printing, and the magazine died an early death. The tenth issue, which came out on January 14, 1894, was the last full number; on March 16 one more issue made its appearance in an incomplete form before the enterprise was finally abandoned. Lautrec was faithful to the end and contributed no less than twelve lithographs to the ten regular numbers. Eight of these are of theatrical or café-concert subjects: *Aux Variétés: Lender et Brasseur* (D. 41) ; *Lender et Baron* (D. 43) ; *Répétition Générale aux Folies-Bergère* (D. 44) ; *Folies-Bergère: Les Pudeurs de M. Prudhomme* (D. 46) ; *Sarah Bernhardt dans Phèdre* (D. 47) ; *A l'Opéra: Madame Caron dans Faust* (D. 49) ; and *Au Théâtre Libre: Antoine dans L'Inquiétude* (D. 51). Two are

scenes at the Moulin Rouge: *L'Union Franco-Russe* (D. 50) , an enormous flaxen-haired courtesan in Russian boots and blouse marching off with a puny Frenchman in a smock; and *Un Rude! un Vrai Rude!* (D. 45) with the figures of Joseph Albert and Lautrec's father. The two remaining lithographs are satirical. One (D. 40) represents an elderly man with a pendulous nose talking to two women, with the caption: *Pour-quoi Pas? — une Fois n'est Pas Coutume* (Why not? — once doesn't count) . The other, entitled *En Quarante* (D. 42) , de-picts a very fat man and a woman of shrewish appearance at a café table.

Lautrec executed for *Le Figaro Illustré,* in addition to his illustrations for Geffroy's articles on *Le Plaisir à Paris,* four re-productions in colour for each of three stories by Romain Coolus. The first of these tales, *Le Bon Jockey,* appeared in July 1895. Two of the illustrations are of racecourse scenes, two of the interior of the Irish and American Bar. In September of the same year the second story, *La Belle et la Bête,* was published. One of the drawings shows the Beauty in bed, asleep; another the king and his chamberlain playing bezique; a third the princely suitor arriving at the castle with a train of servants, an elephant, a leopard, and other animals; and the fourth Beauty with the Beast. These illustrations, as well as those for the third story by Coolus, *Les Deux Sœurs Légen-daires,* which appeared in May 1896, are characteristic of the painter in one of his lighter moods: they exhibit an innocent humour and a refreshing gaiety that are rare in Lautrec's work.

La Revue Blanche also published a number of drawings and lithographs by Lautrec. The issue of March 1894 contained a lithograph, *Carnaval* (D. 64) ; and that of June, seventeen pen-and-ink drawings to accompany an article by Tristan Bernard in the illustrated supplement of the *Revue Blanche, Le Chas-seur de Chevelures* (The Scalp-hunter) . Three lithographs, one of the clowns Footit and Chocolat (D. 98) , one of a young man standing on a beach and pointing a camera (D. 99) , and

one of Anna Held singing in *Toutes ces Dames au Théâtre* (D. 100), appeared in January 1895 in another supplement of *La Revue Blanche, Nib* — a slang word meaning " nothing." Various minor drawings and tail-pieces ornamented the issues of February 15 and March 15, 1895.

Lautrec's most important contribution to *La Revue Blanche* was a pen-and-ink drawing of Oscar Wilde to illustrate an article by Paul Adam, *L'Assaut Malicieux,* published on May 15, 1895. The notorious case of Oscar Wilde was the sensation of that year. The article in *La Revue Blanche* appeared during the interval between the two trials. The first, held in April, had resulted in a disagreement of the jury, and Wilde was released on bail; the second ended on May 25 with a verdict of guilty and a two-year sentence. In general, public opinion in France was more sympathetic to Wilde than it was in England. Paul Adam was one of the unfortunate man's most ardent champions. His article is an impassioned defence of homosexuality and a bitter diatribe against what he considers the hypocrisy of many of Wilde's critics. Beginning with a series of examples of homosexual love among the Greeks, it continues as a frank but somewhat specious justification of Wilde's career:

" The moralists of Paris will not hesitate to censure the author of *Salomé* for having seduced Lord Douglas, whereas they would have commended him and envied him if it had been a Lady Douglas who had yielded to his desires. . . .

" We have a strange conception of justice. . . . It is always the woman who receives the sympathy of Parisian society. Yet, through her indiscretion, a respectable family may be saddled with a vicious or syphilitic descendant, a love-child conceived in the ignominy of a lie, in the foulness of a furnished room, as a result of the stimulation of sexual appetite. A wronged husband may despair, commit murder, or die; the children may be haunted all their lives by the memory of a sordid drama.

All of that counts for nothing in comparison with the truly charming act of a silly woman who pulls up her skirts to satisfy an urgent need.

"Here, on the other hand, we have a man of great intellectual power. Relations with women bore him. He is no longer interested in the idiotic romance of the young misunderstood wife, in the love of smartness and of filth that eternally defiles the conversation of courtesans, in the whole mechanical round of miserable vanities and cheap lies. He is attracted by young men; he gives money to some, loves another who adores him in return. He pays those who are poor, but pours out all the riches of his spirit at the feet of the young man who loves him. Far from doing harm, he creates kindness and enthusiasm. . . . Our scribblers put spurs to their wits. Puns are bandied about. There is a flood of abuse and of wise sayings. Every blackmailing pimp declares M. Oscar Wilde beyond the pale. He will never shake hands with the fellow again, he swears. . . .

"What damage has M. Oscar Wilde done, and why should he feel more ashamed of giving a little money to a boy who delivers telegrams than of paying a flower-girl to go to bed with him? In both cases the sterility of the act damns it. . . .

"What could be more exalted than the passion of young Lord Douglas for M. Wilde? There is no question here of either instinct or money. A poet unfolds the secret of harmonious thoughts before the ignorance of an adolescent. He charms him with the cadence of verses, the beauty of rhythm, the quality of his voice, the fire of his enthusiasm. Dazzled by these spiritual revelations, the young nobleman abandons himself to his friend. He listens to him. He learns from him. He is moved by the same vision of splendour. They are united by their ideas. They are swept away by the same spiritual flood. Lord Queensberry, striking out with his fists made powerful by the consumption of beefsteaks, is much less deserving of our sympathy. . . .

" Our moralists are deficient in deductive skill. If we are concerned only with justice, there should be no excuse for hesitation. When it comes to a choice between the seducer and the pederast, it is the second who is entitled to our indulgence. He does less harm."

Lautrec's drawing of Oscar Wilde is much more realistic and forthright than the somewhat sentimental text it illustrates. Whereas Paul Adam emphasizes — perhaps over-emphasizes — the spiritual aspect of Wilde's relations with Lord Alfred, Lautrec stresses the physical characteristics of his model: the pudgy cheeks and pendulous jowls, the double chin, the heavy nose, the sagging pouches beneath the eyes, the tiny rosebud mouth, pursed and petulant. He is seen in profile, foppishly dressed with gloves in hand and a flower in his buttonhole. All that was feminine in Wilde is ruthlessly exposed and even exaggerated by Lautrec's pen. It is a cruel portrait, on the whole, and must have nullified to some extent the unmistakably sympathetic tone of the article. It is unlikely that Lautrec was as deeply stirred by Wilde's downfall as Paul Adam seems to have been. His own masculinity was too dominant, his sexual life too normal, to permit him to sympathize whole-heartedly with Wilde's aberrations. Male homosexuality did not shock Lautrec any more than Lesbianism, but it interested him less. He painted many pictures of Lesbian couples but none of male lovers; nor did the resorts frequented especially by male homosexuals attract him as did such Lesbian establishments as Le Hanneton and La Souris.

Lautrec had known Oscar Wilde for three or four years, both in Paris and in London. Joyant reports that one of their meetings took place in London during, or just after, the hearing of Wilde's action for libel against the Marquess of Queensberry, father of Lord Alfred Douglas. Wilde was still confident, still defiant, still haughtily contemptuous of British public opinion. But the strain was beginning to tell, and the long evening

that Lautrec spent with him, listening to his grievances and bitter tirades, must have been a difficult one. There were many things about Wilde that Lautrec disliked: his pompousness, his æsthetic pose, his pretensions to an understanding of art which he did not in fact possess. But there was also much that he admired. He respected Wilde as a writer and appreciated him as a wit. When the Irishman saw fit to discard his affectations he had few rivals as a charming companion, a brilliant and stimulating talker.

In addition to the illustration for *La Revue Blanche* Lautrec painted a large portrait of Oscar Wilde in 1895 (Plate 55). The execution is simple, the brush-strokes swift and vibrant. The background of the Thames and one tower of the Houses of Parliament is indicated in the pearly tints of a London mist; the coat is greenish blue, the lapels and cravat a darker blue. The feminine qualities are even more accentuated than in the pen-and-ink drawing. It is one of Lautrec's most masterly characterizations: a complete picture, yet so stark in its economy, its elimination of detail, that it approaches caricature. He made use of the same composition for his lithograph of Wilde in the program of *Salomé* (D. 195) in 1896.

* *

Some of Lautrec's illustrations for books have been discussed already under various headings: *Le Café Concert* (D. 28–38) by Georges Montorgueil (1893); *Yvette Guilbert* (D. 79–95) by Gustave Geffroy (1894); and the English edition of *Yvette Guilbert* (D. 250–260) written by Arthur Byl, with a new set of lithographs (1898). These were primarily picture-books with short incidental texts. But Lautrec illustrated three other books in which the writing was at least as important as the reproductions, if not more important. In 1898 he made a set of eleven lithographs (D. 235–246) for *Au Pied du Sinaï* by Georges Clemenceau, a study of Jewish life in the ghettos of Poland. Before he started work on the illustrations Lautrec

spent several days in the Tournelle quarter of Paris, the home of thousands of poor Polish and Russian Jews; here he made sketches of characteristic types and carefully studied their gestures and the details of their dress. Clemenceau himself appears in two of the lithographs: in one he is seated in the office of a Jewish oculist, Mayer; in the other he is talking to two elderly bearded Jews at Busk, in Poland. The other illustrations portray scenes in the streets, cloth markets, and synagogues of Cracow. A special *de luxe* edition, limited to twenty-five copies, contains three additional lithographs: an episode in a synagogue (D. 247), a cemetery in Galicia (D. 248), and another cemetery at Busk (D. 249).

Lautrec often visited the zoos in the Jardin d'Acclimatation and the Jardin des Plantes to study and make sketches of the various birds and beasts kept in captivity. Many of these notes were used in the preparation of a series of lithographs (D. 297–323) to illustrate a book by Jules Renard, *Histoires Naturelles,* published in 1899. In addition to the cover design — the silhouette of a fox, symbolizing the author's name — the volume contains twenty-two full-page lithographs and six decorative tail-pieces. The illustrations comprise pictures of oxen, rabbits, deer, goats, sheep, a dog, a pig, a horse, a donkey, a bull, a mouse, a snail, and a toad, roosters, ducks, swans, pigeons, peacocks, guinea-fowl, a turkey, a hawk, and a spider. Joyant tells us that the toad that served Lautrec as a model was shipped to him from L'Isle-Adam in a cardboard hatbox, and that the painter fed it, sketched it, and allowed it to hop about the studio floor for several weeks. One day the door was left open inadvertently, and — to Lautrec's great distress, for he had become attached to his new pet — the toad vanished. But Lautrec consoled himself with a colony of praying mantises. When he grew tired of drawing them he sent some of the ferocious insects as presents to various friends: Maxime Dethomas, the sculptor Carabin, and Henri Nocq.

Lautrec's last set of book illustrations was intended for *La*

Fille Elisa by Edmond de Goncourt. This novel, whose heroine was a prostitute, had been adapted for the stage by Jean Ajalbert and presented at the Théâtre Antoine on December 24, 1890. After a run of four weeks it was banned by the censor. Lautrec, whose interest was aroused by the closing of the play, conceived the idea of illustrating a special edition of the novel. Maurice Joyant sent him a paper-covered copy of the 1877 edition published by Charpentier, and in this volume Lautrec experimented with his illustrations; but after sketching in eleven water-colours and five drawings he abandoned the project. In 1931 a facsimile edition, limited to one hundred and seventy-five copies, of the first sixty pages of the book with all of Lautrec's illustrations was issued by the Librairie de France.

In 1894 Lautrec lithographed covers for *Babylone d'Allemagne* (D. 76) by Victor Joze — using the same design as for the poster, on a reduced scale — and for the printed version of Victor Barrucand's adaptation of the Oriental play *Le Chariot de Terre Cuite* (D. 78), for which he had already supplied a program and part of the scenery. Other book covers followed: *Les Pieds Nickelés* (D.128) by Tristan Bernard in 1895; a coloured lithograph, *Débauche* (D. 177–178), for a *Catalogue d'Affiches Artistiques* edited by Arnould in 1896; *Le Fardeau de la Liberté* (D. 214) by Tristan Bernard, *La Tribu d'Isidore* (D. 215) by Victor Joze, and *Les Courtes Joies* (D. 216), a volume of poems by Julien Sermet with a preface by Geffroy, in 1897; *L'Exemple de Ninon de Lenclos Amoureuse* (D. 230) by Jean de Tinan and *L'Etoile Rouge* (D. 231) by Paul Leclercq in 1898; a drawing for the cover of *The Motograph Moving Picture Book* in 1899; and *Jouets de Paris* (D. 333) by Leclercq in 1901.

A great many of the printed musical compositions of his friend Désiré Dihau were embellished with cover sheets lithographed by Lautrec. In 1893 Dihau set to music a group of songs by Jean Goudezki, published under the general title of

Les Vieilles Histoires (D. 18–23) . Lautrec supplied a frontis-
piece and five illustrations; the remainder were executed by
Ibels, Rachou, and other artists. The frontispiece (D. 18) is
an amusing caricature of Dihau, very dignified in his smart
top hat, leading a huge bear (representing Goudezki, who was
a Pole) on a chain through the streets of Paris. Four more
covers for songs date from 1893: *Etude de Femme* (D. 24) ,
a poem by Hector Sombre; *Carnot Malade!* (D. 25) by Eu-
gène Lemercier, a member of the Chat Noir group; *Pauvre
Pierreuse!* (D. 26) , sung by Eugénie Buffet; and *Le Petit Trot-
tin* (D. 27) , with words by Achille Melandri and music by
Dihau.

In 1894 Lautrec produced lithographs for *La Goulue* (D.
71) , a waltz by Bosc; three monologues by Maurice Donnay
that formed part of Yvette Guilbert's repertoire: *Eros Vanné*
(Plate 42) , *Adolphe* or *Le Jeune Homme Triste* (D. 73) , and
Les Vieux Messieurs (D. 74) ; and another " number " of
Yvette's, *Colombine à Pierrot* (D. 96) , with words by Gaston
Habrekorn and music by Dihau. The following year he litho-
graphed covers for fourteen poems by Jean Richepin set to
Dihau's music (D. 129–142) . Delteil notes that " originally
another artist had made designs for these songs; but since
Désiré Dihau did not approve of them, M. C. Joubert [the
editor] entrusted the work, at the suggestion of the composer
himself, to Henri de Toulouse-Lautrec." His last litho-
graphed illustrations for music were for more of the prolific
Dihau's compositions: *Les Rois Mages* (D. 293) , with words
by Delormel and Maly, in 1899, and *Zamboula-Polka* (D. 334) ,
a comic song by Valfe, in 1901.

Two collections of lithographs in album form were issued
while Lautrec was alive. These are not, strictly speaking, il-
lustrations, since they are unaccompanied by any printed text.
One set, undated and without the name of the editor, but prob-
ably executed about 1895, consists of the thirteen prints of
actors and actresses already mentioned (D. 150–162) . A spe-

cial edition of twenty copies of this same series was printed for the members of the Société des XX (des Vingt), a Belgian organization of artists; in this edition each of the plates is reproduced twice, once on white paper and once on buff. An album of ten lithographs in colour without text, but with a frontispiece (D. 179) which also served as a poster to advertise the collection, was published by Pellet in 1896. It was entitled *Elles,* and the edition consisted of one hundred signed and numbered sets. The plates are large, averaging about sixteen by twenty inches. With one exception — *La Clownesse Assise* (D. 180), a portrait of Mademoiselle Cha-U-Kao — all of the lithographs represent women in various stages of undress. *Reveil* (D. 182) portrays a girl in bed, just awake; her arm lies across the pillow, and the one visible eye is half open, half sleepily closed. In *Lassitude* (D. 189) she has thrown herself onto the bed with her hands clasped under her head; every line of her relaxed body indicates exhaustion. In *Au Petit Lever* (D. 187) she is sitting up, having just been awakened by a hideous chinless woman with frizzy hair and a massive bust, dressed in a long nightgown — the typical *madame* of a brothel. In *Petit Déjeuner* she is still in bed but now fully awake; she contemplates cheerfully the breakfast tray held temptingly before her by a fat woman of somewhat pleasanter appearance than the one in the preceding plate. The next four lithographs represent successive stages of a woman's toilet: pouring water into a circular tin bath (D. 183), washing her neck (D. 184), combing her hair (D. 186), and regarding herself in a mirror (D. 185). *Conquête de Passage* (D. 188) is the only plate of the series in which a man appears: a woman, partly undressed, loosens her corset while her lover of the moment watches her from his chair in a corner of the room.

EXHIBITIONS

LAUTREC's works were shown at a number of exhibitions while he lived, and since his death important collections have been placed on view from time to time in most of the principal cities of Europe and America. From the very beginning the critics, on the whole, were kind to him. Two factors contributed to their forbearance. In the first place, while some of the subjects might have seemed a little startling to the more conservative beholders, there was nothing revolutionary in his technical approach. He was not a pioneer in the sense that the Impressionists were pioneers a generation earlier or the Cubists a generation later. He certainly was not, on the other hand, an academician: he had broken away from the stodgy teachings of Bonnat and Cormon in his early twenties and had never been tempted to return to the fold. Still he had a solid tradition behind him. He was accepted as a disciple of Degas, and Degas was an eminently respectable and respected painter by the time Lautrec began to exhibit. The second reason for the relatively cordial response of the critics to Lautrec's work was that he happened to paint during one of those periods of calm that always follow storms. The furious blasts directed against the Impressionists had subsided: by 1890 the rebels

had won their battle, the critics who had opposed them so violently ten or fifteen years before had been forced to eat their words; and the succeeding generation of arbiters took the lesson to heart. The younger critics were chastened and meek; they were not inclined to judge the productions of contemporary artists too harshly, lest they should make another mistake. Had Lautrec lived and painted twenty years earlier, had he exhibited with the Impressionists in 1874, he would have been overwhelmed by the same torrents of abuse that broke over the heads of Cézanne, Monet, Pissarro, Renoir, and their colleagues. By a fortunate chance he was born too late to suffer from that deluge and too early to be engulfed in the next. He rode to fame on the intervening wave, a gentle wave of comparatively liberal unprejudiced criticism. The reviewers were not, of course, unanimous: he was violently attacked by a few, but the campaign carried on even by these was directed more pointedly against his personal life, his character, and, above all, his morals, than against his work.

Lautrec's pictures were first exposed to public view at Bruant's cabaret Le Mirliton. It was a sort of permanent exhibition, beginning in 1886 with two paintings — *Le Refrain de la Chaise Louis XIII* and *Le Quadrille de la Chaise Louis XIII* — and a drawing, *A Saint-Lazare.* To these were added, in 1888, *Rosa la Rouge, A Batignolles, A la Bastille,* and *A Grenelle.* All of these works belonged to Bruant and were sold by him in 1905.

In 1888 Lautrec sent eleven pictures and a drawing to the exhibition of the Société des XX in Brussels. This organization, founded in 1884 by a group of " advanced " Belgian painters, held annual shows in which various foreign artists — also " advanced " — were invited to participate. In 1889 he was represented at two exhibitions in Paris: at the Cercle Artistique et Littéraire, generally known as the Cercle Volney because it was located in the street of that name, by a portrait; and at the Salon des Indépendants by *Au Bal du Moulin de la*

Galette, the portrait of Monsieur Fourcade, and an *Etude de Femme.* In 1890 he exhibited five pictures at the Société des XX and two, including the portrait of *Mademoiselle Dihau au Piano* (Plate 46) that Van Gogh admired, at the Indépendants.

Lautrec exhibited again at the Salon des Indépendants in 1891, but his name does not appear in the catalogue; Joyant presumes that " he must have sent his pictures in too late." Coquiot gives a list of eight paintings that figured in the show, four of which are corroborated by Joyant: *A la Mie* (Plate 50) , *En Meublé,* and portraits of Henri Dihau and Dr Bourges. Coquiot also mentions a portrait of Louis Pascal, but according to Joyant Lautrec painted none of Pascal before 1893, and as Joyant is usually more accurate than Coquiot, we may assume that the latter is mistaken; he may have confused Pascal with the photographer Paul Sescau, whose portrait Lautrec did paint in 1891. It is impossible to identify the other three paintings: a *Portrait de Monsieur G. B.,* an *Etude,* and a picture to which Coquiot gives the most improbable title of *Truc For Live* [sic]. Lautrec's offerings were widely commented on in the press, but most of the critics considered his colour too drab. Octave Mirbeau writes in the *Echo de Paris* for March 30, 1891:

" In spite of the blacks with which he unnecessarily dirties his figures, M. de Toulouse-Lautrec exhibits a genuine spiritual and tragic power in the observation of physiognomy and the discernment of character."

In *La Plume* for April 1891 Jules Antoine expresses the opinion that " Henri de Toulouse-Lautrec's drawing is austere, but his colour lugubrious." And Gustave Geffroy tells us in *La Vie Artistique,* probably with particular reference to *A la Mie:*

" M. de Toulouse-Lautrec presents scenes in equivocal surroundings with a mocking wilfulness, in dirty colours, from

which emerge horrible creatures, the larvæ of vice and poverty."

During the course of the same year Lautrec took part in two other exhibitions. To the Salon des Arts Libéraux he sent the portrait of Sescau and *Au Moulin de la Galette*. The Cercle Volney exhibited an *Etude de Jeune Fille* which was reviewed by Jules Antoine in *La Plume* for Feburary 15, 1891:

" M. de Toulouse-Lautrec has something of the expressive drawing of Degas, but he has more decision and determination; as for his colour, he has deliberately limited his palette to neutral tones; in fact the colour often seems, as in this study of a young girl, to be used only for the purpose of emphasizing the drawing. . . ."

All of these complaints about the dinginess of Lautrec's palette bear witness to the overwhelming success of the Impressionists' long campaign for lighter and more intense colours. Twenty years earlier these same pictures, subdued as they were, would have seemed far too colourful; in 1891 they were criticized for their drabness. And in fact Lautrec's early pictures were somewhat dark, not only in comparison with the works of the Impressionists but in comparison with his own productions of the following years. In the later pictures there is no lack of pure colour: brilliant blues, intense greens, flaming reds, and sparkling yellows. The progression towards a cleaner, more vivid palette seems to have been caused, or at least accelerated, by his own experiments in poster design. In order to attract attention the posters required bright colours without many gradations or half-tones, and Lautrec — consciously or unconsciously — began to apply the same principles of simplification and intensification to the colour schemes of his paintings.

In 1892 Lautrec was represented at four exhibitions: at the

Indépendants by the poster for the Moulin Rouge (Plate 54) and seven pictures, including three of La Goulue; at the Cercle Volney by *Celle qui se Peigne;* by *Le Baiser* at the gallery of Le Barc de Boutteville in the rue Le Peletier, where he exhibited with a new organization, Les Peintres Impressionnistes et Symbolistes; and by nine works at the Société des XX at Brussels. In 1893 he exhibited again at the Société des XX and the Indépendants as well as with the Peintres Graveurs Français, to whose show he sent two posters. But the great event of that year was the exhibition of about thirty of Lautrec's works at the galleries of Boussod, Valadon et Compagnie at 19 boulevard Montmartre. It was not quite a one-man show, since Charles Maurin, the artist who did so much to revive the craft of colour-printing, shared it with him; but it was by far the most important and comprehensive exhibit that Lautrec had yet had.

Although he had been painting and exhibiting for several years Lautrec was only twenty-eight years old when the Boussod, Valadon show opened. It was to his old school-fellow Maurice Joyant that he owed this unexpected opportunity to display so many of his pictures. In September 1890 Theo Van Gogh, manager of the firm of Goupil et Compagnie, art dealers, suddenly collapsed; a stroke of paralysis accompanied his mental breakdown, apparently brought on by the shock of his brother Vincent's suicide in July. After a short sojourn in a sanatorium he was taken to Holland, where he died six months later. Goupil's affairs, which Theo's departure had left in a state of chaos, were taken over by Boussod, Valadon; and Maurice Joyant, who had recently entered the employ of the latter house, was entrusted with the task of reorganizing the galleries in the boulevard Montmartre. He found the rooms choked with pictures, most of which, in spite of the acceptance by many critics of the Impressionist and other " revolutionary " doctrines, were still unsalable at that time. Paintings by Monet, Pissarro, Guillaumin, Degas, Gauguin, Raffaëlli, Jong-

kind, Redon, and other contemporary artists, including Lautrec, were stacked against the walls, unframed and unclassified. Joyant set to work methodically to sort out and make a complete inventory of the collection. When that was done he persuaded his conservative employers, in whose opinion these newfangled paintings were so much trash, to allow him to organize a series of exhibitions in the two small, low-ceilinged rooms of the entresol. First a group of pictures by Pissarro, then selections from the works of Raffaëlli, Carrière, Monet, Berthe Morisot, and Gauguin were presented in turn. The response of the public was by no means sensational, but it was sufficiently encouraging to enable Joyant to continue. Lautrec was prominent among those who supported Joyant in his efforts to popularize the works of these neglected painters. He was a constant visitor at the gallery and took a lively interest in the successive exhibitions.

When Joyant offered to devote one of these shows to Lautrec, the painter accepted the proposal with enthusiasm; but since he was not yet sufficiently sure of himself to exhibit quite alone, he welcomed the suggestion that Maurin's work should be presented to the public at the same time. The exhibition opened in January 1893. A special invitation was sent to Degas, and Lautrec danced with impatience as he anxiously awaited his idol's verdict. Degas arrived, writes Joyant, " one afternoon about six o'clock, wrapped in his overcoat; he examined everything attentively, humming under his breath, made a complete circuit of the gallery without saying a word, and started down the stairs. Then Degas turned, with the upper part of his body just visible above the narrow spiral stairway, and said to the timid and uneasy Lautrec: ' Well, Lautrec, I can see that you are one of us.' I can still see Lautrec glowing with profound happiness over this carelessly uttered compliment."

Among the thirty-odd works exhibited by Lautrec were several paintings of the Moulin Rouge and the Moulin de la

Galette, a few posters, and a number of lithographs. The show was a greater success than even the loyal Joyant had expected it to be, and the critics, in general, spoke well of it. Gustave Geffroy wrote in *La Justice* for February 15, 1893:

" On the entresol of 19 boulevard Montmartre two artists have been installed for a month, each in his own room, with a communicating door between the two. They are M. Charles Maurin and M. H. de Toulouse-Lautrec. . . .

" M. de Toulouse-Lautrec gives evidence of a completely matured taste and a uniformity of style which he will continue to develop logically according to the latent powers within him. The fact that he has conceived and executed with the greatest skill a number of posters is a sure indication of his ability to depict people in motion and to put colours together. [The posters of] Bruant, La Goulue, and more recently Le Divan Japonais have taken possession of the streets with an irresistible authority. It is impossible not to be struck by the amplitude of the lines and the artistic disposal of coloured areas.

" With a different colour scheme, sometimes dark and rich, sometimes muddy, almost dirty even, M. de Toulouse-Lautrec, painter and pastellist, proves himself to be equally expert in the portrayal of a single figure, the spontaneous appearance of an attitude or a movement, the comings and goings of a walking woman, the gyrations of a dancer. There is always something unexpected in the kind of person he shows us. The pose is never the conventional one, already seen and reproduced so many times, and yet it is a natural pose, one of the infinite number of natural poses that the perceptive eye of an artist can discern and present as an epitome of physiological and social existence. There is a traditional side to this art, and the masters who have been the initiators and the successive disciples of it might be named. But it is enough to say that M. de Toulouse-Lautrec follows this tradition, gives it a new

personal quality, and applies it to familiar scenes. He proves his originality by his understanding of the truth, which he knows and which he expresses.

" I do not think it necessary to defend the artist at great length against the attacks directed against him by art critics who are far too deeply concerned with the subjects of his pictures. M. de Toulouse-Lautrec is ostracized, consigned to damnation, on account of the degradation and horror which emanate from the scenes and subjects he selects. The degradation and horror are undeniable, but they are no more to be excluded from consideration than the pity, the sadness, or the bitterness with which other observers with different viewpoints might respond to the same depravities. M. de Toulouse-Lautrec is mocking, cruel, and over-tolerant when he throws open for our inspection his dance-halls, his brothel scenes, and the unnatural sex relationships of some of his models. Yet he remains a sincere artist, his pitiless observation is aware of the beauty of life, and the philosophy of vice which he sometimes proclaims with irritating ostentation nevertheless acquires, by the power of his drawing and the depth of his probing, the value, for purposes of demonstration, of a lesson in moral surgery."

In 1894 the Belgian Société des XX, after ten years of existence, was reorganized as La Libre Esthétique. Lautrec continued to send pictures annually to the exhibitions of the group until 1897. He was also represented at the Salon des Indépendants in 1894, 1895, and 1897. In May 1894 there was an exhibition of his lithographs at the Durand-Ruel galleries, and during the same month he sent several lithographs and a poster to a provincial show organized by *La Dépêche de Toulouse*. Lautrec's design for the Tiffany glass window was exhibited at the Salon de la Société Nationale des Beaux-Arts in 1895, and the *Quadrille au Moulin Rouge* at the Salon des Cent; but his most important show of the year was the display of posters

at the Royal Aquarium in London. This exhibition, organized by the paper-manufacturers J. and E. Bella, for whom Lautrec had executed the poster *Confetti* in 1894, was his first introduction to the British public. Seven more posters were shown at a second exhibition arranged by the firm of Bella in 1896, which was also held at the Royal Aquarium.

In January 1896 Lautrec inaugurated his first strictly one-man show at the galleries of Manzi, Joyant et Compagnie, successors to Goupil, at 9 rue Forest. Michel Manzi, born at Naples in 1849 but a French citizen by naturalization, had been associated with the house of Goupil since 1881. In 1893 he entered into a partnership with Maurice Joyant which lasted until his death in 1915. Manzi, himself a talented draughtsman, was an enthusiastic collector of pictures. He purchased several of Lautrec's works, most of which were sold in 1917; but an unfinished portrait of Manzi by Lautrec, painted on wood, is still in the possession of Madame Manzi.

The exhibition at the Manzi, Joyant galleries comprised paintings, lithographs, and posters. It was at this show that the pictures of brothel scenes were hung in a separate room, kept under lock and key, and displayed only to a selected group of visitors. Gustave Geffroy again defends Lautrec in *La Vie Artistique:*

" An exhibition of lithographs and a certain number of paintings by H. de Toulouse-Lautrec has been opened in the rue Forest. . . .

" It might be possible to criticize his eagerness to discover and exaggerate ugliness. No doubt such a criticism has some justification, but one must be careful not to apply it too generally. There is in Lautrec an innate sense of caricature which it would be a great pity to repress, because it is rich in its exposures of social pretensions and moral blemishes. . . .

" A second criticism which I shall endeavour to refute more vigorously is sometimes made. It tends to label as cynical, if

311

not actually obscene, many of his types and subjects drawn from the so-called life of pleasure that is the life of the prostitute. It is impossible for me to carry away from these works any such impression. Here the dominant quality, far more powerful than all the curiosities and ideas of those who look at them, is respect for the truth."

Two additional minor exhibitions were held in 1896: one in April of the set of coloured lithographs entitled *Elles,* at the offices of the periodical *La Plume;* the other in November, of posters only, at Reims. In 1897 another small exhibition was organized by *La Plume,* and a display of coloured prints by *Le Figaro.*

1898 was a much more important year for exhibitions. There were two major shows: one in April at Lautrec's own studio, one in May — of the same works — at the Goupil Gallery at 5 Regent Street in London. These were large exhibitions comprising no less than seventy-eight items. For the *vernissage* of the preliminary show in Paris Lautrec lithographed a special invitation (D. 232) representing a little girl teaching a poodle to sit up and beg; the text runs as follows:

" Henri de Toulouse-Lautrec begs you to do him the honour of inspecting, on April —— from one to five o'clock, his pictures before they are sent to London. 14 avenue Frochot."

Why the address is given as 14 avenue Frochot when Lautrec's studio was at number 15 is a mystery. Possibly the show was too large to be displayed in its entirety in his one big room and overflowed into the next house.

Heretofore London had seen only Lautrec's posters; this was his first general exhibition across the Channel. It was not a success, with either the critics or the public. England was still under the spell of the romantic, sugary pre-Raphaelites, and Lautrec's forthright, unsentimental painting, so utterly dif-

ferent from the work of the local celebrities, outraged the artistic sensibilities and aroused all the insular prejudices of the conservative British people. There was no lack of interest in the exhibition, to be sure; Lautrec's reputation as a painter of " naughty " subjects had preceded him, and his acquaintance with, and portraits of, the disreputable Oscar Wilde had surrounded his name with a somewhat unsavoury notoriety. There was more than enough prurient curiosity about this scandalous young painter to fill the Goupil Gallery with visitors during the entire run of the show, but nobody dreamed of buying one of his pictures. The critics were almost unanimous in their disapproval; they were profoundly shocked and said so in no uncertain terms. The reviewer of *The Art Journal* for June 1898 wrote:

" Messrs. Boussod, Valadon and Co., of the Goupil Gallery, Lower Regent Street, exhibit a collection of the works of M. Toulouse Lautrec, one of the most extreme of the followers of Degas. His subjects are unlikely to commend themselves to old ladies, but their execution is undeniably clever."

The Daily Chronicle commented on May 10:

" M. de Toulouse-Lautrec typifies the most genuine phase of modern French art — the cult of vulgarity and ugliness. . . . By his show at Goupil's [he] proves that either he is only endeavouring to do something which we shall describe as ' shocking,' or that he has but one idea in his head, and this is vulgarity. But we are not shocked. We are bored. . . . Technically, at times, he is magnificent. . . ."

On the same day the critic of *The Star* struck a similar note:

" For sheer brilliancy of handling, for wonderful technical ability, the Lantrec [*sic*] show at Goupil's should be visited.

313

I must frankly say that I do not care for the types M. de Tou-louse-Lantrec draws. They are distinctly unpleasant to me. In fact, when I said types I made a mistake. There is only one type, male and female. And I think that a man may get as much mannered by painting that alone as by repeating himself in any other fashion. . . . On the other hand, technically, there is much to learn from his work. His handling of water colour, pastel, chalk, and oil, and of all mediums, in fact, is most masterly. He finds the most curious colour combinations, and he records them in the most distinguished fashion. But to me, this continuous insistence on ugliness, vulgarity, and eccentricity, this painting of the same people over and over again, is really monstrous."

When the show closed, the reviewer of *Lady's Pictorial*, writing on June 11, found a crumb of comfort in the thought that, after all, the display of horrors had not lasted forever:

" The Lautrec exhibition is over in this gallery, for which relief much thanks. Again the art of such men as Corot, Dau-bigny, Swan, and Maris hangs here to delight instead of affright us; for despite its cleverness the work of Lautrec is revoltingly ugly, and you cannot get away from that fact."

According to Joyant there were no exhibitions of Lautrec's pictures in 1899. In 1900, the year of the great Exposition in Paris, Lautrec was appointed a member of the commission and jury empowered to select posters for display at the Exposition Universelle Centennale et Décennale de la Lithographie. In May, at an exhibition in his studio, he showed his most recent productions, the output of the twelve months that had elapsed since his release from the sanatorium. In December 1900 a few of his works were placed on view at an Exposition d'Art Mo-derne in Bordeaux during his sojourn in that city.

This was the last exhibition to be held while Lautrec lived.

In 1902, shortly after his death, three important retrospective shows honoured his memory: one at the Salon des Indépendants, one at La Libre Esthétique in Brussels, and a comprehensive exhibition of some two hundred items at the Durand-Ruel galleries. Since then scarcely a year has passed without at least one major exhibit of Lautrec's works in one of the great European capitals or one of the large cities of America.

TRAVEL

ALMOST every summer Lautrec returned to the southern provinces for a holiday. He revisited his native town of Albi, spent a few days or weeks with his family at the near-by Château du Bosc, sometimes travelled as far as Céleyran on the Mediterranean to see his numerous aunts and uncles and cousins, and nearly always found time for a sojourn at Malromé, his mother's favourite residence. But wherever else he went he rarely failed to pass a month or two each year at the village of Taussat, a quiet resort tucked away among the sandy dunes on the shores of the lagoon of Arcachon, about thirty miles west of Bordeaux. Here he found peace, fresh air, and the opportunity to lead a healthy outdoor existence that was so conspicuously lacking in the Montmartre of stuffy bars, garish dance-halls, noisy cabarets, and plushy perfumed brothels. He loved the sights and sounds and smells of Paris too well to remain away for many months at a time; but he loved the sea too. The salt Atlantic wind refreshed him after a strenuous winter. He spent long contented days in his boat, sailing and fishing; he lay for hours on the beach in the hot sun, naked, and swam awkwardly but energetically in the warm shallow lagoon. In the autumn he would return to Paris tanned and full of health,

with renewed mental and physical vigour, to plunge once more into feverish work and still more feverish dissipation.

Lautrec infinitely preferred boats to trains and seldom travelled by land if he could reach his destination by sea, even if he had to follow an indirect and very much longer route. When he went to Arcachon he generally journeyed by way of Le Havre and thence by slow cargo steamer to Bordeaux. He was not in a hurry, and the long sea voyage, sometimes lasting two or three days, was by no means the least enjoyable feature of his holiday. Gales and rough seas, so prevalent in the Bay of Biscay, had no terrors for him; in fact he was inclined to jeer maliciously at the sufferings of his less fortunate fellow travellers, pale and miserable in the grip of seasickness.

He could not bear to be left entirely alone and usually managed to persuade at least one of his friends, Joyant or Maurice Guibert or Maxime Dethomas or some other crony, to travel with him. Joyant describes a voyage from Le Havre to Bordeaux in a small steamer laden with barrels of wine and port:

" Lautrec was king of the ship, the bosom friend of the captain and the chief engineer. At dawn, when the steamer was off the coast of Brittany, he insisted on having it steered close to the shore in order that a supply of lobsters might be purchased from passing fishing-boats; and then the galley was scarcely large enough for the concoction of an enormous dish of *homard à l'américaine,* for which he had a famous recipe; there was plenty of time to reach Bordeaux."

Lautrec generally rented a small cottage or villa for his annual sojourn at Taussat. He seldom painted during the summer holidays. In July 1896, however, he was inspired to paint some large designs on coarse canvas and hang them out of doors as a sort of screen to protect his cottage against the prying eyes of his too inquisitive neighbours. But the paintings (which seem to have been lost) were somewhat obscene, and

317

the outraged neighbours objected. Lautrec's landlord protested formally in a letter, part of which is cited by Joyant:

". . . The tenant who occupies my beach chalet No. 207 has set up, between his own house and the thoroughfare used by the tenants of the chalets in front of him, a fence made of heavy canvas, daubed with designs which I shall not describe. . . . It is not fitting that each tenant should be permitted to erect, on property common to all, whatever construction he pleases . . . especially since these canvases are ornamented with improper pictures from which decent and well-bred parents must protect their children."

Less often Lautrec visited other seaside resorts. He went to Le Crotoy at the mouth of the Somme with Maurice Joyant, to Dinard, Granville, and Arromanches with Maxime Dethomas. But none of these places on the cold and stormy English Channel appealed to him as much as Taussat; he returned there year after year.

He made several trips to Brussels, where his faithful participation in the exhibitions of the Société des XX and its successor La Libre Esthétique brought him into contact with many of the contemporary Belgian artists. With one noteworthy exception his relations with them were exceedingly friendly. In 1890 Lautrec exhibited with the Société des XX for the second time. He was in Brussels when the show opened at the Musée Moderne on January 18 — the date is given by Madeleine Octave Maus in *Trente Ans de Lutte pour l'Art* — and with another guest of honour, Signac, attended the banquet given that night by the members of the group. During the course of the evening he became involved in a quarrel with Henry de Groux, one of the Belgian painters, which might have had serious consequences. The incident is described by Octave Maus, director of La Libre Esthétique, in a lecture delivered at Lausanne in 1918 which is quoted by Joyant:

" [The quarrel] very nearly resulted in a duel with swords between Henri de Toulouse-Lautrec and Henry de Groux.

" Those of you who have some idea of the physical appearance of the two men will be able to appreciate the farcical character of such an encounter.

" A childhood accident which involved the fracture of both legs had reduced Lautrec to the height of a dwarf. His torso, which remained normal in size, was so close to the ground that his friends had nicknamed him — there are very few ladies present — ' Low-arse ' [*Bas du cul*].

" De Groux, sickly, all profile, with a complexion like clay, was no taller than the other. A long greenish cape from which emerged only a small skinny head and a pair of feet made him look like a bell. At Bayreuth he was called ' *Die Glocke.*'

" At a *vernissage* banquet — for in Belgium one cannot take place without the other — an argument arose concerning Van Gogh, some of whose febrile but organic canvases brightened the walls.

" These pictures irritated de Groux. And he began to rail against the painter of Arles, calling him an ignoramus and a charlatan. At the other end of the table Lautrec suddenly bounced up, with his arms in the air, and shouted that it was an outrage to criticize so great an artist. De Groux retorted. Tumult. Seconds were appointed. Signac announced coldly that if Lautrec were killed he would assume the quarrel himself.

" I had all the trouble in the world, the next day, to persuade de Groux to apologize."

According to Madame Madeleine Maus, the other members of the Société des XX were so indignant at the discourteous behaviour of de Groux that the offending painter was obliged not only to apologize to Lautrec but to resign from the organization.

A later trip to Brussels with Maurice Joyant in 1894 was the

occasion of a much pleasanter encounter, this time with Van de Velde, one of the originators of the " Art Nouveau " movement. Although the style of decoration with which his name is associated quickly degenerated into fantastic horrors, the principles were sound, and today Van de Velde is recognized as one of the true pioneers of modern architecture. Lautrec and Joyant were invited to lunch at Van de Velde's house at Uccle, a suburb of Brussels. The Belgian architect had designed the house himself and had surrounded his property with a small colony of craftsmen who, under his supervision, turned out pottery, ironwork, wood carvings, textiles, and other decorative products, many of which adorned the house of the master. The application of Van de Velde's theories of decoration, as described by Joyant, sounds more than a little " arty " today, though it was undoubtedly a courageous and, on the whole, successful experiment in 1894:

" One was immediately charmed and astonished by the practical arrangement of colours and values in this ' home.' Nothing was left to chance; everything in it justified its presence; the library, by its arrangement and furniture, really gave the impression of being a room for work and meditation, while the white nursery for the children suggested the youth and gaiety of its occupants.

" The clothing of the hosts and of the fair-haired hostess, who wore a tea-gown the colour of crushed strawberries, indicated an attempt to harmonize with the coloured glassware of the dining-room; even foods of a certain colour were served on plates of complementary tones.

" This calm hospitable environment presupposed a balanced and deliberate consideration of details, a constant desire for improvement. All the same, the formality and the meticulous attention to arrangement, in which nothing was accidental, made themselves felt a little too obviously."

Lautrec was impressed but inclined to be critical:

" When we took our departure, a little dazzled by the play of light on the table-cloth, by the shadows of the ornamental grilles and stained-glass windows, by the combination of yellow eggs and red beans with purple and green plates — which may have had an unfortunate effect on the cuisine — Lautrec said:

" ' Amazing, isn't it? But in reality the only parts that are wholly successful are the bathroom, the dressing-rooms, and the nursery, which are painted white. As for the rest, it makes one yearn for Menelik's tent with a lot of lion skins, ostrich plumes, black or white naked women, scarlet and gold, giraffes and elephants.' "

Lautrec could not resist the temptation to bring back to Paris a number of samples of " Art Nouveau " textiles and pottery, which he installed in his studio. To provide a proper background for them he ordered new covers from Liberty for his old cushions and had the walls repainted in blue and ochre.

When he went to Brussels, Lautrec never failed to visit the Royal Museum. He enjoyed taking his friends there and acting as guide to its treasures — a somewhat arbitrary guide, according to Joyant:

" Right away, without permitting them to glance at anything else, he would lead them tyrannically to the objects of his particular devotion; he danced with joy over the simplicity of P. Breughel's painting of *The Massacre of the Innocents* against a background of velvety snow, or that of the portrait of an aged alderman by Cranach, with his skull-cap and fur collar; then the *Adam and Eve* by Cranach and the same subject by Jan Van Eyck, the realism of which enchanted him by its attention to detail, an attention that did not destroy the power of the picture as a whole. After a pause in front of Frans Hals,

Memling, and Quentin Metsys, Lautrec would say: ' And now, before we leave, you may glance in passing, if you wish, but without stopping too long, at the Jordaens ': that magnificent series of representations of Flemish flesh."

Lautrec enjoyed prowling about the picturesque old quarter of the town near the cathedral, with its narrow hilly streets and gabled houses, but he refused flatly to undertake any formal sightseeing expeditions: his companions were never able to persuade him to visit Waterloo. Of course he did not neglect the restaurants of Brussels, famous for their cookery and cellars.

His frequent excursions to London were usually made in the company of Maurice Joyant. Lautrec loved the Channel crossing in the paddle-wheel steamer, especially when the sea ran high. During the voyage he followed a routine that never varied. His first steps, as soon as he found himself on the boat, were directed towards the bar; then he would ensconce himself in a corridor near the engine-room and chat with the chief engineer until the steamer reached port. He travelled with a minimum of luggage, sometimes with only a single bag which he carried himself. " But," writes Paul Leclercq, " since his diminutive stature made it impossible for him to carry a valise of ordinary shape, which would have dragged along the ground, he bought in some cheap shop a travelling-bag of khaki canvas, elongated like a sausage, that was certainly unique."

Lautrec had friends in London: Charles Conder, Oscar Wilde, Arthur Symons, and James McNeill Whistler. On a foggy day in 1894 or 1895 he went with Joyant to Whistler's house in Chelsea and spent several hours admiring the work of the older painter. Whistler, whose reputation as a connoisseur of food and drink was equal to that of Lautrec himself, invited his guests to dine at the Café Royal. After a long conference with the entire staff of *maîtres d'hôtel* he selected

an elaborate menu composed almost exclusively of French dishes. The result was all but uneatable, and the chagrined Whistler could do nothing but curse English cooks and cookery. Lautrec, determined to outdo Whistler, promptly returned his hospitality with a luncheon in the grill-room of the Criterion. But the Frenchman wisely ordered nothing but the typically English joints and other dishes in the preparation of which the local cooks excelled, and this time the repast was an unqualified success.

Lautrec made two pencil sketches of Whistler in the latter's studio; in one the American painter wears a straw hat, in the other he wears a top hat and carries a cane.

Lautrec often went to the British Museum, where the Elgin marbles filled his soul with delight. Still more often he went to the National Gallery, where he would stand for hours before the Giottos, the portraits of Philip IV by Velázquez, and the *Battle of Sant' Egidio* by Paolo Uccello. Of a portrait by Piero della Francesca he said: " If one could only paint like that! It's painted as simply as the door of a carriage."

Anglophile as he was, and with an adequate (though by no means perfect) command of the English language, Lautrec naturally enjoyed these jaunts to London. But a week or two was enough: he quickly tired of the formality of English life and was always glad to return to his beloved Paris. One of the things he disliked about London was, paradoxically, the drunkenness. He himself drank very much more than was good for him, so his disapproval was certainly not based on moral grounds; but as practised in England drinking seemed to him a cheerless and sordid ritual completely lacking in the conviviality to which he was accustomed in France. Moreover, he was appalled by the brutal treatment of drunkards by the London police. Shortly after his arrival in London for the opening of his exhibition at the Goupil Gallery in 1898, he happened to witness an encounter between a well-dressed drunk and two or three " bobbies," and the incident gave him

food for thought. The intoxicated reveller, who had just been ejected with some violence from Lautrec's hotel, picked his hat and cane out of the gutter and proceeded to attack the doorkeeper who had thrown him out. At once a pair of burly policemen, summoned by a whistle, fell on the disturber of the peace, knocked him down several times, and carried him off, much the worse for wear, to the station. If that was the way things were done in this strange country, Lautrec decided, he would be very careful not to give the officers of the law an excuse to practise their drastic methods on him. And in fact he was always on his best behaviour when in London and seldom touched anything stronger than a glass of wine.

Lautrec's trip to Holland with Maxime Dethomas about 1895 was not altogether a happy experience. He enjoyed the visit to the picture gallery at Haarlem, with its splendid collection of the works of Frans Hals; and the long lazy voyage by houseboat down the Schelde canal through the flat, sleek, windmill-dotted fields and out into the open estuary as far as the island of Walcheren was pleasant enough. But the manners of the Dutch peasants — especially those of the children — irritated him. His deformed body suggested only one thing to these simple people, a professional " freak " from the sideshow of a circus; and at every landing-stage he was surrounded by a curious crowd, attracted by the prospect of free entertainment and sadly disappointed by the funny little man's indignant refusal to perform his tricks.

In 1896 he travelled to Spain and Portugal with Maurice Guibert. They embarked at Le Havre on the steamer *Chili,* intending at first to go only as far as Bordeaux. But Lautrec persuaded his unwilling companion to remain on board until the boat reached Lisbon and even suggested, hopefully, an extension of the voyage to the port of Dakar on the west coast of Africa. Guibert, however, refused to alter his itinerary to that extent, and Lautrec, protesting, was forced to go ashore at Lisbon. But, having set his heart on reaching Dakar, he con-

soled himself by writing a message to his friends in Paris and handing it to the captain of the *Chili* with instructions to post it at Dakar. Afterwards he always referred to this trip as " my voyage to Dakar." While at sea he made a pencil sketch of the obliging captain and drawings of some of the passengers, one of which he later elaborated into the poster *La Passagère du 54* (D. 366).

From Lisbon Guibert and Lautrec proceeded to Madrid and Toledo, where they (or at least Lautrec) revelled in the display of pictures by El Greco, Velázquez, and Goya. Their nights were spent in the pursuit of entertainment of a different kind: they haunted the dance-halls and brothels of Madrid and liberally sampled the exotic delights of these establishments. But Lautrec, for some reason, completely failed to appreciate the incomparable charm of the Spanish people. In fact he disliked them intensely: Joyant reports that after his return to Paris he was so infuriated by the appearance of a troupe of Spanish dancers at the Bouffes-Parisiens that he was barely prevented from making a scene in the theatre.

Lautrec's pictorial record of this tour through Spain consists of nothing more than half a dozen hasty pencil sketches of Spanish types and a few caricatures of Maurice Guibert. Joyant and other biographers of Lautrec state vaguely that he made a second voyage to Spain, but I have been unable to discover any particulars relating to it. Even the date is unspecified, but it is almost certain that if it took place at all it must have been in 1897 or 1898. After 1898 there is no considerable gap in our knowledge of his movements. The tragic events of the last three years of his life can be traced in detail, month by month.

BREAKDOWN

IT was not dissipation alone, but the attempt to combine dissipation with hard work, that hastened Lautrec's downfall. Night after night he would make the rounds of the cafés and bars of Montmartre, drinking enormous quantities of the most fantastic mixtures. Then he would repair to one of his favourite brothels, only to reappear early the next morning (often wearing the same garments, now creased and soiled, in which he had started out the evening before) at his studio or at the workshop of one of his printers, ready for a long day's work with his brush or lithographic crayon. No constitution, however robust to begin with, could have supported such a strain for very long; and Lautrec, though his general health was excellent in spite of his deformity, was never exceptionally strong. That he was able to burn the candle at both ends even for a few years was probably due to two mitigating factors: his annual vacations in the wholesome environment of Taussat, and his phenomenal ability to fall asleep instantly, in a chair, in a carriage, or wherever he happened to be, and to wake refreshed after a few hours — even a few minutes — of repose. But holidays and cat-naps could only postpone the inevitable collapse, they could not prevent it. Lautrec lived too hard, he tried to

326

cram too much into a few short years. He could not escape the consequences.

As early as 1897 unmistakable signs of deterioration, mental and physical, began to appear. Lautrec grew nervous, irritable, difficult to manage. He flared up at the least hint of interference, the slightest suggestion of moderation or self-control. He drank more and more copiously, he invented new and ever more outlandish messes to pour down his throat. Achille Astre writes that one night in Bordeaux, when Lautrec was already very drunk, he mixed together all the assorted liquors that were left in the bottles behind the bar — cognac, rum, absinthe, Amer Picon, Byrrh, chartreuse, and many others — and not only swallowed the horrible concoction himself but insisted that his companions should follow suit. This devastating mixture he christened, appropriately, a " *tremblement.*"

His friends became seriously alarmed, but they could do nothing with him; he seemed determined to wreck his life as completely and as rapidly as possible. Then, for a very brief period, his sincere well-wishers were encouraged by a ray of hope. Lautrec appeared to be impressed by the example of a certain American army officer, a casual acquaintance encountered in a bar, who, after a voluntary sojourn in an institution for the cure of intemperance, had emerged with a taste for nothing stronger than lemon squash. Like most people who have suddenly " seen the light " the American had turned into an enthusiastic as well as an eloquent reformer. Lautrec listened attentively, but to the great disappointment of his friends he declined to follow the example of the converted sinner. Nor did the solemn warnings of his doctors have the desired effect; they only served to increase his irritability.

His behaviour grew more unpredictable every day, and some of his escapades would have been worthy of his fantastic father. It is not impossible that his eccentricities were, in part, the result of heredity; on the other hand, incipient delirium tremens alone might easily have been responsible for his odd quirks.

In the absence of any contemporary psychological analysis we cannot tell whether his aberrations were due to heredity, drink, or a combination of both.

He began to suffer from curious delusions. Coquiot reports that one evening Lautrec suddenly became obsessed with the notion that his studio was infested with microbes, which he proceeded to exterminate by flooding the entire apartment with gasoline. Then, for some unknown reason, he conceived a grudge against the picture dealer Durand-Ruel; disguised as a beggar he stationed himself in front of the gallery in the rue Laffitte and created a disturbance that upset the whole neighbourhood.

His physical condition changed noticeably for the worse. The stocky body grew heavier and softer, the ruddy complexion became pasty. One night when he was very drunk he missed his footing and fell headlong down a flight of stairs, breaking his collar-bone. The damage was not serious, but he was badly shaken by the accident. Thereafter, in the characteristic associational language of his own invention, any place or situation in which danger lurked became " collar-bone " — *os clavicule*.

He began to disappear, sometimes for one night, sometimes for days on end, with questionable companions. His friends had no idea where to find him. Clashes with the police became lamentably frequent. Fortunately he seldom strayed far from the quarter in which he was well known, and the gendarmes were usually able to bring him home without much difficulty. Occasionally, however, he resisted; and then a black eye or a gory nose would testify to an unseemly struggle. A guard was detailed to accompany him wherever he went and, if possible, keep him out of mischief. Lautrec made no protest against this surveillance. In fact he appeared to be flattered by it, believing (or pretending to believe) that his protector was the District Police Commissioner himself. But the dull-witted guardian was no match for Lautrec, who usually man-

aged to make the " Commissioner " drunk and then give him the slip.

Joyant and other friends did their best to entice him away from the temptations of Montmartre. Joyant carried him off to Le Crotoy and sailed with him about the estuary; there was no liquor aboard the little yacht, and the painter's health improved immediately. Using the exhibition at the Goupil Gallery as a pretext and knowing that Lautrec was afraid to drink too much in England, Joyant persuaded him to go to London in May 1898. These distractions were effective while they lasted, but as soon as Lautrec returned to Paris he slipped back into his bad habits. A trip to Italy was suggested, as well as a more ambitious journey to Japan, a country that Lautrec had dreamed of visiting for years. But it was too late for such simple remedies. By 1898 dipsomania had too firm a grip on Lautrec to be shaken off by any number of sea voyages to distant lands.

One would naturally expect to find that as Lautrec drew closer and closer to the brink of catastrophe his creative powers would have shown a progressive decline. Actually nothing of the sort occurred. He produced fewer paintings each year, it is true: Joyant lists forty-four for 1894, thirty-five for 1895, twenty-six for 1896, sixteen for 1897, and only fourteen for 1898. But if the number of paintings decreased, their quality certainly did not deteriorate; and even the reduction in quantity can be accounted for — at least in part — by Lautrec's growing preoccupation with lithography. In 1898 and the first two months of 1899 he produced not less than one hundred superb lithographs, including the magnificent sets of illustrations for *Au Pied du Sinaï* (D. 235–249), *Histoires Naturelles* (D. 297–323), and the English album of *Yvette Guilbert* (D. 250–260) — an astonishing output for a man fuddled with constant drinking and on the verge of a disastrous breakdown. Possibly a trained psychologist might be able to discern evidences of mental exhaustion in some of these

works, but in only one are the indications of abnormality sufficiently obvious to be apparent to the layman. This is the lithograph, dated February 8, 1899, of *Le Chien et le Perroquet* (D. 277). It is a feverish, confused nightmare, a jumble of unrelated subjects. In the foreground a collie with his tongue hanging out gazes up at a parrot sitting on a perch; the parrot wears spectacles and an absurd little hat and smokes a pipe. In the distance a railway train, belching smoke and apparently travelling at high speed, is being flagged to prevent the destruction of a small poodle standing on the track. It is no more than a hasty sketch and should not, perhaps, be taken too seriously; but in its utter lack of co-ordination it is unique among Lautrec's works.

This seems to have been Lautrec's last production of any kind before the crash. The crisis came suddenly one morning at the end of February. Lautrec became hysterically violent, and his mother decided that it was necessary to put him under restraint. Doctors and nurses were summoned in haste, and the struggling painter was bundled into a closed carriage and driven off to the suburb of Neuilly, where he was interned in a hospital for nervous and mental disorders.

ASYLUM

THE SANATORIUM of Dr Sémelaigne at 16 avenue de Madrid in the Saint-James quarter of Neuilly, directly opposite a corner of the Bois de Boulogne, was no ordinary madhouse. It was an expensive establishment for wealthy private patients, equipped with all the comforts and luxuries that were consistent with the primary purposes of the institution: restraint and cure. The house was a charming villa, built at the end of the eighteenth century, with beautifully proportioned rooms, delicate Louis XVI panels and mouldings, old mirrors, and polished floors. It was surrounded by a large park filled with stately trees, smooth lawns, and well-tended flower-beds, laid out in the formal fashion of its period and embellished with arbours, fountains, artificial " ruins," and groups of statuary by Pajou and Lemoine. The sanatorium no longer exists; a portion of the park has been subdivided into building lots and covered with houses.

The living-quarters for the patients were comfortable but simple. In this part of the building the corridors and staircases were narrow, the doors low, the windows barred; here the smiling country-house atmosphere was superseded by that of a practical, efficient institution. Two small but pleasant rooms were

assigned to Lautrec, one for himself, the adjoining one for his
male nurse or keeper.

His recovery was astonishingly rapid. Alcohol, of course,
was forbidden; and as soon as the opportunity to drink was
withdrawn, his health, both mental and physical, improved im-
mediately. Possibly, too, the shock of finding himself in such
a place had a certain salutary effect. At last he could see clearly
the fate that threatened him if he did not reform. After only
four or five days of diet and complete abstinence he looked and
felt like a different man. His irritability vanished; he was
cheerful and altogether lucid. His mother, who watched him
with anxious eyes, was able to write to Maurice Joyant on
March 12, 1899, only a fortnight after the beginning of his in-
ternment: " He can read and amuse himself a little by drawing.
ing." The desire to work came back almost at once, and with
it his sense of humour. On March 17 he wrote to Joyant, ad-
dressing him facetiously in English as " Dear Sir ":

> " Thank you for your charming letter. Come to see me.
> " *Bis repetita placent.*
>
> <div align="right">Yours,</div>
> <div align="right">T. L.</div>
>
> " Send me some prepared [lithographic] stones and a box of
> water-colours with sepia, some brushes, lithographic crayons,
> Chinese ink of good quality, and paper.
> " Come soon and send Albert [the painter Joseph Albert?]
> with the things.
> " Bring a camera, the garden is wonderful with its Louis XV
> statues. It used to be a rendezvous for courtly lovers."

The faithful Joyant, who had been in constant touch with
the doctors, Lautrec's family, and the painter himself, visited
the sanatorium as soon as he could obtain permission from the
medical authorities. The two friends walked in the lovely gar-
den under the trees, and Lautrec showed Joyant a woodcock's

feather he had picked up a few days before and fashioned into a sort of paint-brush, a rough substitute for the proper implements he lacked. He was in good spirits and made no complaint of his treatment at the sanatorium; but he was determined to leave as soon as he could and already looked forward impatiently to the day of his release. He felt perfectly well already and could see no reason for a long period of internment.

Lautrec knew, however, that before he could regain his freedom he would have to prove his sanity to the complete satisfaction of the doctors. He decided that the most effective proof he could offer must take the form of pictures — pictures that no madman could possibly produce. When the crayons and other materials supplied by Joyant arrived, Lautrec turned his little room into a studio and set to work on the remarkable set of circus drawings (Plates 34–35), which he completed entirely from memory in a few weeks. In addition he painted a portrait of his keeper, a man of pleasant appearance whose sensitive features bear no trace of the brutality so often (though perhaps mistakenly) associated with madhouse attendants. He also made more than a dozen sketches of his fellow patients at " Madrid-les-Bains," as he jocularly called the asylum.

Other devoted friends soon followed Joyant to Lautrec's retreat: Maxime Dethomas, the sculptor Carabin, and Arsène Alexandre. All were agreeably surprised to find him so well, so cheerful, and in such an attractive environment. One person who might have been expected to hasten to Lautrec's side, to take the keenest interest in his welfare, was conspicuously absent: his father. Lautrec wrote a pathetic note to Count Alphonse, an appeal for help in his struggle to be free:

" Papa, here is an opportunity for you to act like a good man. I am imprisoned, and everything that is imprisoned dies! "

Perhaps Lautrec was thinking of his father's own words, written long ago on the fly-leaf of a book on falconry: " Everything

which is deprived of liberty deteriorates and dies quickly." But if Lautrec remembered these words in his extremity, the count had forgotten them. He remained in the country and made no attempt to see or assist his son. He wrote to Joyant that he felt that Henri's internment was the inevitable result of his intemperance, " although there is something revolting, at first sight, in this restriction of the right to drink, a right which belongs to the French people as much as to their neighbours." He did not approve of the examination by the doctors, which he considered useless and for which, he pointed out, he was in no way responsible. Having delivered himself of this characteristic but not very helpful opinion, Count Alphonse washed his hands of the whole business and went hunting.

Naturally the news of Lautrec's internment caused something of a flurry in Paris. If he had faithful friends whose loyalty never failed him for a moment, he had also, during the course of his life, made enemies. His sharp tongue, his uncompromising independence, his contemptuous refusal to pander to the prejudices of men he considered unworthy, had infuriated certain critics whose opinions he had openly scorned for years. His downfall was the signal for an attack, and for a few days after his internment the newspapers dripped venom. On March 26, 1899, *Le Journal* published an article entitled *La Vraie Force* by Alexandre Hepp:

" Toulouse-Lautrec's friends will say that they are not surprised, that his life had to end in this way, that Toulouse-Lautrec was destined for the asylum. He has just been locked up, and now his pictures, his drawings, and his posters will be officially signed by the madness which has for so long been anonymous. Suddenly, even when he tried hard to make his work gracious and smiling, what a spasm of contortion and grimacing would take possession of it, what an epic nightmare of deformation, what an astounding mastery of the bizarre and

334

the horrible! The man himself, deformed, lame, grotesque, was that rare phenomenon, a symbol of his own work; more than one of his extraordinary figures is endowed with his own features and his own manner, as if they were an obsession; the influence of his own physical disability is apparent a hundred times over in the most curious fashion; the artist's body seems to have affected his models directly, cruelly, physically, as if it had no soul of its own to liberate it.

" But it was above all in his attitude towards life that the true mentality of this candidate for the madhouse revealed itself. The conversation of Toulouse-Lautrec seemed to spring from an all-embracing desire to destroy. In the opinion of his talent nobody else had any talent; for this heart nobody else had any heart. The world contained only idiots, knaves, and rogues. . . . I do not deny that these opinions were sometimes justified. But what a strange conception, what a consistently gloomy outlook, what a determination to suspect, disparage, and degrade everything, or rather what a persecution mania! In truth, that is the fashion today. . . . But I am always wary of this passion for destruction, of these arrogant criticisms, of these contemptuous and high-and-mighty superiorities. All of a sudden they collapse. And it is the simple people who remain and are content; it is the good men who are to be envied, those who know how to appreciate the wine even when the cup is cracked. They are the strong ones."

No doubt Monsieur Hepp's diatribe against the forces of destruction was sincere, but its application to Lautrec was rank injustice. Lautrec destroyed himself, it is true, by dissipation; but neither in his own work nor in his criticisms of the work of others did he demolish anything that was worth preserving. His appreciations, as we have seen, were warm and generous, his enthusiasms far more potent than his dislikes.

On March 28 an article by Edmond Lepelletier, *Le Secret*

335

du Bonheur, appeared in *L'Echo de Paris*. This was kinder to Lautrec as a painter but even less trustworthy in its evaluation of the man:

" A chorus of pity, touchingly unanimous and without a discordant note [this must have been written before the publication of the article by Hepp], has been chanted over the fate of the painter Toulouse-Lautrec, who was recently interned in a madhouse. . . .

" An original and powerful artist, Toulouse-Lautrec had — alas! when we speak of him, we must already use the past tense of an obituary notice — rapidly acquired a certain amount of notoriety. A slow worker, an experimenter, a dreamer, he studied each picture for a long time. He painted only after much careful hesitation. He sought neither easy popularity nor widespread publicity. Even his least important productions, put together, simplified, thought over at great length, have a depth and an intensity which assures them an honoured survival. In addition to his paintings and his illustrations, which he made so fresh, so capricious, and so poetic, he became at a single bound a master of the art, apparently so easy but recognized as full of difficulties by all true artists, of the poster. . . ."

So far this is fair enough. But when the journalist goes on to accuse Lautrec of laziness, of wasting his opportunities, of having done too little work — Lautrec, one of the most industrious artists who ever lived and, considering the length of his career, one of the most prolific! — he allows his imagination to run away with him. One might have expected Lepelletier to be more just, or at least more charitable; for years he had been the devoted friend and champion of the dissolute Paul Verlaine, who died in 1896. Apparently he had lavished his entire stock of sympathy on the poet and had none left for the painter:

336

" It is regrettable that this artist, so admirably gifted, should have produced so little. He had in him the seeds of congenital carelessness and hereditary laziness. He was descended, more or less legitimately [!], from the Counts of Toulouse and the Marshal de Lautrec. To have had roots that reach as far into the past as the First Crusade and the battle of Marignan is impressive, but to the imagination only. The fruit of such genealogical trees is generally shrivelled and eaten out by a worm at its heart; it is only near the trunk that these branches of the aristocracy are robust. The last descendant of an exhausted family, the victim of the too exuberant growth of his ancestors, the painter of Montmartre looked like a caricature of his forefathers. Puny, stunted, deformed . . . the unhappy degenerate was well aware of the absurdity of his double misfortune: that of being an abortion, and that of being a nobleman without a penny. . . . Wealth would have increased the stature of this midget who bore the name of a paladin united with that of one of those who fought chivalrously beside Bayard in the prodigious battle of 1515 which has been called the Battle of the Giants. But Toulouse was poor, and his battles were only those which are waged for pocket-money.

" Either through weakness or pride he continued to flaunt the glorious name of his ancestors. He did not have the modesty to adopt a plebeian pseudonym; though it is true that he did not benefit financially by his title, for he made no attempt to barter his birth certificate for the dollars of a daughter of some Chicago meat-packer. . . . Unfortunately Toulouse-Lautrec did not behave at all like an ancestor; his virgin palette and his unused brush, like a shield that was seldom dented and a sword that remained too often idle in its scabbard, proved only too well that all he had inherited from his ancient blood was a fondness for pleasure and a distaste for that proletarian virtue, hard work.

" Through a quirk of character that seemed like a moral chastisement, a visitation of divine wrath upon the seventh

337

generation, this poor fellow, so deformed, so awkward, so un-gainly, was an ardent lover of women. He sought love at ran-dom. . . . He was a hunchbacked Don Juan, pursuing his ideal amidst the most tawdry realities. . . . The sordid de-bauchery, the travelling-salesman adventures that Toulouse-Lautrec delighted in, and into which he led his companions, certainly contributed, together with the chagrin caused by the realization of his physical misfortunes and his moral deca-dence, to his confinement in a cell."

There is some truth in the last paragraph, though the word-ing is unnecessarily harsh; but there is none whatever in the sneers about the " virgin palette " and the " unused brush," in the suggestion that Lautrec was a physical and moral degen-erate from birth, or in the insinuation that he made capital of his name and family connections for the sake of " pocket-money." The most damaging portion of the article, however, comes at the end:

" Now, in this strange paradise of human degeneracy, in this bizarre Valhalla of a madhouse, which has terrors only for those unfortunates who are still burdened with their reason, he is enjoying the greatest possible felicity. He rejoices, with-out frustration, in what he believes to be his strength, his beauty, and his talent. He can produce endless frescoes, he can paint unlimited canvases with staggering skill; at the same time he can embrace glorious bodies, he is surrounded by slim and lovely shapes, and inexhaustible delights fill his constantly refreshed being with new sensations. Thanks to his happy de-rangement he can wander far from the ugliness and sadness of the world towards the enchanted islands of which he is the king. He sells no more art, he buys no more love; he is in heaven.

" We do wrong to pity him, we should envy him. . . . Ah! that fortunate Toulouse-Lautrec! It is only fair to add that he

has suffered enough to deserve his bliss, and that he is entitled, after his experiences with the half-madness which he endured in common with most men, to revel at last in the divine nothingness of complete insanity."

Of course this highflown, fanciful, wholly imaginary description of Lautrec's condition bore not the slightest relation to the truth. The false assumption that the painter had really lost his mind, that he was incurably insane, had to be refuted once and for all. Lautrec himself was helpless; even if he was aware of these attacks — and he probably was not — nothing that he could have said or written, in the circumstances, would have been convincing. But his indignant friends hastened to defend him, and Arsène Alexandre was delegated to write a long article which was published in *Le Figaro* on March 30, only two days after Lepelletier's column appeared. It was headed *Une Guérison:*

"In Paris, one seldom takes the trouble to discover the truth if one has to walk two steps to learn it. . . . This city is sublime, it abounds in great talents, in honest and profound intelligences, and yet it sometimes takes on the disconcerting aspect of a bear-garden.

"During the last few days everyone has been busy burying the painter Henri de Toulouse-Lautrec, a Parisian if ever there was one, and not a single Parisian has taken the trouble to find out if he might not be still alive before pronouncing his funeral oration.

"Floods of ink have been poured over his name and his work; he has been spoken of in the past tense. Some of the articles have been philosophic, others have assumed a tone of friendly compassion; some have been indulgent, some venomous. Not one has been simply accurate. Among the public, among little groups, a legend has been created, and nobody has verified it.

" All this is very Parisian. You have made a position for yourself there, you have played your part for good or evil, you have attracted attention. You disappear for a week: your absence is explained in one way or another, your name is erased, and it's all over: *bon voyage!* If you return, that's your mistake.

" What has been written about Lautrec is incredible. One cannot believe that any of those who have devoted entire columns to him ever knew him. According to these articles the poor fellow's condition is hopeless, he has been condemned to death by his doctors, doomed to complete paralysis: actually he has never been in better health. They say he is mad; that he has lost his memory, the use of his eyes that once observed things in such a ludicrous and penetrating way, the use of his hands that wielded a pencil so bitingly and so subtly: actually he can still draw magnificently and is full of energy. Some say he is a pitiful madman, an unfortunate lunatic: he is really a remarkable artist. He has been called a beggar who would do anything for a five-franc piece: he has an income sufficient to enable him to work as he pleases. They say he produced very little, having a distaste for any serious work: for fifteen years he has been working with a veritable passion, a veritable frenzy, and his production is enormous. Except for these details, all that has been written about him is more or less true.

" Lautrec, to be sure, wore a mask, and very few people have taken the trouble to lift it. He played a part, wilfully, intentionally, and people thought that he was merely being himself. He portrayed his models with an ironic, mocking, even cruel touch, and everyone believed that he was baring his own soul. Because he was injured when he was a child, and traces of that injury remained, he was considered a monster. When he fell ill, he was spoken of as dead.

" Well, it is the real Lautrec that I propose to describe today, and then I shall tell, for the benefit of those who have been mourning him with secret delight and to reassure those who

340

know and understand him better, how he is actually feeling and how well founded is our hope of extricating him from what is nothing more than a temporary scrape. . . ."

After a short discussion of Lautrec's work Monsieur Alexandre continues:

" In his passion for truth, in his determination to paint the brutish side of life as it actually was, he was obliged to seek his models where he could find them — that is, in bars and brothels. And this is where Lautrec's case becomes complex and painful. This curious and courageous little man went down into the inferno, but he got his beard singed. Alcohol, abominable alcohol wrecked the painter for a time, as it has wrecked his models. . . .

" No doubt Lautrec would have been just as great an artist, even a much greater one, if, when he painted the people who frequent bars, he had not found it necessary to drink cocktails by the hundred. But the poor fellow has his weak spots; a great many of them, in fact; I do not despise him for them, but I regret them, and although his faults are sometimes the complement of his virtues, I prefer to recognize what was good, superlatively good, in him. . . .

" This roguish little man, of whom so many of his so-called friends have made fun while they laughed with him and at him, is a profound and gentle person with whom one can discuss anything from the most fantastic absurdities to the most interesting artistic problems. Moreover, his nature is upright and incorruptibly honest. His assumed mockery sometimes concealed a very real unhappiness, and in this life, in which so many people give poetic names to their appetites, he satisfied his own, after all, as best he could. He should have been loved and surrounded by protective care because of his weakness, because of the physical misfortunes that left his mind and his tal-

ent unimpaired; instead he has been laughed at, tossed about like a shuttlecock; people have amused themselves by watching him drink and encouraging him to drink, and many of those who have expressed their pity in hypocritical words have often quenched their thirsts at his expense. Nevertheless he has had some good and honest friends, and it is these who will have saved him, God willing.

" When, just recently, Lautrec began to suffer from the effects of alcohol — no longer its milder consequences, but its very grave dangers — it became necessary to call a halt. It became necessary to remove him instantly from his habitual environment and place him in an asylum where all pernicious drinking was prohibited. Similar measures are taken for morphine addicts, for people suffering from some severe nervous shock.

" But the word ' asylum ' immediately suggests to the public mind such terrifying images! One sees the cell, the strait-jacket, the forced bath, insane cries, the hanging tongue, the haggard eyes.

" Now, this is what I really saw.

" In a suburb near Paris . . . I entered a house not far from the Seine and in the neighbourhood of some woods. A perfectly delightful house, built in the reign of Louis XVI for some powerful and wealthy merchant who spared no expense in its construction. . . .

" It was in this anything but gloomy setting that I saw a madman who was full of wisdom, a dipsomaniac who had stopped drinking, a doomed man who was never in better health. With our good little old friend we paced up and down the long avenues, clambered over the ' ruins,' picked violets, talked of all sorts of things both amusing and serious: the principal and very refreshing subjects of our conversation were the flowers, projects for new pictures, the arbours, the greenhouses, and Pajou's statues.

" With his usual mocking alertness Lautrec cried as soon as

he saw me: ' You've come to interview me.' That, my poor friend, was certainly not my intention; but that is what I did without realizing it, with the best of motives.

" Once, for a moment, we found ourselves alone with Lautrec in the doctor's salon; on a small table were some crystal goblets and a bottle filled with a beautiful liquid the colour of gold. ' That's *quinquina,* you can't have any,' said Lautrec with such a droll air that we all burst into laughter. There was in it something of the child who has been deprived of his dessert, something of the man who is waking from a bad dream, and something of the invalid who feels his health returning by leaps and bounds.

" For in his present condition one might almost send him out into the world again, back to his work, to his studio. There is so much intense vitality in this so-called failure, such a reserve of strength in this so-called abortion, that even those who watched him as he rushed headlong to his doom are amazed to find him so completely rehabilitated. . . .

" However, there's the rub. Caught in a trap and forcibly cured, he has become well and lucid once more. But when he leaves there, tomorrow or in a fortnight or three months hence? When he is again able to smell the fumes of gin, beer, absinthe, or rum which rise, like noxious vapours, from the pavements of Paris at certain hours and in certain streets? When the swarms of thoughtless revellers, of parasitic good fellows, of bizarre and dubious idlers, their appetites whetted by his return from such a distance, swoop down once more on their too easily captured victim and plaything; when his real friends find themselves again almost powerless, in spite of their devotion, to protect him against himself: what will happen then?

" There is something tragic, all the same, in the thought of what the great city sometimes makes of her rarest talents, of her most precious minds. . . . At a distance of three kilometres from us he is cured — but what if he should come nearer?

" Nevertheless, I was reassured and I can reassure others. It

343

would have been too sad otherwise! Now, if I am reproached for having spoken very seriously of a man at whose expense many amused themselves without having understood him, I can reply that the pleasure of performing an act of justice is equalled only by that of holding up to ridicule certain people who, with less reason, are taken too seriously."

Arsène Alexandre's vigorous affirmation of Lautrec's sanity silenced the painter's detractors — only temporarily, it is true, but for the moment effectually. What was even more important, it impressed the doctors on the staff of the sanatorium. Two of them, Dr Dupré and Dr Séglos, were hastily summoned to a consultation on March 31, the day after the article appeared. Their report is quoted by Joyant:

" The undersigned doctors, called into consultation on the case of M. Henri de Toulouse-Lautrec, have noted the following symptoms: M. H. de Toulouse-Lautrec, during an examination that lasted more than an hour, was perfectly calm, and his behaviour was altogether different from that observed at our previous examinations. At no time did he show any signs of either emotional strain, excitement, or mental depression. Moreover, a very careful examination failed to disclose any of the definite delirious hallucinations noticed in our previous report. The patient is entirely aware of his present situation, of the place he is in, the circumstances that brought him here, and the improvement that has taken place in his condition. He is not idle, is interested in what is going on in the world outside, reads newspapers and pamphlets, and has resumed his artistic occupations.

" From a physical standpoint he shows a great improvement in his appetite, his digestion, his ability to sleep, and his general alimentary condition.

" There can be no doubt that such a rapid and notable im-

344

provement must be attributed entirely to the fact that he has been deprived of alcohol by his regimen and isolation.

"It is no less certain that this improvement, still so recent, cannot be maintained and made permanent unless the convalescent continues to follow the same system of physical and mental hygiene.

"Therefore we advise that M. H. de Toulouse-Lautrec be kept in the institution where he has recovered his health for an additional period of several weeks.

"The exact date of his release cannot be determined until after another examination has been made and the opinion of the visiting specialist, Dr Sémelaigne, obtained. This program can be carried out all the more easily in view of the fact that the convalescent himself is in no way opposed to the idea of a prolongation of a regimen which he supports very well, especially since Dr Sémelaigne has recently permitted him to go out on trial excursions as a preparation for his ultimate release."

Accompanied by his keeper, Lautrec went for a walk every day in the Jardin d'Acclimatation, where the sight of the animals in their cages fascinated him as much as ever. Perhaps he looked at them now with different eyes, since he himself was in a sort of cage; but unlike the inhabitants of the zoo he was sure that he would soon be free again. He made no attempt to drink on these outings, but he took an impish delight in encouraging his not very conscientious guardian to stop at one of the cafés in the Bois for a surreptitious nip — or several nips — and was perversely overjoyed whenever he succeeded in bringing the man back to the sanatorium half drunk, while he himself virtuously remained sober. After six weeks of internment he tried to obtain permission to go out with one of his friends, the painter Joseph Albert, unaccompanied by the keeper, whose constant presence bored and irritated him. Since this plan re-

quired his mother's approval, Lautrec wrote to Albert on April 12, 1899:

" I have seen my mother. There is still some difficulty but I think it will be all right. Go to see her and ask her for a written authorization, made out in proper form, to take me out yourself, giving as a reason my need to attend to urgent business — something connected with the jury and the printing for [the Exposition of] 1900, for example. I am a member of the section for posters and must sign some papers. Come to see me if you can. Adèle [Lautrec's mother] will write anything you suggest.

<div align="right">Yours,</div>

<div align="right">Lautrec</div>

" Greetings to the other brothers and tell Maurice [Joyant] that his album [of circus drawings, which Manzi, Joyant et Compagnie were to publish later] is growing.

" The director is not here, the request must be addressed to M. Teinturier, his deputy."

Lautrec seems to have used his position on the poster committee of the Exposition merely as an excuse to spend a few hours outside the walls of the sanatorium. We do not know whether or not the countess wrote the required letter, or whether, if she did, the authorities at the sanatorium granted or refused permission for the outing.

Lautrec remained at " Madrid-les-Bains " for two and a half months. On May 17 another consultation was held at which Dr Sémelaigne as well as the doctors who had examined him in March were present. A report was issued that day:

" The undersigned doctors, summoned to a consultation with Dr Sémelaigne on May 17, at the request of Madame la Comtesse de Toulouse-Lautrec, for the purpose of examining her son M. Henri de Toulouse-Lautrec, have established the following facts:

346

" The physical and mental improvement already noted at the time of the last consultation on March 31 has been maintained. The symptoms of delirium which caused the internment of the patient some months ago, but which had already disappeared before the last consultation, have not returned. The symptoms of alcoholic poisoning are no longer perceptible today, except for a slight trembling. The general state of health is satisfactory; the patient continues to read, to paint, to work. One might therefore consider this a complete and definitive cure if it were not for one symptom of the greatest importance, very apparent to the doctor in charge and noticeable even to the acquaintances of the patient: a faulty memory (amnesia) . Nevertheless, because of the nature and continuation of the general improvement, we can authorize the immediate release of the patient.

" Still, on account of his amnesia, the instability of his character, and the weakness of his will, it will be vitally necessary to provide M. H. de Toulouse-Lautrec, in his life outside, with the material and moral safeguards of constant surveillance, to prevent any possibility of a return to his pernicious habits which would cause a relapse even more serious than his original disorder."

Unfortunately no details as to the nature of the lapses of memory noted are given in the report. The amnesia certainly had not affected his ability to draw: the circus drawings which he executed without notes or models proved that Lautrec's memory was still, in some respects at least, phenomenal. Lautrec himself believed, probably with good reason, that his *tour de force* was largely responsible for the doctors' decision to release him: " I have purchased my liberty with my drawings," he told Joyant proudly.

He realized how desperate his condition was when he was first interned, how urgently necessary were the drastic measures taken by his mother and his friends to place him beyond

the reach of temptation. Nevertheless he was inclined to cherish a certain mild resentment, after his release, against those who had dared to interfere with his freedom of action. He railed, most unreasonably, against the doctors: " Those people," he complained to Joyant, " think that ailments and patients were created just for their benefit."

RELEASE

LAUTREC left the sanatorium as soon as the doctors announced their decision. It was obvious, however, that complete liberty could only lead to disaster: he needed someone to watch him, to keep him interested and amused, to prevent a return to the bottle, against which the doctors had warned him. Fortunately such a watch-dog was available. Paul Viaud, a native of Bordeaux and an old friend of the Toulouse-Lautrec family, was summoned by the painter's mother to take charge of her son. Probably Viaud was as well fitted for this ungrateful task as anyone could have been. Having no business or family ties of his own, he was able to devote all of his time and attention to Lautrec. He was at once gentle and firm, good-natured and alert; he understood Lautrec and was fond of him. Lautrec, on his side, enjoyed Viaud's companionship; he did not object to his friend's tactful surveillance. Moreover, Viaud was afflicted with a poor digestion, a disguised blessing which made it impossible for him to drink even the mildest of intoxicants and thus simplified his task of keeping Lautrec sober. For more than two years, until the day of Lautrec's death, Paul Viaud was his constant companion.

349

For a short time after his discharge from the sanatorium everything went well. Lautrec stuck conscientiously to his good resolutions. He drank nothing, he exercised regularly on his rowing-machine, he worked. He was docile and in good spirits. His friends were tireless in their efforts to provide distraction for him, to invent entertainments. Some of these well-meant schemes were successful, others were not. Among the latter was an attempt to interest him in the displays of gowns and furs, hats and fripperies, at some of the fashionable dressmaking establishments. The parades of smartly dressed attractive young mannequins brought a mild gleam to his eye, but it was soon quenched. The whole atmosphere was too conventional, too genteel, too artificial; the effects were too stereotyped, the poses too studied. Nevertheless he made a few sketches of one of the mannequins, " Madame le Margouin." From these he produced a portrait, *La Modiste,* and a lithograph (D. 325) , both in 1900.

After his liberation Lautrec set about putting his financial affairs in order. Heretofore he had never worried much about money: he spent what his family sent him, sometimes wisely, more often foolishly, and thought no more about it. By 1899, however, his income had become considerably augmented by the sale of lithographs and prints. He seems to have suspected that his family intended to reduce his allowance and throw him more or less on his own resources. Whether his fears were founded on fact or whether they were merely a product of his imagination, it is impossible to say. But to humour him, as well as to curb any undue extravagance on his part, the family consented to a formal settlement. An agreement was drawn up whereby his affairs were to be placed under the control of a lawyer. His income was divided into two parts: the first consisted of his family allowance, the second of his own earnings; and Lautrec stipulated that the magnitude of the second account should be kept secret, so that his relations could not avail themselves of any potential increase in it as an excuse

to cut down the other portion. There appears to have been nothing reprehensible in this arrangement or in any other financial transaction to which Lautrec was a party. Yet his old enemy Jules Roques accuses him of the most contemptible avarice in an obituary notice published in *Le Courrier Français* on September 15, 1901, a few days after Lautrec's death:

" An expert on civil and commercial law, and a wealthy man, he never failed to squeeze every centime from the unfortunate print-sellers who handled his works. He was a combination of accountant and bailiff who adroitly set in motion all the machinery of justice and demanded a deluge of summonses whenever he saw his profits endangered, even to the extent of a very small sum."

This charge can be dismissed as sheer nonsense without the slightest foundation in fact. There is no evidence to indicate that Lautrec ever " squeezed " a penny out of anybody: for some years, at least, his posters, prints, and lithographs cost him more than they brought in. He did once go to law, it is true; but the provocation was extreme and the action completely justified. About 1895 he discovered that a number of his works were being counterfeited, signatures and all, and were being sold as genuine products of his brush and crayon. Lautrec objected, not unreasonably; the police seized the false copies, and the malefactors were promptly arrested, tried, and convicted. Joyant reports that one of them was a notorious forger of works of art who ended his career in exile in New Caledonia.

A few weeks after his release Lautrec went to Le Crotoy with Paul Viaud. His health continued to improve daily in the invigorating sea air. He fished, sailed his boat, and kept away from the taverns. Joyant quotes a letter written by Lautrec from Le Crotoy on June 22, 1899 to an unnamed friend, a journalist who had expressed a desire to write an article celebrating his recovery:

" My dear friend,

" I expect to return to Paris soon, and then we can discuss your article about me. If you are in a hurry call on Arsène Alexandre, who knows more about me than I know myself, and this letter will serve as an introduction to him if he requires one. During the sad experience I have just been through, Alexandre has been the best and most loyal of friends, and it was he who straightened things out for me. Anything he tells you will be correct."

Early in July Lautrec and Viaud set out for Le Havre, where they embarked for Bordeaux. But they lingered at Le Havre for several days before sailing, days which Lautrec spent in a waterfront bar, the Star, which he had discovered the year before. This was, at first glance, a fall from his newly acquired grace; but in fact, at this stage of his convalescence, it was work, not drink, that attracted him to the resort. The Star was full of incomparable models: English sailors, stevedores, jolly entertainers who sang coarse hearty songs, and, above all, the very pretty English barmaid known as Miss Dolly. Lautrec sent to Paris for painting and drawing equipment and set to work as soon as it arrived. Within a few days he produced a painting, *L'Anglaise du " Star " du Havre,* and half a dozen sketches, three of which furnished material for lithographs: *Petite Fille Anglaise — Miss Dolly* (D. 274) ; *Au " Star," le Havre* (D. 275) ; and *La Chanson du Matelot* (D. 276) . On July 11 he wrote to Joyant from the Hôtel de l'Amirauté, Le Havre:

" We acknowledge receipt of the painting materials. Today I made a drawing in sanguine of an Englishwoman at the Star, which I shall send you tomorrow by registered post. . . . I have met Guitry and Brandès; we expect to be at Granville in two days and will keep you informed.

" Greetings from the old ' *chump* ' [Viaud] and myself."

352

A few days later he wrote again:

" Yesterday I sent you by registered post a panel of the head of a barmaid at the Star. Let it dry and have it framed. Thanks for the good news about finances. I hope that my guardian [Viaud] will have reason to be proud of his charge. . . . We leave today for Granville."

Towards the end of July Lautrec and his " guardian " finally set sail for Bordeaux, whence they proceeded immediately to Taussat. Apparently Lautrec was still on his best behaviour. He wrote to Joyant from the Villa Bagatelle at Taussat; the letter is dated merely " July 1899 ":

" Your letter has arrived. We shall be here until further notice.

" I have a whale-boat that once belonged to the custom-house, and a boatman named Zakarie. We go fishing every day. Viaud embraces you and so do I."

During that summer and autumn of 1899 Lautrec did very little work. There was nothing unusual in that: Taussat had always been for him a holiday resort, a place for outdoor recreation, not for painting. He did produce one picture and two or three lively caricatures of Viaud, in one of which a chamber-pot figures conspicuously. Of greater importance was the fact that, while he was at Taussat, Lautrec remained sober and in good health. But when he returned to Paris with Viaud at the end of the year, the temptations of the city overpowered him once more. He rediscovered his old haunts, his dissolute companions. He began to drink again, at first in moderation, then suddenly to excess. Viaud and his other friends cajoled and threatened, but Lautrec paid no attention. The craving for drink was too strong, his resistance too weak. He knew that he was committing slow suicide, but he no longer seemed to

care. The will to live was gone; something was broken in his spirit; he was burnt out. He grew capricious and irritable again, though there were still flashes of his old gaiety. He could still laugh at himself and his own weakness. For an exhibition held in his studio in May 1900 he lithographed an amusing invitation (Plate 57) representing himself in cowboy costume standing before a benign cow, with the inscription:

> *" 5 avenue Frochot*
> " Henri de Toulouse-Lautrec will be very much honoured if you will be kind enough to drink a cup of milk with him on Saturday, May 15, about half past three in the afternoon."

It may be noted in passing that there are two curious discrepancies in this invitation. The address is given as 5 avenue Frochot, although Lautrec's studio was at number 15; and in the year 1900 May 15 fell on a Tuesday, not a Saturday. It is difficult to explain these slips of Lautrec's pen unless we assume that they were due to the haziness caused by alcohol. For by that time, unfortunately, the innocuous " cup of milk " had become a euphemism for something very much stronger. He drank steadily now: it was obvious to all of his friends that nothing could save him. Curiously enough his potations did not affect the quality of his work. His hand remained steady, his vision unblurred, until the end. One of the greatest pictures he ever painted, the portrait of Maurice Joyant (Plate 49), was executed during this year of progressive demoralization.

Very soon after the exhibition in the avenue Frochot Lautrec and Viaud went again to Le Crotoy, then to Le Havre. It was at this time that he met Lucien Guitry once more, at Honfleur, and agreed to design the program for Guitry's production of *L'Assommoir*. A great disappointment awaited him at Le Havre: all of his favourite bars had been either closed or reformed to such an extent that they no longer had any interest for him. He wrote ruefully to Joyant:

354

RELEASE

" Le Havre, 30 June 1900

" Old Chump [in English],

" The Stars and other bars are so closely watched by the police that there is nothing to be done; there are no more barmaids, so I am leaving for Taussat by the Worms Line this evening.

" Yours, H. L. and Co., very Limited indeed! "

The last phrase refers to the financial difficulties in which Lautrec unexpectedly found himself. The arrangement with his family, concluded the year before, after his release from the sanatorium, had already broken down. Lautrec had been wilfully extravagant since his return to Paris, but according to Joyant it was the members of his family, not the painter, who were chiefly responsible for the tension that now ensued. There had been serious floods in Languedoc that year, and the revenues of the family properties were curtailed by the partial failure of the wine crop. In violation of the signed agreement the manager of the estates proposed a corresponding reduction in Lautrec's guaranteed income. Lautrec was furious at what he considered a breach of faith. The violence of his rage must be attributed, at least in part, to the abnormal sensitiveness induced by alcohol, the nervous irritability which had now become chronic. Undoubtedly he was unreasonable, but he was also desperately ill in mind and body. The fact remained that a solemn pledge had been made and broken, and it was not Lautrec who did the breaking. Thenceforth until the end of his life he nursed his grievance; money, for which he had cared little in previous years, suddenly became an obsession. Perversely, spitefully, he took advantage of every opportunity to extort banknotes from his reluctant family.

He remained at Taussat until September, then went to Malromé to spend the autumn with his mother. But instead of returning to Paris as usual for the winter, he went to Bordeaux. There he plunged into work again and produced, within a few

months, the series of paintings of the opera *Messaline*, the drawings of Offenbach's operetta *La Belle Hélène*, and the sketches of the violinist Dancla. In addition he painted one or two portraits and made a magnificent drawing, worthy of Daumier at his best, of a scene at a masked ball: *Bal des Etudiants*. In this Paul Viaud is represented in evening dress, escorting a formidably buxom woman in domino, black gloves, and a mask. On the left is a clown, on the right and in the background the orchestra. On December 6, 1900 he wrote an encouraging letter to Joyant:

" I am working hard. You will soon receive some pictures. Where am I to send them, to the boulevard des Capucines or the rue Forest? Command me.

" I shall take this opportunity to ask you for two or three copies of the play *L'Assommoir*. Send them to the rue de Caudéran, Bordeaux. Here *La Belle Hélène* is delighting us, it is admirably staged; I have already caught the spirit of it. Hélène is played by a fat bitch named Cocyte.

" Viaud embraces you and so do I."

This was followed by a short note a few days later:

" Have you any photographs, good or bad, of *Messaline* by de Lara? I am enthralled by this opera, but the more documentation I have, the better I shall be able to work. The press has been very kind to my efforts. I embrace you."

A letter dated December 23 indicates that Lautrec's family still kept him short of funds. He needed money and meant to have it; but whether he proposed to borrow from Joyant or merely wanted his friend to collect what the family owed him is not clear:

" A merry Christmas and happy new year [in English].

" Send me without delay the programs and texts of *L'Assom-*

356

moir and *Messaline,* and especially the ' *blé* ' [dough] we need
to keep us going."

All this time Lautrec was drinking heavily, and his visits to
the brothels of Bordeaux became more and more frequent. In
the spring his health broke down again. He wrote to Joyant on
March 31, 1901:

" I see by *The New York Herald* that some of my pictures
are to be included in a sale organized by Mancini. Will you be
kind enough to took about the prices and write me about [*sic,*
as quoted by Joyant. The sentence is in English. I have been
unable to locate the original letter].

" I have some pain in my legs but am taking electric treat-
ments.

" I have received the Pope's blessing, here is the Bishop of
Bordeaux.

" He looks like Groult."

Enclosed in the letter was an amusing sketch of Cardinal
Lecot, Archbishop of Bordeaux. Groult was a well-known col-
lector of paintings. The sale referred to took place almost a
month later, on April 25. Four of Lautrec's pictures were sold
at prices that were fairly high for the works of a young artist
who was still living:

En Meublé 3,000 francs	
La Pierreuse 2,100 "	
A sa Toilette 4,000 "	
Gens Chic 1,860 "	

This was not the first time that Lautrec's works had changed
hands at public sales. Joyant lists a number of earlier transac-
tions that followed the sale of the *Courrier Français* drawings
in 1891. In November 1894 one sketch was sold for fifteen
francs and another for thirty; in 1895 a drawing brought 120

357

francs; in 1898 a pastel of *Les deux Amies* was sold for 200 francs. Then prices began to mount: 1,400 francs were paid for a painting, *Jeune Femme Assise,* in April 1899; and 720 francs and 1,250 francs, respectively, for two pictures in May 1901. There is no reliable record of Lautrec's private sales, but he seems to have disposed of very few pictures, for money, during his lifetime. He did sell his lithographs and prints; his paintings were either given away to friends or kept in his studio.

His condition was now serious, and he was once more obliged to conform to a strict regimen. On April 2 he complained wryly to Joyant:

" I am living on *nux vomica:* both Bacchus and Venus are forbidden. I work at my painting and even a little sculpture. When I am bored I write poetry."

If Lautrec really tried his hand at either sculpture or verse, the results have not survived. His last letter from Bordeaux was written on April 16:

" I am very satisfied [in English], I think you will be even more pleased with my new pictures ' about ' *Messaline.*

" I sent off the ' Gros Narbre ' [Lautrec's nickname for Maxime Dethomas] with two chameleons that rolled their eyes horribly. We had *café au lait* together at the station, and away he went, like Saint John the Baptist-Forerunner, to announce my arrival to you."

MALROMÉ

At the end of April Lautrec and Viaud returned to Paris with several huge cases of pictures, the output of the last nine months. His friends were shocked by the change in the painter's appearance. He looked thin and ill, his face was sallow, his appetite poor; he seemed pitifully frail and weak. Yet he was full of energy. He worked feverishly: he painted portraits of André Rivoire and Octave Raquin, one or two pictures of scenes in the Bois, and the important canvas *Un Examen à la Faculté de Médecine*. He seemed to realize that the end was approaching. He gave his studio a thorough house-cleaning such as it had not had for years: he dragged out pictures that he had left unfinished, added a few touches to some, destroyed others, signed those that he considered worth saving. He was preparing for death; he was anxious to put his affairs in order before it was too late.

In July 1901 he went back to Taussat, accompanied as always by the faithful Viaud. The friends who gathered to see him off had no illusions: they were certain that they were saying farewell for the last time. Lautrec knew it too. He was still courageous, but the forced cheerfulness of his smiles and jokes could not conceal his sadness.

This year, for the first time, the refreshing air of Taussat failed to produce an improvement in Lautrec's health. Day by day he grew weaker. By the middle of August his condition was desperate: a sudden stroke of paralysis came as a warning that the end was very near. Viaud sent an urgent message to Malromé, to Lautrec's mother, who came to Taussat at once. With Viaud's help she brought the dying man back to Malromé on August 20 and made him as comfortable as possible. There he lingered for three weeks. Throughout the entire period his mind was perfectly clear, and at first even his stricken body seemed to revive a little. The paralysis must have been slight, for he was not confined to his bed. He was taken out for short drives in a carriage through the beautiful park of the château. Sometimes he joined the family in the dining-room for lunch or dinner, but he had no appetite and could barely force himself to swallow.

He would not remain idle and wait for death, even now. He insisted on working at an unfinished portrait of Paul Viaud which hung over the mantelpiece in the dining-room. The portrait (Plate 58), representing Viaud in the uniform of an eighteenth-century admiral, had been begun the year before but abandoned before it was completed. Now Lautrec had himself lifted onto a ladder and exhausted the last remnants of his failing strength in the effort to carry on the work. But he was too weak to brush in more than a few strokes at a time; at length, unable to hold himself upright on the ladder, he was obliged to give up the struggle. The picture was never finished.

The forms of religion meant almost nothing to Lautrec, but when his mother, who was sincerely devout, urged him to receive the local curé he made no objection. He greeted his visitor with a grim jest: " *Monsieur le curé*, I am happier to see you now than I shall be in a few days, when you come with your little bell."

Dr Gabriel Tapié de Céleyran and some of the Pascal cousins came to see Lautrec at Malromé. His father arrived, but

his appearance seems to have brought small comfort to the dying son whom he had neglected for so many years. Coquiot recounts a number of fantastic stories concerning the count's behaviour at this time:

" The first thing he wanted to do was to cut off his [Lautrec's] beard, alleging that this custom was practised by the Arabs. It was only with great difficulty that he was prevented from carrying out the project.

" Then, armed with a strip of elastic torn from his boot, he endeavoured to chase away the flies which, he insisted, were biting the dying man.

" The day before the funeral, fearing lest the bearers of the body might be injured (if they did not lift it properly, he said, they would rupture themselves), did he not request that a diagram be prepared, in accordance with his own instructions, to show them how to handle the coffin? But this macabre dress rehearsal was refused him.

" After that he announced his intention of following the funeral procession on horseback, because his corns hurt him. And when this proposition was vetoed too, he said: ' Very well! I'll walk barefoot! ' But this also was turned down. Finally, on the very morning of the funeral, when everybody was waiting for him, someone was sent up to his room; and what did he find? There was M. de Toulouse-Lautrec, completely naked and busily trying to cut his own hair! "

In justice to Count Alphonse it should be noted that Maurice Joyant, the most reliable of Lautrec's biographers, repeats none of these anecdotes, though he does not specifically deny them. Probably these tales of the eccentric nobleman's antics are exaggerated; they should be accepted with reserve. Though there was, naturally enough, but little sympathetic understanding between Lautrec and his father, they were still united by a certain curious bond of affection. On September 15 Count

MALROMÉ

Alphonse wrote to Michel Manzi to thank him for a wreath sent from Paris, to be placed on Lautrec's grave. The letter contains two significant sentences:

". . . Joyant used to say of his schoolfellow: he was a gentle soul. Let a father be permitted to add that he did no harm to anyone.

" Towards me, he never displayed a sign of one of those outbursts in which bitterness takes the place of sweetness in the relations between father and son. . . ."

Lautrec died, fully conscious until the last moment, on September 9, two months before his thirty-seventh birthday. He was buried in the little cemetery of Saint-André-du-Bois near the gates of the estate of Malromé. He was not allowed to rest peacefully even in death. His mother learned that the authorities of the commune had under consideration a plan for the abolition of the cemetery of Saint-André, and she had the body of her son removed to the village churchyard of Verdelais, two miles from Malromé, where it lies today. The stone, now covered with moss, bears the simple inscription:

HENRI
DE TOULOUSE
LAUTREC
MONFA

1864–1901

BIBLIOGRAPHY

BOOKS

ALEXANDRE, ARSÈNE (notice de). *Au Cirque* (22 drawings by Toulouse-Lautrec).
Goupil et Cie (Manzi, Joyant et Cie, successeurs), Paris. 1905.

ANONYMOUS. *Guide des Plaisirs à Paris.*
Paris. 1900.

ASTRE, ACHILLE. *H. de Toulouse-Lautrec.*
Editions Nilsson, Paris. 1926.

BONMARIAGE, SYLVAIN. *Henri de Toulouse-Lautrec: sa Vie, son Œuvre.*
Marcel Seheur, Paris. 1931.

BYL, ARTHUR. *Yvette Guilbert* (8 lithographs by Toulouse-Lautrec). Translated by A Texcira de Mattos.
Bliss and Sands, London. 1898.

CATALOGUE: ART INSTITUTE, CHICAGO. *Loan Exhibition of Paintings by Toulouse-Lautrec.* 1930.

CATALOGUE: M. KNOEDLER & CO., NEW YORK. *Toulouse-Lautrec.* 1937.

CATALOGUE: MUSÉE D'ALBI.

CATALOGUE: MUSÉE DES ARTS DECORATIFS, PARIS. *Exposition H. de Toulouse-Lautrec.* 1931.

BIBLIOGRAPHY

CATALOGUE: MUSEUM OF MODERN ART, NEW YORK. *Lautrec.* 1931.

CLEMENCEAU, GEORGES. *Au Pied du Sinaï* (illustrated by Tou-louse-Lautrec).
H. Floury, Paris. 1898.

COQUIOT, GUSTAVE. *Lautrec.*
Auguste Blaisot, Paris. 1913.

COQUIOT, GUSTAVE. *Lautrec.*
Ollendorf, Paris. 1921.

COQUIOT, GUSTAVE. *Les Peintres Maudits.*
André Delpeuch, Paris. 1924.

DANES, GIBSON. *The Stylistic Development of Toulouse-Lautrec.*
Unpublished manuscript of a thesis. 1938.

DELTEIL, LOYS. *Le Peintre Graveur Illustré.* Volumes X and XI.
Loys Delteil, Paris. 1920.

DURET, THÉODORE. *Lautrec.*
Bernheim Jeune, Paris. 1920.

ESSWEIN, HERMANN. *Moderne Illustratoren: Henri de Toulouse-Lautrec.*
R. Piper, München and Leipzig. 1912.

FOSCA, FRANÇOIS. *Histoire des Cafés de Paris.*
Firmin-Didot et Cie, Paris. 1934.

FOSCA, FRANÇOIS (notice de). *Lautrec: 24 Phototypies.*
Librairie de France, Paris. 1928.

FRICHET, HENRY. *Le Cirque et les Forains.*
Alfred Mame et fils, Tours. 1898.

FULLER, LOIE. *Fifteen Years of a Dancer's Life.*
Herbert Jenkins, Ltd., London. 1913.

GEFFROY, GUSTAVE. *Album d'Yvette Guilbert* (16 lithographs by Toulouse-Lautrec).
André Marty, Paris. 1894.

GEFFROY, GUSTAVE. *La Vie Artistique.*
Série I, 1892; série IV, 1895; série VI, 1896; séries VI et VII, 1900. H. Floury, Paris.

GIBSON, FRANK. *Charles Conder: His Life and Works.*
John Lane, The Bodley Head, London. 1914.

GONCOURT, EDMOND DE. *La Fille Elisa* (facsimile edition of first sixty pages with illustrations by Toulouse-Lautrec).
Librairie de France, Paris. 1931.

GUILBERT, YVETTE. *La Chanson de ma Vie.*
Bernard Grasset, Paris. 1927.

JEDLICKA, GOTTHARD. *Henri de Toulouse-Lautrec.*
Bruno Cassirer Verlag, Berlin. 1929.

JOYANT, MAURICE. *Henri de Toulouse-Lautrec.* Two volumes.
H. Floury, Paris. 1926–1927.

JOYANT, MAURICE (notice de). *Henri de Toulouse-Lautrec: 70 Reproductions de Léon Marotte.*
Helleu et Sergent, Paris. 1930.

JOYANT, MAURICE. *La Cuisine de Monsieur Momo, Célibataire.*
Editions Pellet, Paris. 1930.

LANDRE, JEANNE. *Aristide Bruant.*
La Nouvelle Société d'Edition, Paris. 1930.

LAPPARENT, PAUL DE. *Toulouse-Lautrec.*
Editions Rieder, Paris. 1927.

LAPPARENT, PAUL DE. *Toulouse-Lautrec.* Translated by W. F. H. Whitmarsh.
Dodd, Mead and Co., New York. John Lane, The Bodley Head, London. 1928.

LECLERCQ, PAUL. *Autour de Toulouse-Lautrec.*
H. Floury, Paris. 1920.

MACORLAN, PIERRE. *Toulouse-Lautrec: Peintre de la Lumière Froide.*
H. Floury, Paris. 1934.

MAINDRON, ERNEST. *Les Affiches Illustrées, 1886–1895.*
Paris. 1896.

MELLERIO, ANDRÉ. *La Lithographie Originale en Couleurs.*
H. Floury, Paris. 1898.

MONTORGUEIL, GEORGES. *Le Café Concert* (22 lithographs by Ibels and Toulouse-Lautrec).
L'Estampe Originale, Paris. 1893.

MONTORGUEIL, GEORGES. *La Vie à Montmartre.*
G. Boudet, Paris. 1899.

RENARD, JULES. *Les Histoires Naturelles* (illustrated by Toulouse-Lautrec).
H. Floury, Paris. 1899.

RENAULT, GEORGES, and CHÂTEAU, HENRI, *Montmartre.*
Flammarion, Paris. 1897.

BIBLIOGRAPHY

REY, ROBERT. *Suzanne Valadon.*
Nouvelle Revue Française, Paris. 1922.

RICHARDIN, EDMOND. *L'Art du Bien Manger.*
Editions Nilsson, Paris. 1907 (?).

SARRAZIN, JEHAN. *Souvenirs de Montmartre et du Quartier-Latin.*
Jehan Sarrazin, Paris. 1895.

SCHAUB-KOCH, EMILE. *Psychanalyse d'un Peintre Moderne: Henri de Toulouse-Lautrec.*
L'Edition Littéraire Internationale, Paris. 1935.

SYMONS, ARTHUR. *From Toulouse-Lautrec to Rodin.*
John Lane, The Bodley Head, London. 1929.

TAPIÉ DE CÉLEYRAN, GABRIEL. *Généalogie de H. de Toulouse-Lautrec-Monfa.* Unpublished manuscript owned by Madame Gabriel Tapié de Céleyran, Albi.

VALBEL, HORACE. *Les Chansonniers et les Cabarets Artistiques.*
E. Dentu, Paris. No date.

VAN GOGH-BONGER, J. *Vincent Van Gogh: Brieven aan zijn Broeder.*
Maatschappij voor Goede en Goedkoope Lectuur, Amsterdam. 1924.

WARNOD, ANDRÉ. *Bals, Cafés et Cabarets.*
Figuière et Cie, Paris. 1913.

WARNOD, ANDRÉ. *Les Peintres de Montmartre.*
La Renaissance du Livre, Paris. 1928.

WARNOD, ANDRÉ. *Le Vieux Montmartre.*
Figuière et Cie, Paris. 1913.

PERIODICALS

ADAM, PAUL. *L'Assaut Malicieux.*
La Revue Blanche, No. 47, 15 May 1895. Paris.

ALEXANDRE, ARSÈNE. *Une Guérison.*
Le Figaro, 30 March 1899. Paris.

ALEXANDRE, ARSÈNE. *Le Peintre Toulouse-Lautrec.*
Le Figaro Illustré, No. 145, April 1902. Paris.

BIBLIOGRAPHY

ANONYMOUS. *Un Cahier Inédit de Toulouse-Lautrec.*
L'Amour de l'Art, April 1931. Paris.

AVRIL, JANE. *Mes Mémoires.*
Paris-Midi, 7–26 August 1933 (inclusive) . Paris.

BARAGNON, LOUIS-NUMA. *La Médecine et l'Art: Toulouse-Lautrec chez Péan.*
La Chronique Médicale, No. 4, 15 February 1902. Paris.

BERNARD, TRISTAN. *Toulouse-Lautrec Sportman.*
L'Amour de l'Art, April 1931. Paris.

BLANCHE, JACQUES-EMILE. *Les Objets d'Art.*
La Revue Blanche, No. 47, 15 May 1895. Paris.

CHAT NOIR, LE.
1882–1893 (inclusive) . Paris.

COOLUS, ROMAIN. *Le Bon Jockey* (illustrated by Toulouse-Lautrec) .
Le Figaro Illustré, No. 64, July 1895. Paris.

COOLUS, ROMAIN. *La Belle et la Bête* (illustrated by Toulouse-Lautrec) .
Le Figaro Illustré, No. 66, September 1895. Paris.

COOLUS, ROMAIN. *Les Deux Sœurs Légendaires* (illustrated by Toulouse-Lautrec) .
Le Figaro Illustré, No. 66, September 1895. Paris.

COOLUS, ROMAIN. *Souvenirs sur Toulouse-Lautrec.*
L'Amour de l'Art, April 1931. Paris.

COURRIER FRANCAIS, LE. Drawings by Toulouse-Lautrec.
26 September 1886; 21 April, 12 May, 19 May, 2 June 1889;
23 October 1892; 2 July, 9 July 1893; 2 September 1894; 16
February, 3 May, 17 May 1896. Paris.

CRAUZAT, E. DE. *La Loïe Fuller.*
L'Estampe et l'Affiche, 15 December 1897. Paris.

DAUZATS, CHARLES. *Le Monde et les Etoiles des Cafés-concerts.*
Le Figaro Illustré, No. 75, June 1896. Paris.

ECHO DE PARIS (supplément littéraire illustré) . Illustrations by Toulouse-Lautrec.
25 December 1892; 9 December 1893. Paris.

ESCARMOUCHE, L'. Lithographs by Toulouse-Lautrec.
12 November 1893 to 14 January 1894 (inclusive) . Paris.

BIBLIOGRAPHY

FOCILLON, HENRI. *Lautrec.*
> Gazette des Beaux-Arts, June 1931. Paris.

G. B. *Lautrec Raconté par Vuillard.*
> L'Amour de l'Art, April 1931. Paris.

G. M. *Les Toulouse-Lautrec du Docteur.*
> L'Eclair, 18 June 1914. Paris.

GEFFROY, GUSTAVE. *Chronique Artistique.*
> La Justice, 15 February 1893. Paris.

GEFFROY, GUSTAVE. *Le Plaisir à Paris: les Restaurants et les Cafés-concerts des Champs-Elysées* (illustrated by Toulouse-Lautrec).
> Le Figaro Illustré, No. 40, July 1893. Paris.

GEFFROY, GUSTAVE. *Le Plaisir à Paris: les Bals et le Carnaval* (illustrated by Toulouse-Lautrec).
> Le Figaro Illustré, No. 47, February 1894. Paris.

GEFFROY, GUSTAVE. *Henri de Toulouse-Lautrec.*
> Gazette des Beaux-Arts, August 1914. Paris.

GUINON, ALBERT. *Les Bals Masqués* (illustrated by Toulouse-Lautrec).
> Paris-Illustré, 10 March 1888. Paris.

HEPP, ALEXANDRE. *La Vraie Force.*
> Le Journal, 20 March 1899. Paris.

HERS, JEAN DE L'. *La Vie et l'Œuvre d'Henri de Toulouse-Lautrec.*
> Express du Midi, 6 June 1914. Toulouse.

HUYGHE, RENÉ. *Aspects de Toulouse-Lautrec.*
> L'Amour de l'Art, April 1931. Paris.

JOLLIVET, GASTON. *Les Cafés-concerts.*
> Le Figaro Illustré, No. 75, June 1896. Paris.

JONCIÈRES, VICTORIN. *La Musique de Café-concert.*
> Le Figaro Illustré, No. 75, June 1896. Paris.

JOURDAIN, FRANTZ. *L'Affiche Moderne et Henri de Toulouse-Lautrec.*
> La Plume, No. 110, 15 November 1893. Paris.

KOLB, JEAN. *Vedette d'Autrefois.*
> Paris-Soir, 31 January 1929. Paris.

LAZAREFF, PIERRE. *La Triste Fin de la Goulue.*
> Paris-Midi, 31 January 1929. Paris.

368

LECLERCQ, PAUL. *Autour de Toulouse-Lautrec.*
La Grande Revue, November 1919. Paris.

LEPELLETIER, EDMOND. *Le Secret du Bonheur.*
Echo de Paris, 28 March 1899. Paris.

LEPELLETIER, EDMOND. *Actualités: H. de Toulouse-Lautrec.*
Echo de Paris, 11 September 1901. Paris.

MARTEL, TANCRÈDE. *Les Cafés-concerts d'Autrefois.*
Le Figaro Illustré, No. 75, June 1896. Paris.

MÉTÉNIER, OSCAR. *Aristide Bruant.*
La Plume, No. 43, 1 February 1891. Paris.

MICHELET, EMILE. *L'Eté à Paris* (illustrated by Toulouse-Lautrec).
Paris-Illustré, 7 July 1888. Paris.

MIRLITON, LE. Illustrations by Toulouse-Lautrec.
December 1886; January, February, March, August 1887. Paris.

NATANSON, THADÉE. *Sur une Exposition des Peintres de la Revue Blanche.*
Arts et Métiers Graphiques, 15 August 1936. Paris.

NATANSON, THADÉE. *Devant les Affiches de Lautrec.*
Arts et Métiers Graphiques, 15 March 1937. Paris.

PATRICK, EMMANUEL. *Les Bals de Paris: l'Elysée-Montmartre.*
Le Courrier Français, 15 August 1886. Paris.

PATRICK, EMMANUEL. *Les Bals de Paris: le Moulin de la Galette.*
Le Courrier Français, 26 September 1886. Paris.

REVUE BLANCHE, LA. Drawings by Toulouse-Lautrec.
March, June 1894; January, 15 May 1895. Paris.

RIRE, LE. Drawings by Toulouse-Lautrec.
22 December 1894; 26 January, 23 February, 3 August, 21 December 1895; 11 January, 8 February, 15 February, 28 March, 13 June, 24 October 1896; 9 January, 30 January, 24 April 1897. Paris.

RIVOIRE, ANDRÉ. *Henri de Toulouse-Lautrec.*
Revue de l'Art Ancien et Moderne, December 1901 and April 1902. Paris.

ROGER-MARX, CLAUDE. *Toulouse-Lautrec Graveur.*
L'Amour de l'Art, April 1931. Paris.

BIBLIOGRAPHY

ROQUES, JULES. *L'Elysée-Montmartre.*
Le Courrier Français, 20 June 1886. Paris.

ROQUES, JULES. *Nécrologie: H. de Toulouse-Lautrec.*
Le Courrier Français, 15 September 1901. Paris.

SYMONS, ARTHUR. *Notes on Toulouse-Lautrec and his Lithographs.*
Print Collectors' Quarterly, No. 4, May 1922. London.

THOMAS, LOUIS. *Henri de Toulouse-Lautrec.*
La Nouvelle Revue, 1 July 1913. Paris.

WEINDEL, HENRI DE. *La Capitale du Rire: du Quartier Latin à Montmartre.*
Le Rire, 12 January 1895. Paris.

WEINDEL, HENRI DE. *La Capitale du Rire: le " Chat-Noir " et son Ecole.*
Le Rire, 19 January 1895. Paris.

XANROFF. *Cabarets de Montmartre.*
Le Figaro Illustré, No. 75, June 1896. Paris.

SUPPLEMENTARY LIST OF BOOKS
PUBLISHED SINCE 1938

ANONYMOUS. *Toulouse-Lautrec. Twelve Drawings.*
Pantheon Books, New York. 1945.

BILBO, JACK (*pseud.* of Hugo Baruch). *Toulouse-Lautrec and Steinlen.*
Modern Art Gallery, Ltd., London. 1946.

BRIN, IRÈNE (foreword). *Images de Lautrec.*
Collezione dell' Obelisco. Carlo Bestetti, Rome. 1947.

CHARELL, LUDWIG. *Toulouse-Lautrec, 1864–1901. His Lithographic Work.*
M. Knoedler & Co., Inc., New York. 1950.

COOPER, DOUGLAS. *Henri de Toulouse-Lautrec.*
Harry N. Abrams, New York. 1952.

DELAROCHE-VERNET HENRAUX, MARIE. *Henri de Toulouse-Lautrec, Dessinateur.*
Quatre Chemins-Editart, Paris, and Shoman Art Co., New York. 1948.

GILLES DE LA TOURETTE, FRANÇOIS (foreword). *Lautrec.*
 Albert Skira, Geneva, and Fama, Ltd., London. 1947.
JEDLICKA, GOTTHARD. *Henri de Toulouse-Lautrec.*
 Eugen Rentsch Verlag, Erlenbach-Zürich. 1943.
JULIEN, EDOUARD. *Les Affiches de Toulouse-Lautrec.*
 André Sauret, Monte Carlo. 1950.
JULIEN, EDOUARD. *The Posters of Toulouse-Lautrec.* Translated
 by Daphne Woodward.
 André Sauret, Monte Carlo. 1951.
JULIEN, EDOUARD. *Toulouse-Lautrec* (drawings).
 Les Documents d'Art, Monaco. 1942.
KERN, WALTER. *Toulouse-Lautrec.*
 Alfred Scherz Verlag, Bern. 1948.
LASSAIGNE, JACQUES. *Toulouse-Lautrec.*
 Hyperion Press, Paris. 1939.
LASSAIGNE, JACQUES. *Toulouse-Lautrec.* Translated by Mary Cha-
 mot.
 Hyperion Press, London, Paris, New York. 1939.
QUENNELL, PETER (foreword). *Lithographs by Henri de Tou-
 louse-Lautrec.*
 De La More Press. Arcade Gallery Publications, London.
 1942.
ROGER-MARX, CLAUDE. *Les Lithographies de Toulouse-Lautrec.*
 Fernand Hazan, Paris. 1948.
ROGER-MARX, CLAUDE. *Yvette Guilbert Vue par Toulouse-Lau-
 trec.*
 Au Pont des Arts, Paris. 1950.
ROTZLER, WILLY (foreword). *Affiches de Henri de Toulouse-Lau-
 trec.*
 Editions Holbein, Basle, and Editions du Chêne, Paris. 1946.
VINDING, OLE. *Toulouse-Lautrec.*
 Nyt Nordisk Forlag Arnold Busck, Copenhagen. 1947.
ZIGROSSER, CARL (foreword). *A Portfolio of Twelve Reproduc-
 tions of Lithographs by Toulouse-Lautrec from the Philadel-
 phia Museum of Art.*
 American Studio Books, New York and London. 1946.

INDEX

INDEX

INDEX

INDEX